•

Delft Masters,
Vermeer's Contemporaries

•

.

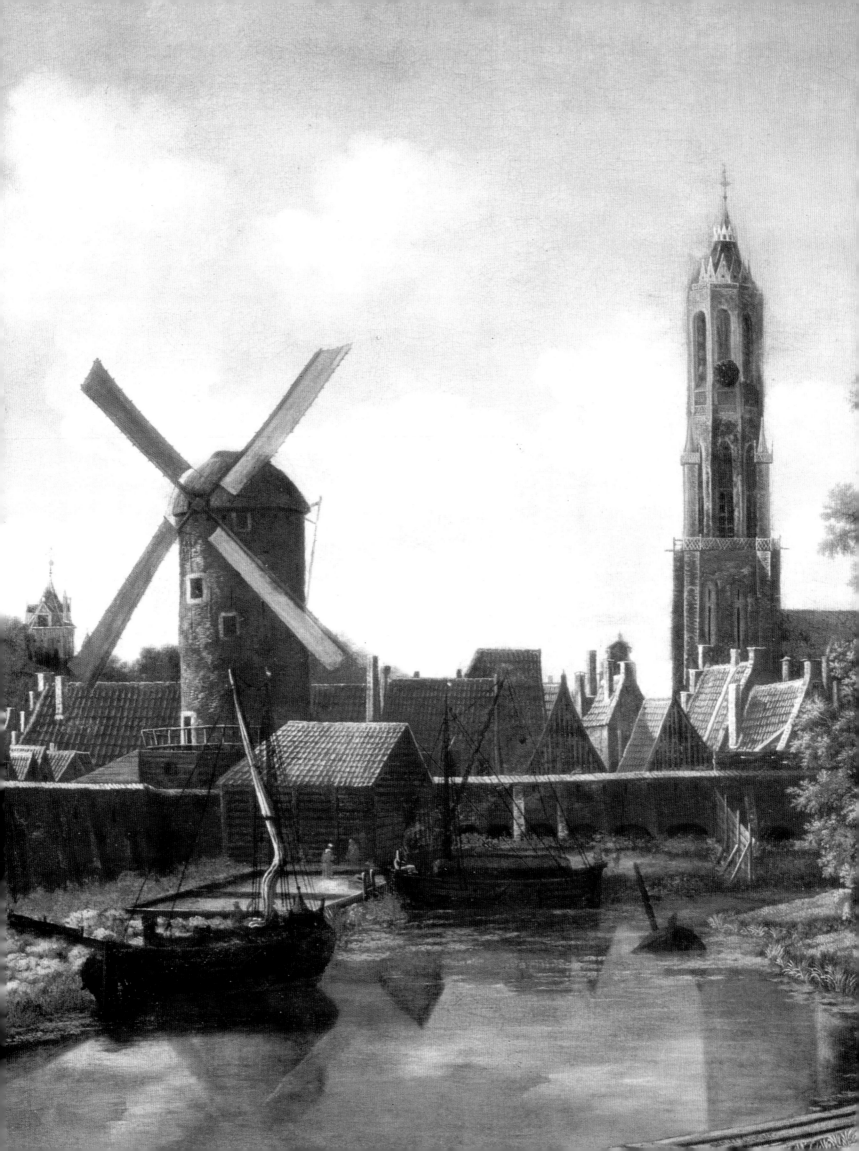

Delft Masters, Vermeer's Contemporaries

Illusionism through the Conquest of Light and Space

•

MICHIEL C.C. KERSTEN
DANIËLLE H.A.C. LOKIN

WITH THE CO-OPERATION OF
MICHIEL C. PLOMP

•

WAANDERS PUBLISHERS, ZWOLLE
STEDELIJK MUSEUM HET PRINSENHOF, DELFT

PUBLISHER
Waanders Publishers, Zwolle
Stedelijk Museum Het Prinsenhof, Delft

DESIGN
Richard van den Dool, Dordrecht

TRANSLATION
Andrew McCormick, Amsterdam

PRINTER
Waanders Printers, Zwolle

© 1996 Uitgeverij Waanders b.v., Zwolle
Gemeente Musea Delft

2nd edition

CIP-GEGEVENS KONINKLIJKE BIBLIOTHEEK DEN HAAG
Lokin, D.

Delft Masters, Vermeer's Contemporaries : Illusionism
through the Conquest of Light and Space / D. Lokin,
M. Kersten, M. Plomp. – Zwolle : Waanders. – Ill. Uitg. in
samenwerking met Gemeente Musea Delft. – Uitg. ter
gelegenheid van de tentoonstelling 1 maart - 2 juni 1996,
Prinsenhof, Delft
ISBN 90-400-9829-8 geb.
ISBN 90-400-9828-x pbk
NUGI 921/911
Trefw.: schilders ; Delft ; geschiedenis ; 17e eeuw.

Cover illustration front:
DANIEL VOSMAER
View of Delft with a Fantasy Loggia, detail ill. 84
Cover illustration back:
HENDRICK VAN DEN BURCH
Woman and Child at a Window, ill. 167
Illustration page 2:
DANIEL VOSMAER
The Harbour of Delft, detail ill. 83

Contents

This publication was made possible with the financial support of:

 Municipality of Delft

Delft 750 Years City of Culture

ABN·AMRO

Bouwfonds Nederlandse Gemeenten

 NV CASEMA kabeltelevisie

J.E. Jurriaanse Stichting

Van der Mandele Stichting

Stichting Het Princenhof, Delft

 stichting VSB Fonds Den Haag en Omstreken

6

Foreword

On 15 April 1246 Willem II, Count of Holland, granted a charter to "his beloved and loyal Magistrates and Citizens of Delft." As part of the festivities surrounding the 750th anniversary of the town's incorporation, the Stedelijk Museum Het Prinsenhof has organised a large exhibition of pictures by *Delft Masters, Contemporaries of Vermeer*, who were active in the city during the period 1650-1675. Their works form the apogee of painting in seventeenth-century Delft.

The past few decades have witnessed the appearance of numerous publications about Delft artists, and much attention has been devoted to genres of painting for which the city is particularly famed. Furthermore, an amazing amount of new information has been culled from local archives regarding the artistic life of the city during our period. The book you are holding is an attempt to make the fruits of this scholarship accessible to a broader audience. In the course of its preparation grateful use was made of the results of the research carried out by such distinguished scholars as Albert Blankert, Christopher Brown, Walter Liedtke, John Michael Montias, Peter Sutton and Arthur Wheelock.

With both the exhibition and the book we were fortunate to receive much valuable assistance. First of all I would like to thank the many lenders, both private and institutional, who were willing to part with their precious possessions for the duration of the exhibition and permitted us to reproduce them in this volume. Without their kind co-operation we would never have been able to present such a broad survey of one of the most important episodes in the history of Dutch art.

Besides the lenders, a great many individuals have contributed to the realisation of both the exhibition and the book. I am extremely grateful to all of them. In particular I would like to mention Marie-José Berger, Christopher Brown, Hans Cramer, Frederik Duparc, George Keyes, Rik van Koetsveld, Walter Liedtke and Peter Sutton.

As for the staff of the Prinsenhof, Marga Schoemaker-van Weeszenberg handled the loans, the photographs and the proofreading, with the assistance of Dolf Schröder, Wil van Reijen-Mienis and Yvonne de Beer-van der Hoorn. Léon van Ginneken took the financial administration of this sizeable project upon himself. And Michiel Kersten

helped me make the definitive selection for the exhibition and was intensively involved in the preparations.

The original Dutch text was admirably edited by Agnes Wiechmann-Oomens and, as regards the art-historical content, Michiel Plomp, who at a late stage of the undertaking agreed to write both the introductory chapter and the epilogue. On short notice Andrew McCormick managed to translate our findings into elegant English.

I would like to express our gratitude to Richard van den Dool, Wim Waanders, Henk van de Wal and Hans van de Willige for doing such a splendid job on the design and publication of the book.

Finally, I would like to thank the museums, institutions, collectors, art dealers, auction houses and private individuals listed on pp. 9 and 10. Without their generous co-operation we would not have been able to realise the exhibition or the accompanying publication.

DANIËLLE H.A.C. LOKIN
Director, Gemeente Musea Delft

8

9

W.R.C. Baronesse van der Feltz-van
 der Borch tot Verwolde
Luis A. Ferré, Ponce
J.P. Filedt Kok, Amsterdam
Jacques Foucart, Paris
Gordon Gilbert, St Petersburg,
 Florida
Adele Gilbert, St Petersburg, Florida
Jeroen Giltaij, Rotterdam
Cory Gooch, Malibu
Olle Granath, Stockholm
Diane De Grazia, Cleveland
W.R. Greeve, Wassenaar
Neil MacGregor, London
Ulrich Großmann, Nuremberg
Maarten van de Guchte, Champaign
Herwig Guratzsch, Leipzig
Anne d'Harnoncourt, Philadelphia
Henning Bock, Berlin
Sally Hibbard, Malibu
Wim Hoeben, Amsterdam
Hans Hoetink, The Hague
Poul ter Hofstede, Groningen
Michal Hornstein, Montreal
Joanne Irvine, Liverpool
David Jaffé, Malibu
Guido Jansen, Amsterdam
Lillie Johansson, Stockholm
Ulf G. Johnsson, Stockholm
Kathleen Jones, Champaign
Roswitha Juffinger, Salzburg
Dorothy Kellett, New York
Marijke de Kinkelder, The Hague
Wouter Kloek, Amsterdam
Claudia Klugmann, Leipzig
Michael Komanecky, Phoenix
Gerbrand Kotting, The Hague
Ingeborg Krueger, Bonn
Alastair Laing, London
Friso Lammertse, Rotterdam
Alexei Larionov, St Petersburg
Rebecca Lawton, Poughkeepsie
Helmut R. Leppien, Hamburg
Sam Line, Liverpool
Irvin M. Lippman, Columbus, Ohio
Thomas Llorens, Madrid
Kurt Löcher, Nuremberg
Michel P. van Maarseveen, Delft
Gayle Mault, Dorking
Nils Messel, Oslo

Fred Meijer, Delft
Mikel Milkovich, St Petersburg, Florida
Miklós Mojzer, Budapest
Jennes de Mol, Moscow
Eyk A. de Mol van Otterloo, Marblehead
Rose-Marie de Mol van Otterloo,
 Marblehead
J.R. ter Molen, Rotterdam
Philippe de Montebello, New York
John Michael Montias, New Haven
E. Muis, Groningen
James Mundy, Poughkeepsie
David McNeff, Liverpool
Renate Trnek Orat, Vienna
Inna Orn, Moscow
Peter Osborne, Liverpool
Susan Oshima, Los Angeles
Minora Pacheo, New York
Waldemar Pail, Salzburg
Mikhail Piotrovsky, St Petersburg
Peter van der Ploeg, The Hague
Joann Potter, Poughkeepsie
Carl Prusa, Vienna
Joseph J. Rishel, Philadelphia
Pim Romeijn, The Hague
Emily Rosen, Cleveland
Pierre Rosenberg, Paris
Christopher Rowell, Dorking
Samuel Sachs ii, Detroit
L.M.A. Schoonbaert, Antwerp
Anne-Cathrin Schreck, Nuremberg
Carl Schünemann, Bremen
Karl Schütz, Vienna
Wilfried Seipel, Vienna
David Sekers, Dorking
Hiromi Shiba-Lecompte, Ponce
Michele Smith-Peplin, Detroit
Irina A. Sokolova, St Petersburg
S.S.A.M. van der Spek
C.M. Spliethoff-van der Linde,
 The Hague
Pieter van Thiel, Amsterdam
Carolyn Thum, Cleveland
Julian Treuherz, Liverpool
Janna van der Velde, Moscow
John Walsh, Malibu
James Weitmann, Columbus, Ohio
Marion Widmann, Bonn
M.L. Wurfbain, Oegstgeest
D.C. Zeverijn, Paris

Introduction

In the 1640s and '50s a number of innovations were rather suddenly introduced at Delft in the painting of architecture, townscapes and genre scenes. We would like to shed some light on these revolutionary developments, not from the perspective of any one artist, but from that of a like-minded group.

Although art historians have discredited the notion of a 'Delft School', there can be no question that the artists in this city did have a number of interests in common, such as optics, light, colour, composition, perspective, and the city as a backdrop for their portraits of daily life. Around the middle of the century the provincial, somewhat derivative character of local painting was transformed and Delft rapidly evolved into an influential centre of art. This transformation manifested itself first of all in the work of painters who settled here in the period 1645-1675, some for a shorter, others for a longer time. These painters still number among Holland's most famous: Paulus Potter, Emanuel de Witte, Gerard Houckgeest, Carel Fabritius and Pieter de Hooch. Notwithstanding the diversity of the themes they treated and the genres in which they worked, they shared a number of artistic interests. It is precisely because their art has such a clearly recognisable identity that the term 'Delft School' enjoyed such a long and successful career. The most salient characteristic of their pictures is the illusionistic rendering of the subject, in which light and perspective play a crucial role. One is immediately struck by the new, more rational approach to the structure of the painted space. The painters experimented with perspective in an unparalleled fashion while at the same time studying the expressionistic potential of light and shadow. Thanks to the unexpected view points, the complex compositional schemes and the natural lighting, the pictures of the Delft masters seem extraordinarily true to life. The serene, silent atmosphere that many of these paintings evoke have left an indelible impression on our image of everyday existence in the seventeenth century.

Based on secondary literature and aimed at a general audience, this book deals with the elements that, in the period between 1645 and 1675, the art of the Delft masters shared. It shows how, in painting architecture, townscapes and genre scenes, they

employed the same pictorial means to enhance the illusionism of the images they created. We invite the reader to take an imaginary stroll with us through the streets of seventeenth-century Delft, to visit the Oude and the Nieuwe Kerk, and to have a look around a few of the houses.

The innovations we are referring to can be detected for the first time in depictions of church interiors. Around 1650 the painting of Gerard Houckgeest and Emanuel de Witte took a radically different course. An ingenious construction involving two orthogonal lines supplanted the traditional single-point (or central) perspective. One of the best practitioners of the genre was Hendrick van Vliet, a native of Delft who began painting the interiors of churches in 1652. His works betray his admiration for the contribution of Houckgeest and De Witte.

In the townscape, the same innovation manifests itself in the early 1650s, with the illusionism of the image again taking precedent. The rendering of the interior underwent a similar development. The changes can be seen especially in the pictures of Pieter de Hooch from the years 1658-1661. While members of the older generation, such as Gerard Terborch, depicted figures in a room against a dark background, thus focusing all the viewer's attention on them, the space in De Hooch's work is precisely defined and the painter situates his figures in a clearly recognizable three-dimensional environment. The painstaking construction of the perspective, the glimpses of other, remote spaces and the minute rendering of the light make these interiors seem almost tangible. The sunshine playing over the objects and figures was one of the artist's most effective tools. Hendrick van der Burch, who was several years older, drew considerable inspiration from his Delft colleague; the art of Cornelis de Man betrays the same influence. Non-Delft painters such as Pieter Janssens Elinga and Esaias Boursse were evidently impressed by the work of De Hooch as well.

Thus, the three genres we shall be discussing are united by their authors' mutual fascination with light and perspective as a means of heightening the illusionism of their pictures between 1650 and 1675.

PAINTING
IN THE CITY OF DELFT
1600 – 1650

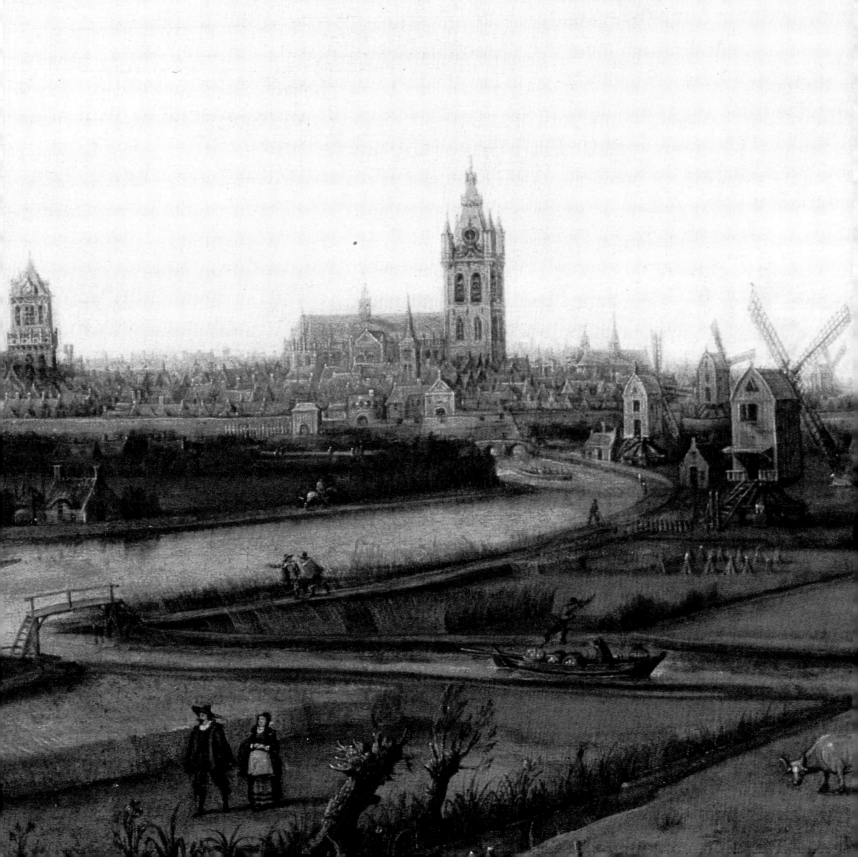

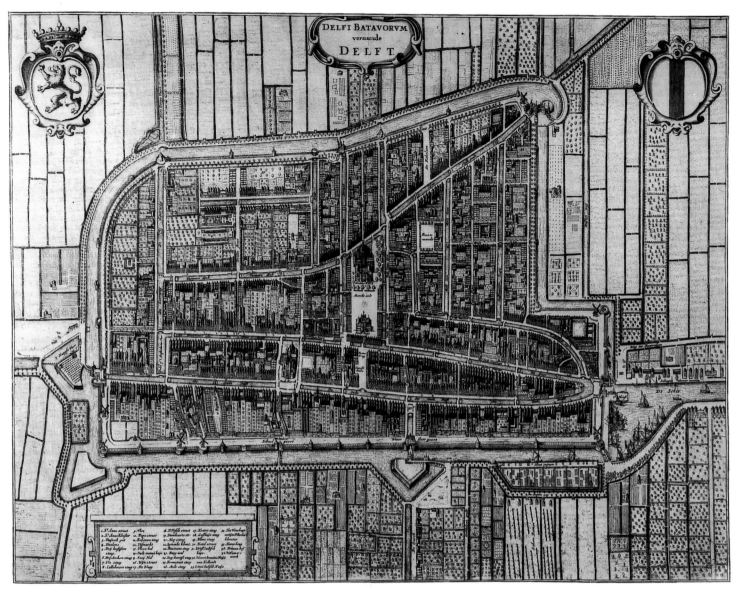

fig. 1
Plan of Delft from the 'Stedenatlas'
of J. Blaeu, 1649
copper engraving
Delft, Municipal Archives,
inv. no. D plan 8

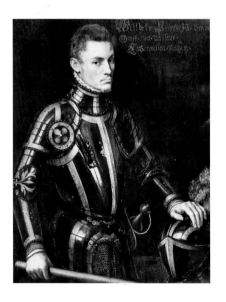

fig. 2
ANTONIS MOR (?) (COPY AFTER —)
Portrait of William the Silent at
Age 22, c. 1555
panel; 104 x 82 cm
Delft, Stedelijk Museum Het
Prinsenhof, inv. no. PDS 75

MICHIEL C. PLOMP

1 Painting in the city of Delft 1600–1650[1]

In May 1598 Aernout van Buchell, canon of the St Pieterskerk in Utrecht, paid a visit to the city of Delft. As he often did, this art historian *avant la lettre* jotted down his artistic observations in a journal. Remarkably, he considered no more than three of the city's living painters worthy of note. Only one of them, the portraitist Michiel van Mierevelt, is still known.[2] The modern art historian is inclined to think Van Buchell was right to devote so little attention to artistic life in Delft. In the late sixteenth century there were no great innovators in the city, after all, nor would there be until about 1650.

In the years between Van Buchell's visit and 1650, artistically speaking Delft was a crucible of the old and new. One important reason was the stream of Flemish immigrants who, as in every Northern Netherlandish city, stimulated late sixteenth-century artistic life enormously. Furthermore, painters in Delft followed artistic developments not only in such nearby towns as Haarlem, Amsterdam and Utrecht, but also in more remote centres such as Middelburg (in the Dutch province of Zeeland) and Rome. As illustrated by the works themselves, local artists borrowed at will from these diverse models until, slowly but surely, they arrived at a style of their own.

Before turning to the various pictorial genres we should say a few words about Delft in the seventeenth century: the city's relations with the House of Orange, its economy and the organisation of its painters.

DELFT: HISTORY AND ECONOMY

When the Dutch hear the word 'Delft', two colours invariably spring to mind: orange and blue. The sojourn here of William the Silent, Prince of Orange (1533-1584), and above all his tragic death in the Prinsenhof, created a lasting bond between the city and the House of Orange. The fact that almost all the Oranges are buried in Delft's Nieuwe Kerk (or New Church), has further strengthened this tie. Delftware, the production of which crested between 1650 and 1720, needs no introduction; indeed it is still one of Delft's most characteristic exports. Both associations colour our story: orange the historical aspects, blue the economic.

On 27 July 1572, when the bloody conflict that would become known as the Eighty Years' War (1568-1648) was only five years old, Delft took the side of William the Silent (fig. 2). The prince had often visited the city, where he was hosted by the learned art-lover Cornelis Musius, prior of the convent of St Agatha. In 1572 William made Delft his principal residence, as he felt that The Hague, lacking walls, was not sufficiently secure. The sessions of the States General and the States of Holland were therefore held in Delft as well. Hoping to make the best of this extraordinary opportunity, the city proposed that, being indefensible, The Hague be razed.[3] Primarily from his quarters in the convent, which had been renamed the Prinsenhof (now the Stedelijk Museum), William the Silent led the revolt against the Spanish oppressors – until, that is, on 10 July 1584, Balthasar Gerards fired the shot that fatally wounded the Prince and gouged a hole in the wall that can still be seen.

Thirty years after his death the States General honoured the *Pater Patriae* with a magnificent tomb designed by Hendrik de Keyser in the Nieuwe Kerk (see Chapter Two). The Prince's son and successor Maurice (1567-1625) spent little time in the city. When not on one or another military campaign he resided primarily in The Hague, which was no longer so vulnerable as it had been. Nor did Delft see much of Frederick Henry (1584-1647) (fig. 3), who succeeded his half-brother Maurice and during whose regime the negotiations that led to the Peace of Münster commenced; the 'Stedendwinger' (or Forcer of Cities), as Frederick Henry was called, preferred either The Hague or one of his recently constructed palaces, Honselaersdijk or Huis ter Nieuburgh, near the town of Rijswijk. Like their father, both princes are buried in the Nieuwe Kerk.

In the days of William the Silent, Delft was chosen as a site for storing artillery, weapons and gunpowder. The reason, as Dirck van Bleyswijck explained in his *Description of the City of Delft* (1667), was that "the position of the city is ideal for this, lying safely inside the country, and having the best harbour on the Meuse [...]."[4] Between 1573 and 1667, no less than eight arsenals were established in or near the city, in former monasteries, for instance. The garden of the Poor Clares was filled with cannons, while the chapel of the convent served as a storeroom for sulphur and saltpetre, the raw materials for making gunpowder. On 12 October 1654 disaster struck: one of the arsenals exploded, killing dozens if not hundreds of people and destroying much of the city (see Chapter Three).

The bond between the House of Orange and Delft may well seem self-evident nowadays, but that was hardly the case in the seventeenth century. Louise de Coligny, the fourth wife of William the Silent, was jeered at as she rode through town en route from The Hague to France, "with dung and filth thrown into her coach [...] and reviled with cries of 'Arminian whore'."[5] The incident may have been caused by theological tensions, in contrast to the political problems her grandson, William II (1626-1650), had to face. In 1649 he visited the principal Dutch towns to drum up support for his military plans. One of his goals was to join forces with France and wrest the Southern Netherlands from Spain. Refused almost everywhere he went, in Delft he was even waylaid by an angry mob and denied the opportunity to present his case to the city council.[6] But the Prince was not about to be brushed off. He arrested six prominent Dutch regents, including Jan Duyst

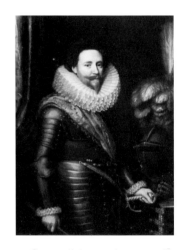

fig. 3
MICHIEL VAN MIEREVELT
Portrait of Frederick Henry of Orange, c. 1620
panel; 110 x 84 cm
Delft, Stedelijk Museum Het Prinsenhof, inv. no. PDS 68c

van Voorhout, burgomaster of Delft, and locked them up in Loevestein Castle. On 15 August the mayor was freed, but forced to lay down all his responsibilities.[7] Meanwhile the Prince laid siege to Amsterdam to compell the regents to go along with his designs. But the entire affair came to an abrupt end when William II was felled by smallpox on 6 November 1650, which marked the beginning of the First Stadholderless Period. In sum, the city council of Delft (like most of the other Dutch cities) was more republican than Orangist.

As one of the towns in Holland with voting rights,[8] Delft had its reasons for resisting the Prince's plans. Being one of Holland's chief industrial centres it had nothing to gain from entanglement in costly wars (fig. 3).[9] It boasted chambers of both the East and West India Companies, and the English trading company known as the Merchant Adventurers used Delft as an entrepôt for their trade with the Northern Netherlands. But even more important for the city were its three industries: beer, textiles and earthenware. Until the sixteenth century the beer breweries were paramount. The loss of the Southern Netherlandish markets to local breweries and the rise in the price of raw materials precipitated the industry's decline in the early seventeenth century. In an attempt to compensate for the loss the Delft city council elected to favour the textile industry, for which Delft had long been known. Then, from the 1640s onward, the manufacture of earthenware rapidly evolved (fig. 4); by 1670 no less than a quarter of the city's population depended on it.

Compared to beer, textiles and earthenware, the 'art industry' in Delft was of a very different, and decidedly smaller, order. The huge influx from Flanders at the end of the sixteenth century triggered an artistic renascence. The craft of silversmithing and even

17

fig. 4
Delftware plate, *Moses Striking the Rock*, 1660
Amsterdam, Rijksmuseum, inv. no. R.B.K. 1976-81

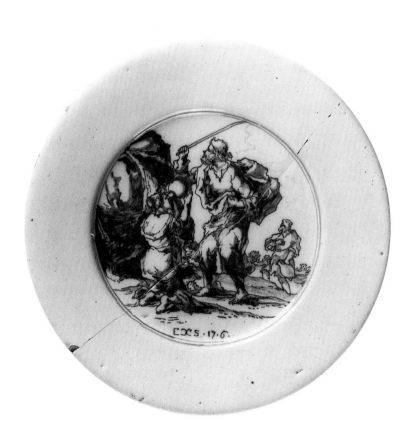

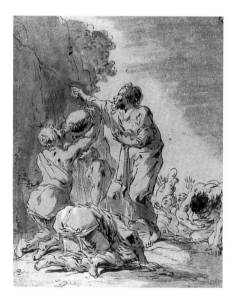

fig. 5
LEONAERT BRAMER
Moses Striking the Rock,
c. 1630-1640
brush and black ink, grey wash;
400 x 310 mm
London, Courtauld Institute
Galleries, inv. no. Witt 2963

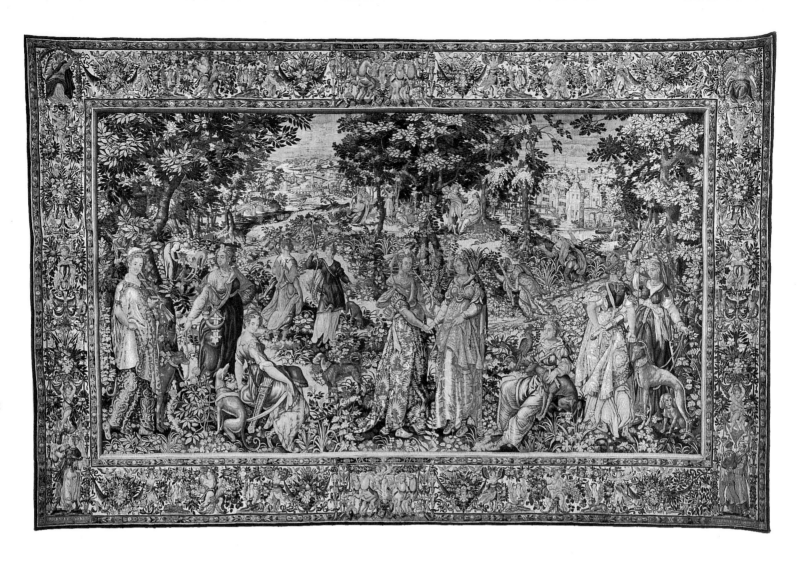

more so that of tapestry-making reached new heights. The workshop of the Flemish *tapissier* François Spiering (1551-1630), who worked primarily for princely clients, made Delft famous round the world (fig.6).[10] Thanks largely to the Flemish arrivals, membership in the local painters' guild of St Luke almost doubled: in 1569 it had thirty-nine members, in 1613 nearly one hundred. This figure includes every category, that is, artist-painters, embroiderers, art dealers, faience-painters, chair-painters and so forth. Counting only the artist-painters, a total of 206 belonged to the guild between 1613 and 1680[11]:

YEAR	1613	1640	1650	1660	1680
PAINTERS	47	58	52	51	31

fig.6
Diana and Procris
tapestry made by François Spiering (design Karel van Mander the Elder), c. 1610
Amsterdam, Rijksmuseum,
inv. no. R.B.K.1954-69B

Although these figures still include the so-called 'kladschilders' (or what would now be called housepainters), the curve is nonetheless striking. For the first four decades of the century it rose continuously, starting with the advent of the Flemings in the sixteenth century. Then at mid-century it levelled off, before declining sharply after 1660.

One should beware of reading too much into these figures, but the following general remarks can be made. In the first decades of the seventeenth century the immigration from Flanders continued with artists such as Hans Jordaens, Bartholomeus van Bassen

and Willem Willemsz van den Bundel. However, most of the artists apparently came from other parts of the Northern Netherlands. In the first half of the century, when the city's economy was on the rise, it appears that a painter could do reasonably well, although one should not forget that many were more or less forced to supplement their income. Even so, a total of fifty to sixty artists during the halcyon days of painting in the city is not much by comparison to surrounding centres.

In such a small community, even minor disturbances could have drastic consequences, and unfortunately these did occur. Paulus Potter packed up and left Delft in 1649, Gerard Houckgeest in 1651, Emanuel de Witte in 1651 or 1652, and Pieter de Hooch around 1660, while Carel Fabritius perished in the gunpowder explosion of 1654. Thus, in the space of ten years a highly gifted group of artists was lost. This will not have made the city more attractive to their confrères, or made them any less susceptible to the siren call of larger, richer towns such as Amsterdam, Haarlem or Leiden. The great exception, of course, was Johannes Vermeer (1632-1675), whose loyalty to his home town never flagged.

Among the members of St Luke's guild there were some sharp contrasts. Not only artist-painters belonged to it, after all, but also chair- and faïence-painters, embroiderers and other craftsmen. As a result there were considerable inequalities in social status and wealth. The portraitist Michiel van Mierevelt and the genre painter Anthonie Palamedesz belonged to the city's social elite and lived in the most expensive houses: that of Palamedesz was worth no less than 3,400 guilders, Van Mierevelt's over 2,000. Van Mierevelt also owned another house in the city, besides properties and debentures (or bonds) in excess of 14,000 guilders.[12] Remarkably, the heterogeneous composition of the guild's membership scarcely changed between 1550 and 1750. One scholar has attributed this stability to the careful supervision of the local authorities and to the small size of the municipality.[13] More recently, however, it was stated that groups of artists only seceded when they wished to introduce quality controls such as diploma works and inspectors.[14] There was apparently no pressing need for this in Delft.

PICTORIAL GENRES IN DELFT
1600-1650

As we have seen, sixteenth-century artistic life in Delft was not particularly noteworthy, the two (short-lived) exceptions being the painter Anthonie van Blocklandt (1533/1534-1583) and the sculptor Willem Danielsz van Tetrode (1525?-before 1588?).[15] Van Blocklandt studied with his uncle Hendrick Sweersz in Delft, where he worked from 1565 until 1572 (before moving to Utrecht, apparently). He was presumably on friendly terms with Cornelis Musius, the aforementioned prior of the convent of St Agatha, and with Van Tetrode. Van Blocklandt was one of the last members of his profession to specialise in altarpieces (fig. 7), which he executed for the Nieuwe Kerk, among other churches.[16] Van Tetrode, who was most likely born in Delft, scored his first (known) successes in Italy. After returning to his home town in 1567 it was not long before he received two important commissions for altars in the Nieuwe Kerk. The court of William the Silent, who resided intermittently at Delft from 1572 until his death in 1584,

seems to have had little impact on the city's artistic life. After all, Michiel van Mierevelt, court portraitist to the House of Orange, was only seventeen when the Prince was murdered. The wardens of the Oude (or Old) and the Nieuwe Kerk were evidently aware of the dearth of talent, for they placed their orders elsewhere. The Oude and above all the Nieuwe Kerk had splendid altars by Jan van Scorel, Maerten van Heemskerck, Pieter Aertsen and Frans Floris who were active in other cities. In their desire for quality, they even went so far as to stipulate that Van Scorel's altarpiece excell that of the cathedral of Utrecht.[17]

fig. 7
ANTHONIE VAN BLOCKLANDT
The Martyrdom of St James,
c. 1570
panel; 314 x 264 cm
Gouda, Stedelijk Museum Het
Catharina Gasthuis, inv. no. 55.164

The first decades of the seventeenth century witnessed an improvement in the city's artistic life. In contrast to its erstwhile provincialism, it now became more receptive to outside influence. From 1580 onwards Flemish immigrants poured into the city in growing numbers. For their part, Delft artists crossed the Alps more often, and closely followed artistic developments in other Dutch towns. In addition to those who immigrated from the Southern Netherlands, many artists from other Northern Netherlandish cities moved to Delft for longer or shorter periods of time. It was during this period that the various specialties within Dutch painting emerged, such as landscape, still life and genre. The emancipation of these categories, which were sometimes still linked to religious themes, can be traced to Flanders. The disappearance of ecclesiastical patronage in the Northern Netherlands and the ascent of the middle class created a market for the immigrant Flemish artists and their new subjects. All of these specialties, from the still life to the history piece, were practiced at Delft between 1600 and 1650, often by masters of prodigious talent.

History painting – narrative scenes based on the Bible, mythology or literature – was considered the noblest specialty. Still life and landscape were perhaps more popular, but history painting was more prestigious. In Delft, it was initially dominated by Anthonie van Blocklandt, who was deeply influenced by Italian art. The young Michiel van Mierevelt (1567-1641) was one of his pupils. Few of Van Mierevelt's early historical works survive. One of them, *The Judgement of Paris*, is only known through a series of four prints by Willem van Swanenburgh, which show that his history pieces were probably very Mannerist.[18] Mannerism, the style that originated in Italy in the wake of the High Renaissance, is characterised above all by an (occasionally excessive) elegance. A second Delft artist who worked in the Mannerist style at the time was Abraham van der Houve (1576-1621). So profoundly was Van der Houve influenced by the Haarlem painter Cornelis van Haarlem that his large canvas *The Golden Age* (fig. 8) – the only known work by Van der Houve – was long ascribed to Van Haarlem.

From about 1615 onward Caravaggist painters were active in the provinces of Holland and Utrecht. As their name suggests, the work of these artists is patently indebted to that of Caravaggio (1571-1610). Their use of colour, handling of light, compositional schemes and penchant for realism betray their admiration for the great Italian master. Caravaggism was primarily an Utrecht phenomenon, but it also occurred elsewhere. Its two most noted exponents in Delft were Christiaan van Couwenbergh (1604-1667) and Willem van Vliet (c. 1584-1642).[19] While it may be cruder, the formal language of the former can be traced to the Utrecht Caravaggist Gerard van Honthorst (fig. 9). Van Couwenbergh must have been well established, as he was one of a group of

21

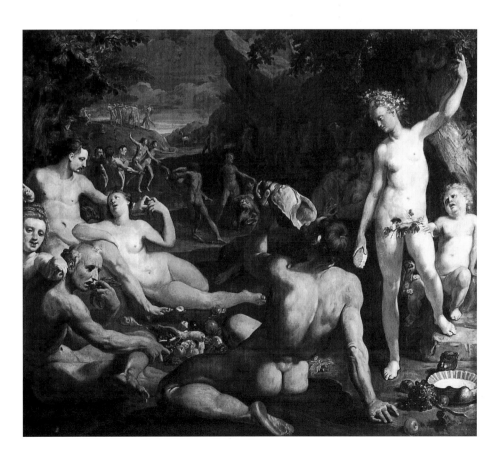

fig. 8
ABRAHAM VAN DER HOUVE
The Golden Age, 1615
canvas; 198 x 229 cm
Brunswick, Herzog-Anton-Ulrich-
Museum, inv. no. 166

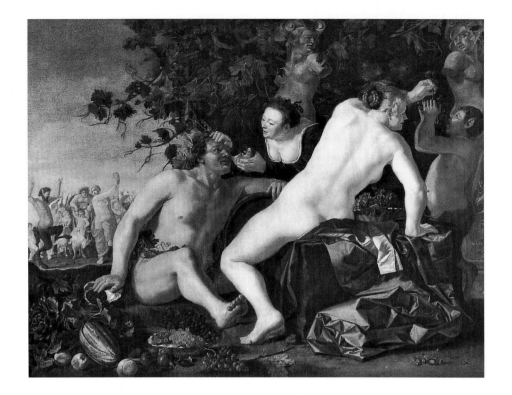

fig. 9
CHRISTIAAN VAN COUWENBERGH
Bacchanal, 1626
canvas; 158 x 205 cm
Vienna, sale (Dorotheum), 1 March
1994, lot 125

22

painters who collaborated on the decoration of Huis ten Bosch. Willem van Vliet, the uncle of the architectural painter Hendrick van Vliet (see Chapter Two), started out painting patently Caravaggesque history pieces before ultimately adopting a more classicist style and turning to portraiture.

 The leading history painter in seventeenth-century Delft was unquestionably Leonaert Bramer (1596-1674). Bramer occupied a place of his own among the painters active in Delft, and was unique in Holland as well.[20] Like many other ambitious young artists, he rounded out his training with an *iter Italicum* in order to study classical art and acquaint himself with the great contemporary masters. Between the ages of eighteen and thirty-one he lived in Italy, where he presumably spent most of his time in Rome. It was in the Eternal City that he became a founding member of the *Bentvueghels*, as the members of the *Schildersbent*, or band of painters – an association of Netherlandish artists – called themselves. Besides compatriots, he also befriended foreign confrères such as Claude Lorrain (1600-1682) and Jean Ducamps (active between 1622 and 1638); he must have witnessed works by Adam Elsheimer (1578-1610), furthermore. Bramer's patrons included prominent persons in the social and ecclesiastical life of Rome. His years in Italy left an indelible mark on his style and technique, but his works betray particular admiration for Caravaggio and Agostino Tassi (1581/1582-1644). Painted with a rapid, nervous touch, they often depict dark scenes that are animated by small, lively figures and often suffused with the mysterious light of torches; not for nothing was he known in Italy as 'Leonardo della Notte'. The structure of the pictorial space in Bramer's work is rarely clear, as for instance in *The Circumcision* (fig. 10), notwithstanding the prospect of the landscape on the right. After returning to Holland Bramer landed prestigious commissions; he worked, for example, for none other than the stadholder in the palaces at Honselaersdijk and Rijswijk. But his most important commission was undoubtedly the decoration of the

main hall (Grote Zaal) of the Prinsenhof in his native Delft. Some of these commissions he executed *al fresco* (murals painted on wet plaster), a technique common in Italy but virtually unknown in Holland. Unfortunately none of these fragile wall paintings survive.[21]

Bramer's reputation as a maverick is further corroborated by his vast graphic oeuvre, comprising no less than thirteen hundred pieces. Most of these were executed in series, based for example on the Old Testament, the New Testament, Ovid's *Metamorphoses* or *The Life of Till Uilenspiegel*. No other artist in Delft did so much drawing. His serial illustrations of classical and contemporary literature were exceptional in Holland. Remarkably, several of his drawings served as models for decorations on Delftware (figs. 4 and 5). Indeed it has been suggested that most of Bramer's drawings were conceived with a view to faïence, but this is implausible.[22]

Bramer had but one disciple: Pieter Pietersz Vromans (active between 1635 and 1654). Vromans' works clearly betray his debt to Bramer, but whether Vromans was actually apprenticed to the master is not known. There has been a good deal of speculation about the exact nature of the relationship between Bramer and another, much more famous Delft artist, namely Johannes Vermeer.[23] The sources tell us that Bramer and Vermeer were well acquainted, and that around 1650, when the younger painter was just starting out, the thirty-six-year-older Bramer was the most prominent artist in the city. Although there are few parallels between their respective styles, there is no indication that Vermeer did not study under Bramer, but neither is there any that he did.

Emanuel de Witte (1615/1617-1691/1692) lived in Delft from 1641 until 1651/1652. Like Bramer, he was apparently fond of strong contrasts between light and shade. Several nocturnal history pieces dating from his years in Delft contain correspondences with

23

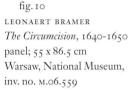

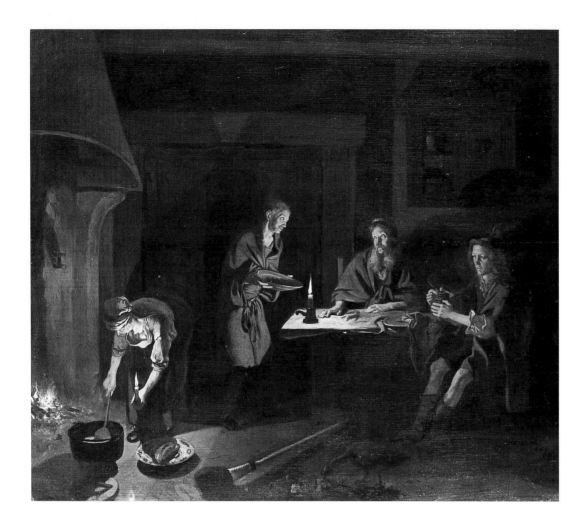

fig. 11
EMANUEL DE WITTE
*Jupiter and Mercury in the Hut of
Philemon and Baucis*, 1647
panel; 54 x 62 cm
Delft, Stedelijk Museum Het
Prinsenhof (on loan from the
Rijksdienst Beeldende Kunst,
The Hague), inv. no. NK 2434

24

fig. 12
DOMENICO FETTI
The Parable of the Lost Silver,
1618-1622
panel; 55 x 44 cm
Dresden, Staatliche Kunst-
sammlungen, Gemäldegalerie
Alte Meister, inv. no. 418

fig. 13
DOMENICO FETTI
*The Parable of the Labourers in
the Vineyard*, 1618-1622
panel; 61 x 45 cm
Dresden, Staatliche Kunst-
sammlungen, Gemäldegalerie
Alte Meister, inv. no. 423

works by Bramer, such as *Jupiter and Mercury in the Hut of Philemon and Baucis* (fig. 11). De Witte's panel pays homage to *The Parable of the Lost Silver* by the north Italian painter Domenico Fetti (1588/1589-1623) (fig. 12)[24]; the woman with her candle by the hearth is an all but literal quotation from that work. The link between De Witte and Fetti is particularly interesting in light of the fact that the young Vermeer may well have borrowed from one of Fetti's paintings in this vein as well: *The Parable of the Labourers in the Vineyard* (fig. 13). Compare, for instance, the figure of Christ in Vermeer's *Christ in the House of Mary and Martha* (fig. 14) to the lord of the vineyard in Fetti's panel: they lean backward in the same manner, the attitude of their heads is virtually identical and they are seated on the same chair.[25] The obvious conclusion would seem to be that De Witte and Vermeer saw these works (or copies of them) by Fetti in the mid-seventeenth century. They would not have had to go to Mantua, where Fetti painted the series. Around 1627 the parable paintings were acquired by George Villiers, duke of Buckingham, then sold at Antwerp in 1648, before entering the collection of Archduke Leopold Wilhelm in Brussels.[26] The two Delft masters must have come into contact with the series one way or another, either during shipment or in Brussels, but no one knows exactly how. Whatever the case may be, having identified the (Italian) prototype of Vermeer's Christ, we can better understand the manner of this early work by Vermeer, which seems so alien to painting in Delft.

25

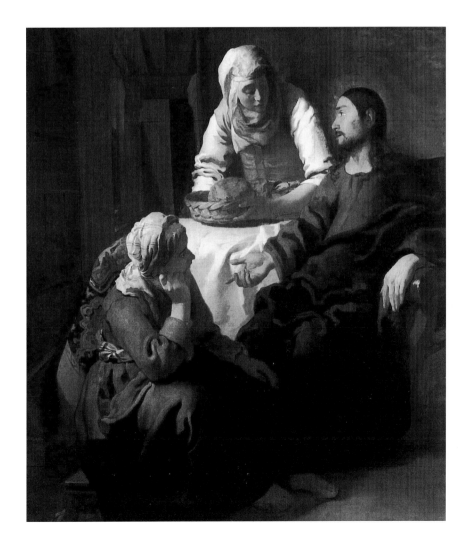

fig. 14
JOHANNES VERMEER
Christ in the House of Mary and Martha, c. 1654-1655
canvas; 160 x 142 cm
Edinburgh, National Gallery of Scotland, inv. no. NK 1670

GENRE

Genre pieces depict scenes from daily life. In the first half of the seventeenth century several main types can be distinguished in the Northern Netherlands: interiors with groups of richly clad, youthful figures, the 'kortegaarden' (guardrooms with soldiers), peasant scenes, and, finally, figures depicted half length. The first three types were executed primarily in Haarlem and Amsterdam, the fourth in Utrecht. Genre pieces are often endowed with a deeper, usually moralistic, level of meaning.

Save the peasant scene, all of these types were practiced in Delft. Anthonie Palamedesz (1601-1673), for example, who was born in the city, painted interiors with galant companies (fig. 15), like those associated with Haarlem and Amsterdam.[27] He may have studied with a Haarlem master such as Dirck Hals or Hendrick Pot. The painted interiors of Palamedesz are generally shallow with a flat background, so that part of one (and sometimes even two) side walls are visible. The light invariably enters these spaces from the upper left, though the source itself is rarely shown. From the 1640s onward Palamedesz concentrated on barrack scenes, illuminating his figures against a dark background. The interior is larger but less orderly, and there is occasionally a vista, as in *Soldiers in a Guardroom* (fig. 16).

The influence of Palamedesz can be felt in the work of two other masters, Jacob Fransz van der Merck (c. 1610-1664) and Jacob Jansz van Velsen (active between 1625 and 1656). In the case of the former, who was only active in Delft for a five-year period (1631-1636), it can be seen in his small, early paintings of individual figures.[28] The amalgamation of stylistic traits from Utrecht and Delft makes Van Velsen's small oeuvre

fig. 15
ANTHONIE PALAMEDESZ
Company, 1632
panel; 47 x 73 cm
The Hague, Koninklijk Kabinet
van Schilderijen Mauritshuis,
inv. no. 615

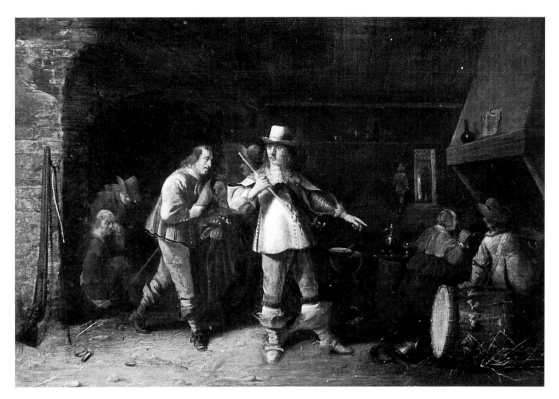

fig. 16
ANTHONIE PALAMEDESZ
Soldiers in a Guardroom, 1640-1650
panel; 41 x 56 cm
Vienna, sale (Dorotheum),
17 March 1960, lot 79

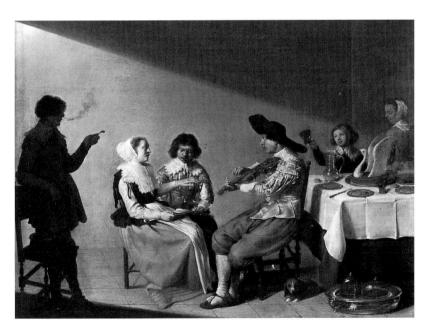

fig. 17
JACOB JANSZ VAN VELSEN
A Musical Party, 1631
panel; 40 x 56 cm
London, The National Gallery,
reproduced by courtesy of the
Trustees of The National Gallery,
inv. no. 2575

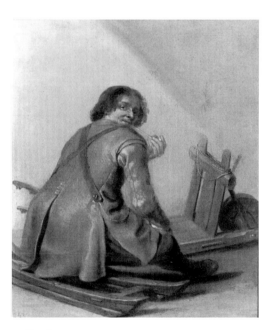

fig. 18
JACOB JANSZ VAN VELSEN
Man on a Sled, c. 1640
panel; 30 x 25 cm
Delft, Stedelijk Museum Het
Prinsenhof, inv. no. PDS 206

particularly interesting. In *A Musical Party* (fig. 17), the grouping of the figures in a shallow space is derived from Palamedesz, while the handling of the light and the silhouetted figure on the left call to mind Utrecht painters such as Gerard van Honthorst. The subject of *The Palmist* alone tells us that Van Velsen was acquainted with Caravaggesque themes.[29] The prosperous artist had a large collection of over one hundred fifty paintings, which suggests that he had many commercial connections, possibly also in Utrecht.[30] In Van Velsen's later oeuvre the figures become larger and the light is less contrasted, as for instance in *Man on a Sled* (fig. 18). In this respect he sometimes seems to anticipate the early Vermeer and De Hooch.[31]

Explicitly Caravaggesque genre pieces were painted by Christiaan van Couwenbergh and Willem van Vliet. The half-length figures, usually clad in beautiful costumes like those associated with the Italian master, are often seen in their work as well. While there is generally a certain rowdiness about Van Couwenbergh's oeuvre, the splendid *Woman Holding a Basket of Fruit* (fig. 19) emanates a dignified tranquillity.[32] Such a picture would surely have appealed to the young Vermeer. Bramer executed some Caravaggesque genre

28

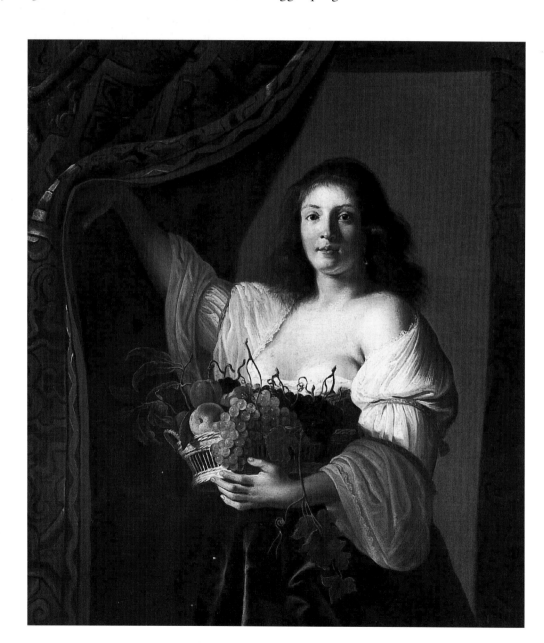

fig. 19
CHRISTIAAN VAN COUWENBERGH
Woman Holding a Basket of Fruit,
1642
canvas; 107 x 93 cm
Göttingen, Gemäldesammlung
der Universität Göttingen,
inv. no. 1970-101

pieces as well, but here again, the idiosyncratic artist insisted on charting his own course. The costumes of his small figures are entirely Caravaggesque, but the figures themselves are invariably shown full length, not half. By the same token, his *Soldiers Resting* from 1626 is apparently the earliest depiction of a guardroom.[33]

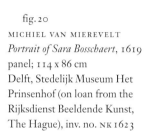

fig. 20
MICHIEL VAN MIEREVELT
Portrait of Sara Bosschaert, 1619
panel; 114 x 86 cm
Delft, Stedelijk Museum Het
Prinsenhof (on loan from the
Rijksdienst Beeldende Kunst,
The Hague), inv. no. NK 1623

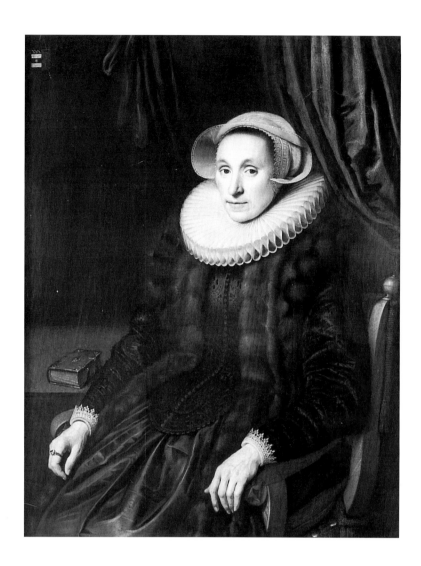

PORTRAITURE

In the first half of the seventeenth century Michiel van Mierevelt (1567-1641) and his workshop dominated the field of portraiture in Delft. Van Mierevelt, who was presumably born in the city, returned in 1583 after an absence of just over two years. He maintained the standards of the portraitists Herman van der Mast and Jacob I Willemsz Delff, which were already high (figs. 3 and 20).[34] Yet his establishment in the city as the third portraitist would not have caused undue competition, since much of Van Mierevelt's time was spent working for the stadholder's court or for patrons in The Hague. Delff and Van Mierevelt were now related, furthermore, as a daughter of Van Mierevelt married a son of Delff. But Van Mierevelt's large workshop ultimately gave him the upper hand. So well known was he abroad that, according to Van Bleyswijck (1667), both the Austrian archduke Albrecht and the English king Charles I sought to monopolise his services. The engravings of his portraits by his son-in-law, Willem

Jacobsz Delff, must have helped consolidate his international reputation. Van Mierevelt's considerable prosperity was crowned by artistic success.

The great refinement and precision of Van Mierevelt's work distinguishes it from that of his two predecessors, Delff and Van der Mast. In the words of Constantijn Huygens, he rendered "the weakness of the flesh, which few can express, with a skilfulness that defies imitation."[35] Compared to the other two, he paid more attention to the space surrounding his sitters, moreover, and to their illumination. To enhance the sense of depth he occasionally added a table, a chair or a curtain and manipulated the contrast between light and shade. Remarkably, Van Mierevelt's portraiture bears no trace of the innovations being made elsewhere in Holland. He was evidently impervious to the virtuoso brushwork and the informality of the portraits of Frans Hals (1581/1585-1666), for instance. The disposition of his sitters can be traced to Antonis Mor (1516/1519-c. 1575) from Utrecht (fig. 2), who had borrowed it in turn from the Venetian master Titian (1474/1519-c. 1575). He evidently put great store by craftsmanship, and judging from his success it duly was recognised. Nonetheless the quality of the work that left his studio was not always of the same calibre. He could hardly keep up with the demand, and often painted no more than the sitter's head and hands, leaving the rest to his assistants.

To be sure, there were other portraitists in Delft, such as Willem van Vliet, Christiaen van Couwenbergh, Carel Fabritius and Anthonie Palamedesz, but they are all better known for their work in other genres. After the death of Palamedesz in 1673, portraiture in Delft languished and the torch passed to The Hague.

Still life

The so-called kitchen piece was very popular in Delft in the early seventeenth century. Its popularity may have had something to do with Pieter Aertsen (1507/1508-1575), whose work was well known in the city. Trained in Antwerp and resident in Amsterdam, together with Joachim Bueckelaer Aertsen had taken the genre to new heights, to say nothing of the important altarpieces he executed for Delft churches.[36] Pieter Cornelisz van Rijck (1568-c. 1628) was one of Aertsen's followers in Delft. His *Kitchen Interior* (fig. 21), featuring a lavish display of meat, vegetables and fish, is characteristic of the genre. Like Aertsen, Van Rijck places a religious scene in the background, the parable of Lazarus and Dives. The scene reminds the viewer not to let himself be distracted by earthly opulence, like the rich man in the parable, but rather to bear in mind the fate of poor Lazarus. Cornelis Delff, son of the portraitist Jacob 1 Willemsz, employed the same compositional scheme, though the tenor of his background scenes is rarely religious. Ultimately Delff went so far as to omit figures altogether and to concentrate on brightly polished copper pots and other kitchen utensils on a table against a closed back wall.

The most important still-life painter in Delft in the first half of the century was decidedly Balthasar van der Ast (1593/1594-1657), who was already an accomplished painter when he arrived from Utrecht in 1632. Like Van Mierevelt he was old-fashioned but highly skilled. Van der Ast was strongly influenced by his master (and brother-in-law) Ambrosius Bosschaert, who had emigrated to Middelburg from Antwerp. At first he

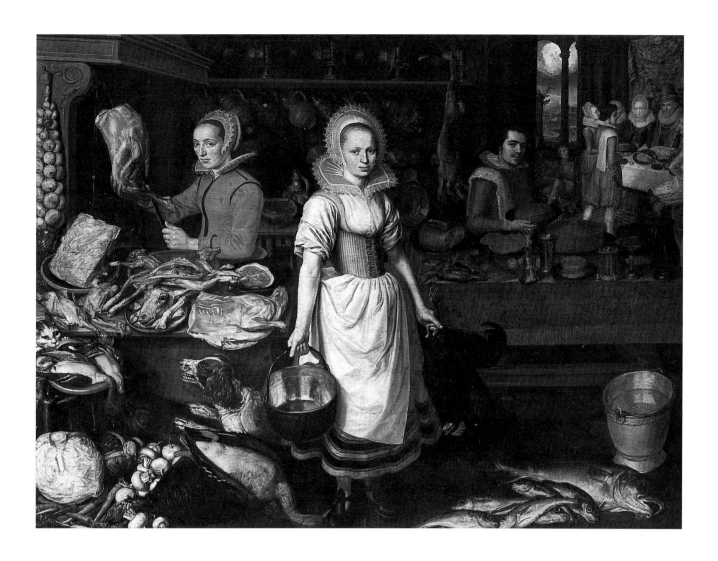

fig. 21
PIETER CORNELISZ VAN RIJCK
Kitchen Interior, c. 1610
canvas; 198 x 272 cm
Amsterdam, Rijksmuseum,
inv. no. A 868

painted very precise, symmetrical still lifes with flowers, fruit or shells, in imitation of Bosschaert. But what distinguished his art, among other things, was that he included all these objects in a single painting, carefully arranging a flower vase, a fruit bowl and several shells in one and the same still life. Compared to Bosschaert's compositions, Van der Ast's are less stiff, just as his manner is more supple; he is also famous for his mother-of-pearl tone. In a work painted in the 1650s (toward the end of his career) he placed the arrangement by a window to create the illusion of light and shadow playing over the objects. A view through the window onto a canal completes this rare 'Delft' still life (fig. 22). The novelty calls to mind his fellow townsmen, who are so famous for their experiments with light and perspective (see Chapters Two and Four).

Long before Van der Ast arrived, flower still lifes were undoubtedly being painted in Delft. One of the early practitioners mentioned by Aernout van Buchell in 1598 – a certain flower painter by the name of Elias – is no longer known. Van Buchell was presumably referring to Elias Lucasz Verhulst, who died in 1601; unfortunately none of his work has come down to us.[37] Colleagues who met Van der Ast in person were Jacob Woutersz Vosmaer (1584-1641) and Evert van Aelst (1602-1657). Some of their work, albeit very little, is still extant. The flower pieces of Vosmaer, a pupil of Jacques de Gheyn, are somewhat more loosely designed than those of Van der Ast. By comparison, the still lifes of Evert van Aelst, with their simplicity and refined lighting, suddenly

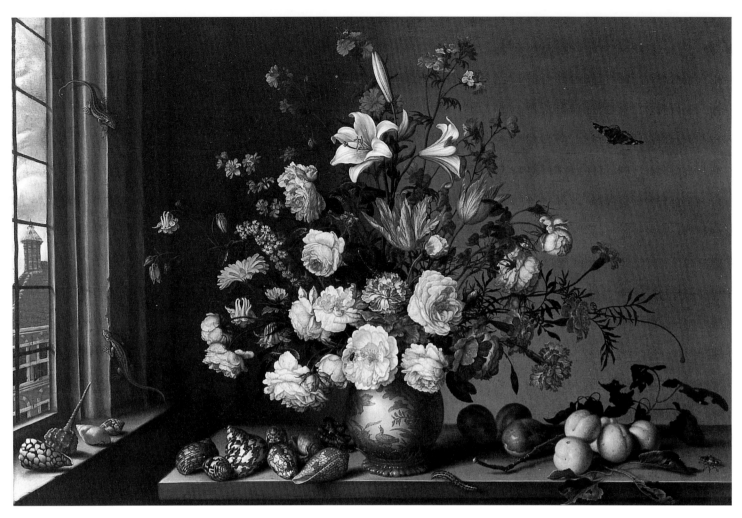

fig. 22
BALTHASAR VAN DER AST
Flower Still Life by a Window,
c. 1650
panel; 38 x 71 cm
Dessau, Staatliche Galerie,
cat. 1929, no. 63

fig. 23
EVERT VAN AELST
Still Life, 1639
panel; 39 x 30 cm
London, sale (Sotheby's),
7 July 1976, lot 16

32

appear 'modern' (fig. 23); now all but forgotten, Van Aelst must have been well known in his day.

Many seventeenth-century still lifes presumably had a symbolic significance. We may assume the kitchen pieces of Van Rijck admonished the viewer to lead a better life, and that the costly flowers of Van der Ast and Vosmaer reminded him of the transitoriness of our existence. The vanitas theme, based on the well-known biblical verse "Vanity of vanities [...] all is vanity" (Eccl. 1:2), is particularly explicit in the works of the Delft brothers Van Steenwijck. Harmen (1612-after 1655) and Pieter (c. 1615-after 1654) learned their trade from David Bailly in Leiden, where (as in Haarlem) the so-called vanitas still life flourished. Skulls, clocks and smoking candles abound in their work. Pieter van Steenwijck's *Allegory on the Death of Maarten Harpertsz Tromp* (fig. 24) is an interesting example. Should the canvas be seen as a form of paean to the fallen naval hero? Does it signify that everything worldly is ephemeral, and that only honour and fame, the reward for a virtuous life, can overcome death? Or is it trying to tell us that Tromp too was but an ordinary man, and that the struggle for earthly glory is vain, as we are all equal before God?[38]

Besides vanitas still lifes, the Van Steenwijcks also painted stable interiors with detailed barrels, baskets, kettles and so forth. The specialty was practiced above all in Rotterdam, most notably by Herman and Cornelis Saftleven and by Pieter de Bloot. It constitutes a hybrid between the still life and the genre scene. Some artists, such as (in Delft) the Van Steenwijcks, Adam Pick (active between 1642 and 1653) and Egbert van der Poel (1621-1664), preferred the rustic still life, while others, such as Ludolf de Jongh and Pieter de Hooch, were more interested in figures (see Chapter Four).

33

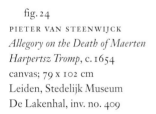

fig. 24
PIETER VAN STEENWIJCK
Allegory on the Death of Maerten Harpertsz Tromp, c. 1654
canvas; 79 x 102 cm
Leiden, Stedelijk Museum
De Lakenhal, inv. no. 409

Relatively few landscapes were painted in Delft, which seems remarkable in light of the genre's extraordinary development elsewhere in Holland between 1600 and 1650. The influence of specialists in the naturalistic landscape from Haarlem and Leiden, such as Esaias van de Velde, Salomon van Ruysdael and Jan van Goyen, was felt only sporadically. The early oeuvre of Anthonie Palamedesz includes several examples. His *fêtes champêtres*, a hybrid between genre and landscape, are characteristic of Haarlem. Characteristic, too, are the low horizon and the handling of the trees in his *Frederick V, Elector Palatine (the Winter King) and his Consort Elizabeth Stuart on the Hunt*.[39] The tree on the right in this last work is particularly striking; its shape is so irregular that it seems out of tune with the rest. The motif was probably added by Jacob van Geel (1584/1585-c. 1638), an artist of Flemish origin who was only active in Delft for several years (1626-1632).

The art of Van Geel shows the Flemish landscape tradition was still vital in Delft. His endeavours in this genre are invariably structured according to a pattern that can easily be traced to the work of the sixteenth-century Southern Netherlandish landscapists. His fantastic trees, covered with moss, are his only original contribution to this tradition (fig. 25). Another Flemish landscapist who was active in Delft was Willem Willemsz van den Bundel (c. 1577-1655). A friend of Gillis van Conincxloo (1544-1607) from Antwerp, he too remained faithful to the pattern of the Southern Netherlandish landscape.

There were really only one or two more or less 'modern' landscape painters in Delft between 1600 and 1650: Pieter Anthonisz van Groenewegen (active between 1623 and 1657) and Pieter van Asch (1603-1687). Groenewegen presumably spent many years in Italy where, along with Leonaert Bramer, he was one of the first *Bentvueghels*. The influence of his Italian sojourn is palpable in his works, which often include (usually imaginary) Roman ruins (fig. 26). Van Groenewegen was one of the first Italianate painters, that is, artists who took the Italian countryside as their subject. The landscapes of Van Asch upheld the Dutch realist tradition of Jan van Goyen and Salomon van Ruysdael, on the other hand, until they became more arcadian later on.[40] Notwithstanding a certain naïve charm, Van Asch's late landscapes are not noted for their originality.

Of a very different calibre are the two landscape painters who appeared on the Delft scene at the end of our period: Paulus Potter (1625-1654) and Adam Pynacker (1620/1621-1673). An animal and landscape painter, Potter joined St Luke's guild on 6 August 1646,[41] but it is not known whether he actually settled in Delft. Three years later he was apparently a member of the painters' guild. The suggestion has been made that a special commission was involved, requiring the master to be registered in the city; could the commission have involved his most famous work, the colossal *Bull*, which he executed in 1647? Potter's keen interest in the rendering of sunlight was crucial to the development of painting in Delft, as evidenced by his silver tones and refined contrejour effects.[42] In this respect Potter may be a harbinger of De Hooch and his Delft colleagues. What is quite remarkable, however, is that Potter was apparently also a step ahead of De Hooch thematically. In his *Great Farm* from 1649 (fig. 27) a woman is seated by a window inside the open doorway of the farmhouse on the right.[43] The intimate, sundrenched scene is highly reminiscent of De Hooch.

fig. 26
PIETER ANTHONISZ VAN
GROENEWEGEN
Italian Landscape
panel; 56 x 90 cm
Amsterdam, Rijksmuseum,
inv. no. A 3965

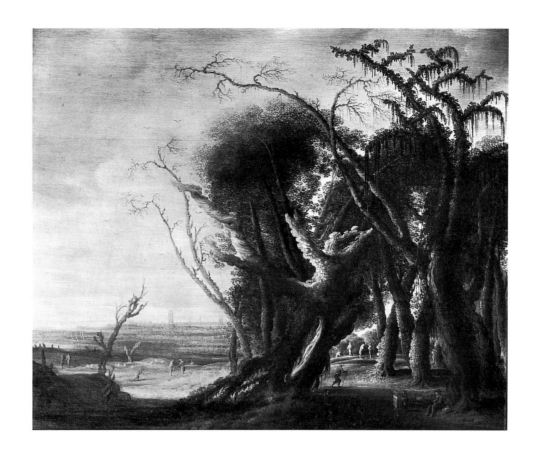

fig. 25
JACOB JANSZ VAN GEEL
Landscape, c. 1630
panel; 59 x 72 cm
The Hague, Kunsthandel
J. Hoogsteder, 1972

35

fig. 28
ADAM PYNACKER
Landscape with Cattle, c. 1650
panel; 36 x 48 cm
Amsterdam, Rijksmuseum,
inv. no. A 322

fig. 27
PAULUS POTTER
The Great Farm, 1649
panel; 81 x 115.5 cm
St Petersburg, The State Hermitage
Museum, inv. no. 820

Although there is no proof that Adam Pynacker actually resided in Delft, there is considerable archival evidence of his having visited the city on a number of occasions between 1649 and 1651.[44] He must have had close ties with the innkeeper, art dealer and painter Adam Pick, and may have had family there.[45] Prior to his brief 'Delft period' Pynacker probably lived in Italy, and his work, like that of Groenewegen, is Italianate. The prominence of cattle in his early oeuvre has been ascribed to the influence of Paulus Potter (fig. 28). Pynacker's affinity with Potter may also account (at least in part) for his superb handling of light.[46]

Within the field of landscape painting there were also hybrids and subcategories, such as marines, cavalry battles and architectural paintings, all of which were likewise practiced at Delft in the first half of the century. The painter Simon de Vlieger (c. 1601-1653), noted for his views of the sea and the coast, spent four years in the city, from 1634 until 1638, but his presence seems to have had little impact on the work of local artists – marines from Delft are all but unknown in any case. There is, however, evidence that three marine painters were active in the city, namely Joachim de Vries, Nicolaes Vosmaer and Heerman Witmond. Only from the hand of the last of these are a few works still extant. No more than a sketch after a painting by Vosmaer has been found, and nothing at all by De Vries.[47] Remarkably, their marines have thus all vanished or been credited to other artists. In Delft, the cavalry battle was primarily the domain of Palamedes Palamedesz (1607-1638), the younger brother of Anthonie who evidently shared his admiration for the Haarlem School, especially Esaias van de Velde. The relatively new specialty of architectural painting was optimally represented by Bartholomeus van Bassen (c. 1590-1652), of Flemish origin, and by Gerard Houckgeest (1600-1661), from The Hague (see Chapter Two).

ART COLLECTIONS

To conclude this survey, let us say a few words about picture collections in Delft, which can tell us something about the artistic environment. Pictures that are on the market for a time or in the hands of a private collector could have an influence on artists living in (or passing through) the city, as evidenced by the borrowings from Fetti made by De Witte and Vermeer. Collecting pictures was reserved for the well-to-do, as a recent study of Delft inventories has shown.[48] According to the same study, interest in history painting (be it religious, mythological or allegorical) declined in the course of the century, while the popularity of the landscape rose. This helps explain the change of subject matter on the part of De Witte and Vermeer and perhaps already on that of Van Mierevelt. The study also showed that local artists were better represented in Delft collections than artists from elsewhere, suggesting a certain parochialism on the part of the owners. Yet one wonders about the results of the study in this regard.[49] The taste of many collectors must indeed have been provincial, but there were certainly exceptions.

There is at least one important piece of evidence to suggest that there were collectors in seventeenth-century Delft who looked beyond the walls of their town. This is the so-called Bramer Album. Around 1653 Leonaert Bramer executed copies of no less than one hundred and seven pictures in eleven Delft collections, including that of Reynier Jansz Vermeer, the father of Johannes. Of these drawings, sixty-nine have been traced.[50] Only

37

thirteen of the forty-three painters represented actually hailed from Delft! The rest were from Leiden, Haarlem, Utrecht and Amsterdam, besides such foreign towns as Antwerp, Frankfurt and Cremona. The Bramer Album also shows that these collectors closely followed artistic developments elsewhere, for it includes several 'modern' pieces. In other words, besides the more parochial collectors, there were also those in Delft who had a broader outlook.

A sheet not previously associated with the Bramer Album beautifully illustrates the fact that there were definitely 'foreign' pictures in Delft: *The Garden of Love* by (or after) Peter Paul Rubens (1577-1640) (fig. 29).[51] As any art historian will agree, it is extremely provocative that this particular composition, which was already famous, was known at Delft in the mid-seventeenth century, and one cannot help but wonder whether it influenced local artists.[52] Certain drawings by Bramer himself lead one to suspect that he, at least, made use of it.[53] But did Pieter de Hooch or Johannes Vermeer also see the work, and if so, did it influence them in some way? There is no clear evidence as yet – unless, that is, the courtly theme of Rubens' work inspired De Hooch to exchange his gloomy peasant scenes for sunnier, more refined subjects. Whatever the answer, Bramer's sketch is one further indication that there was more to be seen in Delft than the work of local artists.

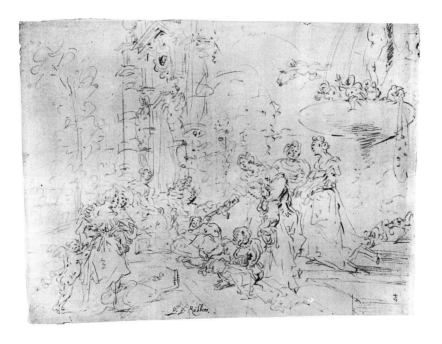

fig. 29
LEONAERT BRAMER
(AFTER PETER PAUL RUBENS)
The Garden of Love, c.1653
black chalk; 302 x 415 mm
Bremen, Kunsthalle (Kriegsverlust),
inv. no. 38/146

CONCLUSION

As we have seen, the rich industrial city of Delft enjoyed a flourishing artistic life in the first half of the seventeenth century. Each speciality had its own, fascinating masters. In the field of history painting, Leonaert Bramer stood head and shoulders above the rest. Anthonie Palamedesz and the intriguing Jacob Jansz van Velsen were the leading genre specialists. Portraiture was qualitatively and quantitatively dominated by Michiel van Mierevelt. As for still life, the palm went to Bartholomeus van der Ast and Evert van Aelst. Landscape was less distinguished, at least until Paulus Potter appeared on the scene.

Before attempting to isolate whatever traits Delft artists may have shared, one should realize our image of painting in the city is fragmentary at best, considering everything that has been lost. In this summary we have touched on many painters, certain aspects of whose art are little known, if at all. Take, for instance, the histories of Michiel van Mierevelt and Abraham van der Houve, the decorations of Leonaert Bramer, the flower pieces of Elias Lucasz Verhulst, the marines of Nicolaes Vosmaer and Joachim de Vries, the still lifes of Evert van Aelst, and so forth. The list of lacunae can easily be extended with the histories of Mattheus de Berch, the kitchen pieces of Michiel van Mierevelt, the still lifes of Pieter van Groenewegen, the genre pieces of Adam Pick and the landscapes of Jacob Vosmaer.[54] And then of course there are the countless other painters who were registered in the Delft guild we know nothing about! It almost seems as though the gunpowder explosion of 1654, like the destructive wave of iconoclasm that swept the Northern Netherlands in 1566, skewed our perception of the city's painting.

If we stand back and look at what remains, several general tendencies emerge.[55] First of all, a strong conservative undercurrent can be detected, as for instance in the work of Michiel van Mierevelt and, to a lesser extent, Balthasar van der Ast. At the same time, however, their work is equally indicative of the consummate craftsmanship that was present in Delft: Willem van Vliet, Jacob Vosmaer and Anthonie Palamedesz are only three of the examples one could cite. The 'fantastic' is likewise characteristic of Delft painting; it is found in the work of Leonaert Bramer and Jacob van Geel, for instance, but also, albeit less conspicuously, in the landscapes with ruins by Pieter van Groenewegen.

But what ultimately united many of these masters, especially as we approach 1650, is a preoccupation with light and space, as is already evident in the portraits of Van Mierevelt. The effects of light are also a major concern in the still lifes of Van der Ast. The history painters Willem van Vliet, Emanuel de Witte and especially Leonaert Bramer clearly had a penchant for dramatic chiaroscuro. If more of Bramer's painted decorations had survived, his preparatory drawings suggest that we might have had a much more favourable impression of his ability to render space. In this sense Bramer is a good example of how the loss of many Delft paintings has distorted the reputation of the city's artists. We can at least be certain that Anthonie Palamedesz was skilled at creating the illusion of space, and that, like his follower Jacob van Velsen, he was keenly interested in light. With all this talent on hand, it did not take much for the artistic life of the city to ignite; the arrival of Paulus Potter in 1646 was presumably the spark. Potter's loose, informal arrangement of figures and animals, and especially his provocative, naturalistic handling of light, prompted the experiments and innovations of Delft painters around the middle of the century.

What a pity that Aernout van Buchell (or a connoisseur of equal standing) did not visit Delft in the 1630s, to say nothing of the 1650s. He would have had much more to write about than he did a half century earlier.

1 This essay benefitted considerably from E.J. Sluijter, "De Schilderkunst van ca. 1570 tot ca. 1650," in Delft 1981, pp. 172-81. Unless otherwise stated, the following is based on that article.

2 Van Buchell gave only the forenames of the three artists. Their surnames can be reconstructed as follows: Michiel Jansz [van Mierevelt], Hubert [Jacobsz Grimani] and Elias [Lucasz Verhulst] (for Elias see also note 37, below). Van Buchell also mentioned two art-lovers: Melchior Wyntgis and Aper Fransz [van der Hoeve]. The latter apparently also painted: see Montias 1982, pp. 55-56.

3 Haak 1984, p. 216.

4 "Zijnde de situatie van dese Stadt daer toe oock recht bequaem, als secuyr binnen 's Lands gelegen, en voorsien met de beste Haven aen de Mase [...]." Quoted from Van Bleyswijck's Beschrijvinge der Stadt Delft (1667) in Delft 1981, p. 15.

5 "met drek en vuiligheit in haer karos [...] beworpen en met naroepen van Arminiaensche hoer gesmaedight." Quoted in Delft 1981, p. 15.

6 Kernkamp 1943, p. 112; Wheelock 1975-1976, p. 179.

7 Van der Aa 1852-1878, II, p. 137.

8 The other five were Amsterdam, Dordrecht, Gouda, Haarlem and Leiden.

9 Delft 1981, pp. 79-90.

10 Delft 1981, pp. 202-09. Aernout van Buchell (cf. note 2, above) had nothing but praise for Spiering and his atelier (see Delft 1981, p. 204).

11 Montias 1982, p. 136.

12 Montias 1982, pp. 121, 129.

13 Montias 1977-A, pp. 93-105.

14 Miedema 1980, pp. 1-14 (esp. p. 10) and Miedema 1987, pp. 1-30.

15 For more on both artists, see Amsterdam 1986.

16 Van Bleyswijck 1667, pp. 249-50.

17 Montias 1982, pp. 11-44.

18 See Amsterdam 1986, p. 419. On two history pieces in Stockholm that were long attributed to Michiel van Mierevelt, see Cavalli-Björkman 1986, nos. 22, 40 (repr.).

19 Until recently, Van Vliet was primarily known as a portrait painter. For Caravaggesque history pieces by his hand see Wansink 1987, pp. 3-10. Both Wansink and M.J. Bok (Utrecht/Braunschweig 1986-1987, pp. 345-46) refer to him as 'Willem van der Vliet'. In keeping with Houbraken and Van Bleyswijck (see bibliography), we use 'Van Vliet'.

20 For more on Bramer, see Wichmann 1923 and Plomp 1994, passim and the review of the latter by Christopher Brown in The Burlington Magazine 136 (1994), pp. 862-64.

21 Drawings related to Bramer's frescoes give some idea of this aspect of Bramer's activity. See Plomp 1994, pp. 63-67, 176-80, 232-36.

22 For more on Bramer as a draughtsman and as a designer of decoration on Delftware, see Plomp 1994, p. 199.

23 Washington/The Hague 1995-1996, p. 17.

24 This was noted by E. Trautscholdt and K. Bauch; see Manke 1963, p. 10 note 2, p. 78, no. 4.

25 For previously proposed prototypes, see The Hague/Washington 1995-1996, pp. 90-95.

26 See Safarik 1990, pp. 67-133 (esp. p. 70) and Lugt 1936, p. 107.

27 See note 39.

28 Haarlem 1986, p. 35, figs. 27a-27b.

29 Delft 1981, p. 178, fig. 189.

30 Bredius 1915-1922, III (1917), pp. 875-86. See also London 1991, pp. 463-64.

31 Delft 1981, p. 178.

32 Braunschweig 1983, no. 11 (as 'Pomona'). I find the proposed identification of the woman unconvincing. To my mind this is a genre piece, presumably the pendant of the Merry Violinist, which is of the same size and likewise dated 1642 (sale London [Christie's], 24 Oct. 1986, lot 139 [repr.]).

33 The Hague 1991, p. 55; for more on Bramer's genre pieces see also Plomp 1994, pp. 301-06 (repr.).

34 For more on Jacob Delff the Elder, see Ekkart 1989, pp. 322-28.

35 "de weekheid van het vlees, die weinige kunnen uitdrukken, weer met een kunst vaardigheid, die niet is na te volgen." Quoted in Delft 1981, p. 176.

36 For more on Pieter Aertsen, see Amsterdam 1986, pp. 342-57 (esp. nos. 230-31 for the reconstruction of a Delft altar). For pictures by Aertsen in Delft inventories, see Montias 1982, p. 252.

37 See note 2. I.Q. Van Regteren Altena made 'Nicolaes Elias' out of this; see Van Regteren Altena 1983, I, p. 112.

38 Delft 1981, p. 180 and the accompanying volume of illustrations (fig. 201) contradict one another in this regard.

39 For a 'Haarlem' fête champêtre by Anthonie Palamedesz, see Berlin 1986, p. 309, no. 781 (repr.). For the royal hunting scene, see Paris 1967, no. 71 (repr.).

40 The Rijksmuseum preserves a good example of each of Van Asch's two types, as well as a self-portrait of the artist holding another painted landscape. See Amsterdam 1976-A, p. 88 (repr.).

41 The Hague 1994-1995, p. 12.

42 Sutton 1980-A, p. 17.

43 The Hague 1994-1995, no. 15 (repr.).

44 Harwood 1988, pp. 13-18.

45 Plomp 1986, pp. 91-92; Blankert 1987, pp. 98-100; Harwood 1988, p. 15 note 12.

46 Harwood 1988, p. 23.

47 Plomp 1986, p. 144, no. 59 (repr.). Together with his brother Daniel, Nicolaes must have painted a Landscape with Ships that was 'geretokeert' (retouched?) by Carel Fabritius. See Chapter Three, p. 101.

48 Montias 1982, pp. 268-71.

49 To be more precise, can such a conclusion be drawn from inventories that give no attribution for three-fourths of the pictures they contain? (See Montias 1982, p. 227.) What is more, as Montias (1982, p. 249) himself pointed out, the compilers of these inventories were naturally much more familiar with the work of local painters than elsewhere, and would therefore have noted their names more often. An entry in a Delft inventory of 1657 is indicative: "thought to be by a master from Amsterdam by the name of Duyster [soo men meent van een meester van Amsteldam genoemt Duyster]" (Montias 1982, p. 233). In fact, the gifted Amsterdam artist Willem Duyster (1598/1599-1635) had already been dead for over twenty years by that time.

50 Plomp 1986, passim; Plomp 1994, p. 237.

51 Bremen 1991, p. 216, no. 1180 (repr.). I am grateful to Alexei Larionov, curator of the Dutch drawings, Hermitage, St Petersburg, for bringing this publication to my attention.

52 Various versions of Rubens' Garden of Love exist (cf. Glang-Süberkrüb 1975, passim). Bramer's copy shows (a repetition of) the Waddeson Manor version. The authenticity of this version has been contested; Glang-Süberkrüb attributed it to Theodoor van Thulden (ibid., pp. 91-94). Although the sketch does not always follow the painting precisely, it cannot be ruled out that Bramer's model was the panel in Waddeson Manor. He executed his sketches in great haste, which could explain the distortions and omissions.

53 See, for instance, Bramer's Figures in a Loggia (Victoria & Albert Museum, London): Plomp 1994, p. 200 (fig. 25).

54 Plomp 1986, p. 103 (Berch), 115 (Groenewegen), 133 (Pick); Delft 1981, p. 179 (Mierevelt); Montias 1982, p. 148 note k (Vosmaer).

55 For more on the question of whether this can be called Delft School, see Liedtke 1992, pp. 23-35.

THE DELFT CHURCH INTERIOR
1650–1675

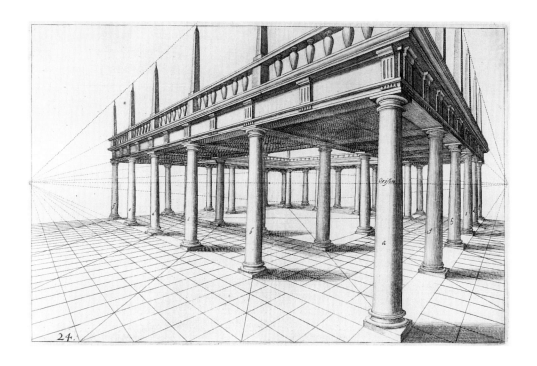

fig. 30
HANS VREDEMAN DE VRIES
Print number 24 from *Perspective*
[...], 1604

42

Delft Masters

DANIËLLE H.A.C. LOKIN

2

The Delft church interior 1650–1675

In 1650 a quiet revolution took place in architectural painting at Delft. Almost from one day to the next the 'old-fashioned' manner of depicting church interiors was supplanted by a new, highly original approach: instead of the straightforward, central perspective that had traditionally been used, artists adopted the two-point system. The two great innovators in the field were Gerard Houckgeest and Emanuel de Witte. Tracing this revolutionary development in the history of the Delft church interior is the purpose of the present chapter. Inevitably, besides Houckgeest and De Witte, the leading roles in our story have been assigned to Delft's hallowed Oude and Nieuwe Kerk (or Old and New Churches).

Houckgeest and De Witte were not the first Delft masters to practice architectural painting. In the late sixteenth century painters throughout the Low Countries had begun to specialise, be it in portraiture, history painting, still life, landscape, townscape, genre or architecture. Works in the last of these categories were called 'perspectives' in the seventeenth century.

Perspective is the art of depicting objects on a flat surface in such a way that they seem three-dimensional, the point being to heighten the verisimilitude of the image. It is based on the principle that the farther away something is, the smaller it appears. Linear perspective was developed in the Renaissance to make this reduction seem natural and convincing. From a single view point (the eye level of the artist) all of the so-called orthogonal lines recede to a vanishing point on an imaginary horizon line. Central perspective is the most common type. On either side of the vanishing point, so-called distance points can also be placed on the horizon line, where the orthogonals converge. Architectural painting entailed a thorough understanding of how perspective is drawn, which artists learned with the help of manuals. An important example of such a manual is *Perspective* by Hans Vredeman de Vries, which first appeared in 1604.[1]

Vredeman de Vries (1527-before 1609), born in the northern Dutch town of Leeuwarden, was the first Northern Netherlandish artist to devote himself exclusively to

fig. 31
PIETER ANTONISZ VAN
BRONCKHORST
The Judgement of Solomon, 1622
panel; 137 x 190 cm
Delft, Stedelijk Museum Het
Prinsenhof, inv. no. PDS 14

architectural painting. The treatise *De Architectura* by the first-century BC Roman architect Vitruvius was one of his chief sources of inspiration. The painter-architect also studied Italian works on the subject, such as *Tutte le opere d'architettura* by Sebastiano Serlio from 1537. Vredeman de Vries published his findings in various richly illustrated books on perspective construction (fig. 30). An inveterate traveller, he carried out commissions in Antwerp, Prague, Amsterdam, The Hague and elsewhere. His pictures, which he painted in collaboration with his son Paul, represent palaces, church interiors, squares and halls, and are carefully constructed according to the laws of central perspective. He preferred an elevated view point and a low vanishing point, which keeps the viewer at a distance.

PROLOGUE:
*"THE MOST DIFFICULT AND MOST REALISTIC IN ART,
NAMELY VIEWS OF TEMPLES AND CHURCHES,
FURNISHED WITH HISTORIES."*[2]

In early seventeenth-century Delft, Pieter van Bronckhorst and Bartholomeus van Bassen specialised in architectural painting, often taking the prints and model books of Hans Vredeman de Vries as their point of departure.

Pieter van Bronckhorst (1588-1661), born at Delft on 16 May 1588, started out as a history painter. Only in later life did he begin depicting imaginary architecture in the context of his historical works. By 1613 Van Bronckhorst was already a member of St Luke's guild at Delft. In 1622 he painted a *Judgement of Solomon* for the city's Tribunal (fig. 31). When he was finished, the artist asked for 30 guilders over and above the 120 that had been agreed upon, which implies that he was either very pleased with the results or that it had taken him more time than planned. His request was apparently not considered unreasonable, for "the treasurer Van der Graeff [paid] Pieter Anthonis van Bronckhorst, painter, for making a perspective, including the *Judgement of Solomon* [...], the sum of 150 guilders, that is, 120 negotiated by him and 30 as a gift, since he complained and since the gentlemen were of the opinion that he had asked too little. Paid 150."[3] Van Bronckhorst's perspective shows the courtyard of a palace with a long gallery, which is just to the left of centre. The gallery has an upper storey and is enclosed by buildings. Through it a second hall can be seen with a prospect of a landscape at the end. The tunnel perspective enhances the sense of depth, as do the buildings in the foreground and the incidence of light from the left.

Upon closer inspection of the panel, one notices a dramatic scene from the Bible depicted on the right. At the behest of King Solomon a soldier is about to slay an infant with his sword, since two women claimed to be its mother. One of the women tries to prevent the soldier by grasping his weapon. Her plea that the baby be given to the other woman tells Solomon, shown seated on a throne with a canopy, that she is the real mother, and in his wisdom he will award the child to her. The Tribunal of Delft, responsible for justice in the city, commissioned the picture in token of their commitment to interpreting the law fairly.

The architect-painter Bartholomeus van Bassen (c. 1590-1652) also belonged to the Delft painters' guild in 1613. Before settling in the city he probably made a journey

44

to Italy, as indicated by the traces of Roman and Venetian influence that can be detected in several of his works. Van Bassen did not spend many years in Delft, for in 1622 he became a master in the guild at The Hague. The artist is especially noted for his imaginary churches with Renaissance elements. By concealing the vanishing point behind a pillar or some other architectural element he explored applications of central perspective other than the tunnel-like structure favoured by Vredeman de Vries and Van Bronckhorst. Van Bassen never leaves any doubt as to the source of light, which he effectively employs to enliven his compositions.

In his *Tomb of William the Silent in an Imaginary Church* at Budapest (fig. 32), Van Bassen has the light enter by way of a window and a portal. By placing the tomb in the centre of the composition he obscured the vanishing point. The handling of light, the central perspective and the colour accents serve to focus attention on the monument. The tomb's popularity with painters, due in part to its symbolic significance, makes it well worth a visit.

The tomb was designed by the Amsterdam sculptor and master builder Hendrik de Keyser (1565-1621), who was commissioned by the States General in 1614 – thirty years after the assassination of the Prince in 1584 – to build a worthy resting place for the 'Father of the Fatherland'. De Keyser enjoyed an international reputation as the best

45

fig. 32
BARTHOLOMEUS VAN BASSEN
*Tomb of William the Silent in an
Imaginary Church*, 1620
canvas; 112 x 151 cm
Budapest, Szépmüvészeti Múzeum,
inv. no. 1106

The Delft church interior

fig. 33
Tomb of William the Silent in the
Nieuwe Kerk at Delft, designed by
Hendrik de Keyser (1565-1621).
Photo: Tom Haartsen, Ouderkerk
aan de Amstel

46

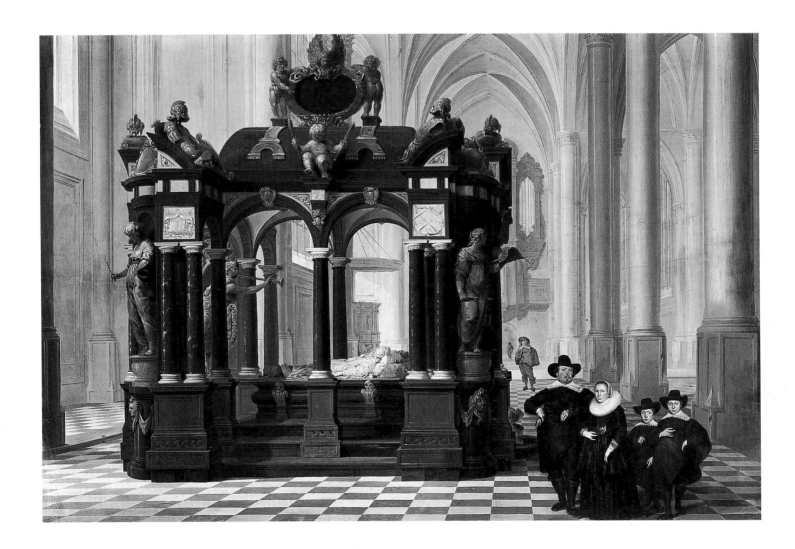

artist in his field. As it happened, he did not live to see the tomb's completion in 1621. The harmonious integration of sculpture in the architecture of the monument is particularly remarkable. Under an elegant canopy, supported by four columns, lies the effigy of the Prince on a marble deathbed. At the front is another statue of William the Silent as he appeared in life, clad in a suit of armour and seated with the staff of a field marshal in his right hand. *Fama*, the allegorical figure of Fame, dominates the back of the tomb. At each of the four corners stands *Aurea Liberta*s (Golden Liberty) and the cardinal virtues *Justitia* (Justice), *Religio* (Faith) and *Fortitudo* (Courage). Two epitaph-holders and torchbearers complete the ensemble. The various symbols and texts recall the illustrious achievements of the deceased on behalf of the nascent Republic of the United Provinces (fig. 33).[4]

The tomb was not yet finished when Van Bassen painted his canvas in 1620, but he probably saw it under construction. The elaboration of the canopy, the attitudes of the figures and their attributes, and the colours of the various marbles are all true to life. There is only one, rather conspicuous difference: the classical armour, modelled as figures on the corners, does not occur on the actual tomb in the Nieuwe Kerk. It may be that the statues were originally planned and that Van Bassen knew them from Hendrik de Keyser's designs.[5] Or they may in fact have been executed and then removed at some later point.[6] Why the painter placed the tomb in a fantastic church remains unclear to this day. Given his rendering of the mausoleum and his evident knowledge of central perspective, he was clearly capable of accurately depicting the choir of the Nieuwe Kerk at Delft. That Van Bassen followed tradition nonetheless by using an imaginary setting may reflect the particular wishes of a patron.

Dirck van Delen (1605-1671) treated the same subject twenty-five years later. In his *Tomb of William the Silent in an Imaginary Church* (fig. 34), he portrays the patron together with his wife and children beside the monument, likewise located in a non-existent church. His inclusion of the armour parallels Van Bassen's handling of the theme as well. Yet Van Delen's panel deviates in many respects from both his colleague's treatment of the theme and the tomb itself. The shields supporting the armour in Van Bassen's canvas are missing, there are no obelisks on the corners and the colours of the canopy are almost the reverse of what they are in actuality. The pileus, or cap of freedom, that *Aurea Libertas* holds in her left hand is of a different model, just as her coiffure, her costume, the position of her right hand (with the scepter) and her feet do not accord with reality. It therefore seems implausible that Van Delen, who was consul of the Province of Zeeland and a resident of Arnemuiden, painted the tomb from life. At least one writer has suggested that he may have studied under Van Bassen, meaning he could have seen that master's portrait of the tomb in his studio.[7]

Gerard Houckgeest (1600-1661)

In 1639 Gerard Houckgeest, who came from The Hague, was inscribed in the guild of Delft in 1639, where he had lived from the time of his marriage to Helena van Cromstrijen in 1635. The artist was probably taught by Bartholomeus van Bassen, like whom he first specialised in fantasy church interiors, often based on engravings and publications by Hans Vredeman de Vries. One of Houckgeest's most characteristic works

fig. 34
DIRCK VAN DELEN
Tomb of William the Silent in an Imaginary Church, 1645
panel; 74 x 114 cm
Amsterdam, Rijksmuseum,
inv. no. A 2352

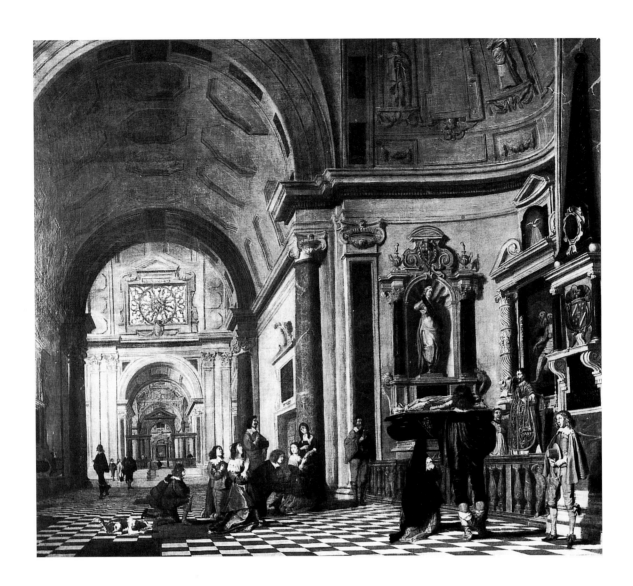

from this period is the *Interior of a Renaissance Church* in the Museum Het Prinsenhof, presumably from 1642 (fig. 35).[8]

Suddenly, almost from one day to the next, Houckgeest abandoned this traditional approach to architecture and, in 1650, started painting Delft churches from life. What exactly happened between 1648, when he was still under the spell of Van Bassen, and his *Nieuwe Kerk with the Tomb of William the Silent* in the museum at Hamburg from 1650 (fig. 36) is a question that has never been resolved. The works of Van Bassen and Houckgeest would seem to indicate a growing interest on the part of both artists in the naturalistic portrayal of church interiors. They rendered light and shadow more convincingly in the course of time, and by placing the view point closer to the picture plane they managed to make the architectural spaces they depicted seem more accessible. Their thorough comprehension of perspective and their painstaking observations ultimately enabled them to achieve what one author has rather aptly described as "a realistic, imaginary church."[9]

The logical sequence of the development we have just outlined in the art of Houckgeest is the faithful depiction of an actual church. Naturally the one he settled on was located in Delft. The artist approached the interior of the seventeenth-century church from an angle seemingly chosen at random. He was apparently intent upon

fig. 35
GERARD HOUCKGEEST
Interior of a Renaissance Church,
c. 1642
canvas; 145 x 169 cm
Delft, Stedelijk Museum Het
Prinsenhof, inv. no. PDS 47

fig. 36
GERARD HOUCKGEEST
*Nieuwe Kerk with the Tomb of
William the Silent*, 1650
panel; 125.7 x 89 cm
Hamburg, Hamburger Kunsthalle,
inv. no. 342

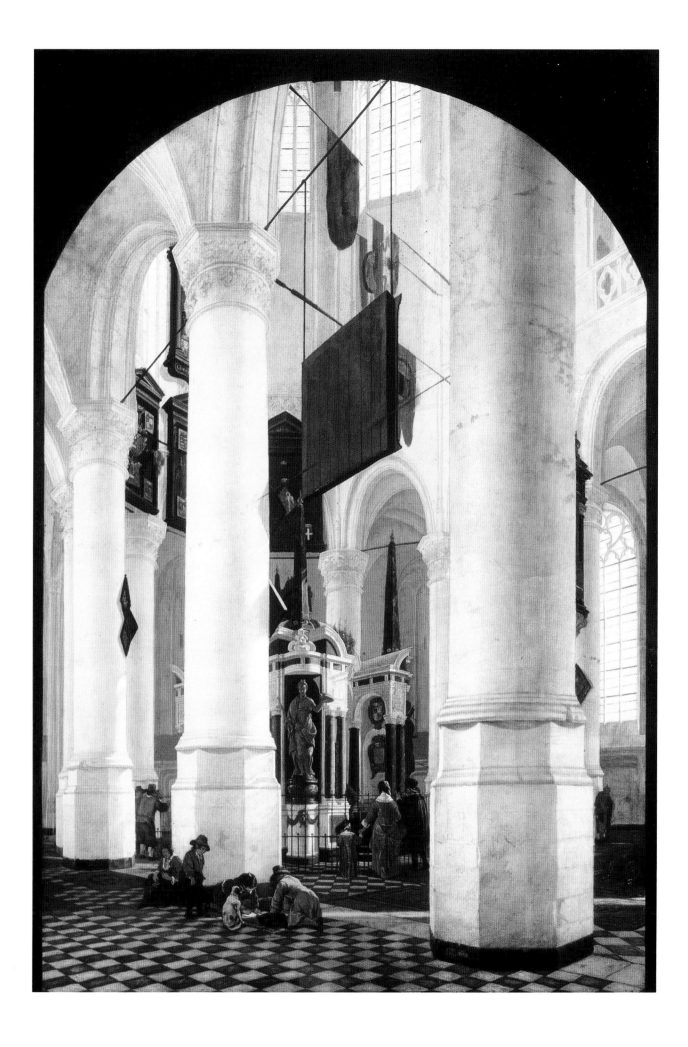

The Delft church interior

making the world he observed seem all but tangible. To that end he experimented with new perspective constructions, unconventional view points and surprising vistas. Instead of simply looking down the length of the nave and placing his vanishing point on the horizontal axis of the composition, the painter took up an ostensibly arbitrary somewhere else in the church. The ingenious design is constructed along two orthogonals, with vanishing points outside the image.

The oblique construction enabled the artist to create a complex pattern of columns and arches. Thanks to the 'random' character of the angle, the view makes a more credible, less contrived impression while at the same time providing manifold opportunities for variation. The same compositional devices that enhance the informal atmosphere of the panel also create the illusion that the viewer is actually in the church. The handling of the light not only heightens the sensation of three-dimensional space but also binds the various elements of the architecture together, thus unifying the whole.

Houckgeest's manipulation of light is innovative compared to that of his older colleagues such as Bartholomeus van Bassen and Dirck van Delen. But light was not his only concern; he also displayed a lively interest in colour contrasts. The same characteristics are also found in the work of Houckgeest's fellow townsman Emanuel de Witte, whose brilliant renditions of Delft church interiors are more or less contemporaneous. Houckgeest does not deserve credit for all these innovations, however; the ground was prepared by Pieter Saenredam, who began painting actual church interiors as early as 1628.

Born in Assendelft, near Zaandam, Saenredam (1597-1665) was a son of the engraver Jan Saenredam and received his training, which lasted over ten years, from Pieter de Grebber. After trying his hand at landscapes, portraits and book illustrations, he eventually went on to specialise in church interiors. Of those artists who were active in this field, Saenredam was the first to lower the horizon to the eye level of his figures, thus creating a monumental effect. The artist accentuates the illusory recession by enlarging the foreground elements and reducing the figures in the background – approximating the optical effect of a tunnel, in other words. Combined with the low view point, this draws the eye not only into the image but also past the columns and up to the vaulted ceiling. Saenredam was also the first painter to treat the interiors of existing churches. He took his measurements and made his sketches from life; based on these observations, he then worked the perspective out precisely in a construction drawing which he transferred to the painting's wooden support. The master executed both the construction drawings and the final paintings in the studio. Characteristic of his church interiors is the monumentality of the architecture, which tends to dwarf the few, incidental figures. The inactivity of these figures intensifies the hushed atmosphere that his work emanates (fig. 37).

One way or another Houckgeest must have become acquainted with the art of Saenredam; it is inconceivable that the architect-painter from Delft would not have known the work of his prominent colleague at Haarlem. Moreover, we know of at least one occasion when the two artists could conceivably have met.[10] Saenredam could well have induced Houckgeest to paint existing church interiors. He may have

also inspired the low view point his colleague favoured. In contrast to the Haarlem master, however, the small figures in Houckgeest's pieces are no longer subordinate to the architecture, but play an independent role. But the most important difference is that, in contrast to Saenredam's central perspective, Houckgeest depicted his church interiors from a seemingly 'random' angle. The question of how the artist so unexpectedly arrived at this approach in 1650 has fascinated many students of his art. We have already noted that both he and Van Bassen had long been interested in illusionism. Perhaps, however, his decision to portray the tomb of William the Silent may have had something to do with the fascinating view point.[11] If we are to understand the choice of the theme and the possible consequences, we must first review a bit of Dutch history.

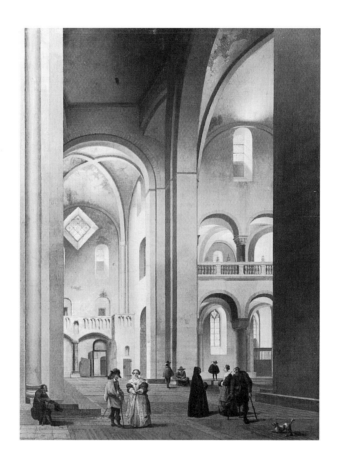

fig. 37
PIETER SAENREDAM
Transept of the Mariakerk in Utrecht,
1637
panel; 59 x 45 cm
Amsterdam, Rijksmuseum,
inv. no. A 858

51

From 1647 until 1650 the Northern Netherlands were ruled by the ambitious young stadholder William II of Orange. On 14 March 1647 the Prince succeeded his father Frederick Henry as stadholder. Disappointed by the Peace of Münster in 1648, he planned to restore the treaty with the French, whose co-operation he wanted in order to wrest the Southern Netherlands from Spain. He was also keen to help his brother-in-law Charles II ascend the English throne. Fearing war with Spain and England, the States of Holland opposed William's designs. The conflict escalated after the Prince was poorly received by the principal cities of Holland, which he visited in June 1650 to gather support for his policy. On 14 July the situation came to a head when William had six delegates to the States of Holland, including the one from Delft, Jan Duyst

The Delft church interior

van Voorhout, imprisoned in the castle of Loevestein. Immediately thereafter he dispatched 12,000 troops to Amsterdam to bring the city to submission. In October, however, he contracted smallpox and died on 6 November 1650. Upon the untimely death of the Prince, who was only twenty-four, the States of Holland seized the opportunity to curtail the powers of the Oranges: the so-called First Stadholderless Period commenced.[12]

Remarkably, 1650 was also the year that Houckgeest painted his first realistic picture of a Delft church, revolutionising the genre by choosing a vantage point seemingly at random. The tomb of William the Silent figures prominently in this realistic scene, and as various authors have argued, there can hardly be anything random about its coinciding with the view point. Aside from the more general connotation of the transitoriness of life, Houckgeest's portrait of the famous monument should surely be seen as a tribute to William the Silent and, by extension, the House of Orange.[13] Without wishing to dispute this argument, it seems surprising that there was no objection to the covert character of this tribute, which after all shows nothing more than the knee of the *Pater Patriae*! It may be that a less cautious declaration of pro-Orangist sentiment, such as Dirck van Delen's *Tomb of William the Silent in an Imaginary Church* (1645) (see figure 34), would have been unwise in 1650. In other words, the Hamburg panel, whose monumental format points to a special commission,[14] may have been ordered by an Orangist, who instructed Houckgeest for political reasons to be discreet. We may never know what the answer is, but the artist's 'stopgap' solution – if indeed we may call it that – was so successful that before long everyone wanted a picture of a church interior. Unfortunately, very little is known about republican attitudes toward Orangist themes in art, but the decline in sales of portraits of members of the House of Orange at Delft around 1650 may indicate that their supporters were on their guard.[15]

We can at least be certain that Houckgeest manipulated both the composition and the light in order to lead the eye of the observer to the figure of Liberty. As regards the composition, he did so by means of the standpoint, the disposition of the columns and the enclosure of the top with standards, escutcheons and hatchments. The refined handling of the light, which falls precisely on the left part of the tomb, along the contour of *Aurea Libertas*, serves the same purpose. The low view point makes the church seem all the taller and the architecture all the more complex. The arched framework, which Houckgeest attached to the rectangular panel when the picture was finished, is rather remarkable, especially since the device had never before been used in architectural painting. By obscuring the capital of the foremost column the artist managed to keep the viewer at a distance and enhance the illusion of depth.

Two children are seen playing in the left foreground, their hands precisely illuminated by a band of light from the right.[16] A boy and a watch them attentively. A woman seated against the second column on the floor nurses a baby. Around the tomb of William the Silent a gate has been introduced. A man in black addresses a woman holding a little girl by the hand as he points to the statue of the seated Prince, whose right knee is all that is shown. The figure of Liberty stands at the corner of the monument. A man on the far left leans against the gate – philosophising perhaps about the brevity of life with the figure on his left?

In the seventeenth century churches were primarily places where services were held. Since time immemorial, however, people had also been buried in them, as evidenced by the many tombstones, funeral processions, gravediggers and hatchments in churches that are depicted in art.[17] Church interiors therefore lend themselves to artistic reflections on mortality. The monumental tombs honouring the heroes of the past meant that they were also public spaces where people could gather. Hence the presence of figures strolling and conversing, children playing, and even dogs in these works.

Houckgeest's *Oude Kerk in Delft with the Tomb of Piet Heyn* (fig. 38) makes it easy to imagine churches as public spaces.[18] There are striking parallels between this panel and that in Hamburg, which likewise dates from 1650. Once again the view point is low. An enormous column in the centre of the composition obstructs our view, but dramatically increases the sense of depth at the same time. By means of diagonal perspective Houckgeest accentuated the complexity of the space and the height of the

fig. 38
GERARD HOUCKGEEST
Oude Kerk in Delft with the Tomb of Piet Heyn, 1650
panel; 68 x 56 cm
Amsterdam, Rijksmuseum,
inv. no. A 1971

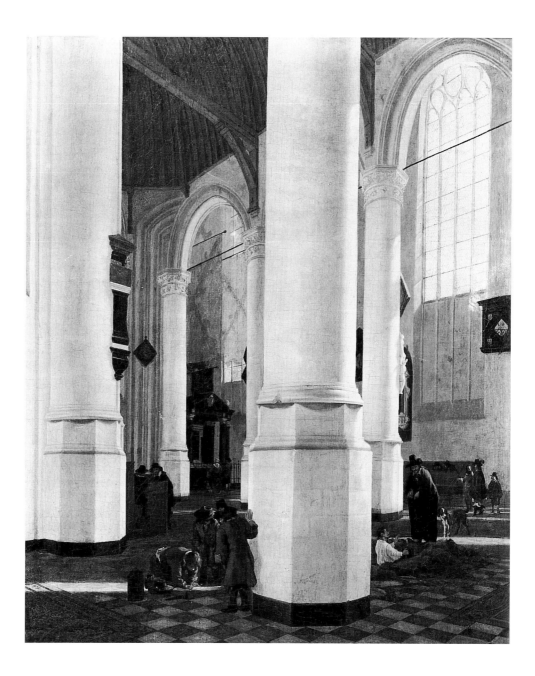

building, thus faithfully reflecting the church itself. The column in the centre leads the eye to the left, where part of the tomb of Piet Heyn can just barely be discerned in the background. As in the portrait of the tomb of William the Silent, a man, a woman and a child stand before the gate, gazing reverently upon the naval hero's final resting place. In the foreground a boy kneels on the floor, absorbed in his task, while four others look on; sunlight falling from the right pierces the gloom behind the foremost column, illuminating the little scene. On the right a gravedigger, having already dug a sizeable hole, leans on his shovel as he pauses for a chat; a band of light picks out the figure of his interlocutor. The illusion of reality is complete.

One year after painting the monumental Hamburg canvas of William the Silent's tomb, Houckgeest returned to the same theme in a panel preserved in The Hague (fig. 39). Although half the size of the 1650 version, the piece shows the interior of the church from virtually the same angle. Once again Houckgeest opted for an arched format, by using a panel that had been sawn off at the top. Here too the view point is low and the perspective diagonal. In contrast to the earlier work, however, the master

fig. 39
GERARD HOUCKGEEST
*Interior of the Nieuwe Kerk in Delft
with the Tomb of William the Silent,*
1651
panel; 56 x 38 cm
The Hague, Koninklijk Kabinet van
Schilderijen Mauritshuis, inv. no. 58

places the observer farther forward and a bit more to the left, so that the tomb is closer to the picture plane. A column occupies the same central position as in the painting of the Oude Kerk (see figure 38), so that more of the interior is visible to the left. Thanks to the lucid structure of the ambulatory, the tomb's location in the centre of the choir is more clearly evident. The round arches above the columns in the first version are now really Gothic. The pattern of the floor tiles, which the painter used to construct the diagonal perspective, is less overbearing, since Houckgeest managed to strike a balance between tiles and tomb slabs. The boys at play have disappeared, as has the woman with her baby. A little girl with a dog at her side gazes at the monument with a respectful attitude. Two men advance from the left, and the couple admiring the tomb now have a little boy with them.

The oblique orientation, the low vantage point and the hatchment suspended from a draught bar were not the only devices whereby Houckgeest directed the spectator's attention to the monument. He also subtly manipulated the sunlight flooding the church to draw the eye to the figure of Liberty again, picking out her forehead, the edge of her hat and her left leg. This too may have been intended as a form of homage to the Father of the Fatherland.

The *Ambulatory of the Nieuwe Kerk, Delft* from 1651 (fig. 40), likewise preserved in The Hague, occupies a unique position in Houckgeest's oeuvre. In choosing a horizontal format the artist experimented with the optical effect of a wide-angle view, measuring between 100 and 150 degrees. As a result, the upper zone of the composition is filled with ribbed vaults. Constructing the perspective of such vaulting is very difficult and demands considerable knowledge of geometry and arithmetic. In doing so Houckgeest may have used an engraving from *Perspective* by Hans Vredeman de Vries (see figure 30).[19] The format of that work is likewise horizontal and the disposition of the vanishing points identical. It is interesting to note that a year later his fellow townsman Carel Fabritius adopted a similar format for his *View in Delft* (see fig. 72), which is one further indication that artists in Delft shared an interest in optics and perspective during the period between 1650 and 1675. As a consequence of the wide viewing angle, the tomb of William the Silent at the back of the choir is no longer the focus of the composition. The diminutive figures merely complement the architecture, moreover, and have no individual traits. Their role within the composition is thus negligible.

In the *Interior of the Jacobskerk, The Hague* (fig. 41),[20] likewise from 1651, the viewer is drawn directly to the small domestic scene in the foreground. Seated on the floor against a chair screen, a woman nurses a baby. A small boy holds the woman's shawl for her, with a sleeping dog at his side. A man, seen from the back with his hands in his pockets, has a hammer in the belt of his apron of the kind used to work stone floors. On the far left can be seen an open grave. Sunlight illuminates the pile of earth beside it as well as the chair screens. The pulpit owes its prominence to the central perspective. The vanishing point, high at the back of the choir, leads the eye to the plaque on the pulpit, where Psalm 19 is indicated.[21]

The psalm, which opens with the familiar words "The heavens declare the glory of God; and the firmament sheweth his handywork." It is a hymn to God's creation and His law. The prominence of the allusion to it tells us something about the

fig. 40
GERARD HOUCKGEEST
*Ambulatory of the Nieuwe Kerk in
Delft*, 1651
panel; 65.5 x 77.5 cm
The Hague, Koninklijk Kabinet van
Schilderijen Mauritshuis, inv. no. 57

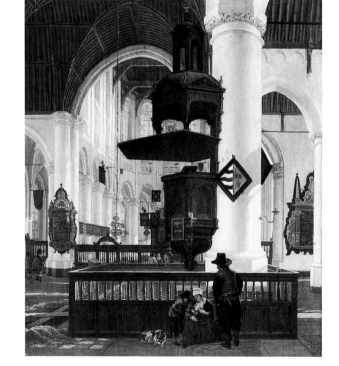

fig. 41
GERARD HOUCKGEEST
Interior of the Jacobskerk, The Hague,
1651,
panel; 53 x 43.4 cm
Düsseldorf, Kunstmuseum,
Gemäldegalerie

message the artist was seeking to convey. His contemporaries would have immediately recognised the pulpit as the place where the faith is preached, the mother nursing the child as a token of brotherly love (*Caritas*) and the gravedigger by the open grave as a reference to death. The panel thus constitutes an emblem of the three spiritual virtues, Faith, Hope (in eternal life) and Charity.[22] The frequent occurrence of these motifs in depictions of seventeenth-century church interiors can hardly be coincidental. There are many covert personifications of this kind, the one more explicit than the other.

Little is known about Houckgeest's working methods. Like Saenredam, we may assume he prepared his paintings with sketches from life, yet no drawings by his hand survive. That he set up his easel in the churches he portrayed is unlikely, however, for certain elements in his work suggest he had a collection of drawings on hand. For instance, the pulpit in the *Interior of the Jacobskerk, The Hague* actually belongs to Delft's Oude Kerk. The master would not have simply incorporated it from memory in another work; it is more likely based on a sketch he made in the church itself. Nor is this the only indication that Houckgeest prepared his interiors on paper: in the 1650s, long after he had moved away from Delft, he continued painting interiors of Delft churches.

The *Interior of the Nieuwe Kerk, Delft* (fig.42), dated 1653, was not actually painted in Delft. After moving away from the city in 1651, Houckgeest lived for some time in Steenbergen before moving to a large estate at Bergen op Zoom in 1653. It was in this last town that he painted several interiors of the Grote Kerk, which is dedicated to St Gertrude and popularly known as the pepper mill. Thanks to the income generated by the beer brewery he owned at Delft and inheritances he had

57

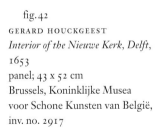

fig.42
GERARD HOUCKGEEST
Interior of the Nieuwe Kerk, Delft,
1653
panel; 43 x 52 cm
Brussels, Koninklijke Musea
voor Schone Kunsten van België,
inv. no. 2917

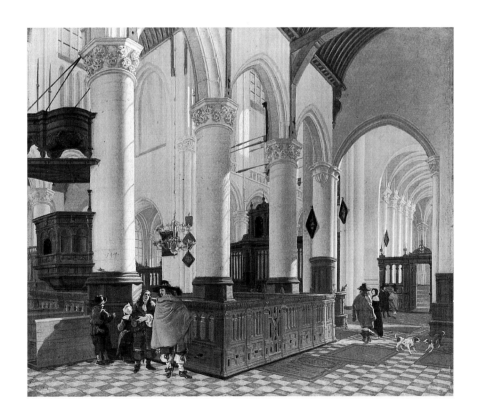

received along the way, he had become a prosperous landowner and was no longer financially dependent on the sale of his art. This may explain the relatively modest extent of his oeuvre.[23]

As in the *Ambulatory of the Nieuwe Kerk* (see figure 40), Houckgeest opted for a horizontal format. The centre of attention is not the tomb of William the Silent, however, but the chair screens around the baptismal font below the pulpit, in the midst of the nave. A richly dressed man is seen standing in the left foreground; with an ample cloak slung over his left shoulder he converses with another man. A boy stands writing on the base of the column to which the pulpit is anchored, under the watchful eye of a girl. The diagonal recession leads the observer irresistibly to the right; the sunlight and the pattern of the tiles reinforce this oblique movement, thus heightening the sensation of three-dimensional reality. Thanks to their size and disposition, the figures play a more important role than those in the panels from 1650 and 1651; the sunlight accentuates their gestures, furthermore.

In 1654 Houckgeest treated the *Oude Kerk at Delft* once more (fig. 43).[24] He painted the view of the church's interior in an arched format, as he did in the two pictures of the tomb of William the Silent (see figs. 36 and 39). Here the illusion is taken a step farther, in as much as the arch is now distinguished by the artist as real stone or marble. Before the niche a curtain on a rod is drawn to one side, casting an imaginary shadow on the arch. Deceptively realistic elements like these also occur in the work of Emanuel de Witte and Hendrick van Vliet. Costly pictures were sometimes shielded from sunlight in the seventeenth century; a curtain attached to the frame by means of a small brass rod could be drawn across them. In Houckgeest's panel the trompe l'oeil curtain augments the suggestion of reality, but also confuses the viewer rather amusingly.

Toward the end of his career the figural elements in Gerard Houckgeest's works become larger, in token of their growing importance within the overall composition. This development betrays the influence of Emanuel de Witte. A man, seen from behind, and a woman figure prominently in the *Oude Kerk, Delft*, before the chair screen to the right of the central column. Their attitude, the details of their costumes, their gestures and facial expressions, but also the handling of light and the use of colour, are patently indebted to De Witte.

Emanuel de Witte (c. 1616-1691/1692)

Emanuel de Witte, born in Alkmaar, was inscribed in Delft's guild of St Luke in 1642. He was presumably living in Delft by 1641, for his daughter was baptised there that year. According to the eighteenth-century artists' biographer Arnold Houbraken, he studied at Delft under the still-life painter Evert van Aelst (1602-1657). De Witte started out as a figure painter and specialised initially in nocturnal settings of biblical and mythological subjects (fig. 44).[25]

In 1650 De Witte's manner underwent a far more radical change than did Houckgeest's. He ceased to paint history pieces altogether and turned his attention to perspectives. Although he had never tried his hand at church interiors, his work in this field was estimable from the start. De Witte was deeply influenced by Houckgeest;

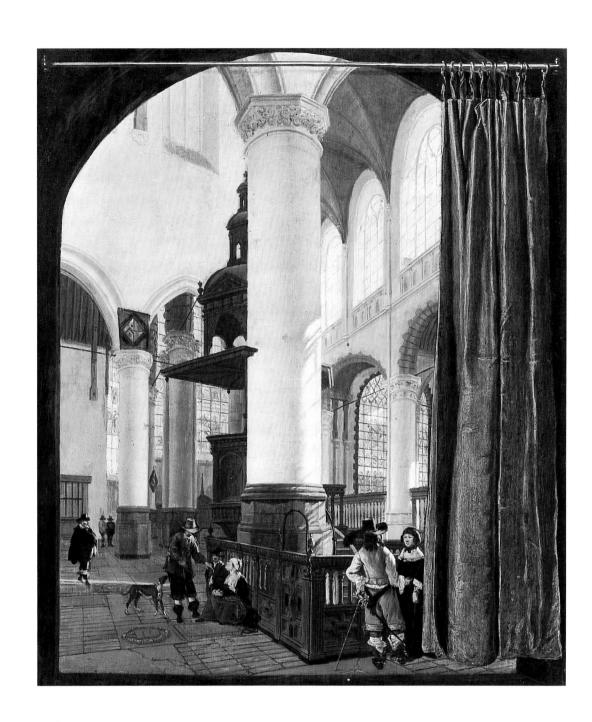

fig. 43
GERARD HOUCKGEEST
The Oude Kerk at Delft, 1654 (?)
panel; 49 x 41 cm
Amsterdam, Rijksmuseum,
inv. no. A 1584

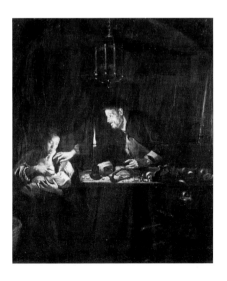

fig. 44
EMANUEL DE WITTE
The Holy Family, c. 1650
panel; 51 x 43 cm
Delft, Stedelijk Museum Het
Prinsenhof (on loan from the
Rijksdienst Beeldende Kunst,
The Hague), inv. no. NK 2263

60

fig. 45

EMANUEL DE WITTE
Interior of the Oude Kerk, Delft, 1650
panel; 48.3 x 34.5 cm
Montreal, Mr. and Mrs. Michal
Hornstein. Photo: Christine Guest,
Montreal

not only did he borrow the designs of his fellow townsman in the 1650s, but he also imitated Houckgeest's method of constructing – which, it must be said, he never entirely mastered.

In contrast to his confrères Houckgeest and Van Vliet, De Witte did not focus on the actual structure of the architecture in his interiors. Of greater interest to him was the effect of sunlight, which enabled him to unify his compositions and to strike a balance between the areas of light and shade.

One of the first architectural pieces of Emanuel de Witte is the *Interior of the Oude Kerk, Delft* (fig. 45), which has been securely dated to 1650.[26] Already at this early stage, the panel shows how, unlike Houckgeest and Van Vliet, De Witte utilised light to evoke a sense of depth. While they achieved convincing spatial effects through the lucidity of architecture, De Witte did so primarily by manipulating the sunlight streaming into the church.

The depiction of human activity fascinated De Witte. Walking figures, playing children and dogs enliven his church interiors. In this case, two small boys are seen drawing on the base of the central column. In the lower left corner the outline of an open grave can just be seen. The gravedigger himself is not shown, but a bench, some planks, a rope and a broom point to his presence. The dogs wandering loose in the church are striking; some churches even employed people to get rid of them.

In the *Interior of the Nieuwe Kerk, Delft, with the Tomb of William the Silent* (fig. 46), from 1650 or 1651, De Witte employed one-point perspective. By situating the vanishing point to the left of centre at the back of the church, below the organ loft, the artist diverts the eye from the tomb, which is largely obscured by the column in the foreground, to focus all the more attention on the interaction of the figures. De Witte opted for the same arched format as Houckgeest (see figure 39); the curvature of the arch is discreetly echoed by the wooden barrel vault of the ceiling.

De Witte's use of diagonal perspective in the *Interior of the Oude Kerk, Delft* from 1651 (fig. 47), which belongs to the Wallace Collection, London, was undoubtedly inspired by Houckgeest as well. Like his older colleague, he took up a position in the southern aisle of the nave and recorded the view of the northern transept and the choir. The angle of the view accounts for the candid, uncalculated impression that the panel makes. Yet De Witte did take some liberties for the sake of his composition. The triforium in the choir is not entirely accurate and the gallery of the transept is shown with three instead of five arches. The columns are farther removed from one another than in actuality and the capitals have been altered as well. The largely empirical construction of the perspective is imprecise, moreover; De Witte probably neglected to make a construction drawing beforehand, preferring to elaborate the situation sketch directly on the panel. The placement of the vanishing point is such that the eye is drawn irresistibly to the pulpit. Horizontal elements such as the chair and choir screens compress the space and mitigate the sense of depth. The figures in the fore-ground are so large and so prominent that the picture could almost be a genre scene set in the interior of a church; they invite comparison with the figures in the domestic scenes of Gerard ter Borch, Nicolaes Maes and especially Pieter de Hooch (see Chapter Four).[27]

The sermon would become one of Emanuel de Witte's favourite themes, affording him plenty of opportunity to paint figures. The theme may derive from Pieter Saenredam, who had depicted two different church interiors with preachers in the late 1640s. In Saenredam's works it is difficult to imagine that anyone is actually speaking, however, while in De Witte's one can almost hear the crowd talking through the sermon.[28] Notwithstanding this extraordinary naturalism, of which the London panel is a superb example, the artist may well have intended the congregation to personify Faith, Hope and Charity collectively, rather than visualising these virtues as Houckgeest did in the form of isolated personifications.

In 1652 De Witte left Delft and settled in Amsterdam, where besides countless interiors of local churches he also painted market scenes, harbours and a few domestic

fig. 46
EMANUEL DE WITTE
*Interior of the Nieuwe Kerk, Delft,
with the Tomb of William the Silent,*
c. 1650-1651
panel; 68 x 48.7 cm
Hamburg, Hamburger Kunsthalle,
inv. no. 203

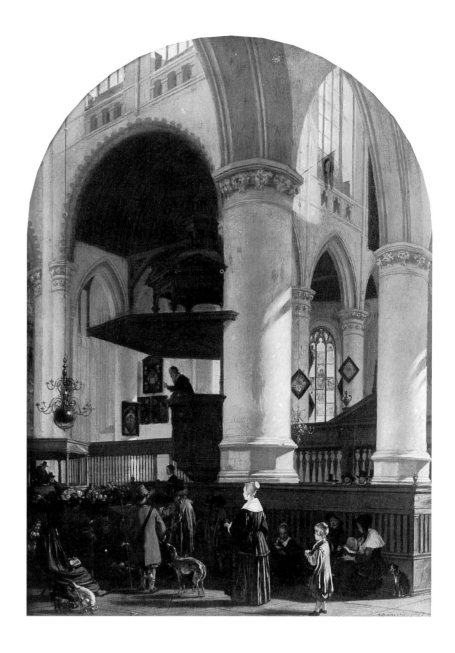

interiors. But even though he no longer lived in Delft, De Witte remained loyal to the town's churches. One example is his *View of the Tomb of William the Silent in the Nieuwe Kerk, Delft* (fig. 48). In that painting De Witte utilised two distance points in order to render the tiled floor, but did not bother to construct the perspective accurately: the orthogonals fail to converge at a central vanishing point.[29] The lack of precision is not noticeable, however, since the artist resolved the problem as usual by manoeuvring the light. The emphasis on the human element is again characteristic of De Witte. Whereas Houckgeest kept the staffage to a minimum, the interiors of De Witte are replete with small figures. And as the panel clearly shows, De Witte's painterly manner was much looser than that of his meticulous colleague; his brushwork is more fluent and his impasto thicker.

The design of the *Interior of the Nieuwe Kerk, Delft* from 1664 (fig. 49) is virtually the same as that of the artist's panel at Hamburg from thirteen years before (see figure 46). Once again the vanishing point is situated below the organ loft and a column largely blocks our view of the tomb. However, as we have seen before in De Witte's work, the

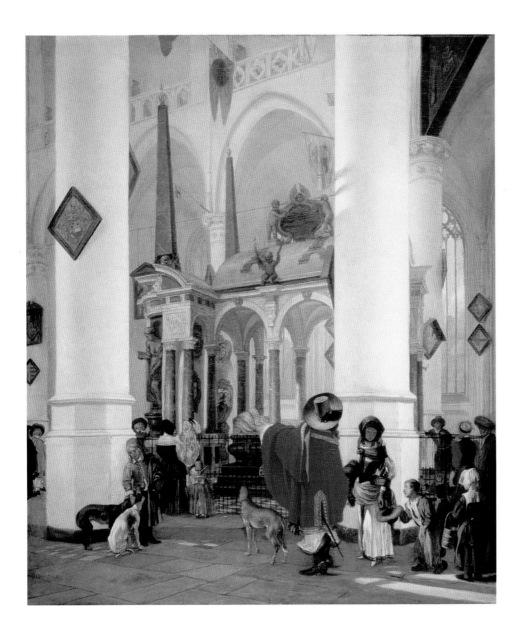

fig. 48
EMANUEL DE WITTE
*View of the Tomb of William the
Silent in the Nieuwe Kerk, Delft,*
1656
canvas; 97 x 85 cm
Lille, Musée des Beaux-Arts,
inv. no. 902

one-point perspective is not correct in every respect. Instead of at the vanishing point, the lines of the triforium converge above the choir screen. A man and a boy are seen standing in the foreground, both of them with their backs to us. They are farther away than the figures in the Hamburg version, but since De Witte altered their format and also shifted the columns by choosing a different vantage point, this is not noticeable. A window is now visible on the right and the obelisk on the corner of the tomb dominates the upper righthand corner of the composition. The sun streams through the windows of the choir from the southeast, creating sharp contrasts between the light and shadow. De Witte was evidently fascinated by the effects of light and used it to bind the various elements of his design together.

The tomb of William the Silent, which Houckgeest constantly emphasised, seems to have been of less interest to De Witte. He never positioned himself in such a way as to enhance the importance of the figure of Liberty within his composition. This is already evident in the panel at Hamburg (see figure 46), where the view of the monument is obstructed by the column in the foreground. In the Salzburg canvas, too, the tomb is only very discreetly highlighted by a single ray of sunlight. The motto *Te vindice tuta libertas*

fig. 50.B
Detail of the tomb of William the
Silent, the virtue *Fortitudo*. Photo:
Tom Haartsen, Ouderkerk aan de
Amstel

fig. 49
EMANUEL DE WITTE
Interior of the Nieuwe Kerk, Delft,
1664
canvas; 79 x 67 cm
Salzburg, Landessammlungen–
Residenzgalerie, Czernin collection,
inv. no. 557

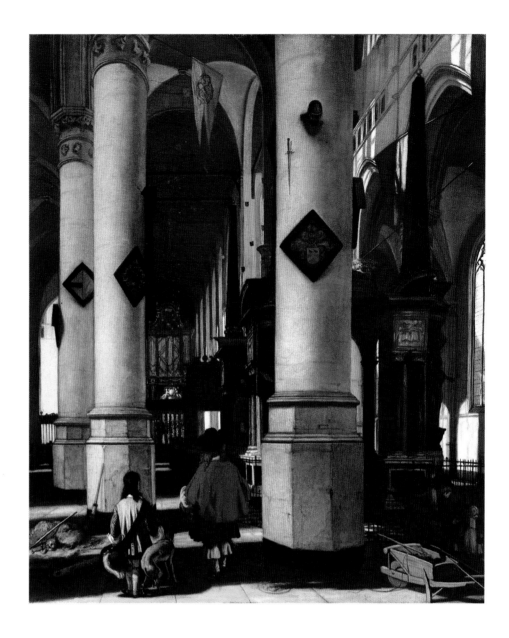

fig. 50.A
Detail of the tomb of William
the Silent with the motto *Aurea
Libertas*. Photo: Tom Haartsen,
Ouderkerk aan de Amstel

fig. 50.C
Detail of the tomb of William
the Silent with the motto *Sævis
Tranquillus in undis*. Photo: Tom
Haartsen, Ouderkerk aan de Amstel

(With your protection, liberty is safe), above an open Bible in the lower righthand corner, is given an additional accent. The allegorical statue of *Fortitudo* (Strength, Courage) can also be seen, clad in her lion skin and holding the oak sprig in her right hand; the combination of the motto with this particular virtue was invented by Emanuel de Witte. In reality *Fortitudo* stands beside the motto *Saevis Tranquillus in undis* (At peace amid the raging sea) (fig. 50). De Witte intended this modification to visualise William the Silent's greatest gift to the Netherlands, even if it is hardly recognisable. The understated presence of the tomb, without accents or specific details, was apparently sufficient so far as the artist's patron was concerned.

In the *Interior of the Oude Kerk, Delft* (fig. 51) sunlight again serves an important purpose within the composition. Through windows beyond the left side of the image it illuminates the columns and plays over the gleaming surface of the bronze chandelier, augmenting its plasticity. Behind the clear Gothic windows a few whisps of cloud can be seen in the sky. No sooner have one's eyes grown accustomed to the shadows than one's attention, like that of the man wearing a cloak with a dog, is drawn to the memorial plaque. The man, who is consistently seen from the back, is a recurrent motif in De

66

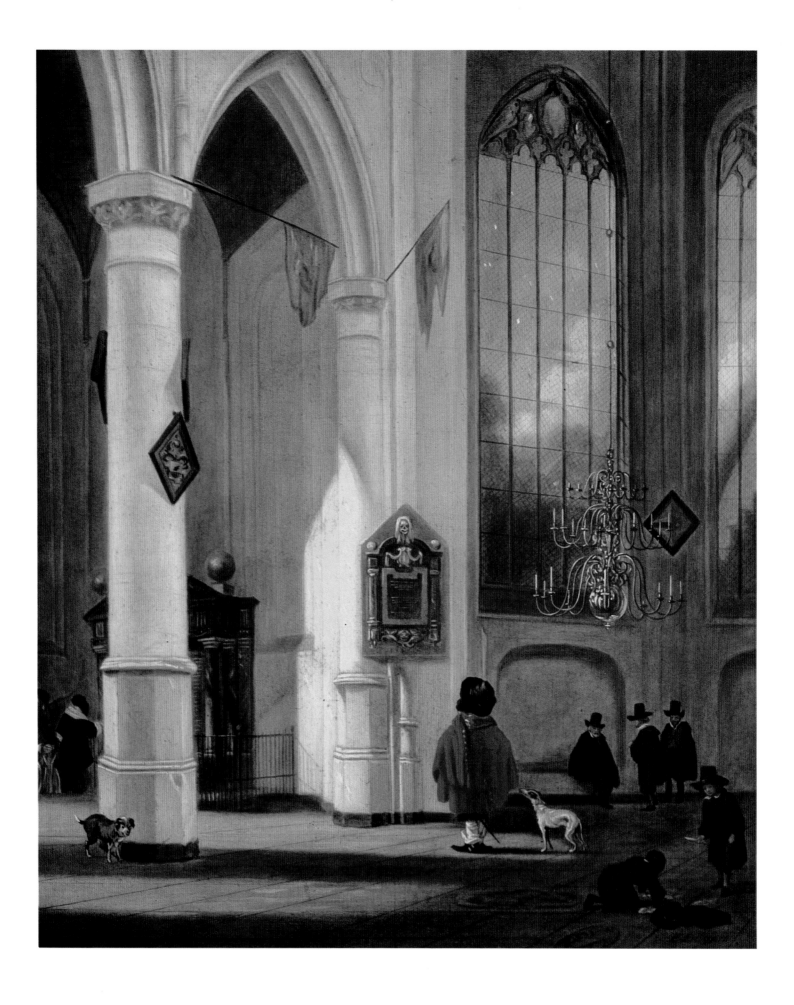

Witte's paintings. The painter evidently used the mantle, which is nearly always bright red, as a means of highlighting the figure. The diagonal perspective ensures that the spectator explores the rest of the image only in the second instance. Two boys are playing in the right foreground, while three men converse farther back. On the left a woman points out the tomb of the naval hero Piet Heyn to her child, as the man beside her addresses someone outside the image.

From the 1660s onward De Witte concentrated almost exclusively on imaginary church interiors, often composed of architectural elements from various different, existing ones. The *Interior of a Protestant Church* (fig. 52) comprises the pulpit from the Oude Kerk at Delft, for instance. The theme of the sermon plays a subordinate role in this work, inasmuch as the pulpit, which is overshadowed by the organ in reality, is omitted. A richly decorated memorial plaque, affixed to a column, catches the eye, especially since the sunshine highlights the relief. The same sunshine creates a lovely pattern of light and shadow on the floor, which continues as far as the wall. In the right foreground stands Emanuel de Witte's trademark, the man with the mantle and his canine companion. The artist has aligned the horizon with the upper edge of the

fig. 51
EMANUEL DE WITTE
Interior of the Oude Kerk, Delft
panel; 52 x 43 cm
Stockholm, Hallwylska Museet,
inv. no B.31

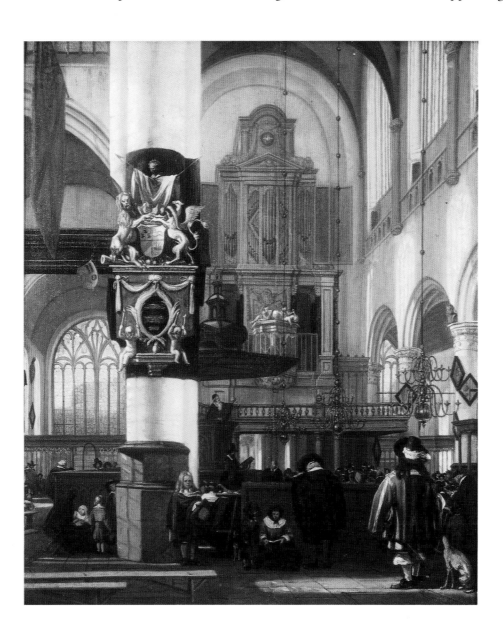

fig. 52
EMANUEL DE WITTE
Interior of a Protestant Church
panel; 47 x 39 cm
Antwerp, Koninklijk Museum voor
Schone Kunsten, inv. no. 789

The Delft church interior

68

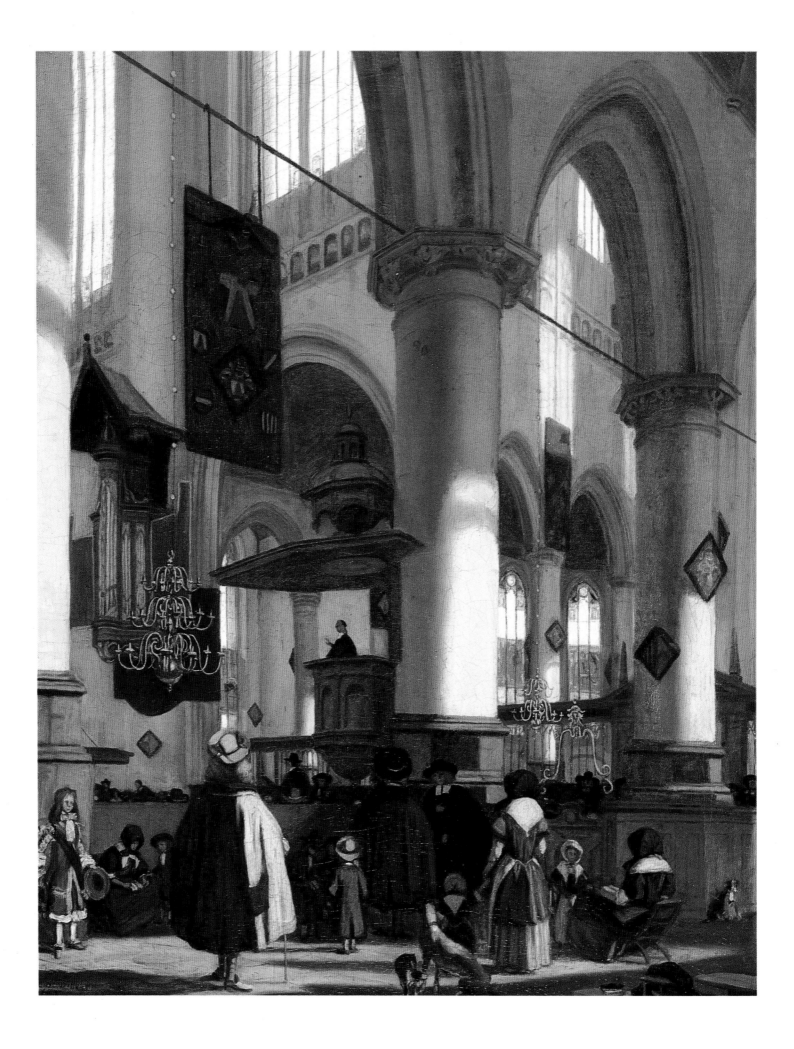

screen and the balustrade of the organ loft. De Witte employed these horizontal elements to flatten the space; by concealing the vanishing point behind a massive column he diminished the sense of depth further still. Rather than carefully calculating the perspective, however, the artist worked it out on the panel, based on his own observations. Hence the failure of the orthogonals on the floor and in the triforium to converge at the vanishing point.

For whatever reason, the atmosphere of De Witte's architectural paintings changed around 1670. His palette became less vibrant, as browns, ochres and greys began to predominate. The artist used the sunlight in his subsequent works to heighten a small figure or an architectural element with white. Remarkably, over thirty years after moving to Amsterdam, he continued painting the interior of Delft churches, such as that of the Oude Kerk in this canvas from 1682 (fig. 53). The artist may have received commissions from natives of Delft who were living in Amsterdam and wanted a souvenir.

fig. 53
EMANUEL DE WITTE
Interior of the Oude Kerk, Delft, during a Sermon, 1682
canvas; 60,3 x 47,5 cm
The Netherlands, private collection. Photo: Tom Haartsen, Ouderkerk aan de Amstel

HENDRICK VAN VLIET (C. 1612-1675)

The third important architectural painter was Hendrick van Vliet, who was born at Delft and received his training from his uncle, the portrait and history painter Willem van Vliet. He may have also studied under Michiel van Mierevelt.[30] In 1632 he became a master in the guild of his native town. At first Van Vliet painted traditional portraits for the most part, becoming skilled at church interiors in later life. Dirck van Bleyswijck said he was, like his uncle, a good portraitist, "and is also not unlucky in mythologies and histories, both in day and night lighting. He understands perspective well, which may be seen in his modern or contemporary temples. When he has made them at his best, they are very well foreshortened and illusionistic, as well as colored naturally."[31] Van Vliet was the only living master whom Van Bleyswijck included in his *Beschryvinge*,[32] which is a clear indication of the author's esteem for the master, and of his prominence. Houckgeest and De Witte's departure from Delft in the early 1650s left him with a monopoly on the painted church interior in the city.

Van Vliet's earliest architectural painting, which already betrays the influence of Houckgeest, dates from 1652. Since, like Emanuel de Witte, he did not start out in this genre, he looked to the example of his fellow townsman Gerard Houckgeest to learn how to construct architectural space. Although he was content to follow in most cases, he did experiment with vantage points so as to include more of the interior and enhance the illusion of depth.

Van Vliet began, like Houckgeest and De Witte presumably, by making sketches of Delft's churches. In doing so he not only showed an interest in the representation of space but also noted people chatting and children at play. Thanks to the survival of one of his sketchbooks we know something about his working methods. The sketchbook comprises nineteen sheets which are all drawn on both sides. In addition to thirty portraits Van Vliet sketched three church interiors, a memorial plaque, the pulpit of the Nieuwe Kerk and three sheets of figure studies.[33]

Comparison of one of the church interiors in the sketchbook (fig. 54) with the *Interior of the Nieuwe Kerk, Delft* from 1655 (fig. 55) shows how Van Vliet prepared his paintings

fig. 54
HENDRICK VAN VLIET
Sketchbook with studies of church
interiors and figures
black and red chalk, heightened
with white; 27 x 21.6 cm
Rotterdam, Museum Boymans-
van Beuningen

fig. 55
HENDRICK VAN VLIET
Interior of the Nieuwe Kerk, Delft,
1655
panel; 61 x 53 cm
Moscow, Pushkin State Museum
of Fine Arts, inv. no. 571

on paper. The sensation of three-dimensional reality is much more convincing in the finished panel than it is in the sketch, even though the latter was done from life. Van Vliet emphasised the verticality of the church by altering the viewpoint, so that the pulpit and the surrounding chair screens are fully visible. The vanishing points of the diagonal perspective lie well outside the image on an imaginary horizon line that runs across the top of the choir screen. Combined with the distant vista to the left, they lend the interior a tremendous sense of recession.

The open grave in the foreground is a motif seldom used by Houckgeest and De Witte in this fashion. The seventeenth-century viewer would have doubtless recognised it as a *memento mori*: an admonition to lead a pious life, as death can strike at any moment. The reference to Psalm 37 on the plaque affixed to the pulpit lends this motif an extra dimension: one need not envy sinners their pleasures in this life, for they shall receive their just deserts in the next.[34]

More so than his two colleagues Van Vliet employed illusionistic effects, such as trompe l'oeil arches and curtains. He was also fascinated by the effects of the sunlight streaming into the church and the expressive possibilities offered by contrasts between

light and shadow, which are so characteristic of Emanuel de Witte. Consider, for instance, the *Interior of the Oude Kerk, Delft, with a Funeral Procession* from 1657 (fig. 56). A large group of men is seen processing into the church through the main entrance below the tower. The strong sunlight flooding the church is unfiltered. The silhouettes of the mourners following the casket stand out sharply against the whitewashed walls of the northern aisle. A gravedigger in the foreground is hard at work, while his cohort gazes thoughtfully at the procession. On the right, beside the massive central column, stand a woman in black and a girl.

The subject, presumably borrowed from Emanuel de Witte, is unusual for Van Vliet.[35] The suggestion has been made that the painting was commissioned as a visual record of a prominent citizen's funeral in 1657. The deceased could have been a city councilman, for instance, given that there are only men in the procession. Two members of Delft's town council did indeed die in 1657.[36] It stands to reason that the other

fig. 56
Interior of the Oude Kerk, Delft, with a Funeral Procession, 1657
panel; 75.7 x 64.4 cm
Oegstgeest, M.L Wurfbain Fine Art

members of the council would have accompanied their colleague to his final resting place, as a way of paying their respects to him.

The absence of the customary identification of the deceased by means of a hatchment or coat of arms does not support the theory that the painting was commissioned. In 1637, moreover, Pieter Saenredam had painted a funeral procession in the Sint Laurenskerk at Alkmaar.[37] There the casket is likewise carried and accompanied by men in black wearing hats, while the procession is headed by a man bearing a hatchment. Women and children stand watching from a distance. As in Van Vliet's panel, a gravedigger is working in the foreground. Beside a neat pile of sand, with all his tools arranged around him, he too leans on a shovel as he regards the approaching throng.

The processions in these two paintings are strikingly similar. This visual evidence, coupled with the contemporary regulations and protocols pertaining to the funerals of nobles and prominent burghers – who walks where and carries or accompanies what – indicate that seventeenth-century funerals were predominantly reserved for men, and that women were scarcely involved.[38]

That a prominent Delft citizen commissioned the *Oude Kerk, Delft, with the Tomb of Admiral Tromp* from 1658 (fig. 57) seems much more plausible.[39] Two years after the death of the Admiral in 1653, Tromp's widow, Cornelia Teding van Berkhout, contracted the sculptors Rombout Verhulst and Willem de Keyser, and the architect Jacob van Campen, to build a suitable tomb for her late husband on behalf of the States General.[40] She probably also commissioned Van Vliet to paint a church interior incorporating the tomb, after it was finished in 1658.[41]

The tomb of the naval hero Maerten Harpertz Tromp (1578-1653) is portrayed in such a way as to heighten the verisimilitude of the painting. The artist adopted one-point perspective and placed the vanishing point well outside the image. Van Vliet not only leads the eye of the viewer directly to Tromp's monument at the left, but also accentuates the depth of the space. The arch motif covers much of the dark barrel vaulting and seals off the image very nicely.

To judge from the three boys in the midst of the foreground, the figures on the left admiring the hero's tomb and the various little groups scattered about the church, Van Vliet was evidently an accomplished figure painter. He was also capable of using the sunlight to emphasise the transparency of the bunting on the flags at the back of the church.

Van Vliet appropriated Houckgeest's innovations and added an invention of his own: the view from one of the aisles, preferably the corner of the transept, to the choir, or from the nave to the transept. As in the *Interior of the Oude Kerk, Delft* from 1659 (fig. 58), the observer is shown Tromp's tomb from the southern aisle of the nave. This vantage point enabled Van Vliet to create a remarkable spatial effect, because it brought much of the ribbed vaulting of the transept into view. The painter employed an oblique perspective construction with vanishing points well beyond the perimeter of the canvas so as to heighten the sense of depth.

The arched framework conceals part of the capital of the column in the foreground, thus masking the massiveness of the stone arches. By not aligning the framework with the columns, Van Vliet opened yet another prospect on the left, and gave his

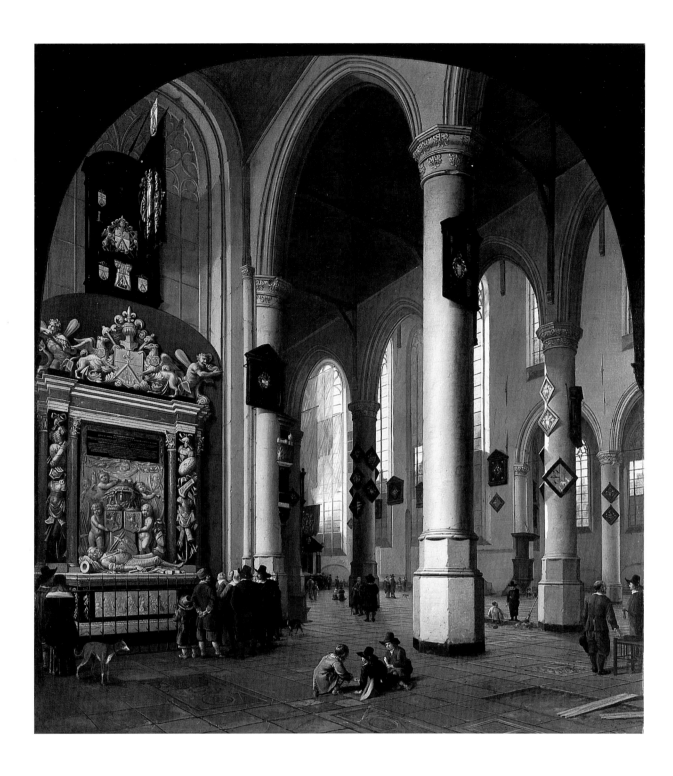

fig. 57
HENDRICK VAN VLIET
*The Oude Kerk, Delft, with the Tomb
of Admiral Tromp*, 1658
canvas; 123.5 x 111 cm
Toledo, Ohio, The Toledo Museum
of Art. Purchased with funds from
the Libbey Endowment. Gift of
Edward Drummond Libbey,
inv. no. 1984.80

penchant for spatial effects free rein. The staffage is dwarfed by the monumentality of the space; only the gravedigger, so characteristic of Van Vliet, occupies a prominent position by the open grave.

In the late 1650s Van Vliet concentrated not only on accurately rendering the space in his perspectieves, but also on visualising daily life in his church interiors. In the *Sermon in the Oude Kerk, Delft* (fig. 59) he returned to one of Houckgeest's compositions and Emanuel de Witte's theme of the sermon (see figure 47). From the southern aisle the viewer is able to see the pulpit by way of the first column on the left. We are now very close to the congregation, which has gathered for the sermon, and can almost touch the man with the red coat, as it were – a motif Van Vliet doubtless borrowed from De

Witte as well. The artist arranged the columns in such a way that they seem insecurely anchored to the floor. The enormous height of the church is only defined when the light strikes it. The sunbeams play over the various forms, augmenting the plasticity of the columns and illuminating the choir so that the preacher is silhouetted sharply against the background. Van Vliet made thoughtful use of colour to reinforce the diagonal orientation of the design and to underscore the centrality of the pulpit. The white of the collars, hats and columns and the red of the coat contrast with the greyish yellow tones of the walls and the mat brown of the pulpit, the choir screen and the ceiling vault.

Comparison between this canvas and the version by De Witte in the Wallace Collection (see figure 47) shows that Van Vliet took over the theme, but that he devised his own solutions for the elaboration of the space and the disposition of the figures. From

fig. 58
HENDRICK VAN VLIET
Interior of the Oude Kerk, Delft, 1659
canvas; 76.5 x 70 cm
Leipzig, Museum der bildenden
Künste, Sammlung Speck
v. Sternburg, Lützschena,
inv. no. 1 1568/591

74

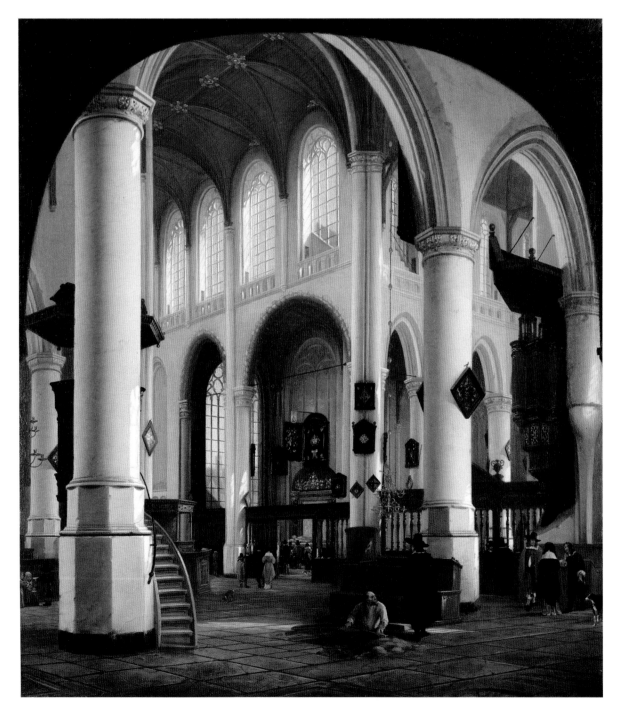

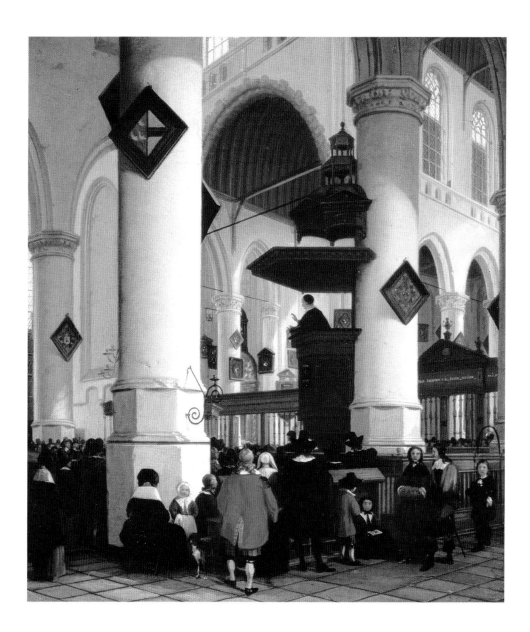

fig. 59
HENDRICK VAN VLIET
Sermon in the Oude Kerk, Delft,
c. 1659
canvas; 39,5 x 35 cm
Vienna, Gemäldegalerie der
Akademie der bildenden Künste,
inv. no. 685

1660 onward, however, he began copying the paintings of Gerard Houckgeest for no apparent reason. The *Interior of the Nieuwe Kerk, Delft, with the Tomb of William the Silent* is identical to a painting by Houckgeest from 1650 (fig. 60), but more than twice as large. Van Vliet deviated from his model only incidentally. By positioning himself a bit farther away, the master afforded a better view of the capitals and the vault. Van Vliet articulated the tiled floor with the tomb slabs more precisely and his figures are more detailed. There was no such thing as copyright in the seventeenth century and thus nothing to prevent artists from 'plundering' the work of their colleagues. Although nothing is known about his motives, it seems as though Van Vliet, the only painter who specialised in architecture at Delft as from 1653, could not keep up with the demand. By the time of his death in 1675 he had painted over two hundred and twenty-five church interiors in the course of twenty-five years, which gives some idea of how popular his perspectives were.[42] He may, of course, have copied the work of others at the request of his patrons.

The *Interior of the Nieuwe Kerk, Delft, with the Tomb of William the Silent*, painted around 1660 (fig. 61), is not a copy but a variant, invented by Van Vliet himself. By

The Delft church interior

opting for a virtually square format he was able to include more of the choir without allowing the tomb to disappear into the background, as in the *Ambulatory of the Nieuwe Kerk in Delft* of Gerard Houckgeest (see figure 40). By approaching his subject at an angle, in this case from the choir to the transept, the artist 'coincidentally' created a distant vista and heightened the sensation of depth considerably. Besides the many standards, flags and hatchments which do not appear in Houckgeest's panel, a striking difference between the two pictures is the draught bars between the columns, which Van Vliet faithfully recorded but Houckgeest decided to omit.

Van Vliet repeated the composition in 1667, altering the view point only slightly. In the *Interior of the Nieuwe Kerk, Delft, with the Tomb of William the Silent* (fig. 62) he also added an open grave in the foreground. On the tomb slab sits a woman, seen from behind, with a child on her right. The attitude of the little boy looking up at her suggests she is nursing a baby. These figures, too, are presumably personifications of the spiritual virtues Faith, Hope and Charity.

The *Interior of the Nieuwe Kerk, Delft, with the Tomb of William the Silent* (fig. 63) displays the same alterations. On the steps of the pulpit is seated a mother nursing a baby

76

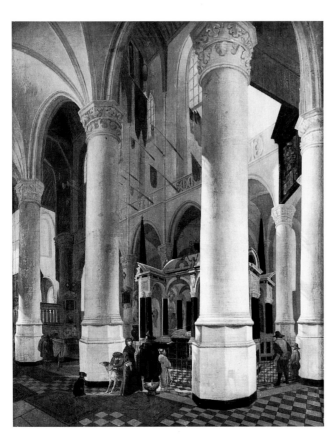

fig. 60
HENDRICK VAN VLIET
Interior of the Nieuwe Kerk, Delft, with the Tomb of William the Silent,
c. 1660
canvas; 117 x 90 cm
Stockholm, Nationalmuseum, inv. no. NM 464 (formerly as Houckgeest)

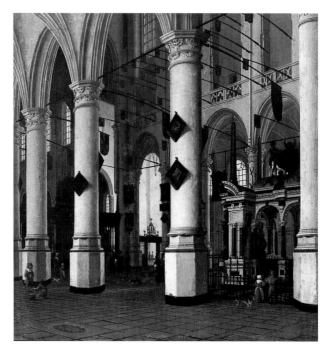

fig. 61
HENDRICK VAN VLIET
Interior of the Nieuwe Kerk, Delft, with the Tomb of William the Silent,
c. 1660
panel; 41 x 39 cm
Stockholm, Nationalmuseum, inv. no. NM 683

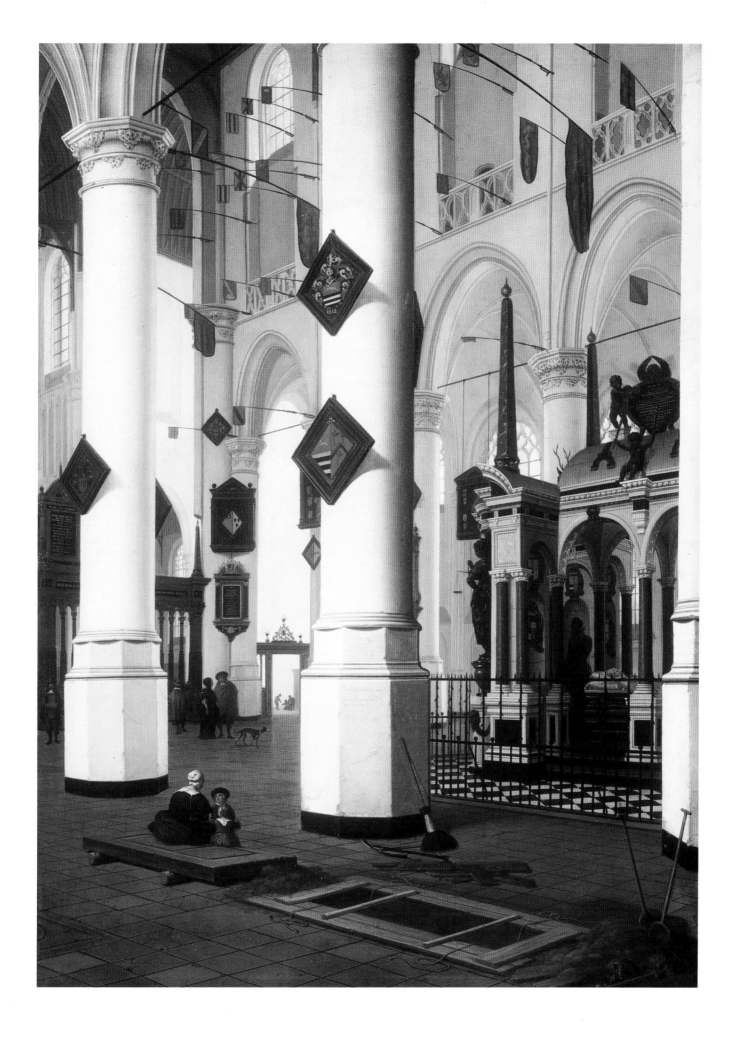

The Delft church interior

with a child at her side. The open grave is missing, but the hatchments are prominently displayed on the columns. A painted curtain covers a quarter of the image, concealing all but part of the tomb. So intent was the artist upon deception that he 'mounted' the rod on a trompe l'oeil frame.

Van Vliet never ceased to search for new possibilities and variations. In his *Interior of the Nieuwe Kerk, Delft*, for instance, which was painted around 1660-62 (fig. 64), he chose a view point that had never been attempted. Until then the tomb had always been depicted from the southern part of the ambulatory, but here the view is from the northern part to the southern transept. The tomb is completely obscured by the immense column in the foreground. Only the pileus of *Libertas* is visible, silhouetted against the second column from the left. As usual, figures gaze with reverence at the monument. The relatively high horizon and the powerful diagonal movement lead the eye directly to the pulpit in the background. The rendering of the woman with child on the bench below the pulpit is particularly lifelike; the master did not neglect to illuminate

fig. 63
HENDRICK VAN VLIET
*Interior of the Nieuwe Kerk, Delft,
with the Tomb of William the Silent*
canvas; 100.5 x 91 cm
Delft, Stedelijk Museum Het
Prinsenhof (on loan from the
Rijksdienst Beeldende Kunst,
The Hague), inv. no. NK 2433.
Photo: Tom Haartsen, Ouderkerk
aan de Amstel.

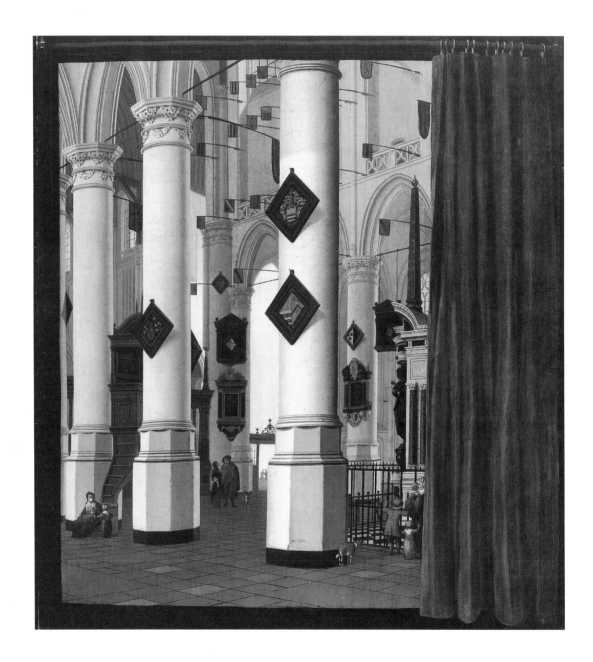

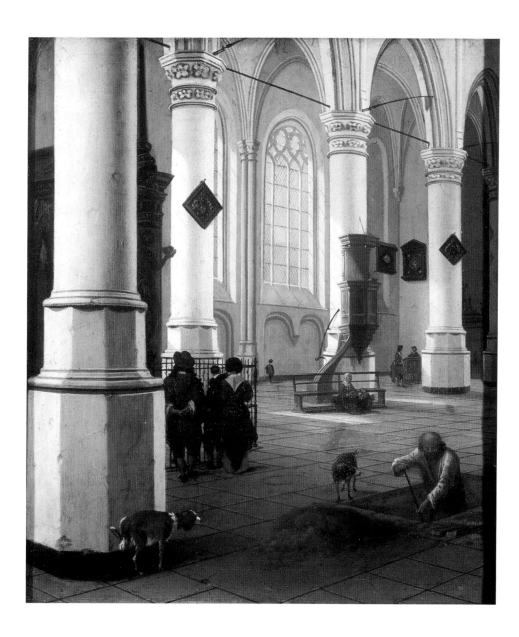

fig. 64

HENDRICK VAN VLIET
Interior of the Nieuwe Kerk, Delft,
c. 1660-1662
panel; 40.5 x 35 cm
Antwerp, Koninklijk Museum voor
Schone Kunsten, inv. no. 196

the lovely vignette with a ray of sun. Oblivious of the others, the gravedigger in the foreground goes about his work, under the scrutiny of two dogs in the shaded foreground – a silent reminder of our ephemeral existence.

The *memento mori* theme predominates in the *View in the Nieuwe Kerk, Delft, with the Memorial Plaque of Adriaen Teding van Berkhout* from 1661 (fig. 65). The gravedigger and the skulls are an unequivocal allusion to the brevity of human life. But the text on the choir screen

"WAT GY BEGEERT IN UW. GEBEDEN. GELOVENDE.

[ZUL]T GY ONTFANGEN. MAT. 2 I.V. 2 2.

[And all things, whatsoever ye shall ask in prayer, believing,

ye shall receive]"

indicates the believer can trust that his prayers will be heard. A woman with child can be discerned in the distance below the pulpit. Here Van Vliet created the illusion of space by applying the rules of central perspective to a wide field of vision. He took up a position in the choir, and looked across the nave to the western entrance. The sunlight streaming into the nave from the southern lends credence to the illusion.

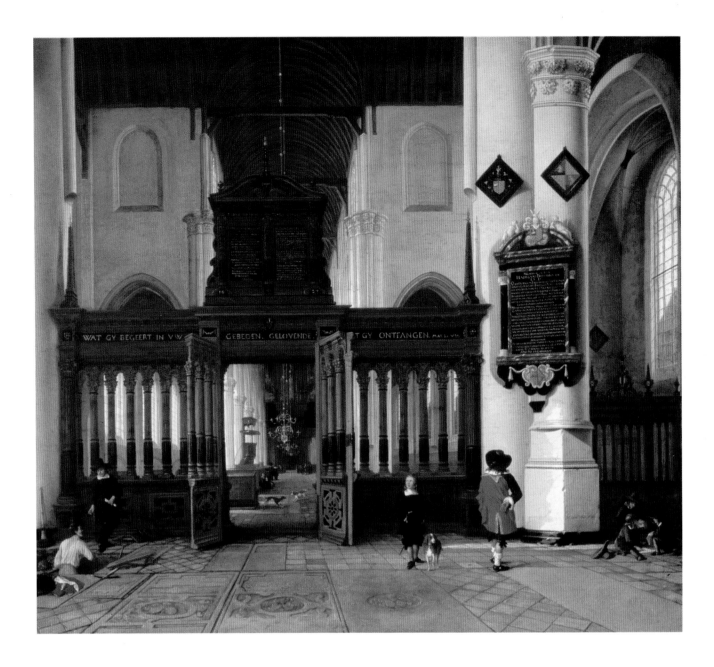

Like De Witte, Van Vliet was fond of highlights, which he used for instance to accentuate the pillar with the marble plaque. The plaque is further emphasised by the now familiar man in the red mantle. The memorial was placed in the Nieuwe Kerk in honour of Adriaen Teding van Berkhout (1571-1620), a member of the Court of Holland and the Council of State, who married a daughter of the Delft brewer and burgomaster Paulus van Beresteyn. According to family lore, Hendrick van Vliet was commissioned to paint the canvas by his son Paul Teding van Berkhout.[43]

An interesting detail in the painting with the plaque in memory of Adriaen Teding van Berkhout is the two pillars that have been cut away to make room for the obelisks on the choir screen. A virtually identical pillar occurs in another church interior by Hendrick van Vliet that has been inconclusively identified (fig. 66). Given the correspondence between the two paintings it has been suggested that the latter likewise represents the Nieuwe Kerk, and that Van Vliet simply omitted the choir screen.[44]

fig. 65
HENDRICK VAN VLIET
View in the Nieuwe Kerk, Delft, with the Memorial Plaque of Adriaen Teding van Berkhout, 1661
canvas; 112 x 100 cm
Delft, Stedelijk Museum Het Prinsenhof (on loan from the Stichting Teding van Berkhout).
Photo: Tom Haartsen, Ouderkerk aan de Amstel.

fig. 66
HENDRICK VAN VLIET
Church Interior, c. 1670-1675
canvas; 96 x 81 cm
Delft, Stedelijk Museum Het Prinsenhof, inv. no. PDS 105. Photo: Tom Haartsen, Ouderkerk aan de Amstel.

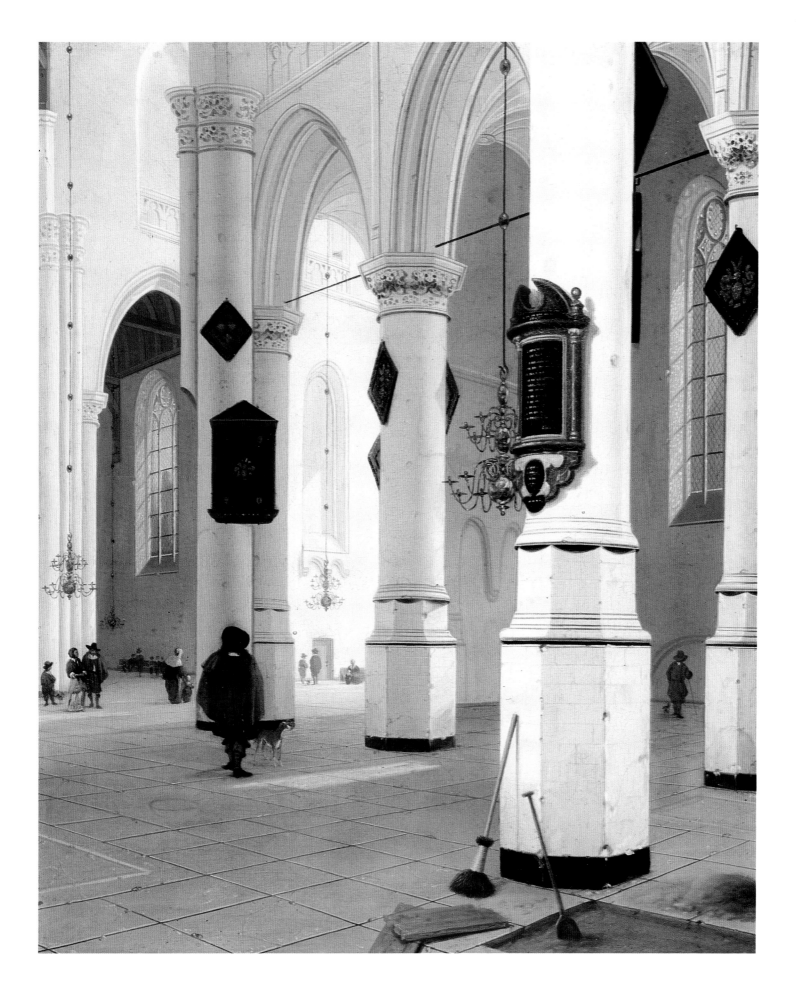

The Delft church interior

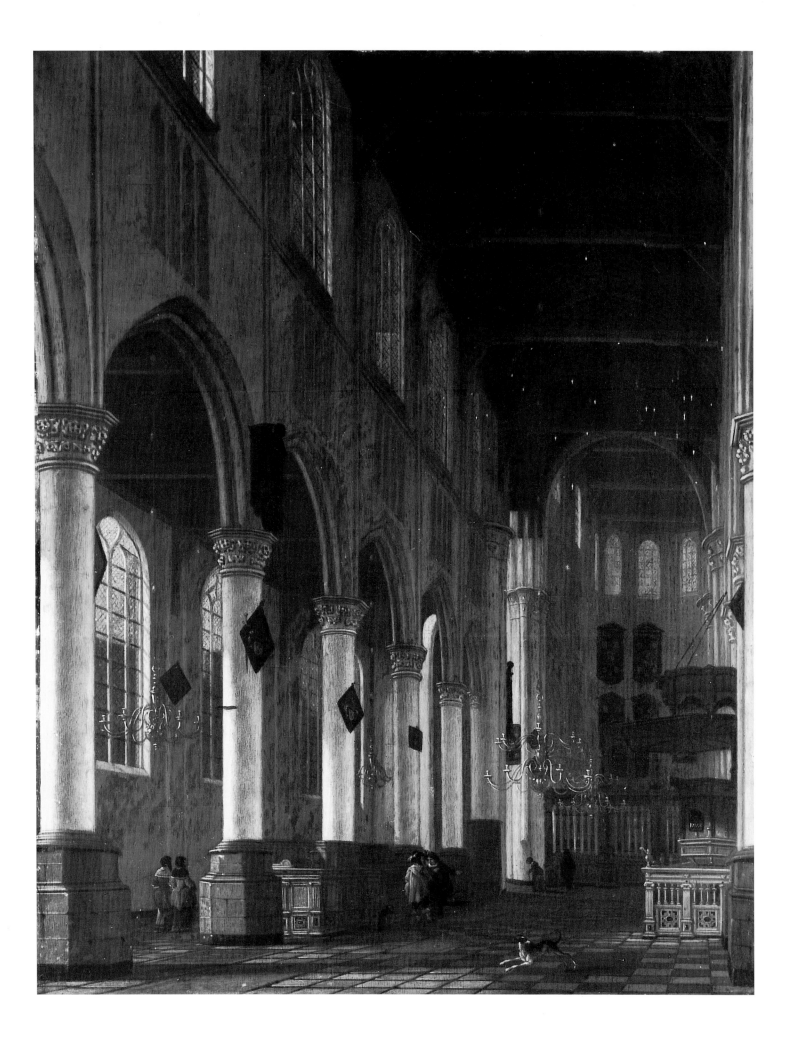

Careful comparison of the other elements points up a number of discrepancies between the canvas and the architecture of the Nieuwe Kerk, such as the triforium under the Gothic arch above the side aisle and in the transept, the disposition of the hatchments and the absence of the plaque in memory of Teding van Berkhout. Van Vliet is also thought to have narrowed the choir of the Nieuwe Kerk and omitted the column in the interest of the composition. It seems evident that toward the end of his career, Van Vliet, like De Witte, designed fantastic interiors by combining elements derived from existing Delft churches. Based on the palette and the handling of the light the Prinsenhof canvas can be dated between 1670 and 1675.[45] At that time Van Vliet was wont to use aquamarine to depict light, as well as ochres and greys. Thus, the mantle of the man looking at the hatchment is no longer red but charcoal grey. The sunlight coming through the clerestory windows dispels the chilly atmosphere of the tall building and patches of light play over the windowframes.

CORNELIS DE MAN (1621-1706)

Born in Delft in 1621, Cornelis de Man entered the guild of St Luke in 1642. Thereafter he travelled for nine years, visiting Italy, among other places, before returning to his native city around 1654. Between 1657 and 1696 he was a headman of the guild no less than thirteen times, along with Johannes Vermeer in 1672. De Man is known primarily for his portraits and genre scenes (see Chapter Four). Why he painted several church interiors around 1660 remains a mystery. He may have done so on behalf of his fellow townsman Jacobus Crucius – the preacher was presumably related to the artist and twice painted by him – or perhaps he received a commission from one of the other preachers he portrayed.[46] The church interiors of Cornelis de Man are almost always based on compositions by Hendrick van Vliet.

The *Interior of the Nieuwe Kerk, Delft* (fig. 67) shows a view of the choir from the nave. Thanks to the angle, part of the northern aisle is also visible. De Man employed central perspective, but the lines of the floor and the barrel vault do not all converge at the same point; evidently the artist had difficulty with the sounding board above the pulpit as well. De Man has the sunlight enter the church from the left, whereas in fact the north side is always in shade. There is scarcely any trace of daily life, so vividly represented in the work of Van Vliet, in this work by De Man.

When De Man's figures are more prominent one is inevitably struck by how stiff and lifeless they appear. Consider, for example, the couple and the man in the foreground of the *Interior of the Oude Kerk, Delft* (fig. 69). Although the artist borrowed the composition from Van Vliet (see figure 50), the illusion of space is less credible. The handling of the cool light seems somewhat artificial, even if De Man did successfully use both it and the colour accents to unify the work.

There are many parallels between the design of De Man's *Interior of the Oude Kerk, Delft, with Pulpit* (fig. 68) and a work by Gerard Houckgeest (see figure 42). De Man may have known the painting and borrowed the perspective construction from it. The theme would seem to have more in common with the *Jacobskerk, The Hague*, however, which is likewise by Houckgeest (see figure 41). Psalm 65, a hymn to God, is indicated

fig. 67
CORNELIS DE MAN
Interior of the Nieuwe Kerk, Delft
panel; 57 x 44 cm
Darmstadt, Hessisches
Landesmuseum, inv. no. GK 292

on the pulpit. A nursing mother sits in the shadow against the chair screen, and as in Houckgeest's version, a little boy holds her shawl to one side. A man works a tomb slab with hammer and chisel in the left foreground. The presence of Faith, Hope and Charity may be one further indication that Cornelis de Man had close relations with the clergy.[47]

After 1665 Cornelis de Man turned his attention to genre scenes, which are remarkable for the carefully constructed perspective. The artist often used the pattern of the floor tiles to help him render the space accurately. The experience he had gained from painting complex church interiors presumably served him well.

fig. 68
CORNELIS DE MAN
Interior of the Oude Kerk, Delft, with Pulpit, c. 1660
canvas; 64.1 x 77.4 cm
Chicago, The Art Institute
of Chicago. Gift of Mr. and Mrs.
Morris I. Kaplan, inv. no. 1965.1176

84

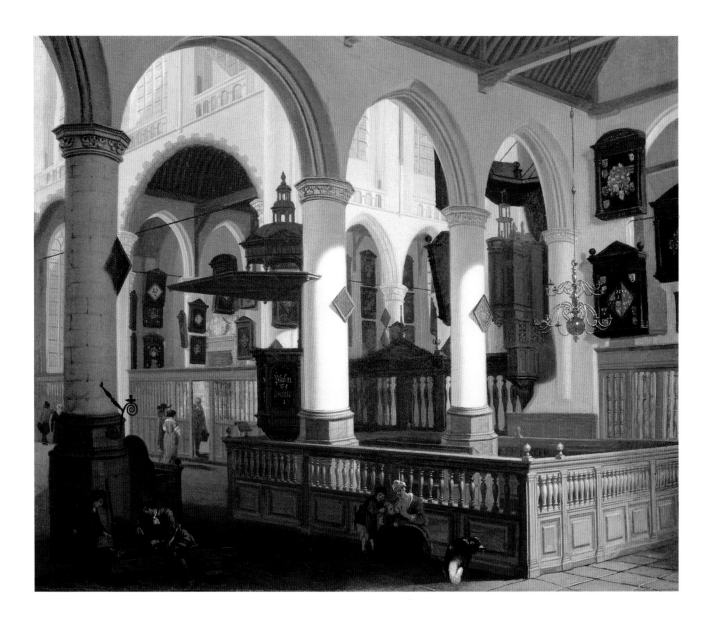

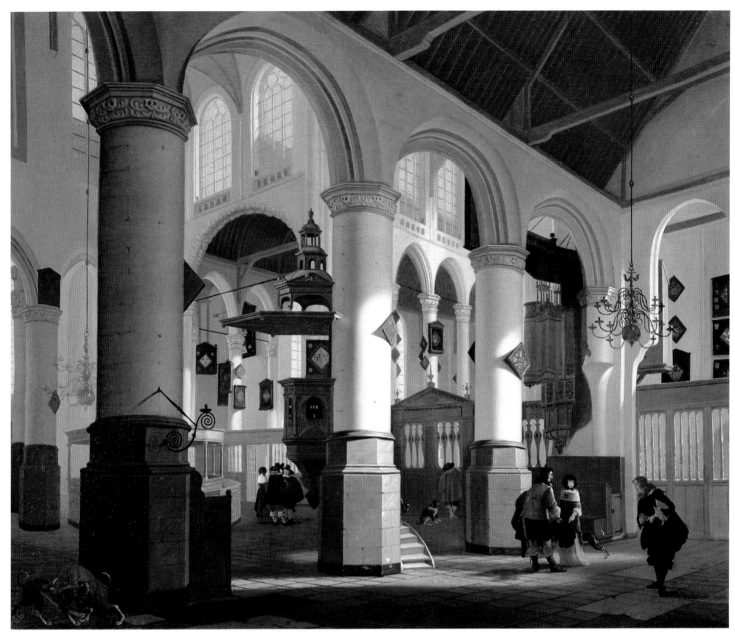

fig. 69
CORNELIS DE MAN
Interior of the Oude Kerk, Delft,
c. 1660
canvas; 101.5 x 121 cm
Columbus, Ohio, Columbus
Museum of Art, Howald Fund II,
inv. no. 81.018

1 The complete title of the book, which appeared in 1604, is *Perspective: dat is de hooch-geroemde conste eens schijnende in oft door-siende ooghen-ghesichtes pung/op effen staende muer/penneel oft doeck/eenige Edificien/'t sy van Kercken/ Tempelen/Palleysen/Salen/Cameren/Gaelderyen/Plaetsen/Ganghen/Hoven/Merk ten ende Straeten/Anticq oft Moderne/ende sulcx meer alhier vethoont/gestelt op sijne gronts-linien/ende 't fondement der selver met beschrijvinge claerlijck uytgelegt/ nut/dienstelijck ende grootelicx van noode/voor allen Schilders/Plaet-snijders/Beeld-houders/Goudtsmeden/Bouw-meesters/Ingenieurs/Steenmetsers/Schrijnwerckers/ Timmer-lieden/ende alle Liefhebbers der Consten/om te studeren 't haerder belieften/met cleyne moeyten.*

2 "het zwaarste en werkelijkste in de Konst, namelyk gezigten van Tempels en Kerken, gestoffeert met historien." Houbraken 1718-1721, vol. 1, p. 132.

3 "door den thesorier van der Graeff aen Pieter Anthonis van Bronckhorst, scilder, over het maecken van perspectyff begrypende het oordeel Salomonis [...], de somme van hondert vyftich guld., te weeten 120, by hem daervoor bedongen ende tot vereeringe 30, alsoo hy claechde ende oock mrs oirdeelen, dat hy te weynich hadde bedongen. Compt 150,00." Delft, Municipal Archives, *Lopende Memorialen*, 1622 (fol. 213).

4 Delft 1981, vol. 2, E. Jimkes-Verkade, p. 214ff.

5 Rotterdam 1991, p. 83.

6 Rotterdam 1991, p. 83.

7 Rotterdam 1991, p. 95.

8 Rotterdam 1991, p. 165. Jeroen Giltaij wrote the following about this canvas: "Though the painting in Delft [...] bears the date 1642, it is inscribed on a tombstone and presumably refers to the deceased; no signature has been found. The painting does not look like a Houckgeest, and it was probably made much later."

9 Liedtke 1982-A, p. 23.

10 In March 1651 Saenredam came to Delft on behalf of the city of Haarlem to record the funeral of Prince William II in the Nieuwe Kerk. See Wheelock 1975-1976, p. 174.

11 Wheelock 1975-1976, p. 179.

12 S. Groenveld, *De Prins voor Amsterdam*, 1967; Naspel op Munster. S. Groenveld, *Het stadhouderschap van prins Willem II*, 1968.

13 Wheelock 1975-1976, p. 181.

14 The idea of a commission stems from Wheelock; see Wheelock 1975-1976, pp. 179-81.

15 The connection between the declining sales of the portraits and the First Stadhouderless Period was drawn by Roelof van Gelder in his review of Montias 1982 (*NRC Handelsblad* 28 Jan. 1983, Cultureel Supplement, p. 6). See Montias 1982, p. 246.

16 Rotterdam 1991, p. 170: "Blade, on the other hand, seeks a symbolic meaning in the figures, in this case the children poring over their exercise books on the floor of the church. Could they indeed allude to 'leringh', or mutual instruction?"

17 On 15 May 1830 a law was enacted in the Kingdom of the Netherlands prohibiting burial of the dead in churches: exh. cat. *Dood en Begraven, sterven en rouwen 1700-1900*, Centraal Museum, Utrecht 1980.

18 Although the panel is still attributed to Hendrick van Vliet in the catalogue of the Rijksmuseum Amsterdam from 1976, Walter Liedtke has convincingly shown that it must be by the hand of Gerard Houckgeest. See Liedtke 1982-A, p. 99.

19 Wheelock 1975-1976, p. 177.

20 The work was stolen from the Stadtgeschichtliches Museum, Düsseldorf, in 1946.

21 Psalm 19: "The heavens declare the glory of God; and the firmament sheweth his handywork. Day unto day uttereth speech, and night unto night sheweth knowledge. There is no speech nor language, where their voice is not heard. Their line is gone out through all the earth, and their words to the end of the world. In them hath he set a tabernacle for the sun. Which is as a bridegroom coming out of his chamber, and rejoiceth as a strong man to run a race. His going forth is from the end of the heaven, and his circuit unto the ends of it: and there is nothing hid from the heat thereof."

22 Blade 1971, pp. 34-50 and De Vries 1975, pp. 25-56.

23 Liedtke 1982-A, p. 25.

24 The last digit of the date is illegible, but it is presumably a four. See Rotterdam 1991, p. 177.

25 Houbraken 1718-1721, vol. 1, p. 283.

26 Manke read the date of the painting as 1654 in her 1963 biography of De Witte, but in light of the composition, Walter Liedtke pushed it back as far as 1650. See Liedtke 1982-A, p. 83 and Appendix III.

27 *Catalogue of Pictures, The Wallace Collection IV*, Dutch and Flemish, John Ingamells, 1992, p. 437, inv. no. P254.

28 The composition was later repeated by Hendrick van Vliet. See fig. 59.

29 Rotterdam 1991, p. 186.

30 Houbraken 1718-1721, vol. 1, p. 95.

31 Dirck van Bleyswijck 1667, p. 852: "synde ook niet ongeluckig in Inventien en Historien, soo dach als nacht-lichten, hem de perspectiven wel ver-staende, gelijck te zien is aen sijn moderne of hedendaegse Tempels, wanneer hij die op sijn best heeft gemaeckt, synde als-dan seer wel verschietende en ingaende oock natuyrlyck gecoloreert." Trans. Liedtke 1982-A, p. 57.

32 Liedtke 1982-A, p. 57.

33 Rotterdam 1991, p. 316.

34 Psalm 37: "Fret not thyself because of evildoers, neither be thou envious against the workers of iniquity. For they shall soon be cut down like the grass, and wither as the green herb. Trust in the LORD, and do good; so shalt thou dwell in the land, and verily thou shall be fed. Delight thyself also in the LORD; and he shall give thee the desires of thine heart."

35 Liedtke 1982-A, p. 64 note 16 and p. 107 no. 69.

36 Kunsthandel M. Wurfbain bv, vol. v, pp. 220-21.

37 Pieter Saenredam, *The Southern Aisle of the Sint Laurenskerk at Alkmaar with a Funeral Procession*, 1637 (panel; 76.2 x 54.6 cm). Penhurst, Major Philip Sidney.

38 Exh. cat. Utrecht 1980, *Dood en begraven, sterven en rouwen 1700-1900*, Centraal Museum.

39 Rotterdam 1991, p. 215.

40 A. Bredius, "Aanbesteding van Tromp's tombe," *Archief voor Nederlandsche kunstgeschiedenis* 5 (1882-1883), pp. 62-66.

41 Rotterdam 1991, p. 215.

42 Liedtke 1982-A, pp. 105-14.

43 Rotterdam 1991, p. 219.

44 Rotterdam 1991, p. 225.

45 Liedtke 1982-A, p. 109.

46 Brière-Misme 1935, pp. 3, 17-18.

47 Liedtke 1982-A, p. 121.

88

fig. 70

DANIËLLE H.A.C. LOKIN

3 Views in and of Delft
1650–1675

Of all the genres in which painters specialised during the seventeenth century, the townscape developed last of all.[1] A townscape is a painting, drawing or print showing a topographically precise view in or of a town. Few town views were painted in Delft that fit this description perfectly. Instead, local artists tended to paint outdoor genre scenes in an architectural setting, such as a street or courtyard. In doing so they often placed recognisable Delft topography in the background and experimented with the perspective. This specific Delft variant doubtless contributed to the emancipation of the townscape, the *View of Delft* by Johannes Vermeer (fig. 111) being the highpoint.

Prints and drawings played an important role in the prehistory of the townscape. Cartographers, who drew maps, and the makers of topographical prints published descriptions of places with illustrations in the late sixteenth century. Southern Netherlandish artists such as Hans Bol (c. 1543-1593) and Pieter Bast (c. 1570-1605) used recognisably Dutch towns as a backdrop in their drawings and prints of the months of the year or biblical themes. From 1590 onward Pieter Bast executed prints of various Dutch cities, usually on a commission basis. This may point to the growing self-consciousness of Dutch urban dwellers, who, encouraged by their successes in the struggle against their Spanish oppressors, were keen to cast their towns in the best possible light.[2] In the same period the production flourished of topographical material in the form of prints, as appears from the sizable oeuvre of the Amsterdammer Claes Jansz Visscher (1587-1652), an etcher and engraver of townscapes and plans.

In the first decades of the seventeenth century the innovations in the production of topographical prints had little influence on painting. What was being painted at the time in the field of architecture in general and of townscapes in particular can be divided into three categories: fantasy architecture, townscapes as a backdrop for historical events, and urban panoramas. The last category was reluctantly taken over from the world of prints and drawings.[3] Examples of fantasy architecture, imaginary church interiors and above all Italianate palaces and courtyards were painted by artists such as Bartholomeus van Bassen and Gerard Houckgeest (see Chapter Two). Depictions of historical events in an

fig. 71
HENDRICK VROOM
View of Delft from the Southwest,
1615
canvas; 71 x 160 cm
Delft, Stedelijk Museum Het
Prinsenhof, inv. no. PDS 108a.
Photo: Tom Haartsen, Ouderkerk
aan de Amstel

urban context include the *Disbandment of the Waardgelders on the Neude at Utrecht in 1618* (fig. 70), painted by Paulus van Hillegaert in 1622, and the *Burning of the Amsterdam Town Hall* by Joost Droochsloot from 1652. Hendrick Cornelisz Vroom (1566-1640) painted two early examples of town profiles, both of which feature Delft. Little is known about the origins of these important works. We may assume the Delft Town Council commissioned the *View of Delft from the Southwest* in 1615 (fig. 71). That Vroom was selected is not surprising. Initially a painter of marines and harbour views, occasionally incorporating views or profiles of towns, he later devoted himself entirely to urban panoramas. Shortly after 1615 Vroom painted a *View of Delft*, this time from the north-west. In 1634 he presented the work to the Town Council in memory of his mother, who was buried in the Oude Kerk, and also in token of his affection for the city, where he had learnt the first principles of painting.[4]

Only after 1650 did the town view develop into an independent painterly genre; for a number of reasons artists in Delft made a particularly important contribution to this. The young Gerard Houckgeest, who was active here from 1635 until 1651, concentrated first of all on depicting imaginary architecture and demonstrated considerable interest in the expressive possibilities of perspective. From 1650 onward, however, he favoured existing architecture and painted a number of splendid church interiors in Delft, where he was resident.

Other Delft artists also became fascinated with the illusion of space and depth. After Gerard Houckgeest left the city, the presence of above all Rembrandt's talented pupil, Carel Fabritius, was of great significance. Fabritius employed perspective in order to situate genre scenes in an urban setting. Precisely this particular combination of genre subjects in streets and courtyards is, as we shall see, a cardinal characteristic of Delft.

CAREL FABRITIUS (1622-1654)

Carel Fabritius was baptised on 27 February 1622 in the village of Midden-Beemster, just north of Amsterdam, as the eldest son of Pieter Jan Carelsz and Barbertje Barentsdr van der Maes. Ten other children followed him. Carel's grandfather, Carel Pietersz, was one of many Flemish immigrants to the Northern Netherlands who with his family fled the Spanish onslaught in 1584. We know that young Carel started out as a carpenter, for when he joined the church at Midden-Beemster he was registered as such. In 1641 he married Aeltge Hermansdr van Hasselt and moved to Amsterdam, where he continued working as a carpenter, but also received artistic training. Along with Samuel van Hoogstraten (1626-1678) from Dordrecht, Fabritius spent some time in Rembrandt's studio. At first he painted portraits primarily, which are patently influenced by his distinguished teacher.

In 1642 one of Carel's children died, followed in 1643 by both his wife and second child. A few years later Fabritius presumably moved to Delft, where around 1647 he is said to have received commissions for wall and ceiling paintings. In 1650, in any case, he lived on the Oude Delft and married a local widow, Agatha van Pruyseen.[5] A year later the couple moved to the Doelenstraat. On 29 October 1652 Fabritius joined Delft's guild of St Luke.

It was also in 1652 that Fabritius executed his *View in Delft, with a Musical Instrument Seller's Stall* (fig. 72). This small painting shows the corner of the Oude Langendijk and the Vrouwenrecht, looking in a northwesterly direction with the Nieuwe Kerk in the centre. To the left of the church, behind the stall of a dealer in musical instruments, the Town Hall can just be seen. On the right the houses of the Vrouwenrecht are depicted. Fabritius reinforced the spatial effect in his painting through the play of sunlight on the buildings and the contrasts between light and shadow. The striking difference in format between, on the one hand, the dealer and the viola da gamba in the foreground and, on the other, the woman on the water and the Nieuwe Kerk further enhances the sensation of depth. As a result, the boundary between the illusion of the painting and the reality of the viewer blurs.

One of the more remarkable aspects of this work is the peculiar distortion of the perspective, which is not unlike the effect of a photograph taken with a wide-angle lens. The layout closely resembles the *Ambulatory of the Nieuwe Kerk in Delft* by Gerard Houckgeest (see figure 40). Perhaps Fabritius wished to create an illusion of space and depth, but found ninety degrees – the traditional angle prescribed by Vredeman de Vries in his treatise *Perspective* – too small to suit his needs. This would explain why, like Houckgeest, he chose an angle of one hundred forty degrees. Another explanation is that the painting is meant to be seen through a concave lens or in a convex mirror, to correct the distortions.[6] Or it may once have formed part of a perspective box, a so-called 'peep-show' that gave the spectator a perfect illusion of three-dimensional space.[7] Of course, considering its small format (15.4 x 31.6 cm), the painting could actually be a study – a finger exercises, as it were. Whatever the case may be, Fabritius must have been satisfied with the results, for he signed and dated it on the wall to the left of the lute.

His clever mastery of perspective won fame for Fabritius. As Dirck van Bleyswijck wrote in 1667, he was "an outstanding and excellent painter, who was so quick and sure in

91

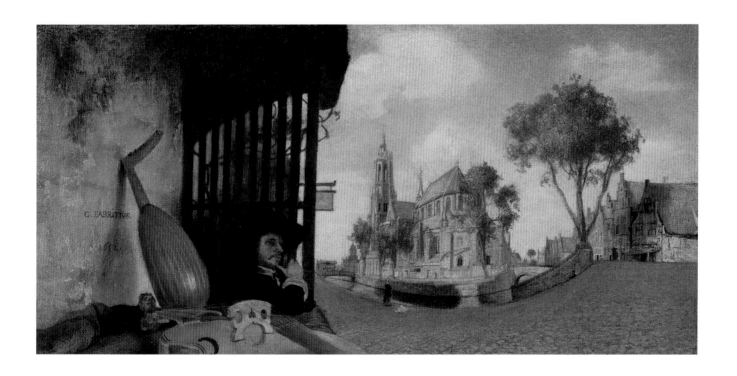

the use of perspective and natural colours and in putting them on canvas that (in the judgement of many connoisseurs) he has never been equalled."[8] And as Samuel van Hoogstraten added in 1678, "With this knowledge [of how to make a small place appear large] it is possible to make a small room seem very large: [...] Fabritius has also made such wonders here, as is to be seen similarly at Delft in the house of the art-loving late *Dr Valentius* and elsewhere; but it is regrettable that his work was never placed in a large royal building or church; for this kind of painting depends enormously on the place to which it is applied."[9]

The illusion of space is not the only remarkable aspect of Fabritius' *View in Delft*. The canvas constitutes an important contribution to the emancipation of the townscape. Although it is a perspectival experiment, the image includes a precise topographical depiction of the corner of the Oude Langendijk and the Vrouwenrecht at Delft.

As to the accuracy of *The Sentry* from 1654 (fig. 73) we can be less certain. Does it incorporate elements of Delft topography or not? Although there is nothing experimental about the perspective in this case, the picture attests to the inventiveness of Fabritius, particularly in his treatment of light and space. The viewer finds himself in the foreground of the image, as it were, looking down at the soldier. The eye is immediately drawn to the vista through the arch, yet it is the seated man, the evident focus of the canvas, to which it inevitably returns. The soldier sits loading his musket with legs spread

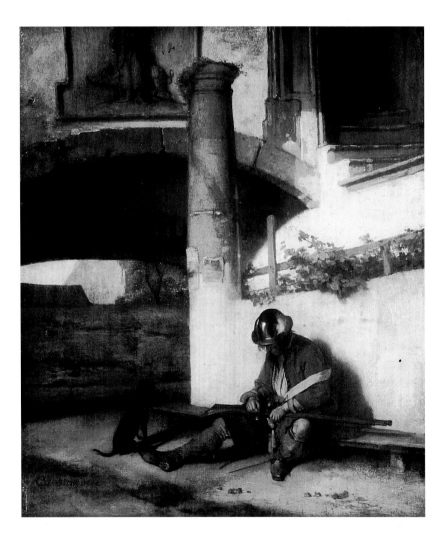

fig. 73
CAREL FABRITIUS
The Sentry, 1654
canvas; 68 x 58 cm
Schwerin, Staatliches Museum,
inv. no. G2477. Photo: E. Walford,
Hamburg

wide against a bare wall; he does not make a particularly vigilant impression, especially not in contrast to the dog, who watches him intently.

Fabritius obscured part of the relief above the arch. The saint whose head cannot be seen is recognisable as Antony the Abbot by his attribute the pig. The shadowy passageway in the upper right is not further defined. The form of the arch accentuates the scene and the diagonals converge in the column, just under the two placards. The soldier is brightly illuminated by the sun. Fabritius preferred gay colours and bright tones. This light palette, the sensitive rendering of the sunlight, the uncommon view point and the complex space are characteristic of the work of many Delft painters between 1650 and 1675. Undoubtedly his unusual approach inspired fellow citizens such as Daniel Vosmaer and Pieter de Hooch.

Fabritius' deceptively naturalistic works won renown for him as well. Trompe l'oeil was very popular in the seventeenth century. The Dordrecht artist Samuel van Hoogstraten, who worked together with Fabritius in Rembrandt's studio, was a specialist in this genre and may have induced him to pursue it.[10] In 1654, for instance, Fabritius painted *The Goldfinch* (fig. 74). The panel is intentionally misleading; the viewer is supposed to think he is looking at a real bird. The artist's thematic choice is original: nothing like it in Dutch painting is known. The curious little picture is indicative of the penchant for illusionism on the part of Delft painters. Gerard Houckgeest, Emanuel de Witte and Hendrick van Vliet began painting arches and curtains before their church interiors as early as 1650, thus clouding the distinction between liminal and pictorial space (see Chapter Two), but the verisimilitude of the goldfinch is unsurpassed.

Sadly, the famous disaster of 12 October 1654 claimed the life of Fabritius. While he was painting the portrait of Cornelis Decker, the former sacristan of the Oude Kerk, his house was destroyed by the explosion of the arsenal. The artist lay mortally wounded beneath the rubble. As the seventeenth-century poet Arnold Bon wrote,

93

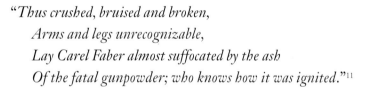

"Thus crushed, bruised and broken,
 Arms and legs unrecognizable,
 Lay Carel Faber almost suffocated by the ash
 Of the fatal gunpowder; who knows how it was ignited."[11]

He died from his wounds shortly afterwards, and was buried in the Oude Kerk on 14 October.

Fabritius' untimely death contributed to the myth regarding the importance of his work. The rediscoverer or Vermeer, Thoré-Bürger, who owned *The Goldfinch* around 1865, proclaimed him the link between Rembrandt and Vermeer. Thereafter he was often seen as a precursor and even a teacher of Vermeer, so that until recently, he was consistently described in the literature of art as the nestor of the so-called Delft School, and credited with having led the city's painters to experiment with perspective. However, the few paintings by his hand that are still known – no more than eight in all – do not support this hypothesis. More likely Fabritius shared the interest of his Delft colleagues in the artistic potential of light, colour, perspective and space.

fig. 74
CAREL FABRITIUS
The Goldfinch, 1654
panel; 33.5 x 22.8 cm
The Hague, Koninklijk Kabinet
van Schilderijen Mauritshuis,
inv. no. 605

EGBERT VAN DER POEL, DANIEL VOSMAER
AND THE EXPLOSION OF THE POWDER MAGAZINE

Like Carel Fabritius, Daniel Vosmaer and Egbert van der Poel availed themselves of perspective to make their work seem more naturalistic.

Little is known about the painter Egbert van der Poel (1621-1664) beyond the fact that he was born at Delft in 1621, as the son of the goldsmith Lieven Adriaensz van der Poel and Anneken Egberts. In 1650 he joined Delft's guild of St Luke. On 10 June 1651 the banns of his marriage to Aeltgen Willems van Linschooten were published and on 25 June the couple married at Maassluis.

Van der Poel started out painting peasant scenes, markets and landscapes. His interest in townscape is evidenced by the *Fish Market*, dated 1650 (fig. 76), showing an unidentified quarter in the vicinity of a harbour. Behind the tower the sails of ships are visible. The low horizon lends the panel a tremendous sense of depth. With the exception of a stall with a housewife in the right foreground, most of the market is in shadow. Two storks await their chance to snatch the discarded fish offal.

The explosion of the powder magazine in Delft at half past eleven on the morning of Monday, 12 October 1654 was a catastrophe that claimed the lives of hundreds and left many wounded. The years that followed witnessed a proliferation of pictures chronicling the devastation. The disaster had a lasting impact on the art of Egbert van der Poel, who was living beside Carel Fabritius in the Doelenstraat at the time; indeed, one of his own children was among the victims. Whether Van der Poel actually witnessed the calamity we cannot be sure, but he treated the explosion itself and its lamentable consequences repeatedly (figs. 75 and 77). All his works on the theme – over twenty of which survive – bear the same date, although not all of them were painted that year by any means. There was evidently tremendous interest in the subject, which the artist catered for very well.

fig. 76
EGBERT VAN DER POEL
The Fish Market, 1650
panel; 61.3 x 75 cm
The Hague, Koninklijk Kabinet
van Schilderijen Mauritshuis,
inv. no. 698

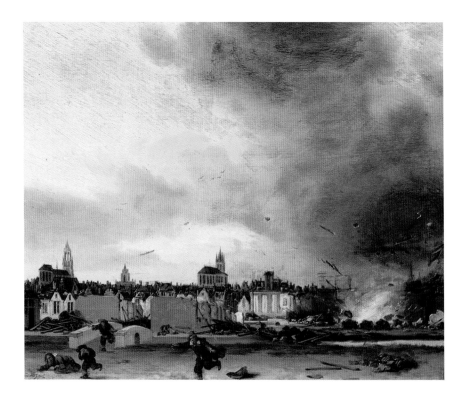

fig. 75
EGBERT VAN DER POEL
*The Explosion of the Powder
Magazine at Delft on Monday,
12 October 1654*
panel; 32 x 31 cm
Delft, Stedelijk Museum Het
Prinsenhof (on loan from the
Rijksdienst Beeldende Kunst,
The Hague), inv. no. NK 2430.
Photo: Tom Haartsen, Ouderkerk
aan de Amstel

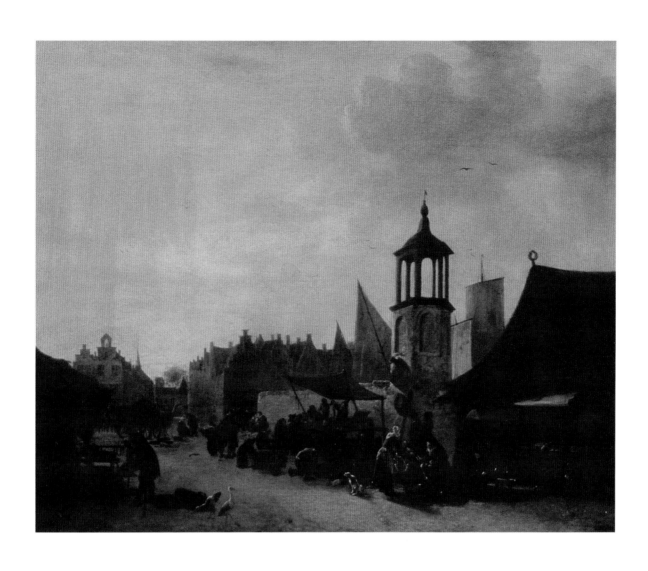

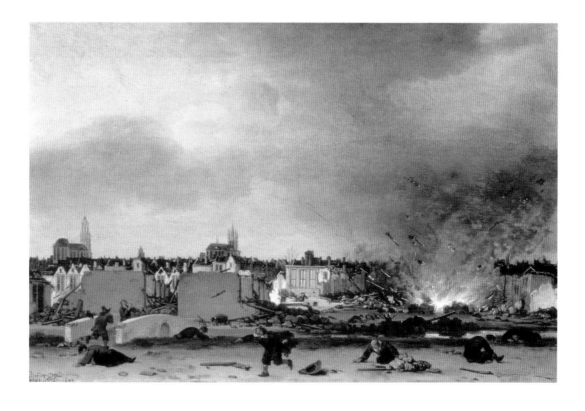

fig. 77
EGBERT VAN DER POEL
*The Explosion of the Powder
Magazine at Delft on Monday,
12 October 1654*
panel; 31 x 47.5 cm
Delft, Stedelijk Museum Het
Prinsenhof (on loan from the
Rijksdienst Beeldende Kunst,
The Hague), inv. no. NK 2784.
Photo: Tom Haartsen, Ouderkerk
aan de Amstel

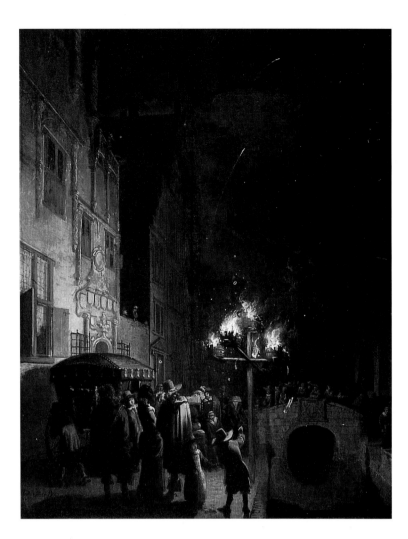

fig. 78
EGBERT VAN DER POEL
Fête on the Oude Delft, c. 1645
panel; 55 x 43 cm
Delft, Stedelijk Museum Het
Prinsenhof, inv. no. PDS 85. Photo:
Tom Haartsen, Ouderkerk aan de
Amstel

96

Each time, Van der Poel approached the devastated quarter from the same low vantage point, thus accentuating the extent of the area that had been leveled by the blast. Although the compositional and spatial schemes correspond to the artistic changes that took place at Delft after 1650, the handling of the light and the use of colour remain traditional. His pictures therefore lack the characteristic atmosphere readily associated with Delft.

In 1655 Van der Poel left Delft for Rotterdam. There he continued to paint the explosion of the magazine, but also specialised in nocturnal festivities (fig. 78), conflagrations and moonlit views (*maneschijntjes*). The artist died in 1664.

Van der Poel's fellow townsman, Daniel Vosmaer (1622-after 1666), likewise treated the disaster regularly. Born at Delft in 1622, Vosmaer was the fourth son in an artistic family. His grandfather Wouter was a painter, his father Arent a goldsmith and two of his brothers, Abraham and Nicolaes, likewise lived by the brush. In 1650 Daniel Vosmaer was inscribed as a master in St Luke's guild at Delft. There is documentary evidence that, together with his brother Nicolaes and Carel Fabritius, he collaborated on a painting that is unfortunately lost. Fabritius made the preparatory drawing, Daniel painted the landscape, Nicolaes the sea, and Fabritius supposedly added the final touch.[12]

Like Van der Poel, Vosmaer presumably witnessed the disaster in 1654. He painted

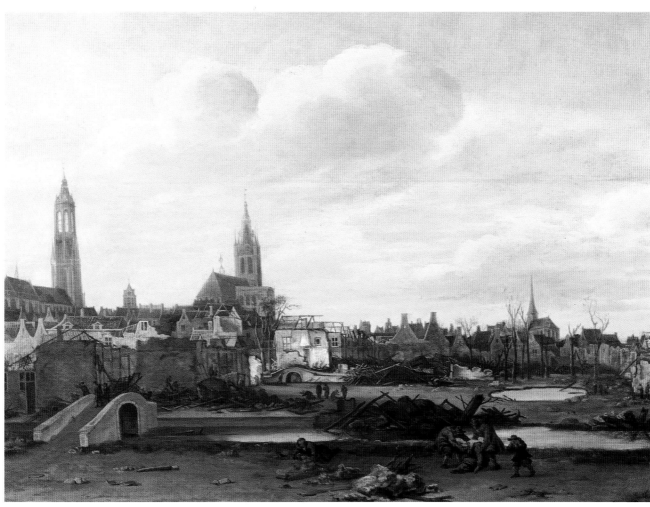

fig. 79
DANIEL VOSMAER
*The Explosion of the Powder
Magazine at Delft on Monday,
12 October 1654*
panel; 72 x 97 cm
Delft, Stedelijk Museum Het
Prinsenhof, inv. no. PDS 107.
Photo: Tom Haartsen, Ouderkerk
aan de Amstel

fig. 80
GERBRAND VAN DEN EECKHOUT
*Delft after the Explosion of the Powder
Magazine in 1654*
pen and wash; 10.9 x 13.6 cm
Berlin, Kupferstichkabinett
Staatliche Museen zu Berlin–
Preußischer Kulturbesitz,
inv. no. 12815

not only the *moment suprême* but also various versions of the devastation. A good example is the painting of the ravaged quarter as it appeared after the fire was extinguished (fig. 79). Vosmaer opted for a horizontal format with the towers as vertical accents, and recorded the scene from the same position that Van der Poel took up time and again. Neither artist was apparently aware of the possibilities light offers for arranging the composition. Vosmaer represented the extent of the damage in great detail. The magazine itself has been wholly destroyed, leaving only a barren expanse with the Oude and the Nieuwe Kerk in the distance. The toll is enormous, the houses in the immediate vicinity having all been ruined. The blackened trees have been stripped of their leaves by the sheer force of the blast. Vosmaer underscored the piteous consequences for the populace with the dramatic gestures of the diminutive figures in the vast open space. One of the wounded lies in the centre and two men are seen carrying a litter on the far left. In the foreground two men are helping a woman, while a small boy still holds his hands to his ears, stunned by the 'thunderclap' that was supposedly heard all the way to Texel.

News of the tragedy spread rapidly. Gerbrand van den Eeckhout, a pupil of Rembrandt, made a drawing (fig. 80) of the aftermath for an Amsterdam pamphlet by Jan Philipsz Schabaelje.[13] Van den Eeckhout recorded a miracle. A little girl no more than fifteen months was pulled alive from under the rubble twenty-four hours after the blast, still seated in her highchair. As Dirck van Bleyswijck reported, "she thanked her rescuers with a friendly laugh. One of her hands was slightly injured; in the other she held the apple she was playing with. Not only the girl was saved but also an eighty-year-old man who had lain under the rubble for over thirty-six hours was freed from his perilous position unscathed. Until forty-eight hours after the disaster various other people, buried alive under the heaps of stone and plaster, rose again as from the dead. At first they were given up for dead as the mass and weight of the fallen walls and beams kept anyone from reaching them."[14]

In the wake of the disaster the first expressions of sympathy reached the Town Council. The States General sent a letter of condolence and Elizabeth Stuart, the widow of Frederick v, Elector Palatine, paid a visit to the devastated quarter. Nor was she the only one. Many Dutchmen came to witness the scene of the disaster, as noted, for instance, in a painting by Daniel Vosmaer, *Delft after the Explosion of the Powder Magazine in 1654* (fig. 81). A man and woman, richly dressed, walk arm in arm along the rubble. They approach a boy together with a child seen from the back. The boy's head is bandaged and his right arm is in a sling. The couple themselves bear striking resemblance to the man and woman in *A Family Gathering in a Courtyard* by Pieter de Hooch (see figure 99), where the child occurs as well. The artists were undoubtedly acquainted from meetings of the guild of St Luke and Vosmaer may have executed drawings after De Hooch for use later on.[15]

Vosmaer placed the figures and the architecture realistically in space. The viewer's attention goes directly to the couple and the children, as the painter closed off the foreground with horizontal elements. The low horizon lies on the eye level of the man and woman and the vanishing point precisely between them, thus heightening the illusion of depth. By placing the trees, behind the rubble on the left, next to the tower of

fig. 81
DANIËL VOSMAER
Delft after the Explosion of the Powder Magazine in 1654
canvas; 67.6 x 55.6 cm
Philadelphia, Philadelphia Museum of Art, The John G. Johnson Collection, cat. no. J 500. Photo: Graydon Wood, Philadelphia

the Nieuwe Kerk, the artist counterbalanced the predominantly horizontal character of the composition with a number of vertical accents.

Compared to Vosmaer's painting of the disaster (see figure 79), light plays an important role. The tree-trunks, façades and remains of the houses stand in direct sunlight, enhancing the intensity of the colours greatly.

In *View in a Dutch Town* (fig. 82), vivid colours likewise predominate. Once again sunlight floods the scene, picking out the top of a ruined wall in the foreground, which neatly ascends from left to right. By blocking our access to the image with the wall, the artist gives us the sense of peeking over it. The illusion of depth can be explained in part by the placement of the horizon on the eye level of the observer. Vosmaer accentuated the size of the open area before the trees and houses by reducing the size of the figures. The wall belongs to a house, only a small part of which is visible. Immediately behind the edifice stands a tall tree.

The closure of this particular image by means of a rising wall is a rather unusual experiment, an experiment, moreover, that one can only imagine at Delft in the late 1650s. Vosmaer's colleagues were keenly interested in odd vantage points. Consider, for instance, the positions taken up by the painters who specialised in church interiors (see

fig. 82
DANIËL VOSMAER
View of a Dutch Town, c. 1662
panel; 66 x 53 cm
Poughkeepsie, New York,
The Frances Lehman Loeb Art
Center, Vassar College, Purchase
Agnes Rindge Claflin Fund,
inv. no. 1962.2

fig. 83
DANIEL VOSMAER
The Harbour of Delft, c. 1652
canvas; 85.5 x 101 cm
Ponce (Puerto Rico), Collection
Museo de Arte de Ponce, The
Luis A. Ferré Foundation,
inv. no. 590088

Chapter Two). Vosmaer collaborated with the master of perspective, Carel Fabritius, on at least one picture, and probably knew his *View in Delft* (see figure 72). Whereas Fabritius placed the stall of the instrument seller in the left foreground, Vosmaer positioned the wall, the tree and the house on the right – a much less subtle solution, to be sure. Here again the damage was probably caused by the explosion of 1654, but lacking the towers of the Oude, Nieuwe and Lutherse Kerk, an exact identification is impossible.

On the other hand, Vosmaer's townscape leaves no room for doubt that the city involved is Delft (fig. 83). Seen from the south, the canvas describes a location between the Rotterdam Gate and the Eastern Gate, where there is an indentation in the ramparts. At the spot where the wall makes a turn, on the corner of the Asvest and the Zuiderstraat, stands the Spring Mill. Built in stone in the fifteenth century presumably, it was often called the Stone Mill. Shortly after 1700 the mill was destroyed by fire and in 1732 the remains were pulled down.

In this painting Vosmaer abandoned the low, horizontal design he had favoured in the past. Instead, he filled the upper half of the image with the monumental forms of the mill and the tower. The recession in the foreground is not always correct. With the bright

Views in and of Delft

colours, the reflection of the buildings in the water and the complete lack of human activity, the scene evokes a splendid, hushed atmosphere.

It is tempting to speculate that the *View in Delft* by Fabritius (see figure 72) inspired Vosmaer to paint the *View of Delft with a Fantasy Loggia* from 1663 (fig. 84), and to consider the latter a reflection of the works by Fabritius in this genre that are now lost.[16] Like that in the canvas by Fabritius, the angle of vision in Vosmaer's picture is wide. From a loggia the viewer sees a not altogether truthful depiction of the western part of Delft. The city walls with the roundels are prominently shown. Two of the roundels are surmounted by post mills: the one on the left is the Gasthuismolen,[17] the other the Steckmolen. The towers of the Nieuwe Kerk, the Oude Kerk and the Town Hall are silhouetted against the sky; the steeple of the Walloon Church is also recognisable.

By surrounding his view of one part of Delft with a loggia Vosmaer gave further evidence of his abiding interest in perspective. Although art historians have always assumed that the loggia sprang from the painter's imagination, there were two architectural elements in Delft that could have served Vosmaer as an example. In the

fig. 84
DANIEL VOSMAER
View of Delft with a Fantasy Loggia,
1663
canvas; 90.5 x 113 cm
Delft, Stedelijk Museum Het Prinsenhof (on loan from the Rijksdienst Beeldende Kunst, The Hague), inv. no. NK 2927.
Photo: Tom Haartsen, Ouderkerk aan de Amstel

Town Hall on Market Square is a gallery where the Tribunal was housed. The structure of the columns, the four arches and their framing and the floor with the black-and-white tiles are all identical to Vosmaer's loggia.[18] Only the vaults are different, but Vosmaer could well have modelled his on those of the canopy of the tomb of William the Silent in the Nieuwe Kerk.

Whatever his visual sources may have been, Vosmaer's experiment with the loggia shows all too clearly that his knowledge of perspective was not equal to the task. In constructing the tiled floor he ignored the distance points on the imaginary horizon, seriously distorting the recession. There is also something curious about the vaults, as evidenced by the rosettes which are not always aligned. These imperfections not-withstanding, the canvas documents the artist's fascination with perspective, light, atmosphere and space.

STREET SCENES

The work of the relatively unknown Dutch master Jacobus Vrel has regularly been linked to that of Johannes Vermeer. Where exactly he was active can only be inferred from stylistic correspondences. Delft is certainly a possibility, although he is not mentioned in the Municipal Archives. The few datings of his paintings range from 1654 until 1662.

Vrel specialised in two genres: domestic interiors, which contain many parallels with the work of Pieter Janssens Elinga, Esaias Boursse and Pieter de Hooch (see Chapter Four), and street views, showing the houses frontally in most cases, as in Vermeer's *The Little Street*. Vrel's street scenes do not really fit into in the seventeenth-century tradition of the townscape. Compared to the work of specialists such as Gerrit (1638-1698) and Job Berckheyde (1630-1693) and Jan van der Heyden (1637-1712) (see figures 114 and 115), Vrel's makes a clumsy, almost naïve impression. The entire image is invariably filled with lofty brick façades, and there are never any trees or plants (figs. 85, 86 and 87). The small figures have a marionette-like quality and, as their feet do not cast shadows, they sometimes even appear to float! There is little or no human activity: the figures stand or sit without moving.

The *Street Scene* from c. 1660 (fig. 88) is not signed, but once bore the false signature *VMEER*. It belonged to the collection of Théophile Thoré-Bürger, who is credited with having rediscovered Vermeer. The Frenchman believed the panel really was by the master's hand, although there are more differences between it and Vermeer's work than similarities. Vrel emphasised above all the narrow streets with tall buildings, which largely prevent the sunlight entering. The sky is hardly visible and the bricks of the façades and pavement predominate. The clarity and openness that characterise so much of Delft genre painting, including Vrel's own domestic interiors, are lacking in the artist's street scenes.

The street scene that Jan Steen (1626-1679) painted in 1655 – known as *A Burgomaster of Delft and his Daughter* (fig. 89) – undoubtedly contributed to the changes in Delft in the field of townscape and genre. In 1649 Jan Steen married Margaretha van Goyen, daughter of the painter Jan van Goyen (1596-1656). In 1654 Steen's father, a brewer from Leiden, took out a three-year lease on the brewery 'The Snake' on the Oude

fig. 85

JACOBUS VREL

Street Scene

panel; 50 x 38 cm

Hamburg, Hamburger Kunsthalle,

inv. no. 228

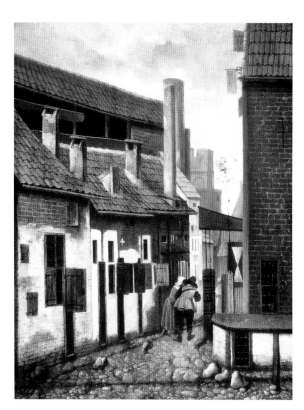

fig. 86

JACOBUS VREL

Street Scene

panel; 36.3 x 27.8 cm

London, by courtesy of Sotheby's

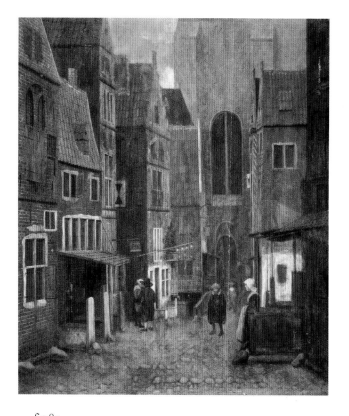

fig. 87

JACOBUS VREL

The Street

panel; 48.9 x 41.9 cm

Philadelphia, Philadelphia Museum

of Art, The John G. Johnson

Collection inv..no. 1542. Photo:

Graydon Wood, Philadelphia

Delft, which Jan managed. The artist did not join Delft's guild of St Luke, however, but remained registered at Leiden. It was at about the time that Steen went into business at Delft that he painted this large portrait, presumably on commission from one of his neighbours. A prominent gentleman is seen sitting on the stoop of his house on the Oude Delft. The tower of the Oude Kerk and the façade of the High Polder Council of Delfland can be seen in the background. Beside the man stands a young woman, perhaps his daughter, who raises the hem of her elegant dress. Steen's patron apparently wished to have his charity visualised, for he inclines benevolently toward a woman beggar with a child and gives her alms. Not only *Caritas* but also *Vanitas* figures in the work. By placing a vase of flowers prominently in the open window, Steen undoubtedly meant to remind the observer of the transitoriness of life.

The carefully arranged composition of this painting points to the influence of Delft, even if Steen did not follow the rules of perspective. All the pictorial motifs are arranged in a triangle. There is no central vanishing point, and the receding lines, including those of the stoop, the paving stones and the walls, intersect at random somewhere in the centre of the image. Besides the compositional scheme, the filtered light – ensuring the uniform brightness and intensity of the colours – is also characteristic of Delft.

105

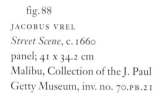

fig. 88
JACOBUS VREL
Street Scene, c. 1660
panel; 41 x 34.2 cm
Malibu, Collection of the J. Paul
Getty Museum, inv. no. 70.PB.21

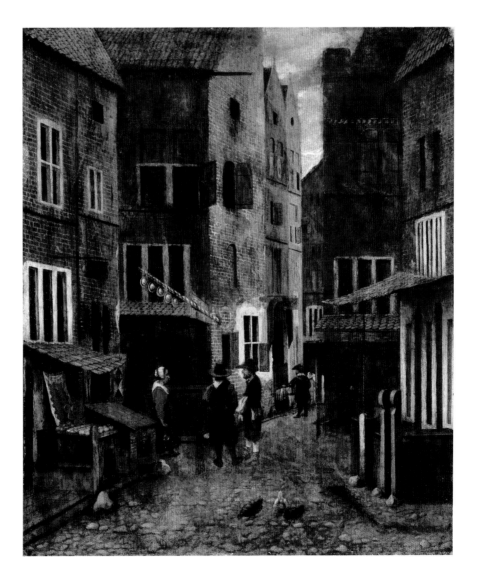

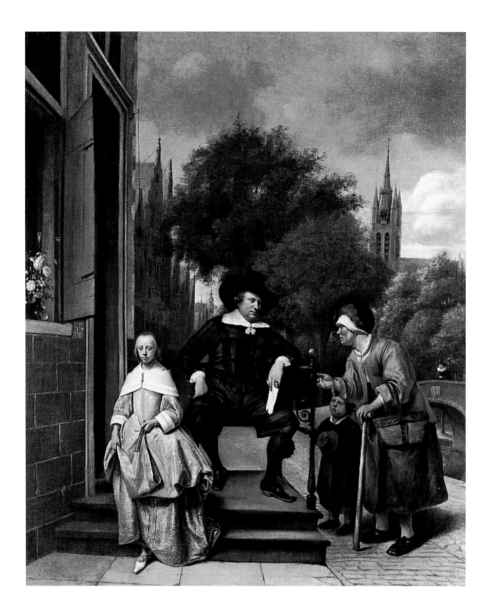

fig. 89
JAN STEEN
*A Burgomaster of Delft and
His Daughter*, 1655
canvas; 82.5 x 68.5 cm
United Kingdom, private collection

COURTYARDS

The bright, light tints, colourful palette and theme of *The Grinder's Family in a Courtyard* (fig. 90) have earned a special place for this work in the oeuvre of Gerard Terborch (1617-1681). The artist painted the canvas around 1653. When he paid a visit to Delft that year he may have been introduced to innovations in the area of perspective, light and space (see Chapter Four).

In a shabby courtyard a man is busy sharpening a scythe on a large grindstone as another man looks on. Terborch painted not the idealised image of a respectable household, but the premises of an elderly artisan. Notwithstanding the dirt and disorder of the scene the motif of the woman checking a child for nits or lice, a task reserved for mothers in seventeenth-century Holland, signifies domestic virtue.

Around 1657 Pieter de Hooch first painted a *Courtyard of a House in Delft* (fig. 91), which as regards composition displays remarkable correspondences with the work of Terborch, albeit in reverse image.[19] Two women go about their daily activities in an enclosed courtyard. The woman on the left draws water while the one on the right does the wash under a child's watchful eye. The tower of the Oude Kerk rises above the houses

in the background. While in Terborch's work, all the lines converge at a point above the back of the supine grinder, De Hooch gathered all the lines together at the right hand of the woman at the washtub. He made his figures larger, furthermore, so that his courtyard seems smaller than Terborch's.

PIETER DE HOOCH (1629-1684)

Pieter de Hooch was born at Rotterdam, the son of the master bricklayer Hendrick Hendricksz de Hooch and Annetge Pieters. About his youth and training nothing is known. He may have been a pupil of the Haarlem landscape painter Nicolaes Berchem (1620-1683). De Hooch initially painted barrack-room scenes in dark, brownish yellow tones (see Chapter Four). In August 1652 he was first mentioned as a resident of Delft. A year later he was in the service of the cloth merchant Justus de la Grange, alternately in Delft, The Hague and Leiden. In that period De Hooch presumably gave most if not all of his production to De la Grange to support himself, for the merchant had eleven of the artist's pictures in his collection. Although he had moved to Delft three years earlier, the artist did not inscribe himself in the local guild of St Luke until 1655. In 1660/1661 De Hooch took his family to Amsterdam, where he died in an insane asylum in 1684.

107

fig. 90
GERARD TERBORCH
The Grinder's Family in a Courtyard,
c. 1653-1655
canvas; 72 x 59 cm
Berlin, Staatliche Museen zu
Berlin–Preußischer Kulturbesitz,
Gemäldegalerie, inv. no. 793.
Photo: Jörg P. Anders, Berlin

fig. 91
PIETER DE HOOCH
Courtyard of a House in Delft, c. 1657
panel; 68 x 57.5 cm
Toledo, Ohio, The Toledo Museum
of Art. Purchased with funds from the
Libbey Endowment, gift of Edward
Drummond Libbey, inv. no. 49.27

De Hooch's best works date from his Delft period. The series of courtyards, which he painted around 1658, forms a highpoint in the development of genre painting – outdoor scenes, which revolve around women performing their everyday chores. The interest in and popularity of this theme grew enormously in the 1640s, the tasks themselves freighted with moral associations. Virtues as diligence, modesty, piety, inquisitiveness, thrift and loyalty vanquished lethargy, sloth, indolence, gluttony, luxury and greed. Taking her lead from Psalm 51, the mother governed the household, kept the peace, prodded her family to live an upright life and stood for absolute cleanliness.[20] She checked the children for nets and lice and got the maid to sweep the floor. The sitting room is tidy, and the bed is neatly stacked with pillows in their clean linen cases. To get the linen spotlessly white housewives laid it out on bleaching fields.

In *Woman and Child on the Bleaching Field* (fig. 92), painted between 1657 and 1659, De Hooch adopted a diagonal composition. The field is surrounded by the stone walls of the courtyards behind the houses. The walls block the view of the second plan with the exception of two vistas. With the diagonals in the design and the vanishing point placed precisely between the heads of the man and woman in the vista on the right, the artist managed to create a convincing illusion of depth. De Hooch intentionally accentuated the space by placing the tower of the Nieuwe Kerk behind the Oude Kerk. Given the view point and the angle of the Oude Kerk, the Nieuwe Kerk would not normally be

108

fig. 92
PIETER DE HOOCH
Woman and Child on the Bleaching Field, c. 1657-1659
canvas; 73.5 x 63 cm
United Kingdom, private collection

visible, since in reality it stands much further to the right. The palette consists of sub-dued yellow, ochre and brown tints; only the skirt of the housewife is accented with bright red. The scene is evenly lit, the sun casting the Oude and the Nieuwe Kerk in a warm golden glow.

Illusionistic effects and experiments with light and perspective characterise the oeuvre of Pieter de Hooch. Like most Delft painters he also studied the effects of light, often depicting his figures in summer sunshine. Although the scenes are often set in an enclosed courtyard, there is almost always a vista to a space beyond. As a result, the spaces form a continuous whole. Locations like these were especially common in the neigh-bourhood of the Binnenwatersloot, where the wife of the painter lived before they married. De Hooch constructed the image precisely according to the laws of perspective, clarifying the construction by means of the regular patterns in the floors. His art gives us a glimpse of the strictly ordered, private character of daily life in contemporary Holland.

The number of figures in De Hooch's pictures is usually limited to three or four. The figures themselves are static, captured at a moment when, for whatever reason, they are motionless. This enhances the impression of order and peace, as in *A Woman and Two Men in an Arbour* (fig. 93). Rendering the space was the painter's highest priority; the figures were often added only later.

It appears as though De Hooch did nothing more than record his surroundings,

109

fig. 93
PIETER DE HOOCH
A Woman and Two Man in an Arbour,
c. 1657-1660
panel; 69,2 x 54 cm
New York, The Metropolitan
Museum of Art. Bequest of Harry G.
Sperling 1973, inv. no. 1976.100.25

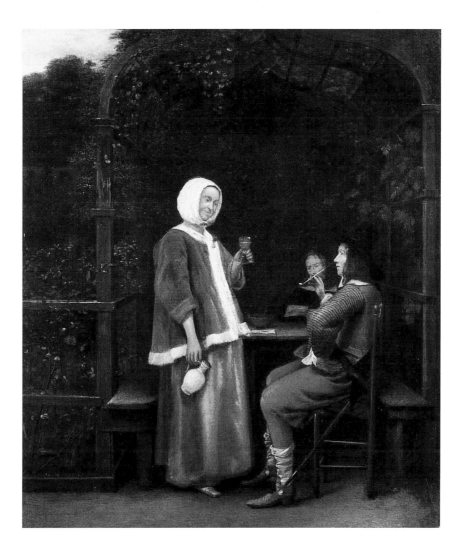

especially since the towers of the Oude and/or Nieuwe Kerk figure in his outdoor scenes. But appearances are deceptive, for like most seventeenth-century painters, De Hooch carefully assembled the image from existing architectural elements.

This point is clearly demonstrated by two paintings, both entitled *Courtyard of a House in Delft* and painted in 1658. The compositional and spatial schemes are identical. Differences, as in the floors and vistas, are hardly noticeable at first, but are actually significant, in accordance with the theme involved. The courtyard with two men and a woman (fig. 94) represents the pleasures of this world. While enjoying a pipe and a tankard of beer the two men amuse themselves with a woman who, standing by their table, raises her glass. She appears to accept the advances of the elegant man in the hat. The mantle and rapier of one of the gentlemen have been hung nonchalantly over a shutter. In the doorway sits a child with a dog on her lap. A stone plaque is anchored in the wall above the door, partly obscured by the grapevine growing over it.

The other courtyard stands for domesticity (fig. 96). Maternal care is visualised by the woman with the child on her hand, cleanliness by the pail and broom. In the hallway stands a housewife with her back to the observer. The plaque above the entrance, which is less elaborate than its counterpart and largely obstructed by a grapevine, is an implicit

fig. 96
PIETER DE HOOCH
Courtyard of a House in Delft, 1658
canvas; 73.5 x 60 cm
London, The National Gallery.
Reproduced by courtesy of the
Trustees of the National Gallery,
inv. no. NG 835

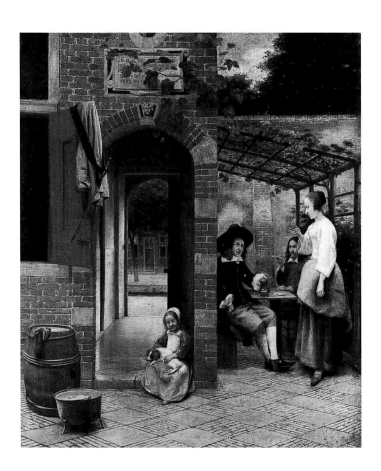

fig. 94
PIETER DE HOOCH
Courtyard of a House in Delft, 1658
canvas; 68 x 57.5 cm
New York, private collection

fig. 95
Plaque from the monastery
Hieronymusdale, 1614
Delft, private collection

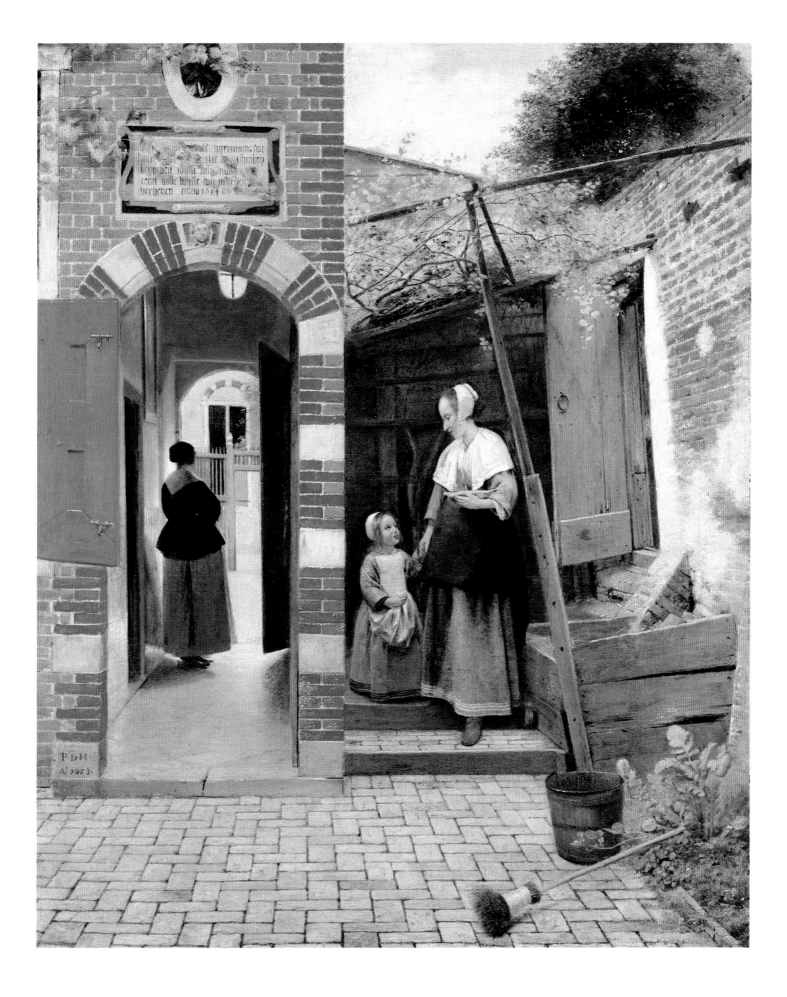

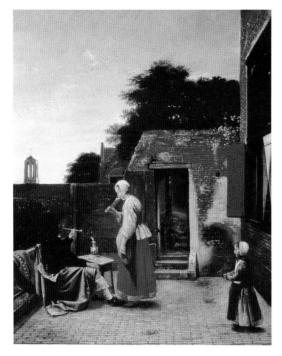

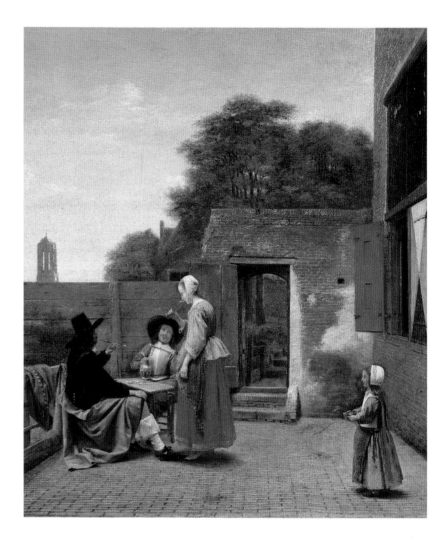

fig. 98
PIETER DE HOOCH
*A Man Smoking and a Woman
Drinking in a Courtyard at Delft*,
c. 1658-1660
canvas; 78 x 65 cm
The Hague, Koninklijk Kabinet
van Schilderijen Mauritshuis,
inv. no. 835

fig. 97
PIETER DE HOOCH
A Courtyard at Delft, c. 1660
canvas; 68 x 58.4 cm
Washington, National Gallery of
Art, Andrew W. Mellon Collection,
inv. no. 1937.1.56(56)/PA

reference to Psalm 128. "Thy wife shall be as a fruitful vine by the sides of thine house: thy children like olive plants round about thy table." The plaque above the hall from the monastery Hieronymusdale survives. The text reads "This is [the monastery] Sint Hieronymusdale. Prithee observe patience and submission, for we must descend ere we can be raised anno 1614" (fig. 95).[21]

That De Hooch incorporated the same motifs in different pictures is also evidenced by *A Courtyard at Delft* (fig. 97) and *A Man Smoking and a Woman Drinking in a Courtyard at Delft* (fig. 98), both painted between 1658 and 1660. The images are identical, with the exception of the number of figures. In the Washington version, which was probably executed first, a second man sits behind the small table, holding a tankard in his hand and looking up at the woman with a merry expression on his face. Why De Hooch copied this scene so precisely is not known. He may have simply been content with the results and therefore decided to repeat it. Or the repetition may indicate such pictures were in great demand, since copying would of course have been more expedient than starting again from scratch. The space is painstakingly constructed along two diagonals which intersect at the vanishing point in the centre of the arch above the doorway. The handling of the surface of the brick wall is astonishingly realistic; every repair and crack is recorded. The texture is strikingly similar to the façades in Vermeer's *The Little Street* (see figure 110).

Nothing is known regarding any commissions that De Hooch may have received, but the *Family Gathering in a Courtyard* (fig. 99) is presumably a group portrait. The painting occupies a special place in the oeuvre of De Hooch, who usually included no more than three or four figures in his works. The group is arranged with evident forethought. On the right sit an older man and two women at a table before an arbour, all of them dressed in sober black with white collars. Behind them stand two men in elegant grey costumes. On the left a couple poses in costly attire; holding an apple in her left hand, the woman raises her skirt slightly with her right, exposing a red petticoat. Through the gate a man can be seen in the centre ground; his attitude corresponds with that of the man in the red mantle often found in the church interiors of Emanuel de Witte (see Chapter Two). The tower of the Nieuwe Kerk looms in the distance.

The sitters do not interact, neither do they show any emotion. Only the two men standing on and by the stairs gaze directly at the viewer. The hushed atmosphere of the

fig. 99
PIETER DE HOOCH
Family Gathering in a Courtyard,
c. 1657-1660
canvas; 114 x 97 cm
Vienna, Gemäldegalerie der
Akademie der bildenden Künste,
inv. no. 715

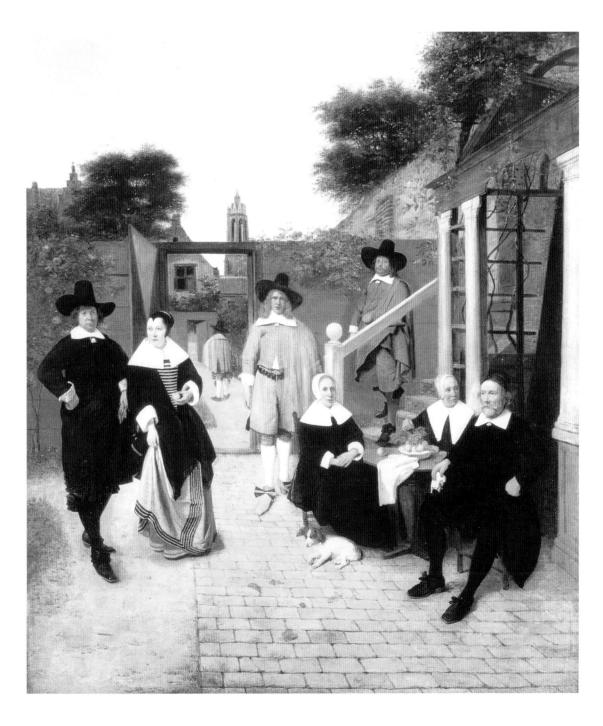

scene, which is evenly lit with natural light, is enhanced by the subdued tones of the ochres, browns, greys and reds. The artist balanced the design by carefully disposing the white accents of the collars, cuffs, stockings, towel and handkerchief. Given the stylistic parallels between this canvas and the courtyards from 1658, it was probably painted between 1658 and 1660.

A Woman and Child in a Courtyard (fig. 100), likewise painted between 1658 and 1660, features the same arbour we have just encountered in the family portrait. Carrying a basket of linen and holding a pitcher in her hand, a woman gazes tenderly at the child at her side. As the personification of domestic virtuosity, no wonder she is situated in the centre of the image. A couple sits conversing and drinking in the arbour, a thinly veiled renunciation of earthly delights.

The dross of the earth comes right to the threshold of the house and must be vigorously scrubbed away. The *Woman with Broom and Pail in a Courtyard* (fig. 101) seems very conscious of her civic duty to purge the street and her courtyard of any stain.

fig. 100
PIETER DE HOOCH
A Woman and Child in a Courtyard,
c. 1658-1660
canvas; 73.5 x 66 cm
Washington, National Gallery
of Art, Widener Collection,
inv. no. 1942.9.34(630)/PA.
Photo: Richard Carafelli,
Washington

114

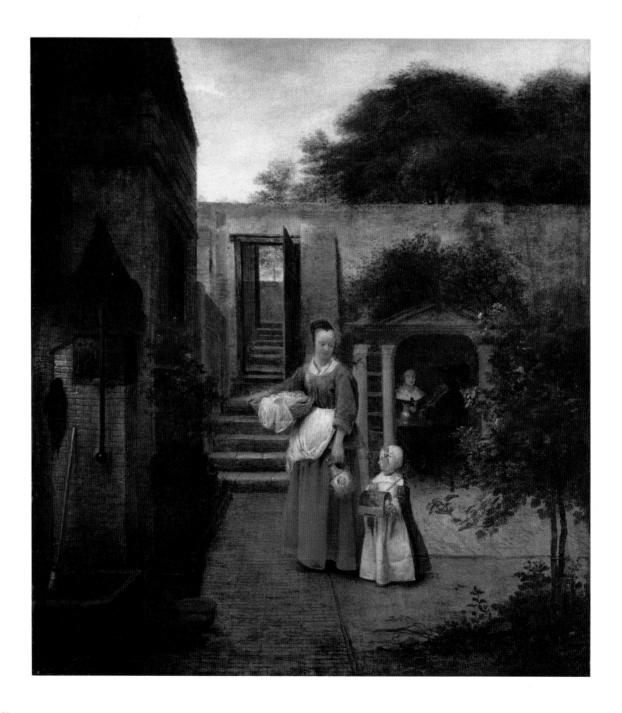

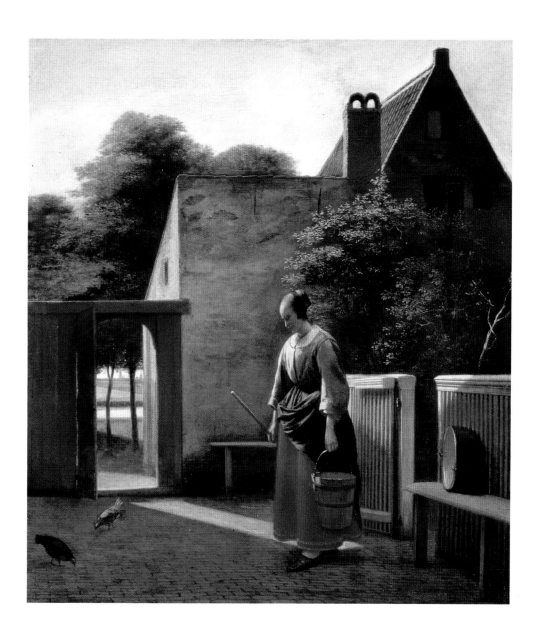

fig. 101
PIETER DE HOOCH
Woman with Broom and Pail in a Courtyard, c. 1658-1660
canvas; 44 x 42 cm
United Kingdom, private collection, by courtesy of Sotheby's

Woman with Servant in a Courtyard (fig. 102), painted around 1660, is likewise composed of various elements that also occur in other paintings, such as the pump and the arbour in the background (see figure 100). The wall at the end of the garden presumably forms part of the fortifications surrounding Delft. In the seventeenth century the gardens of the houses on the western side of the Oude Delft ran through to the fortifications. Seen from the back, the housewife gestures to the maid, who is busy cleaning a fish; although her mistress apparently speaks to her, she shows no reaction, but stares blankly straight ahead. Using central perspective, De Hooch placed the vanishing point on the left beside the head of the man in the distance. The composition, constructed along two diagonals, reveals the artist's search for the proper balance between the various pictorial elements, to which end he adapted the image. Originally there was another roof seen from the side, that of the house at the back of the garden was taller and the door was located elsewhere. The head and right side of the maid have also been altered. De Hooch added some subtle colour accents, such as the yellow cloth that hangs over the wooden fence, and suffused the scene with subdued daylight.

Around 1660 the Rotterdammer Ludolf de Jongh (1616-1679) painted a *Scene in a*

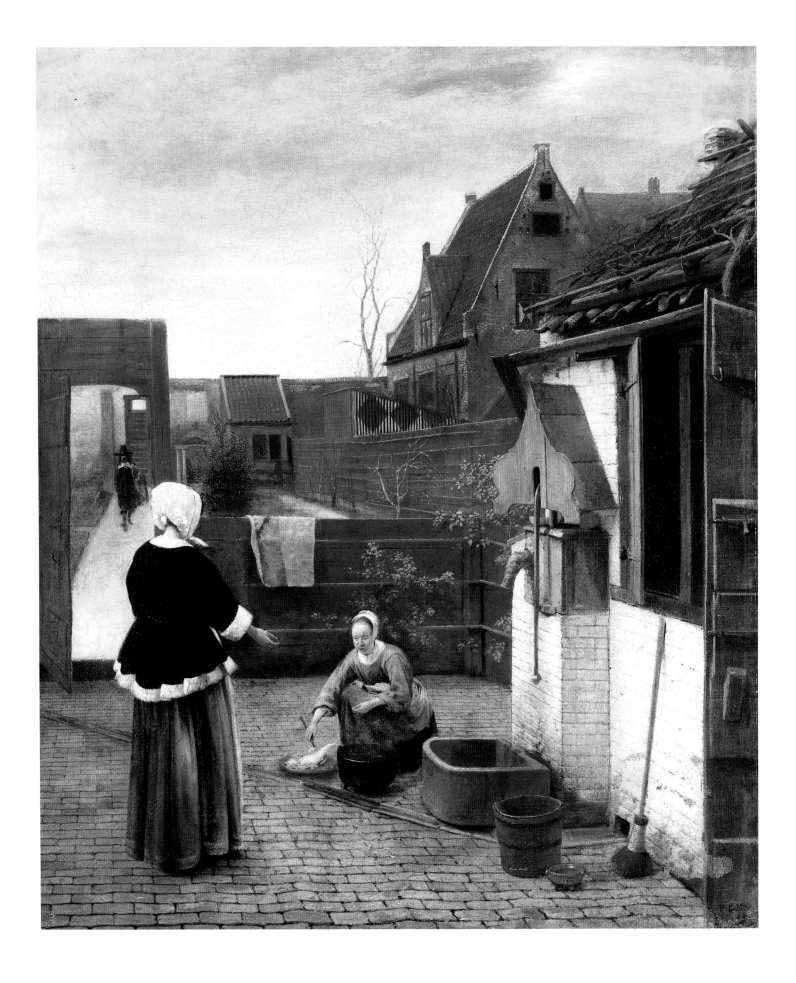

Courtyard (fig. 103) which bears striking resemblance to the work of Pieter de Hooch. With an identical gesture a housewife gives instructions to her maid, who instead of crouching, bends over a large dish. Against the façade of the house on the right grows a grapevine. Not only the subject but also the composition is similar; De Jongh's work lacks the persuasiveness of De Hooch's, however, and is less naturalistic.

Woman with a Basket of Beans in a Vegetable Garden by Pieter de Hooch dates from c. 1660 (fig. 105). At that time the artist was living in Amsterdam, but still using the compositions with courtyards that he painted in Delft. Domestic virtuosity is once again the theme, albeit less explicit in this case. Here De Hooch presumably intended to illustrate Psalm 128.[22] The grapevine thrives on the façade and the housewife has just picked some of the fruits of her garden for her family.

Emanuel de Witte, who likewise lived in Amsterdam, painted a *Vegetable Market* in the same period, with the Nieuwe Kerk at Delft in the background (fig. 106). Although market scenes usually have a double meaning, especially when the sale of poultry is involved,[23] here De Witte depicted an anomymous housewife, who carefully and above all thriftily goes about her duties as head of the household.

The bright light, the vistas and the staggered spaces of De Hooch profoundly influenced many painters. That is clearly manifest in a *Young Woman in a Court* (fig. 107) and *Woman with a Child Blowing Bubbles in a Garden* (fig. 104) by his brother-in-law Van der Burch.

In 1663 De Hooch paid another visit to Delft. At about that time he painted two more outdoor scenes which are highly reminiscent of his Delft courtyards.[24] *A Woman and a Maid with a Pail in a Courtyard* (fig. 108) signifies domestic virtue while *A Company in a*

117

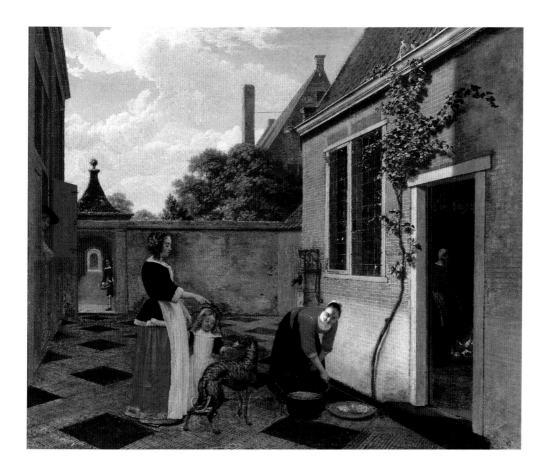

fig. 103
LUDOLF DE JONGH
Scene in a Courtyard
canvas; 67.3 x 82.3 cm
New York, The Metropolitan
Museum of Art, Bequest of
Mr. William K. Vanderbilt, 1920,
inv. no. 20.155.5

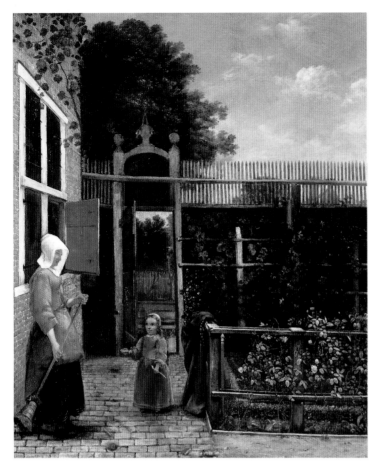

fig. 104
HENDRICK VAN DER BURCH
Woman with a Child Blowing Bubbles
in a Garden, c. 1660
panel; 59.2 x 49.7 cm
Zurich, Kunsthaus, Stiftung Betty
und David M. Koetser, inv. no. KS 36

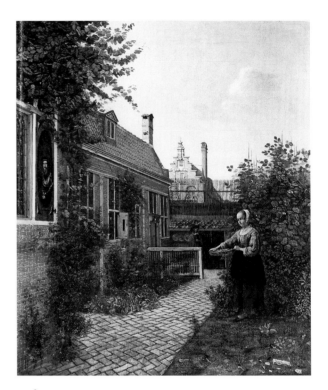

fig. 105
PIETER DE HOOCH
Woman with a Basket of Beans in
a Vegetable Garden, c. 1661
canvas, relined; 69.5 x 59 cm
Basel, Öffentliche Kunstsammlung,
Kunstmuseum, inv. no. G. 1958.22.
Photo: Martin Bühler, Basel

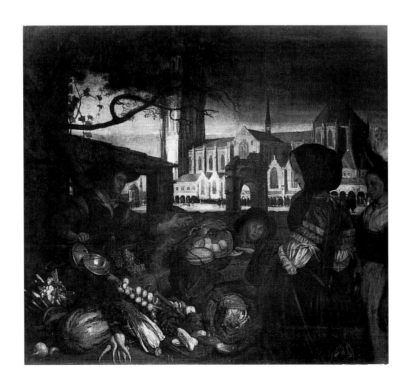

fig. 106
EMANUEL DE WITTE
Vegetable Market, c. 1660
canvas; 71 x 80.5 cm
Basel, Öffentliche Kunstsammlung,
Kunstmuseum

Courtyard behind a House (fig. 109) evokes a more epicurean outlook on life. Both paintings incorporate vistas and feature the same compositional schemes. The façade of the house and the gate bordering the courtyard and the garden are also identical. Nor is this the first time we have seen these elements: they also occur in *Woman with a Basket of Beans in a Vegetable Garden* (see figure 105). The construction of the perspective in these scenes is accurate and the lighting bright. Once again the integration of the figures in the space is completely convincing. De Hooch's observation and registration of the light decidedly inspired his fellow townsman Vermeer.

VERMEER, MASTER OF LIGHT

As evidenced by the two examples that survive, both of which date from shortly after 1658, Johannes Vermeer (1632-1675) was one of the greatest practitioners of the townscape.[25] Delft, where so many innovations were being made in church interiors and outdoor genre scenes, formed the context for their creation.

fig. 107
<small>HENDRICK VAN DER BURCH</small>
Young Woman in a Court
panel; 48 x 35.5 cm
Champaign, Krannert Art Museum
and Kinkead Pavilion, University of
Illinois, inv. no. 51-1-1

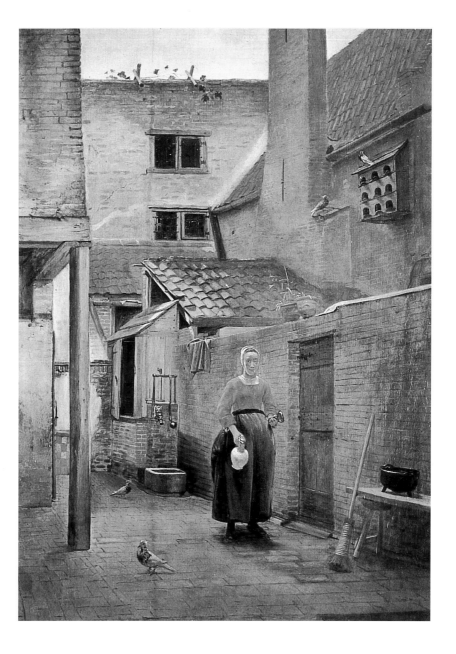

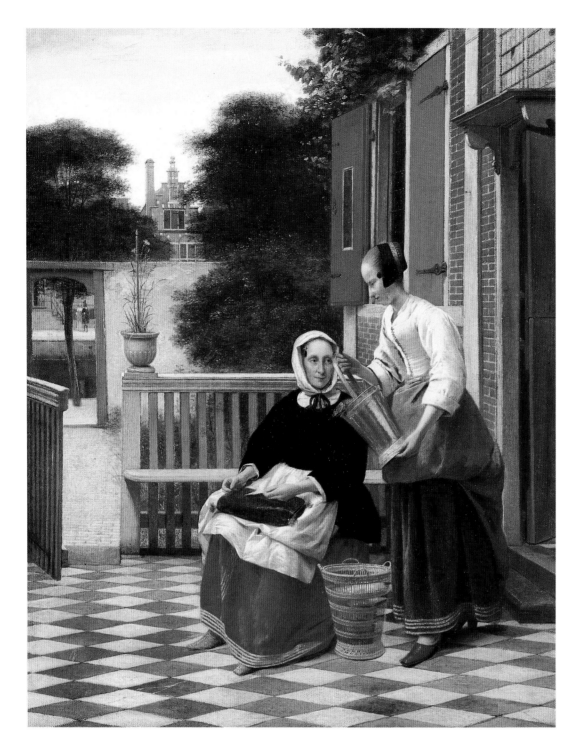

fig. 108
PIETER DE HOOCH
A Woman and a Maid with a Pail in a Courtyard, c. 1660-1665
canvas; 53 x 42 cm
St Petersburg, The State Hermitage Museum, inv. no. 943

The first of Vermeer's two urban portraits is *The Little Street* (fig. 110). The artist treated the houses in his canvas as a continuous, virtually uninterrupted whole. The truncation of the façades, the textures of the various architectural elements and the bright palette account for the uncanny naturalism of the work. There are many points of comparison with the courtyards of De Hooch (see figures 96 and 98). Although *The Little Street* appears to be a faithful transcription of reality, it cannot be linked to Delft topography. There has been a good deal of speculation about the sixteenth-century elements in the step gable and the open gateway to the small courtyard.[26] The scene has an ineffable, timeless quality. Like De Hooch, Vermeer took the opportunity to eulogise domesticity, albeit less overtly. The stoop and street are spick-and-span, indeed there is no grime

fig. 109
PIETER DE HOOCH
A Company in a Courtyard behind a House, c. 1663-1665
canvas; 61 x 47 cm
Amsterdam, Rijksmuseum, inv. no. SK-C-150 (on loan from the City of Amsterdam)

anywhere. A woman with a broom can be seen in the passageway. The children playing on the sidewalk may be an allusion to the role of the mother who, seated in the doorway, does her sewing. As with De Hooch, the grapevine growing up the façade of the house on the left symbolises love and marital fidelity.

The phenomenal effect of light is what makes Vermeer's other townscape, the monumental *View of Delft* (fig. 111) from c. 1660, so unforgettable. Both the colours and the light are strong, the water glistens, and beyond the dark clouds in the foreground the sunlight plays over the rooftops. Vermeer's vision of a skyline is unique. He probably recorded the silhouette of his native town from the first floor of a building on the Hooikade, where the Schie flows into the Kolk. The southern entrance to the city was not only where the harbour lay, but also the one spot where no trace of the 1654 disaster could be seen. Unlike his more topographically-minded colleagues, he shows us not a panorama of the city as a whole (see figure 71), but a closely observed portrait of only a part.

If we compare Vermeer's *View of Delft* with that of Abraham Rademaker (1676/1677-1735) (fig. 112), it becomes clear that Vermeer manipulated reality to suit his compositional requirements. In actual fact the gates are further from one another than in

fig. 111
JOHANNES VERMEER
View of Delft, c. 1660
canvas; 98 x 117.5 cm
The Hague, Koninklijk Kabinet van
Schilderijen Mauritshuis, inv. no. 92

fig. 110
JOHANNES VERMEER
The Little Street, c. 1658
canvas; 54,3 x 44 cm
Amsterdam, Rijksmuseum,
inv. no. A 2860

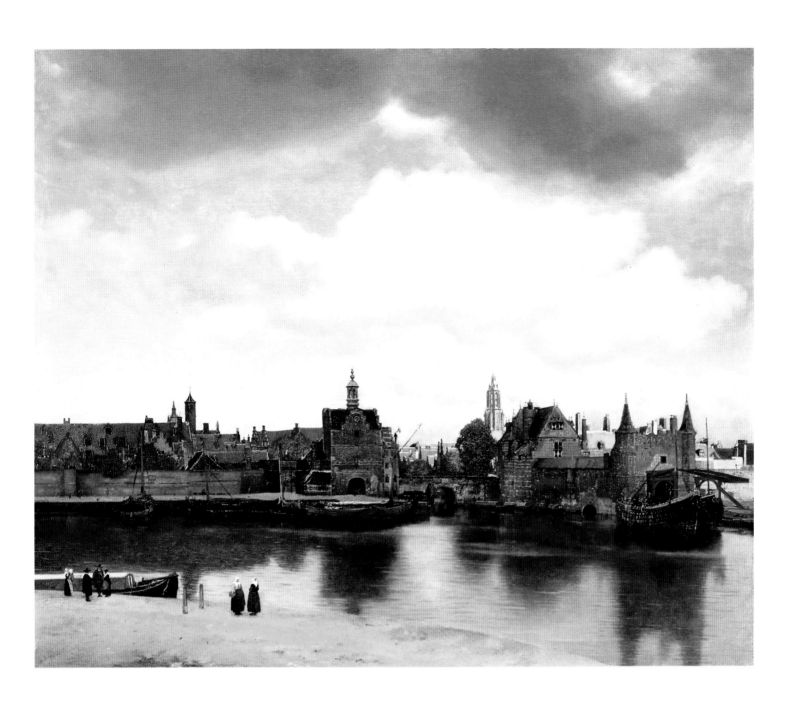

fig. 112
*View of Delft with Schiedam and
Rotterdam Gates*
pen and wash; 225 x 450 mm
Delft, Stedelijk Museum Het
Prinsenhof, inv. no. PDT 36

Rademaker's drawing and the arch of the bridge is much flatter. The most notable difference between the canvas and the sheet, however, concerns the tower of the Nieuwe Kerk. Vermeer makes it much larger than it would have been, had he followed the rules of perspective more strictly. He further emphasised the Nieuwe Kerk, moreover, by placing it in direct sunlight. The artist's motives may have been political: the church contained the tomb of William the Silent, after all, which was the preeminent symbol of the young Republic. Vermeer's townscape underscored Delft's prestige as the location of the monument and thus gratified its proud, seventeenth-century citizens.

The south side of Delft seems to have held a particular fascination for artists, to judge from the number of depictions of that particular quarter. Within a short span of time Vosmaer painted his picture of the mill (see figure 83) and Vermeer his *View of Delft* (see figure 111), besides the drawing of the location by Jan de Bisschop and the other two by the Rembrandt pupil Gerbrand van den Eeckhout.[27] The circumstances surrounding the creation of the sheets were probably practical. The Rotterdam Gate was the place where boats departed for Rotterdam, Schiedam and Delfshaven. While waiting for their boats, one can well imagine artists walking and drawing there. The drawing of the *City Walls of Delft* by Gerbrand van den Eeckhout from 1645-50 (fig. 113) shows part of the walls that has not previously been recognised. The structure on the corner of the wall at the right can be identified as the Austrian Tower, located at the southeast corner of the city.[28] Van den Eeckhout's sheet emanates the same tranquillity as the other townscapes. Even on board the two boats in the foreground there is no activity.

Jan Jansz van der Heyden (1637-1712)

It may seem curious that the courtyards of Pieter de Hooch and Vermeer's magnificent *View of Delft* inspired not one Delft artist to specialise in townscapes. But for Jan van der Heyden, who lived in Amsterdam, De Hooch's outdoor genre scenes were probably an important source of inspiration. It was above all the abundant sunlight and the intense colours that attracted him.

Born in 1637 at Gorinchem as the third child of Jan Goris Claesz and Neeltje Jansdr Munster, at age thirteen Van der Heyden moved to the Amstel city together with his

fig. 113
GERBRAND VAN DEN EECKHOUT
The City Walls of Delft, c. 1645
pen and wash; 127 x 194 mm
Paris, Collection Frits Lugt, Institut
Néerlandais, inv. no. 4445

family. In the course of his extensive travels he painted views of the cities he visited in the Dutch Republic and abroad. The artist's handling of light is particularly remarkable. Rather than the golden glow so characteristic of the seventeenth-century Italianate landscapists, like De Hooch he used bright daylight to illuminate many of his urban views. An excellent example of this is *The Oude Kerk on the Oude Delft at Delft* from 1675 (fig. 114). The luminous tones are typical of Van der Heyden. In contrast to Vermeer's *View of Delft* (fig. 111) he did not work with contrasts between light and shadow but placed the Oude Delft at nearly a right angle to the picture plane and lit it evenly.

Van der Heyden is noted for the precision of his pictures, which are meticulously elaborated brick by brick. His minutely painted *View of the Oude Delft* (fig. 115) is indicative of his working method. According to the eighteenth-century painters' biographer Arnold Houbraken, he was accustomed "to draw everything from life and afterwards to apply it to the panel, which he then worked so thoroughly that his thoroughness has rarely been equally. For he painted every brick in the buildings, both those in the foreground and those in the distance, so precisely that one could clearly see the mortar between them, without his work losing in or appearing hard if one viewed his pictures as a whole from a certain distance. He also took the reduction of the bricks into 125

fig. 114
JAN VAN DER HEIJDEN
The Oude Kerk on the Oude Delft at Delft, 1675
panel; 45 x 56.5 cm
Oslo, Nasjonalgalleriet,
inv. no. NG.M.00029.
Photo: J. Lathion, Oslo

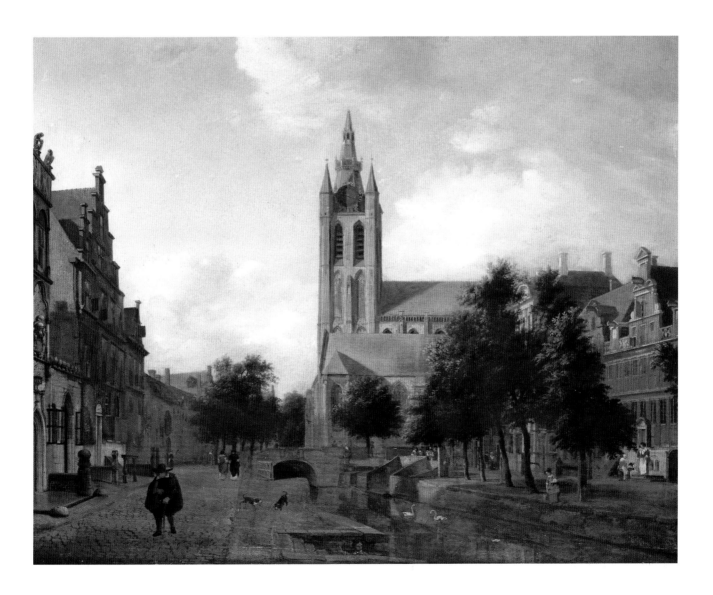

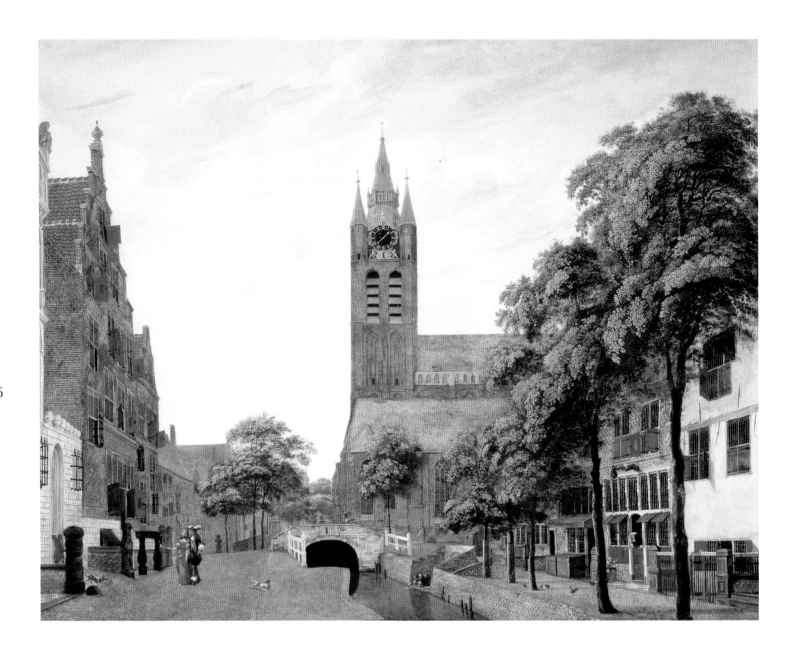

consideration, in proportion to the recession of the buildings. Concerning which it is still thought that he had discovered a special artifice or means, because it seems to all those who know the uses of the brush impossible to achieve something like that by painting in the usual way. Be that as it may, it is worthy of praise and astonishing."[29] Thus, Houbraken could not imagine Van der Heyden executed his paintings without having recourse to some sort of device, although there is no evidence of this. If the painter did use something, it was probably nothing more than a magnifying glass.[30]

Van der Heyden was extraordinarily versatile. He was renowned not only for his town views, landscapes and still lifes, but also for his many discoveries. He designed systems for both street illumination and fire-fighting in Amsterdam and, together with his brother Nicolaes, developed the fire hose, which they patented in 1677. He founded a factory to manufacture his inventions, moreover, which he turned over to his son Jan van der Heyden the Younger in 1692, along with the municipal offices he held. Van der Heyden continued painting until late in life, for the love of it presumably, as he did not need the additional income. The inventory drawn up after his death in 1712 lists over seventy

fig. 115
JAN VAN DER HEIJDEN
View of the Oude Delft, c. 1700
panel; 55 x 71 cm
Detroit, The Detroit Institute
of Arts, Founders Society Purchase
with funds from Mr. and Mrs.
Edgar B. Whitcomb, inv. no. 48.218

pictures by his hand, as part of an estate valued at 84,000 guilders – a veritable fortune for that day.

The urban profiles of Van der Heyden did not grow out of the Delft tradition, even if the artist was inspired by the city's filtered light. Rather, in their detailing and use of colour they anticipate the innumerable townscapes produced in the eighteenth century. As the last genre that developed in the second half of the Golden Age, it was not in the 1600s but the 1700s that the Dutch townscape flourished. The precise depiction of topography had the greatest appeal at the time.

127

1 Amsterdam/Toronto 1977, p. 18.

2 Amsterdam/Toronto 1977, p. 73.

3 These three categories derive from B. Haak, "De geschilderde stad," in Amsterdam/Toronto 1977, pp. 190-91.

4 Amsterdam 1993-1994, Rijksmuseum, *Dawn of the Golden Age. Northern Nederlandish Art 1580-1620*, p. 525.

5 Brown 1981, p. 149.

6 Brown 1981, pp. 123-26, summarises the various views of this painting, especially the discussion between Wheelock and Liedtke.

7 Liedtke 1982-A, p. 65.

8 "[...] een seer voortreflijk en uytnemend konstschilder die in matery van perspectiven als mede natuyrlijk colorenen ofte leggen van sijn verwe soo prompt en vast was dat (na 't oordeel van veele konst-kenders) noch noyt sijns gelijck heeft gehad." Bleyswijck 1667, vol. 2, p. 852; trans. Brown 1981, p. 159.

9 "Door deeze kennisse kan men ook een kleyn vertrek zeer groot doen schijnen: [...] Fabritius heeft hier ook een wonder meede gedaen, gelijk tot Delft ten huize van den konstliefdigen Heer Zal: Do. Valentius, en elders noch te zien is; maer 't is te bejammeren dat zijn werken niet ergens in een vast Koninklijk gebouw of Kerke geplaetst zijn: want deezen aert van Schilderyen bint zich geweldig aen de plaets, daer men ze toe maekt." Samuel van Hoogstraeten, *Inleyding tot de hooge schoole der Schilderkonst: Anders de Zichtbaere Werelt*, Rotterdam 1678, p. 274; trans. Brown 1981, p. 160.

10 Blankert 1987, p. 165, note 28: "Between 1651 and late 1654 Van Hoogstraeten travelled to Vienna, Rome and back to Vienna, where he executed 'illusionistic' paintings. When he returned to Holland at the end of the same year, Fabritius had just died. The contact between the two masters, which led the two of them to a similar 'illusionistic' style, must have therefore occurred before Van Hoogstraeten's departure in 1651. That makes it all but certain that this 'illusionism' had already taken definitive shape in or before 1651."

11 "Aldus gekneust, geplettert en gebrooken, Aan Arm' en Beenen dat onkenbaar was, Lag Carel Faber schier versmoort in d'as, Door 't heyloos Kruyd; wie weet hoe aangestoken?" Bleyswijck 1667, vol. 2, p. 852. "Op welck seer ongeluckig toeval Arnold Bon, dese versen heeft gepast: Op de droevige, en ongeluckigste Doot van den allervermaersten, en Konst-rijcksten Schilder, carel fabritius [...]." [On which unhappy accident Arnold Bon has written these verses: 'On the sad and most unfortunate death of the most renowned and skilful painter, Carel Fabricius'.] Trans. Brown 1981, pp. 159-60.

12 Valentiner 1932, p. 209.

13 J. Schabaelje, *Historisch Verhael van het wonderlick en schrickelick opspringen van 't Magasyn-huys, voor-gevallen op den 12 october 1654 binnen Delft, Amsterdam* [T. Houthaeck].

14 "[...] zou zij haar redders uit dank een vriendelijke lach gegeven hebben. Eén van haar handjes was een weinig bezeerd; in het andere hield zij een appeltje vast om mee te spelen. Niet alleen het meisje is gered, ook een grijsaard van tachtig jaar, die meer dan zesendertig uren onder de puinhopen gelegen had, is kerngezond uit zijn benarde positie bevrijd. Tot achtenveertig uur na de ramp zijn er nog verscheidene mensen, levend onder de stenen en kalkbergen bedolven, als uit de dood herrezen. Zij werden in eerste instantie dood gewaand, omdat men hen niet kon bereiken door de massa en zwaarte van de neergestorte muren en balken." Bleyswijck 1667, p. 630.

15 Donahue 1964, p. 24.

16 Blankert 1987, p. 102: "A curious, rather clumsily drawn painting by the Delft artist Daniel Vosmaer is perhaps a reflection of the larger works that Fabritius must have painted in this field."

17 *Genealogische en historische encyclopedie van Delft*, Delft 1984, pp. 296-97: "De Gasthuismolen, ook wel Bordeelmolen genoemd (bordeel = rondeel; rond buitenwerk van een wal), was een standerdmolen, in gebruik als koren- en moutmolen. In 1675 waaide hij om. Daarop vroeg en verkreeg de eigenaar van de Roosmolen op de Oostenrijkse Poort toestemming zijn molen te verplaatsen naar waar de omgewaaide molen tegenover de Dirklangenstraat had gestaan. Het werd een stenen stellingmolen, die zich tot in onze tijd als enige van de molens binnen Delft heeft weten te handhaven. Thans is molen De Roos eigendom van de vereniging 'De Hollandse Molen' en nog steeds in bedrijf."

18 Michel van Maarseveen of the Stedelijk Museum Het Prinsenhof, Delft, kindly brought these correspondences to my attention.

19 See Philadelphia/Berlin/London 1984, p. 96, no. 8.

20 Psalm 51, verses 7 and 9: "Purge me with hyssop, and I shall be clean; wash me, and I shall be whiter than snow. [...] Hide thy face from my sins, and blot out all mine iniquities."

21 "Dit is Sint Hieronimusdaelle, wildt U tot paciencie en lijdt saamheyt begeeven, wandt wij muetten eerst daellen, willen wij worden verheeven anno 1614." The plaque is located at Oude Delft 159.

22 Psalm 128: "Blessed is every one that feareth the Lord; that walketh in his ways. For thou shalt eat the labour of thine hands; happy shalt thou be, and it shall be well with thee. Thy wife shall be as a fruitful vine by the sides of thine house; thy children like olive plants round about thy table; Behold, that thus shall the man be blessed that feareth the Lord. The Lord shall bless thee out of Zion; and thou shalt see the good of Jerusalem all the days of thy life. Yea, thou shalt see they children's children, and peace upon Israel."

23 When a vendor in a market scene was shown selling a woman poultry (a 'vogel', or bird, in Dutch), it was seen as a visual pun on the Dutch verb 'vogelen', to copulate. See Amsterdam 1976, cat. no. 40.

24 Sutton 1980-A, p. 147.

25 Montias 1989, p. 364. The catalogue of the 1696 sale of the pictures that belonged to the Delft bookseller Jacob Dissius lists a third work with 'some houses'.

26 There are various opinions as to the exact location of the houses in *The Little Street*. The view could be from the back of Mechelen, the inn of Vermeer's father, to the houses on the Voldersgracht. It has also been suggested that this is the house where Vermeer himself lived on the Oude Langendijk. Or perhaps Vermeer depicted the Nieuwe Langendijk 22-26; a late medieval house stood on this spot in the seventeenth century which matched the façade of *The Little Street*. We will never know for certain, because just like Pieter de Hooch, Vermeer manipulated reality.

27 W. Sumowski, *Drawings of the Rembrandt School*, vol. 3, New York 1980, p. 1450, no. 670; for the Jan de Bisschop drawing, see Amsterdam/Toronto 1977, pp. 150-51.

28 This drawing by Van den Eeckhout was identified by Michiel C. Plomp.

29 "[...] alles naar 't leven af te tekenen, om het naderhand op panneel te brengen, 't welk hy dan zoodanig uitvoerig bewerkte, dat zyns gelyk in uitvoerig schilderen, maar zelden gezien is: want hy schilderde ider steentje in de gebouwen, zoo wel die op den voorgrond stonden, als hy die in afstand vertoonde, zelf zoo, dat men de kalk tusschen de groeven der zelve duidelyk kon zien; en wel zoo dat het geen hinder aan het werk deed, of eenige hardigheit veroorzaakte, wanneer men de stukken met een generaal oog in wat afstant beschoude. Daar by nam hy ook de vermindering der steenen, naar mate van de verkleining der gebouwen in agt. Waar omtrent men nu noch gelooft, dat hy een byzondere konstgreep, of middel heeft uitgevonden gehad, om dat het aan allen die het gebruik van 't penceel kennen, onmogelyk schynt dat het op de gewone wyze van schilderen geschieden kan. Doch het zy daar mee zoo 't wil, 't is pryslyk en verwonderlyk." Houbraken 1718-1721, vol. 3, p. 63. Translated in part by Christopher Brown, *Dutch Townscape*, London 1972, p. 10.

30 Lyckle de Vries, *Jan van der Heyden*, Amsterdam 1984, p. 59.

PIETER DE HOOCH AND
DELFT GENRE PAINTING
1650–1675

130

MICHIEL C.C. KERSTEN

4

Pieter de Hooch and Delft genre painting 1650–1675

Our notion of seventeenth-century Dutch genre painting would be very different without the extraordinary pictures of Pieter de Hooch (1629-1684). The manner in which the master depicted everyday life in the Golden Age has never been equalled. At Delft around 1658 he painted a breathtaking series of interiors with women performing their daily domestic tasks, which are meticulously rendered by the artist with evident affinity. Through their refined depiction of the scene the Delft interior pieces create the impression of being an unadulterated image of reality: they make the world of the seventeenth century seem almost tangible.

The society these pictures show is sunny and seemingly carefree. There is no story involved: the artist 'merely' depicts ordinary events. These everyday domestic scenes, such as peeling an apple, feeding a child or pouring from a pitcher of milk, seem like modern snapshots at first sight. At a random moment in time, a random event is captured in paint. On closer inspection, however, it becomes evident that the composition, the light, the perspective and, finally, the colour have all been methodically calculated. However reliably Delft interior pieces may seem to reflect life in the 1600s, they are usually far more artificial than one suspects.

Through their superb handling of light, lucid spatial effects and warm colours, the painters of Delft interiors transformed the utterly ordinary scenes they depicted into a sublime work of art. The ineffable atmosphere of these works is consistently described in terms of 'serenity' and 'tranquillity'. These various elements have fascinated generations of art historians, collectors and museum visitors. Since the rediscovery, at the end of the last century, of the work of Johannes Vermeer (1632-1675) and his contemporaries, critics have been lyrical about it. However, the art-historical thinking of our day places more emphasis on objectifying observation. As a corollary of that, the artistic context in which the works were created and the relations between the artists in- and outside Delft receives much attention. The scientific study of the paintings themselves with the help of infrared reflectography, x-radiography and chemical analysis of the paint pigments has become increasingly important as well. With the help of modern scientific disciplines art

fig. 116
PIETER DE HOOCH
A Woman and Child in a Pantry,
c. 1658
canvas; 65 x 60.5 cm
Amsterdam, Rijksmuseum,
inv. no. A 182

historians attempt to avoid the subjective and aesthetic 'impressions' of yore. Yet some things cannot be explained in scholarly language; hence the many intuitive remarks and observations found in even the most recent monographs on Johannes Vermeer.[1]

PIETER DE HOOCH (1629-1684)

At first Pieter de Hooch specialised in painting dark interior views of stables and inns with soldiers drinking and playing cards. In 1658 he altered his work almost as radically as did the Delft painters of church interiors, Gerard Houckgeest (c. 1600-1661) and Emanuel de Witte (c. 1616-1691/1692) in 1650 (see Chapter Two). De Hooch changed not only the subject of his paintings, but also his manner, his palette and the structure of his compositions. That year the gloomy stables disappeared and De Hooch painted a series of domestic interiors (fig. 116), which are distinguished by the geometric construction of the space, the clear, luminous palette and the clever control of the perspective. These interiors exerted an enormous influence on his contemporaries; indeed a number of artists were so mesmerised by De Hooch that their work is sometimes difficult to distinguish from his. However spectacular the transformation of De Hooch's work around 1658 may have been, it did not occur in isolation. Like most artists of his day, he drew inspiration from the art of his contemporaries. Thus, there are countless thematic and stylistic comparisons to be made between him and painters in Rotterdam, Amsterdam, Leiden and, of course, Delft itself. De Hooch's astonishingly naturalistic interiors are unsurpassed, but nonetheless indebted to his contemporaries. In the following, therefore, we will occasionally make short digressions in order to place the artistic development of the master in the context of its day.

About the life of Pieter de Hooch exceptionally little is known. As noted in Chapter Two, he was born in Rotterdam in 1629 to the bricklayer Hendrick Hendricksz de Hooch and the midwife Annetge Pieters. According to the eighteenth-century artists' biographer Arnold Houbraken, together with his fellow townsman Jacob Ochtervelt (1634-1682), De Hooch was apprenticed for some time to the Haarlem painter Nicolaes Berchem (1620-1683).[2] Though we do not know exactly when, this was presumably after 1645, the year Berchem returned from Italy.[3] Some years later De Hooch moved from Rotterdam to Delft, where according to evidence in the Municipal Archives he was living on 5 August 1652. At that time he stood as witness to a will, together with the painter Hendrick van der Burch (1627-in or after 1666).[4] A wide variety of notarial acts suggest that Pieter de Hooch and Hendrick van der Burch were in regular contact, especially in the 1650s and '60s.[5] The bond between the two artists was further strengthened by De Hooch's marriage to Jannetge van der Burch, Hendrick's sister.[6] A year after his marriage De Hooch registered in Delft's guild of St Luke. He was evidently in poor financial straits at that point, for he could only pay one fourth of the twelve-guilder admission fee. On 1 January 1656 he handed over another three guilders; the remaining six he probably never paid. In 1660 or 1661 De Hooch took his family to Amsterdam, where on 15 April 1661 a daughter was baptised in the Westerkerk. Twenty-three years later, on 24 March 1684, Pieter de Hooch was buried in the same city, in the churchyard of the Sint Anthoniskerk.[7]

From the Delft period of Pieter de Hooch some fifty pictures have been recognised. At first, until about 1657, he worked primarily on panel, thereafter almost exclusively on

canvas. The artist usually signed his work, but only from 1658 did he occasionally date it. Until recently there was little known with any certainty about his early oeuvre, the more so since many erroneous attributions and false signatures clouded our perception of it. Thanks to the research of Ronald Fleischer (1978) and, above all, Peter Sutton (1980), we now have a much better understanding of De Hooch's artistic development.[8]

'BOERENHUYSEN' AND 'KORTEGAARDES'

In his years in Rotterdam and in his first years in Delft, until about 1655, Pieter de Hooch painted interiors of stables and guardrooms with peasants and soldiers smoking, drinking and throwing dice or playing the popular game of trictrac, a game similar to backgammon. These military scenes were called 'kortegaardes' in seventeenth-century Dutch, a bastardisation of the French 'corps de garde' (soldiers on guard). In these pictures, creating the illusion of space is still hardly of interest to the artist. The rooms

fig. 117
PIETER DE HOOCH
The Merry Drinker, c. 1650
panel; 50 x 42 cm
Berlin, Staatliche Museen zu
Berlin – Preußischer Kulturbesitz,
Gemäldegalerie, cat. no. B 33

are usually dimly lit, the palette rather subdued, sombre and monochrome. The earliest example of an inn with boisterous peasants by De Hooch is in Berlin (fig. 117). *The Merry Drinker* of c. 1650 shows three peasants in a gloomy space; only the central figure is shown in a strong light. The panel is painted in yellow ochres and brown earth colours, against which the reds of the drinker's jerkin and hat clearly stand out. There are many points of comparison between *The Merry Drinker* and the oeuvre of the Southern Netherlandish painter Adriaen Brouwer (1606-1638).[9] Both De Hooch's *Merry Drinker* and Brouwer's *Sleeping Boor* (fig. 119) place the central figure prominently before a wooden partition, brightly lit against a dark background. De Hooch could have been

familiar with the Southern Netherlandish peasant genre, with figures in the foreground and vivid highlights, through the work of his Rotterdam colleague Hendrick Martensz Sorgh (1609/1611-1670).[10] Besides characteristic Rotterdam stables with peasants carousing in the background, Sorgh also painted close-up scenes of peasants smoking and drinking which betray the influence of Brouwer (fig. 120).[11] This panel by Sorgh evinces the artist's fascination with the highly expressive countenance of the principal figure, which is so caricatural that it must have sprung from the artist's fertile imagination. There is also something stereotypical about De Hooch's *Merry Drinker*, but, in contrast to Sorgh's peasant type, this spirited drunkard has distinctly individual features. His broad gesture and jolly face are unequivocal: in his drunkenness he extols the virtues of beer, which he holds aloft.

A few years after *The Merry Drinker* De Hooch painted the *Trictrac Players*, showing two soldiers and a woman playing trictrac before a wooden partition in a dimly lit stable (fig. 118). The standing soldier, wearing a coat of bluish grey, is about to toss the dice. Like the woman, he regards the seated soldier, who, with one arm resting on his hip, smokes a pipe and stares straight ahead. Straw is scattered about the stone floor, along with a broken pipe and a playing card. The theme of the picture is characteristic of the artist's oeuvre from the first half of the 1650s, when virtually everything he painted was in the barrack-room genre. Like merry peasants, scenes of soldiers and officers amusing themselves were immensely popular. While the earliest depictions of military life in Dutch art were rather noisy, often uproarious scenes of soldiers in large groups (fig. 121), after 1650 these works became more composed and were restricted to a few figures. The change of atmosphere in the soldier paintings is decidedly related to the Peace of

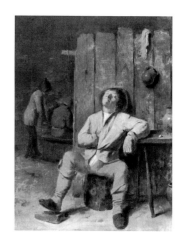

fig. 119
ADRIAEN BROUWER
Sleeping Boor, c. 1635
panel; 36.8 x 27.6 cm
London, The Wallace Collection.
Reproduced by permission of the
Trustees of the Wallace Collection,
inv. no. P 211

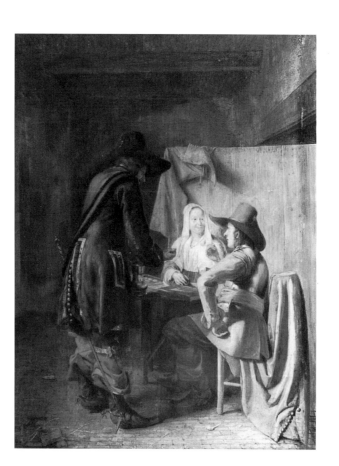

fig. 118
PIETER DE HOOCH
Trictrac Players, c. 1652-1655
panel; 46 x 33 cm
Dublin, National Gallery of
Ireland, courtesy of the National
Gallery of Ireland, inv. no. 322

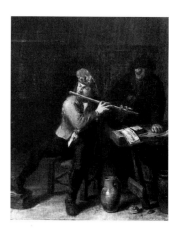

fig. 120
HENDRICK MARTENSZ SORGH
Boor Playing the Flute
panel; 33 x 26.5 cm
Whereabouts unknown. Photo:
Rijksbureau voor Kunsthistorische
Documentatie, The Hague

Münster, which was signed in 1648, putting an end to actual warfare within the Republic.

Like De Hooch's *Merry Drinker*, the *Trictrac Players* is also painted in yellowish browns. These harmonious monochrome tones are enlivened by strong chromatic accents, such as the woman's white chemise, the red stockings of the standing soldier leaning forward and the orange sash of the seated soldier in a cuirass. A number of

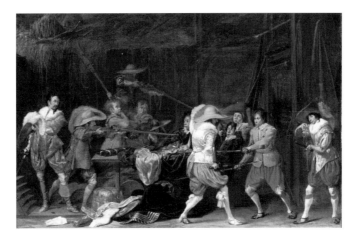

elements in this painting are characteristic of De Hooch's work, such as the careful grouping of the figures and the preference for depicting them in profile. De Hooch successfully suggests interaction between the figures, which is reinforced by the diagonal orientation of the group. But there is also another purpose behind the thoughtful disposition of the figures: it guides the eye of the viewer into the image by way of the coat slung over the chair. The chair functions as a repoussoir, that is, a motif placed in the foreground that, like a coulisse, served to enhance the sense of depth.

De Hooch's soldier scenes were influenced by the Rotterdam painter Ludolf de Jongh (1616-1679), who in the late 1640s often painted peasants and soldiers in stables (fig. 122).[12] There are striking parallels between the work of these two artists (see page 162), and it stands to reason that De Jongh would have inspired his younger colleague. De Jongh was the first of the two to depict figures so prominently in the foreground and to link them to carefully conceived compositional devices. A similar interest in such figural arrangements is also found in the early 1650s in the work of the Deventer artist Gerard Terborch (1617-1681). During that decade, Terborch likewise painted numerous scenes of military life (fig. 123).[13] He was one of the first Northern Netherlandish painters to reduce the number of figures in his compositions to three or four, and to enlarge the size of his figures with respect to the rest of the composition. By carefully arranging them in relationship to one another he was able to heighten their cohesiveness and, at the same time, to create a sense of space and depth. Thus it would seem that De Hooch could have drawn inspiration from both Ludolf de Jongh and from Gerard Terborch when he came to pay greater attention to the grouping of his figures. De Jongh may have also induced De Hooch to pay particularly close attention to the space in which a given scene is set. As we shall see, in the next stage of De Hooch's development, defining space became paramount.

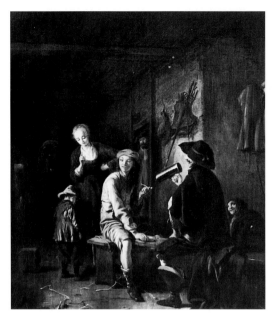

fig. 122
LUDOLF DE JONGH
The Reprimand, c. 1650
panel; 50.5 x 43.5 cm
Whereabouts unknown. Photo:
Rijksbureau voor Kunsthistorische
Documentatie, The Hague

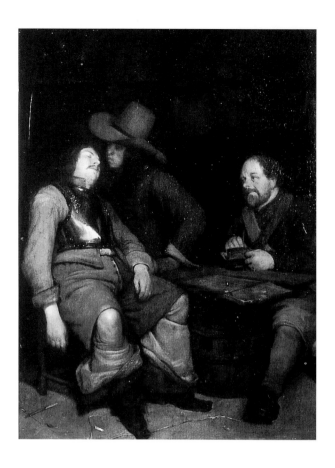

fig. 123
GERARD TERBORCH
Guardroom with a Soldier Sleeping,
c. 1652-1653
panel; 54.5 x 40.5 cm
Cologne, Wallraf-Richartz-
Museum, cat. no. 1001

EN ROUTE TO A NEW DEFINITION OF SPACE

After 1655 – by which time the artist had already been living in Delft for three years – we see the work of De Hooch change both stylistically and thematically. The master becomes more interested in the perspectival rendering of space and its lighting. Glimpses of other rooms or the outdoors give the image depth and lure the eye to the light. The panel *Three Soldiers and a Hostess*, preserved in Zurich, is typical of Pieter de Hooch's production during this period (fig. 124). For the first time in his oeuvre, the space is clearly defined. The rather abrupt foreshortening recalls the peasant interiors of his colleague Ludolf de Jongh, from whom De Hooch often drew inspiration in this period. Indeed the composition of this picture seems to have been directly borrowed from that artist's *Soldier Paying a Hostess* (see figure 161). The bright illumination is also new: the warm sunlight enters through the stable door, accentuating the chromatic difference between the brown of the stable and the strong, bright colours of the figures' costumes. Hence the lively, naturalistic impression the image creates.

The change in subject matter of De Hooch's pictures in the second half of the 1650s also involved the gender of the protagonists: whereas before about 1657 he painted carousing soldiers and rollicking peasants for the most part, women now began to figure much more conspicuously in his work. The woman holding a child in *Soldier with Dead Birds* (fig. 126) is a striking example.[14] Besides depictions of mixed 'elegant companies', women like these became the most important subject of the artist and continued to hold his attention for the duration of his career. The choice of this theme has been linked to his personal circumstances.[15] The woman and child in the master's paintings from this period could well have been modelled on his wife Jannetge and their little boy Pieter.

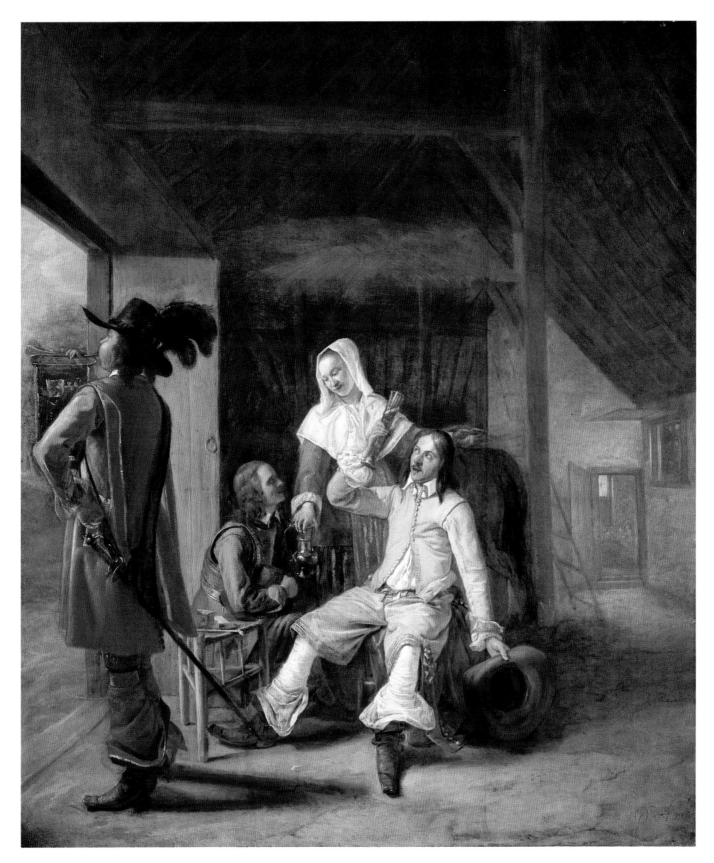

fig. 124
PIETER DE HOOCH
Three Soldiers and a Hostess,
c. 1650-1655
panel; 77.2 x 66 cm
Zurich, Kunsthaus, Stiftung Betty
und David M. Koetser, inv. no. KS 35

The child seems to be about one or two years old, the same age as Pieter, who was baptised in the Oude Kerk on 2 February 1655. It is tempting to think De Hooch looked to his family for inspiration, but if in fact he did so, his aim would not have been to portray them, but to create a symbol of the virtuous housewife. The subject was very popular at the time, witness the countless images of industrious, hardworking women completely absorbed in their household chores.[16]

One of the first of De Hooch's works to focus fully on a woman is *Mother and Child with a Sweeping Woman* (fig. 125) in a Swiss private collection, from about 1657. It was probably that same year that he painted a comparable scene of an interior with a woman and child. These works were followed by dozens of others in a similar vein. The Swiss panel clearly shows once more how De Hooch utilised sunlight, which in this case enters the scene from behind, to define the space more convincingly. He cleverly exploited the direction of the light in order to augment the sense of depth within the composition. Like most of the master's other designs from this period, the picture is structured diagonally, with the vanishing point situated precisely behind the head of the maid. The observer's gaze follows the oblique line to the view of the kitchen, so that, as in *A Soldier with Dead Birds*, the recession seems completely natural. The treatment of light in this panel is ingenious. From the leaded windows in the upper left the sunlight falls on the whitewashed wall. The reflection light runs parallel to the diagonal along which the women are arranged, and illuminates like a spotlight the top of the maid's head. As a result there is a radiance – the contre-jour effect – around her head. The backlighting, which serves to accentuate the contour of the figure, is characteristic of the artist. The motif recurs in almost every interior he painted in the following years. Comparable light effects and a similar prospect are also found in a painting at Paris: *A Woman Preparing Vegetables, with a Child* (fig. 133). Through an open doorway, the viewer looks into a sunlit courtyard. No other Dutch artist incorporated

138

fig. 125
PIETER DE HOOCH
Mother and Child with a Sweeping Woman, c. 1657
panel; 43 x 32 cm
Switzerland, private collection

fig. 126
PIETER DE HOOCH
Soldier with Dead Birds
panel; 53.5 x 49.7 cm
London, The National Gallery.
Reproduced by courtesy of the Trustees of The National Gallery, inv. no. NG 3881

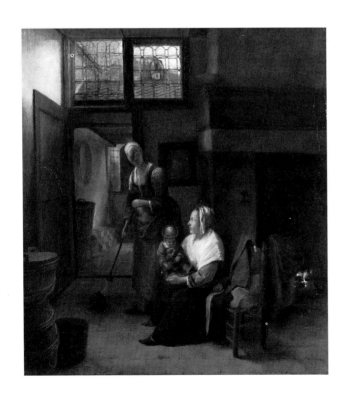

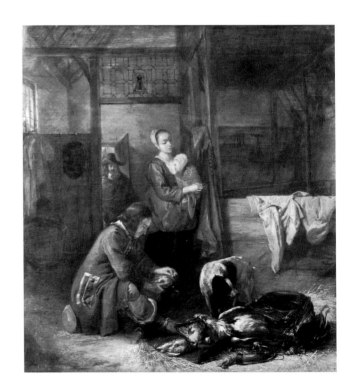

such vistas in his pictures as consistently or as often as De Hooch. He was not the first painter to employ the motif, however; credit for that goes to the Dordrecht master Nicolaes Maes (1634-1693), who painted vistas of the same kind two years earlier. His earliest works in which this motif occurs date from 1655. In the *Interior with a Sleeping Maid and her Mistress ('The Idle Servant')* in the National Gallery in London, for instance, he lets us glimpse another room in the upper left. In the years 1655-1657 Maes elaborated the motif further in four pictures, all entitled *The Eavesdropper* (fig. 127). These complex, symmetrical compositions each include not just one but two vistas: one looking upward, the other downward.

Did De Hooch know this motif from the work of his Dordrecht confrère? Maes, who was a pupil of Rembrandt in Amsterdam in the early 1650s, doubtless travelled regularly between that city and Dordrecht. On those occasions he would certainly have stopped now and then at Delft, which lay on the route between the two cities.[17] Ever since the beginning of the 1650s it had been the home of the painter Carel Fabritius (1622-1654). Ten years earlier Fabritius had studied in Amsterdam under Rembrandt at the same time as Maes' fellow townsman Samuel van Hoogstraten (1627-1678).[18] One can easily imagine Maes visiting Fabritius, either through his older colleague and fellow towns-man, Van Hoogstraten, or on his own initiative, the more so since Fabritius, like Van Hoogstraten, experimented with illusionistic painting (see Chapter Three, p. 93).[19] That Maes would have contacted De Hooch on a visit to Delft is perfectly conceivable. In any case, it is undeniable that there was interest in illusionism and perspective in both Delft and Dordrecht.[20]

Remarkably, interest in perspective as well as in the effects of space and light can already be detected ten years earlier at Amsterdam and Leiden. In this regard the work of the relatively obscure Amsterdam painter Isaack Koedijck (1617/1618-1668) should be

139

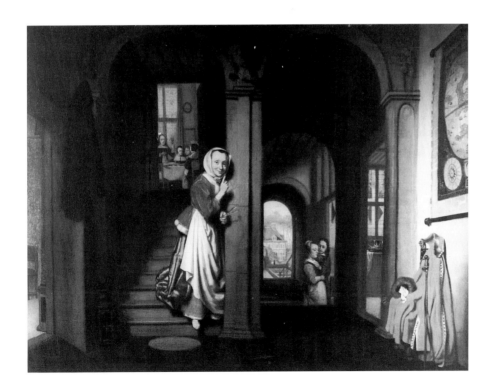

fig. 127
NICOLAES MAES
The Eavesdropper, 1657
canvas; 92.5 x 122 cm
Dordrecht, Dordrechts Museum
(on loan from the Rijksdienst
Beeldende Kunst, The Hague),
inv. no. NK 2560

Pieter de Hooch and Delft genre painting

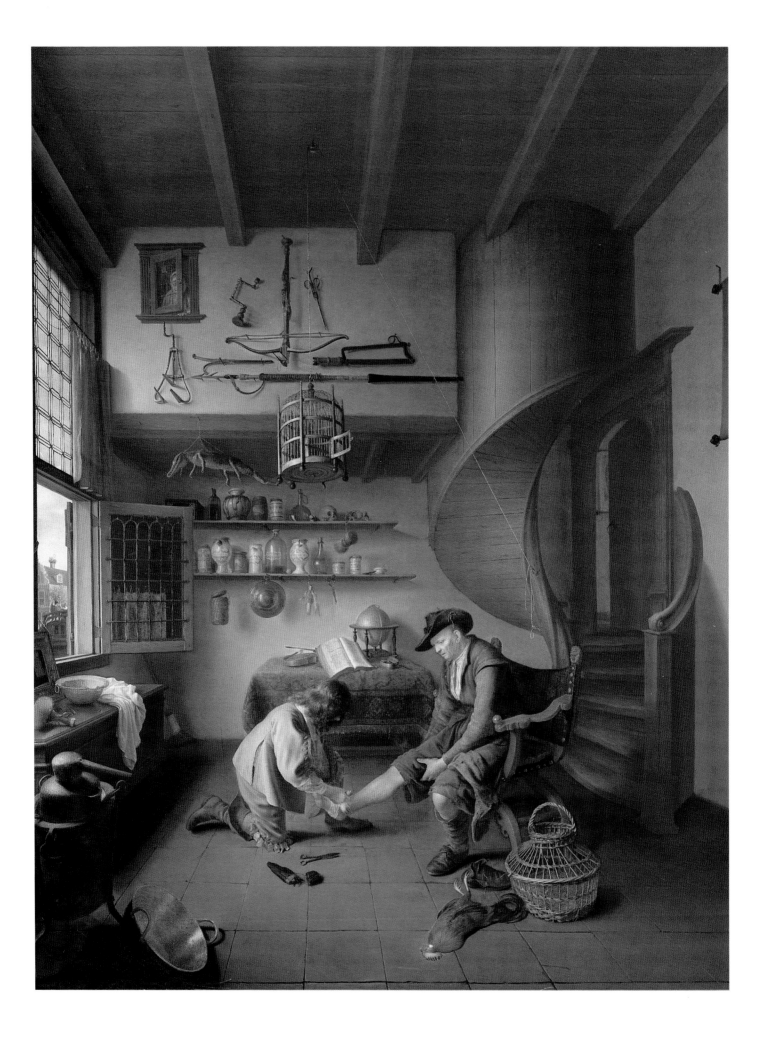

mentioned first of all.[21] The perspective structure of a number of his pictures bears notable resemblance to the work of De Hooch from the second half of the 1650s. One such work is *The Foot Operation*, painted between 1645 and 1650 (fig. 128), an interior with a surgeon treating a man's right foot before a window. The arrangement of the box-like space calls to mind paintings by De Hooch of a decade later. The correspondence between Koedijck's *The Empty Glass* (fig. 130) and De Hooch's *Girl Drinking with Two Soldiers* (fig. 131) is even more arresting. The orthogonal lines of the window, the receding ceiling beams, the bare floor, the view into another space and even the position of the table are all strikingly similar. In *The Empty Glass* Koedijck not only constructs the space with geometrical precision, but also successfully manipulates the light coming through the window to make the room seem more realistic.

At about the same time, in the late 1640s, the Leiden painter Adriaen van Gaesbeeck (c. 1621-1650), who died prematurely, likewise displayed a keen interest in the representation of sunlight filtered by windows. Van Gaesbeeck owed this interest to the example of Gerard Dou (1613-1675), the Leiden painter who at an early stage, around 1635, invented a type of interior that is characterised by a man or woman at work next to a large, brightly illuminated window.[22] Carefully observed details, such as the utensils and provisions in the kitchen where a maid peels a turnip before an open window, bespeak Van Gaesbeeck's admiration for his fellow townsman (fig. 132). The interest in the meticulous depiction of household effects in a space rendered in perspective links this panel to that of Koedijck. From the early 1650s, in the wake of Dou and Van Gaesbeeck, other artists were evidently concerned with the rendering of light and intent upon exploring its potential in the context of their compositions. One artist particularly adept at manipulating light was Quiringh Gerritsz van Brekelenkam (c. 1620-1668) who, between 1653 and 1665, executed over thirteen views of tailors' workshops. In these beautifully lit scenes a master and his apprentices are seen mending clothes cross-legged on a table before a window. A panel belonging to an American private collection illustrates how the artist deftly employs light

141

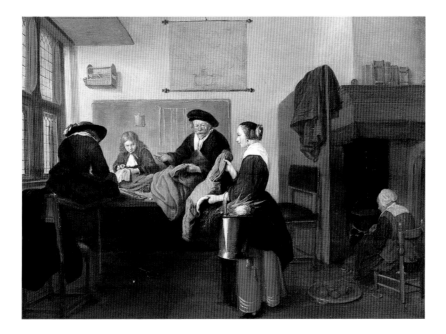

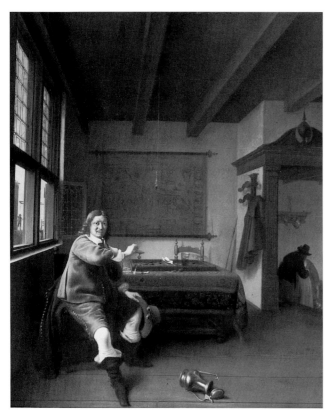

fig. 130
ISAACK KOEDIJCK
The Empty Glass, 1648
panel; 66 x 55 cm
Sale London (Sotheby's) 6 July
1994, lot 1. Photo: Courtesy of
Sotheby's, London

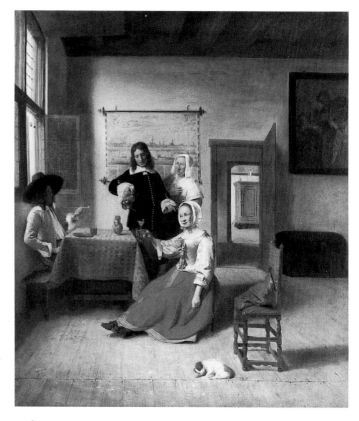

fig. 131
PIETER DE HOOCH
Girl Drinking with Two Soldiers, 1658
canvas; 68.8 x 60 cm
Paris, Musée du Louvre,
inv. no. RF 1974-29. Photo: Agence
Photographique de la Réunion des
Musées Nationaux

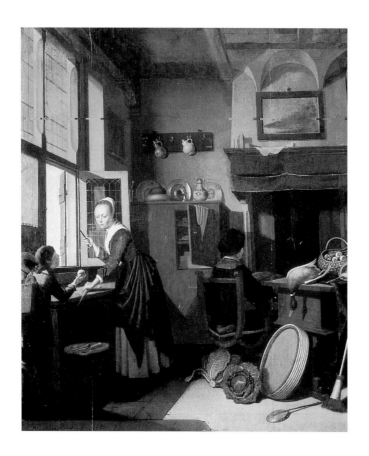

fig. 132
ADRIAEN VAN GAESBEECK
Maid Working in the Kitchen, 1648
panel; 70.8 x 57.8 cm
Sale Amsterdam (Christie's)
13 November 1995, lot 134. Photo:
Courtesy of Christie's, Amsterdam

to define the space and depth of the workshop (fig. 129). The clearly articulated and well-ordered space is reminiscent of De Hooch's sunny rooms with their white plaster walls.

All of these paintings eloquently attest to the fascination of many Dutch painters in the 1640s and 1650s with the geometrical structure of space and with the role that light plays. De Hooch was therefore not alone in his efforts to capture the effect of sunlight flooding an interior. However, no other artist equalled the artistic virtuosity with which Pieter de Hooch turned it to his advantage.

143

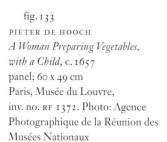

fig. 133
PIETER DE HOOCH
A Woman Preparing Vegetables, with a Child, c. 1657
panel; 60 x 49 cm
Paris, Musée du Louvre,
inv. no. RF 1372. Photo: Agence Photographique de la Réunion des Musées Nationaux

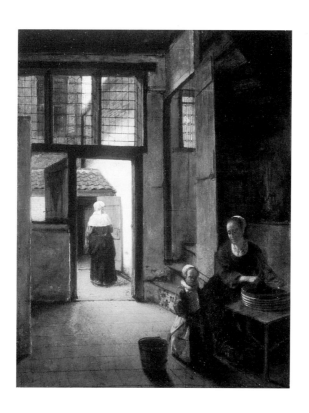

1658: THE EMERGENCE OF THE NEW DELFT INTERIOR

In 1658 an enormous change manifestly occurred in the work of Pieter de Hooch. The poorly lit stables and domestic interiors now give way once and for all to bright, white-washed walls that create a convincingly realistic impression through the correct use of perspective, the definition of the space and the warm sunlight flooding through the windows and doors. It seems as though the artist galvanised all the knowledge he had gained from previous experiments with perspective and lighting. Up until then no painter had been so successful at creating the illusion of space in a genre scene. De Hooch's figural types were also transformed. While his stock figures had previously been poor peasants and slovenly soldiers in untidy stables or other tenebrous spaces, he now began painting diligent, virtuous mothers, or groups of elegant, well-dressed men and women in neat, orderly interiors that bespeak considerable prosperity. As if conscious that these interior scenes were in fact innovative, only now, in 1658, did the master begin to date his paintings.

The first evidence of this sea change is *A Merry Company with Two Men and Two Women* in New York (fig. 134). This painting is indicative of De Hooch's new type of interior.

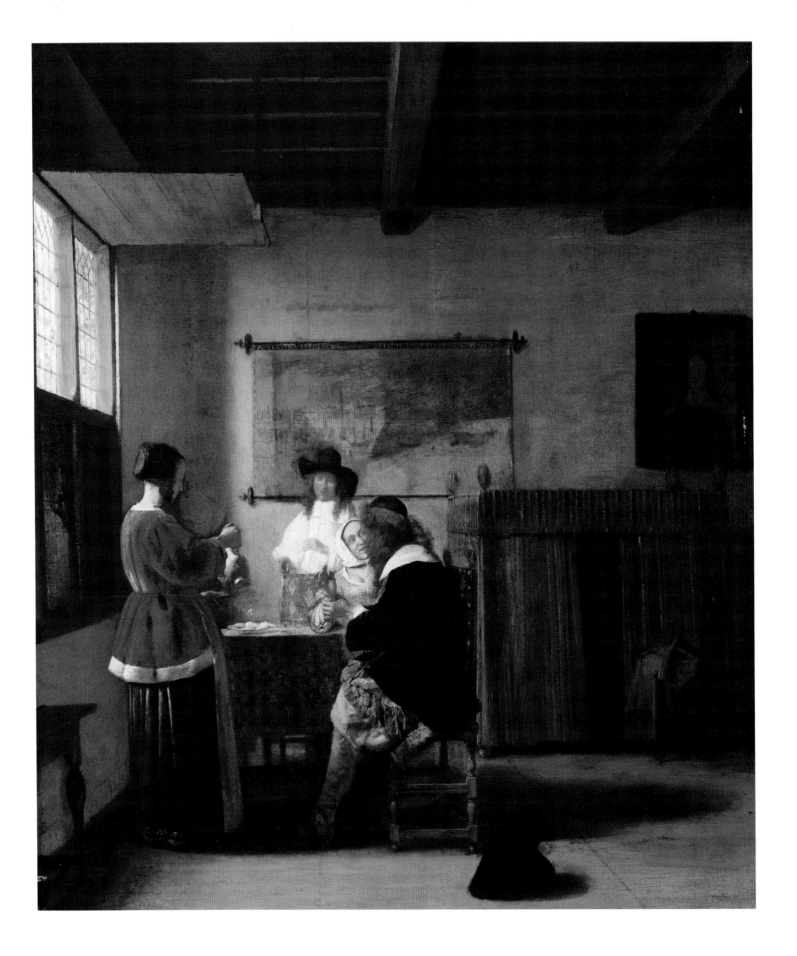

Never before had the artist constructed the perspective with such care, and with evident success. The composition is precisely aligned and the recession completely convincing. Naturally the sense of depth in such paintings results not only from the geometry, but also from the handling of light, the rendering of the atmosphere and the palette.[23] It is the masterful control of all these factors that makes this work so special. The warm sunlight floods the room by way of windows above two members of an elegant company who are engaged in conversation. The sun illuminates the countenance of the woman as she gazes intently at the man. The illumination of this motif, and its placement near the centre of the picture plane, promptly catches the viewer's attention.

In the New York panel, one is struck by the pains the painter took to group the figures and determine their respective positions. The heads of both men coincide with the diagonal that runs from the lower right to the upper left. The head of the standing man obscures the point where the orthogonals converge, a construction we have already encountered several times in De Hooch's oeuvre (see figure 126), which was intended to make the perspectival recession seem more natural. The sunlight, which falls from the left, emphasises the oblique orientation of the composition. Through the well-considered disposition of the figures De Hooch succeeded in evoking an atmosphere that can best be described with the words 'tranquillity' and 'peace'. This impression is of course intensified by the rather static quality of the scene. A woman standing on one side of a table pours a glass of wine, under the watchful eye of a man at the other end. In the middle of the composition a man and woman are seated at the corner of the table, the woman gazing at the man with a merry expression. There is no other action to be seen. The figures are 'frozen' in place, as it were, and any trace of anecdote has been suppressed.

Brown, dark tones are still predominant in the background of the *Merry Company*, but in De Hooch's subsequent endeavours these give way once and for all to bright lighting. The structure of the space becomes even more apparent. The artist replaces the wooden floors with gleaming, black-and-white tiles whose pattern heightens the sense of depth to the maximum. As in most of De Hooch's works, the observer looks into the light, which pours through the windows and the open door. A particularly successful example of light's manipulation can be seen in a picture that belongs to the British Royal Collection (fig. 135). The card players are fully illuminated by the strong sunshine, which bathes both the courtyard and the interior. As a result – and this is new in De Hooch's oeuvre – there is no longer such a clear distinction between interior and exterior, which now form a single, sundrenched entity, as it were. Besides the continuity between interior and exterior in this work there is also a striking harmony between the space and the figures in it.

The high priority which the artist placed on the rendering of depth and the illusion of space in the late 1650s is evidenced by *A Woman Drinking with Two Men* in London (fig. 136). The paint surface, slightly worn in some spots, can tell us something about De Hooch's working methods in this case. It was only after he had finished the smallest details of the room that De Hooch actually placed his figures in it. This is clearly shown by the serving maid at the right of the image. The paint has now worn so thin that the layers of paint beneath her dress are visible. The tiles, which have been carefully painted

fig. 134
PIETER DE HOOCH
A Merry Company with Two Men and Two Women ('The Visit'), c. 1657
panel; 67.9 x 58.4 cm
New York, The Metropolitan Museum of Art, The H.O. Havemeyer Collection. Bequest of Mrs. H.O. Havemeyer, 1929, inv. no. 29.100.7

145

in accordance with the laws of perspective, continue beneath the figure. The floor is also visible through the nearly transparent paint of the chairs and tables. And we can even see with the naked eye that De Hooch altered the position of the woman, who originally stood farther to the left.

As in other works by De Hooch from this period, the placement of the figures in the London canvas was carefully planned. For instance, an oblique line can be drawn from the lower left, past the feet of the figures, to the upper right, and another from the head of the girl with the glass, over the head of the seated man. The diagonals intersect on the right, just outside the image. Typical, too, are the rich, pure colours of the costumes; these stand out strongly in the sunshine which comes from the left, highlighting the contour of the woman standing on that side.

ELEGANT COMPANIES

Whereas the manner in which Pieter de Hooch simulated space and light was entirely original and unrivalled by any other artist, his themes were more traditional and somewhat less surprising. Scenes of elegant groups of richly dressed 'jonkertjes' (dandies) and 'juffertjes' (damsels) making music, singing or drinking wine had been painted ever since the 1620s.[24] The genre flourished above all in Haarlem, where a great many masters specialised in carousing, boisterous companies. Besides Willem Duyster (1598/1599-1635) and Pieter Codde (1599-1678) (fig. 137), they included Dirck Hals (1591-1656) and Willem Buytewech (1591/1592-1624). In Delft, Anthonie Palamedesz (1601-1673) painted dozens of scenes of this kind. His work is characterised by a monochrome, usually light background before which, in a wide, horizontal frieze, numerous richly clad figures are depicted. However, because his figures are not clearly organised but scattered

146

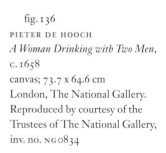

fig. 136
PIETER DE HOOCH
A Woman Drinking with Two Men,
c. 1658
canvas; 73.7 x 64.6 cm
London, The National Gallery.
Reproduced by courtesy of the
Trustees of The National Gallery,
inv. no. NG 0834

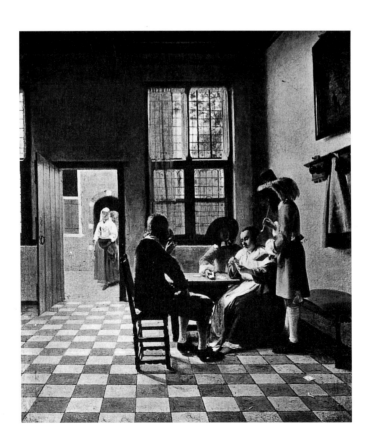

fig. 135
PIETER DE HOOCH
The Card Players, 1658
canvas; 76.2 x 66 cm
London, The Royal Collection,
Her Majesty Queen Elisabeth II,
inv. no. CW 85

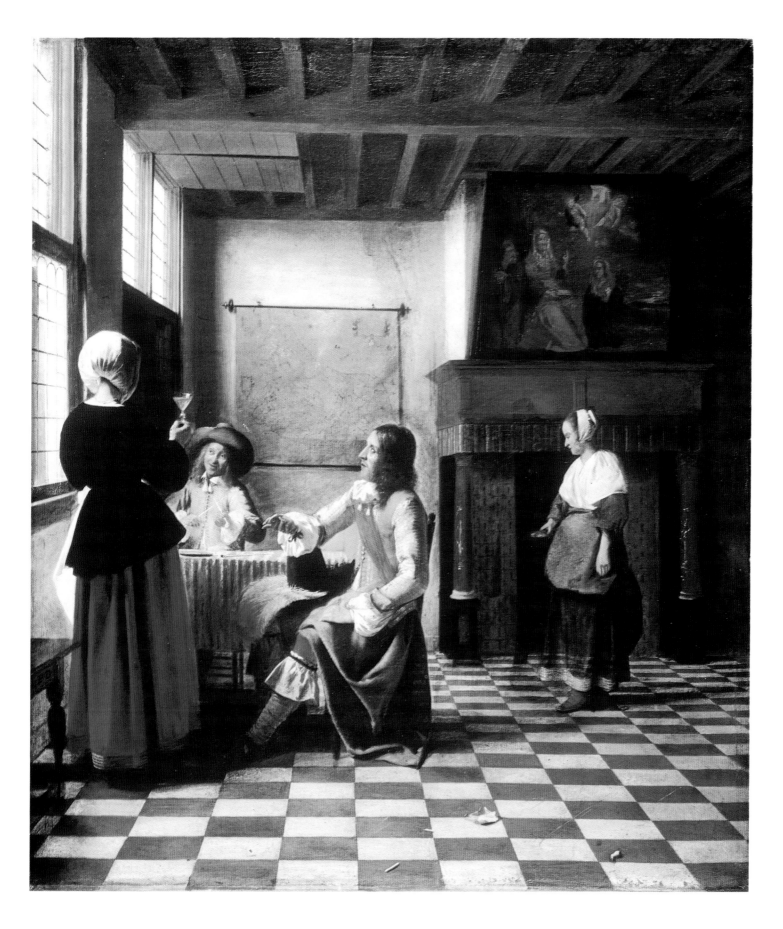

Pieter de Hooch and Delft genre painting

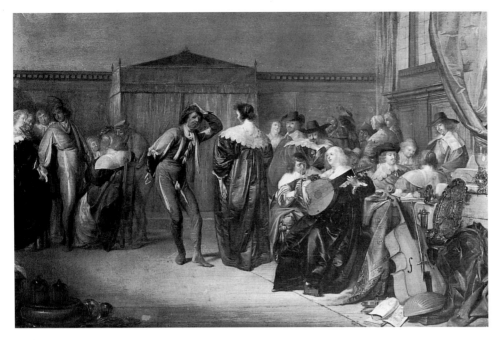

fig. 137
PIETER CODDE
Merry Company
panel; 50 x 76.5 cm
The Hague, Koninklijk Kabinet
van Schilderijen Mauritshuis,
inv. no. 392

fig. 139
JACOB VAN LOO
Merry Company
canvas; 76.2 x 63.6 cm
Formerly coll. Prince Laddislas-
Georges Radziwill. Photo:
Rijksbureau voor Kunsthistorische
Documentatie, The Hague

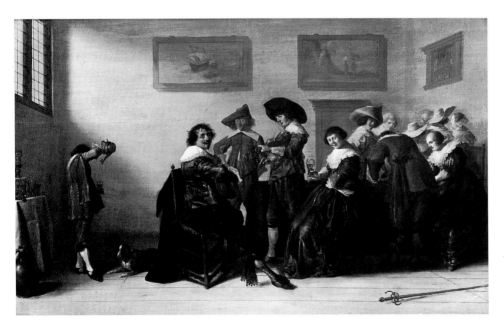

fig. 138
ANTONIE PALAMEDESZ
Merry Company, 1633
panel; 54.5 x 88.5 cm
Amsterdam, Rijksmuseum,
inv. no. A 1906

fig. 140
Soldiers in a Guardroom, c. 1640
panel; 33.4 x 42.5 cm
London, Victoria & Albert
Museum, inv. no. CAI.84

fig. 141
Woman Writing a Letter and a Maid
canvas; 45.8 x 36.6 cm
Whereabouts unknown. Photo:
Rijksbureau voor Kunsthistorische
Documentatie, The Hague

about either individually or in small groups, these pictures make a rather chaotic, albeit colourful impression. The *Merry Company* in the Rijksmuseum at Amsterdam is a good example (fig. 138).

Around the middle of the 1650s a renewal of this genre occurred, with Gerard Terborch making the most important contribution. At first, until in the 1650s, Terborch executed miliatary scenes, such as *Soldiers in a Guardroom* (fig. 140), which still contain many similarities to the art of, for instance, Anthonie Palamedesz. Around 1650, however, the character and atmosphere of his works change: the guardrooms are supplanted by sumptuously appointed interiors with a few elegant figures in the latest fashions. *Woman Writing a Letter and a Maid* (fig. 141) suggests how fascinated he was with the rendering of the lustrous material and the folds of the costly velvet costumes trimmed with fur. In the genre scenes of Rembrandt's pupil Gerbrand van den Eeckhout (1621-1674) and the figure painter Jacob van Loo (1614-1670) a similar revolution also occurred between 1650 and 1655. The work of these two artists is populated by lavishly dressed women and men who amuse themselves playing cards or music. While in the stately compositions of Van Loo the splendid, expensively decorated interiors are portrayed with remarkable clarity (fig. 139), Van den Eeckhout often situated elegant passtimes out of doors in a portico supported by classical columns, where the pattern of the black-and-white tiled floor is particularly striking. Compared with the work of De Hooch from around 1658, the theme of the elegant passtime as it was treated by Terborch, Van den Eeckhout and Van Loo is virtually identical. The great extent to which some pictures by Gerbrand van den Eeckhout were associated with the work of De Hooch is suggested by the fact that they have been attributed to Pieter de Hooch in the past.[25] Like his contemporaries, De Hooch experimented with light and perspective, as we have seen. The results are incomparable, however: the bright rooms bathed in sunlight with the carefully grouped figures and, finally, the unity and connection between interior and exterior are unmatched.

MANIPULATING REALITY

The art of Pieter de Hooch makes an exceptionally true-to-life impression. Did the painter faithfully depict an actual scene or an event he had observed with his own eyes? The answer is no. Like most artists of his day De Hooch manipulated reality to suit his artistic needs and calculated his compositions. His working method is clearly illustrated by a series of pictures from the years 1658-1660, specifically a number of interior scenes of a woman who is busy arranging bed linen by a box bed.[26] The same room can be seen in two paintings, one of which is in Karlsruhe and the other in Washington, DC (figs. 142 and 143). Why the composition was repeated is not known. The painter was presumably satisfied with the painting and had clients who were interested in the composition. At first sight the small and very attractive 'Kolf' Players in Polesden Lacey (fig. 144) seems simply to repeat a detail in the canvases at Washington and Karlsruhe; on closer inspection it becomes evident, however, that the tiled floor is continued into the front part of the house, while in the two other pictures a stone floor can be seen in that space. Another difference between the paintings is that in those at Karlsruhe and Washington a gate is visible outside, at some distance from the door, which is replaced in the painting at Polesden Lacey with a broad street or forecourt. Furthermore, the artist has set the scene

fig. 142
PIETER DE HOOCH
Woman by a Box Bed, c. 1658-1660
canvas; 51.8 x 60.6 cm
Karlsruhe, Staatliche Kunsthalle,
inv. no. 259

150

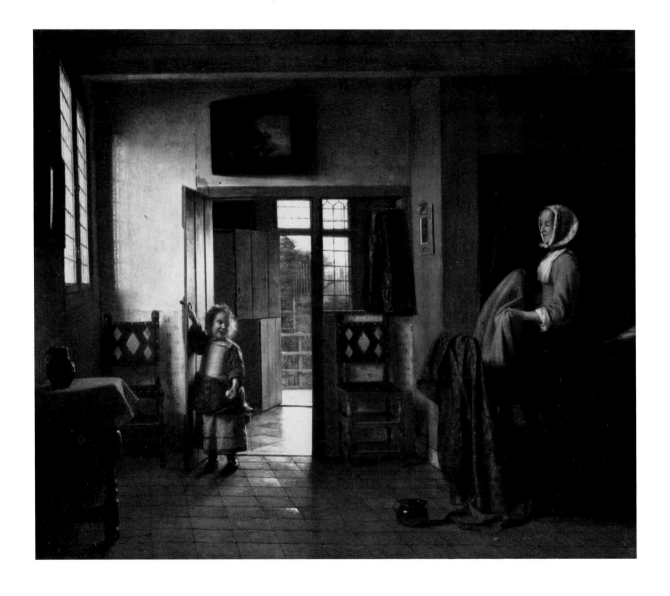

fig. 143
PIETER DE HOOCH
Woman by a Box Bed, c. 1658-1660
canvas; 51 x 60 cm
Washington, DC, National Gallery
of Art, Widener Collection,
inv. no. 629

fig. 144
PIETER DE HOOCH
'Kolf' Players, c. 1658-1660
panel; 63.5 x 45.7 cm
Polesden Lacey (The McEwan
Collection), near Dorking, Surrey,
United Kingdom, The National
Trust for Places of Historic Interest
or Natural Beauty, inv. no. 44.
Photo: National Trust Photographic
Library/Derrick E. Witty

in the winter, as indicated by the barren trees. Thus one can only guess at what the artist actually saw, as opposed to what he imagined. Thanks to the phenomenal talent of the painter, each of the many variations makes an equally natural and realistic impression. De Hooch's uncanny ability to combine the same elements in scenes of very different character and atmosphere is also illustrated by *A Woman Delousing a Child's Hair* in Amsterdam (fig. 145). The setting is the same interior as that in the pictures at Washington and Karlsruhe, but now the artist has illuminated the right wall of the room and left the other in shadow. By the light falling through the upper window a woman rids her daughter of a common pest. Another example of De Hooch's penchant for combining the same compositional elements in a variety of different ways is preserved in New York. The canvas shows a room similar to that in *A Woman Delousing a Child's Hair*, but in the New York canvas the artist has replaced the earthenware tiles on the floor with flagstone.

DEPARTURE FROM DELFT

Like many artists who were active in Delft, Pieter de Hooch and his family moved to Amsterdam in 1660 or 1661, probably for financial reasons. The wealthy elite who lived in Amsterdam had a magnetic effect on artists. Around 1652 Emanuel de Witte, the noted specialist in Delft church interiors, had already made the move, and many others would follow. At first the change did not really resolve his pecuniary problems. On the occasion of the burial of one of his children in the Leidse Kerkhof at Amsterdam he gave the Regulierspad, outside the city walls, as his address, where we know there were only small, very simple houses.[27]

It is sometimes difficult to determine whether paintings from the period around 1660 were painted while the artist was still in Delft or after he had moved to Amsterdam. The problem is caused by the fact that he did not always date his work. One example is *A Soldier Smoking, with a Woman by a Hearth*, which was painted between 1660 and 1663 (fig. 146). The canvas shows a shaded corner of an interior with an impressive hearth, the mantel rests on sculpted figures. The room exudes opulence. The man's costly costume is embellished with white lace and ribbons. Once again the figures are carefully arranged with respect to one another: here the artist utilised the triangular design, reinforced by the gaze of the girl and the oblique fall of light, to focus the viewer's attention on the couple. De Hooch devised a rather cunning means of suggesting depth in this case. As it was not possible to evoke the sensation of space through the recessional lines of the walls, the artist availed himself of the pattern of the black-and-white tiled floor. On the same level as the threshold, the imaginary horizon line, he placed two so-called distance points on either side of the image. Proceeding from these points De Hooch constructed the accurate perspective pattern of the tiled floor. He did so by drawing lines from the distance points to the lower edge of the canvas. Johannes Vermeer often applied a similar method.[28] The low horizon in *A Soldier Smoking, with a Woman by a Hearth* and the great distance between the central vanishing point and the two distance points give the observer the impression of being able to step into the image, as it were.

fig. 145
PIETER DE HOOCH
A Woman Delousing a Child's Hair,
c. 1658-1660
canvas; 52.5 x 61 cm
Amsterdam, Rijksmuseum (on
loan from the City of Amsterdam,
A. van der Hoop bequest),
inv. no. C 149

153

fig. 146
PIETER DE HOOCH
*A Soldier Smoking, with a Woman
by a Hearth*, c. 1660-1663
canvas; 71.5 x 54 cm
The Netherlands, private
collection. Photo: Tom Haartsen,
Ouderkerk aan de Amstel

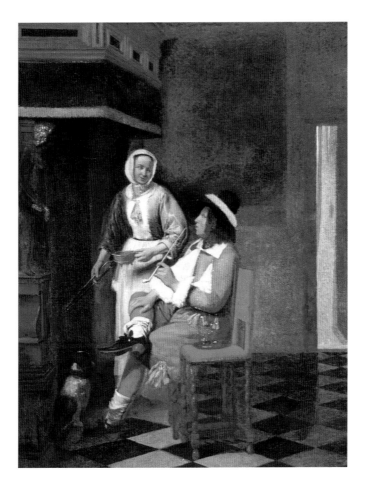

Pieter de Hooch and Delft genre painting

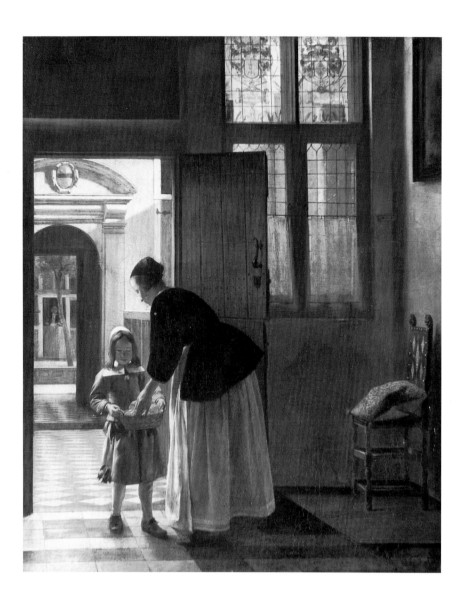

154

An excellent example of De Hooch's mastery of spatial construction and the care with which he calculated the placement of his figures in the early 1660s is his *Boy Handing a Woman a Basket in a Doorway* at London (fig. 147). Never before had the artist succeeded in painting so convincingly an uninterrupted vista from a room, through a courtyard to a portal. The view through a series of open doors and gates leads the eye irresistibly to the street where, on the opposite side of the canal, a woman leaning on a hatch looks out of her house. This prospect, combined with the openness of the image, gives one the sensation of actually being in the same room as the woman and the boy, who stand in the warm, bright sunlight streaming in through the open doorway. The boy is shown with his back to the light, so that the sunlight plays over his head and shoulders. He watches intently as the woman takes a loaf of bread from his basket, which is brightly illuminated.

Not long after moving to Amsterdam, De Hooch executed paintings that are noted for their precision and refinement. Examples include the *Woman Lacing her Bodice beside a Cradle* at Berlin (fig. 148), and *Two Women beside a Linen Chest, with a Child* at Amsterdam from 1663 (fig. 149). The vistas and the themes recall the artist's years in Delft, but the space is more shadowed, so that the image makes a more sober, darker impression. The bright sunlight falling from behind lends the canvas a golden tone, accentuating

the intensity of the colours. The warmth of the scene can be ascribed to the dim light in the foreground. With evident care De Hooch painted the contrasts between the half-shaded areas and the bright sunlight as well as the subtle transitions from light to shadow. In these years the master displayed a growing propensity for unmixed colours. Although he was not an outstanding figure painter, the figures in these pictures are more accomplished than ever. The volume of the body of the woman in the Berlin canvas, her animated pose and tender expression as she regards her child are altogether apposite. The room is spotlessly clean as usual: even the legs of the dog reflect in the shine of the polished floor. In this period vertical accents occur with growing frequency in De Hooch's works. To stay with the example of the Berlin canvas, these accents include the patterns of the curtains of the box bed, the handle of the brass bedwarmer, and the open doorway in the distance. As for perspective, both of these works testify to De Hooch's consummate artistry. None of his contemporaries suggested so deftly the interrelationship of figures and objects in space. One cannot help but admire his use of light to structure his composition.[29]

Stylistic aspects that intrigued the painter in the years immediately following his move to Amsterdam, such as the subtle transitions between light and shadow, the tempered sunlight, the rendering of shadowy space, recur in the *Woman Reading a Letter by a Window* from 1664 (fig. 151). On the left, bathed in warm sunshine, a young woman reads a letter before an open window. The light only picks out certain parts of her figure

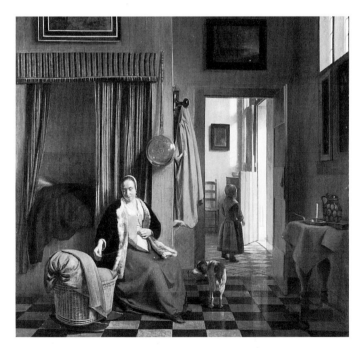

fig. 148
PIETER DE HOOCH
Woman Lacing her Bodice beside a Cradle, 1661-1663
canvas, 92 x 100 cm
Berlin, Staatliche Museen zu Berlin – Preußischer Kulturbesitz, Gemäldegalerie, inv. no. 820B.
Photo: Jörg P. Anders, Berlin

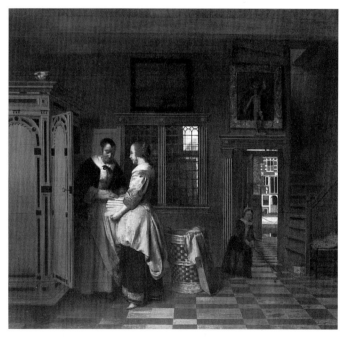

fig. 149
PIETER DE HOOCH
Two Women beside a Linen Chest, with a Child, 1663
canvas; 72 x 77.5 cm
Amsterdam, Rijksmuseum, inv. no. C 1191

while the backlighting beautifully defines the contour of her head. The room is in semi-darkness. On the right can be seen an open book on a tabled covered with a Persian carpet – a compositional counterweight that serves to balance the image. Through the window the viewer can see out over the roofs of Amsterdam, with the Westertoren rising above them. In analogy to its effect in the room, the sun illuminates only certain parts of the city; the rest lies in the shadow of the clouds. The blue leather chairs with the gilt decoration and the lion's heads – the same sort of chairs that are seen in so many works by Johannes Vermeer – previously appeared in *Woman by a Box Bed* (figs. 142 and 143). The theme of a woman reading or writing a letter was exceptionally popular in the third quarter of the seventeenth century. Besides Gabriel Metsu (fig. 150) and Johannes Vermeer, Gerard Terborch often treated this theme as well. In Delft, the stylistic influence of Terborch on the grouping of figures in De Hooch's work was evident; now, in Amsterdam, he also borrowed themes and motifs from Terborch, such as a woman reading a letter (compare also fig. 141). Here De Hooch also seems to imitate Terborch's brilliant rendering of shining silks and brocades.

At painting figures De Hooch proved to be competent, but he could certainly not be called a figure painter *pur sang*: the depiction of space was always of primary importance to him, and his figures were subordinate to it. In the earlier works his figures occasionally appear somewhat wooden. Their poses are often the same or at least similar; his repertoire of attitudes was apparently limited. It therefore seems all the more remarkable that an artist who was so preoccupied with space and light would have painted such a splendid group portrait of a now unknown Amsterdam family in 1663 (fig. 152). Yet the portrait is

156

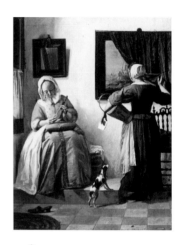

fig. 150
GABRIEL METSU
Woman Reading a Letter
panel; 52.5 x 40.2 cm
Dublin, National Gallery of Ireland
(coll. Sir Alfred Beit), courtesy of
the National Gallery of Ireland,
cat. no. 4537

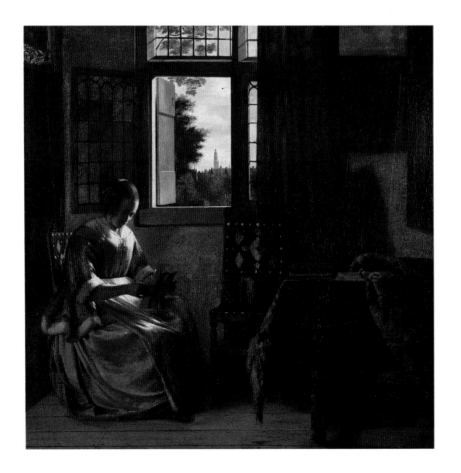

fig. 151
PIETER DE HOOCH
*Woman Reading a Letter by a
Window*, 1664
canvas; 55 x 55 cm
Budapest, Szépmüvêszeti Múzeum,
inv. no. 5933. Photo: András Rázsó,
Budapest

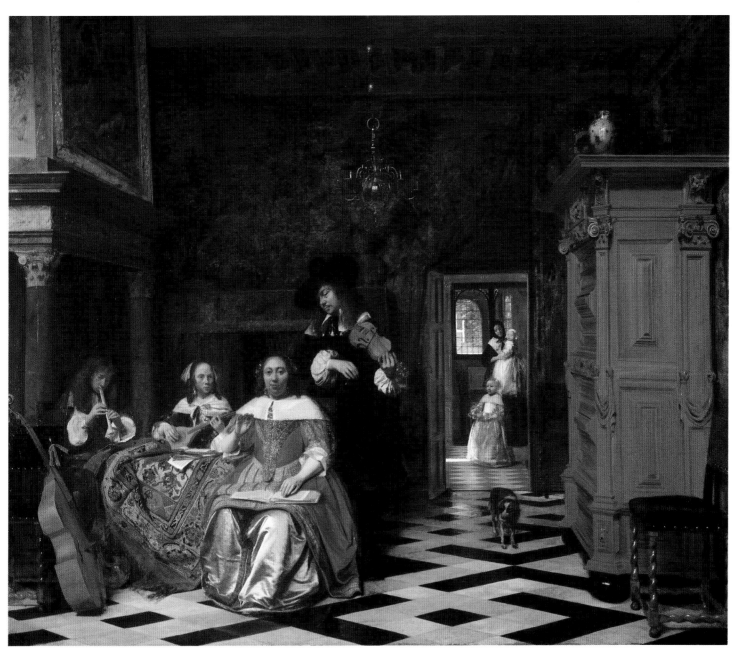

fig. 152
PIETER DE HOOCH
Family Making Music, 1663
canvas; 98.7 x 116.7 cm
Cleveland, The Cleveland Museum
of Art, gift of the Hanna Fund,
inv. no. 51.355

fig. 153
EMANUEL DE WITTE
Portrait of a Family, 1678
canvas; 68.5 x 86.5 cm
Munich, Bayerische
Staatsgemäldesammlungen,
Alte Pinakothek, inv. no. FV 2

undeniably a highpoint in the artist's oeuvre. This painstakingly elaborated canvas characterises the development of his work following his departure from Delft. The simple, sober and sparsely furnished rooms from the Delft period made way for the affluent, fashionable interior decoration of a patrician family. The costly gilt leather and rich tapestries with which the room is hung have supplanted the whitewashed walls that the artist was wont to paint in Delft. The cupboards and tables with their ornate carving have driven out the simple utensils of the past. The atmosphere of comfort and prosperity that this painting evokes is typical of the change in Dutch painting that occurred around 1660. This development undoubtedly reflects the rapid economic ascent of Amsterdam. Artists such as Gabriel Metsu, Jan Steen and Emanuel de Witte (fig. 153) painted comparable, expensively furnished rooms, animated by superbly dressed patricians.

De Hooch's growing predilection for elegance and for richly appointed interiors is nowhere so manifest as in a series of pictures he painted around 1663-1665. As in the Amsterdam group portrait, the walls in these works are enriched with gilt leather. More than ever, De Hooch sought to ensure the significance of these images would not escape the viewer. Whereas in the past his themes were intentionally ambiguous, here the artist leaves no doubt as to the erotic connotation of these works. They are unquestionably brothel scenes, with the gentlemen 'having a gay time' with the female company. That the picture is not about honourable love but rather a sensual appetite is clarified by the drawn curtains of the four-poster bed or, in another instance, by a painting in the background of a naked couple in an intimate embrace. The *Officer and a Woman Conversing, and a Soldier at a Window* at Nuremberg is the most interesting as regards the illusion of three-dimensional space (fig. 155). Near the very centre of the image a man is seated on a chair with a woman standing beside him. His position within the composition enables him to serve the same visual purpose as the large column in the centre of church interiors painted by Houckgeest and De Witte, which (as we saw in Chapter Two), divides the image in half. As in the churches, in the Nuremberg canvas there is a small subsidiary scene on either side of the central figural group. The eye is guided to them by the diagonal pattern of the tiled floor. On the left, a man gazes out an open window, while on the right, through an open door, we glimpse a kitchen where, beside a hearth, a woman sits. Again, the pattern of the tiles is constructed with the help of two distance points on either side of the image. The vanishing point is located precisely behind the head of the girl in the foreground. The horizon line and the vanishing point are situated on the level of her eyes, so that the ensemble makes a natural, convincing impression.

The motif of the woman glimpsed through the doorway in the Nuremberg canvas forms the theme of a number of other works by De Hooch. One particularly beguiling example is the *Woman Peeling Apples* at London (fig. 154). Pictures like these can ultimately be traced to the Dordrecht artist Nicolaes Maes, who was mentioned earlier as the 'inventor' of the compositional device known in Dutch as a *doorkijkje* – literally, 'through-view' – or vista, which became popular especially among Delft artists as a means of suggesting depth. In the mid-1650s Maes painted a series of women who, seated beside a window, perform domestic tasks, often in the company of a child. Pieter de Hooch's theme corresponds perfectly with this tradition. Scenes of this kind were

fig. 154
PIETER DE HOOCH
Woman Peeling Apples, c. 1663
canvas; 70 x 54 cm
London, The Wallace Collection.
Reproduced by permission of the
Trustees of the Wallace Collection,
inv. no. P23

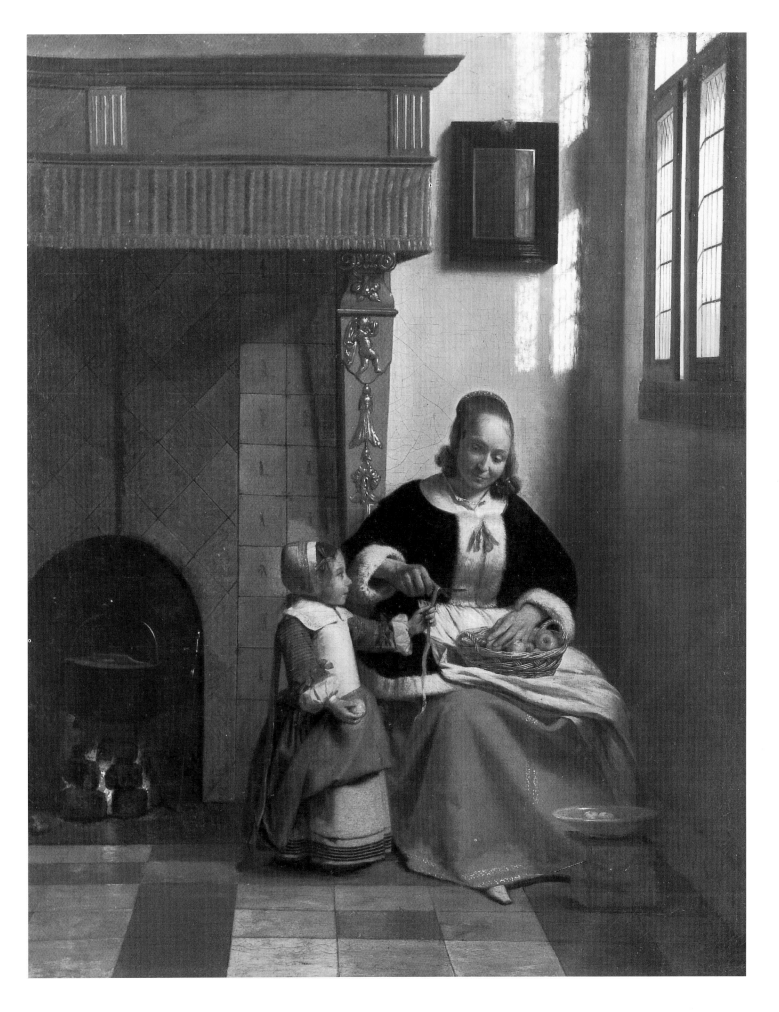

fig. 155
PIETER DE HOOCH
*Officer and a Woman Conversing, and
a Soldier at a Window*, c. 1663-1665
canvas; 60 x 63 cm
Nuremberg, Germanisches
Nationalmuseum (on loan from the
City of Nuremberg), inv. no. GM 406

fig. 156
PIETER DE HOOCH
Woman Placing a Child in a Cradle,
c. 1663-1667
panel; 45 x 37 cm
United Kingdom, private collection

meant to eulogise the virtuous, diligent housewife, who sets a good example for her children. The message can therefore be succinctly formulated as 'like mother, like child', or, 'jong geleerd is oud gedaan'.[30] A painting in an English private collection is a variation on the theme of the exemplary housewife (fig. 156). A young woman, bending over a wicker crib, lays her baby in it. In this touching scene the mother's concern for her child is clearly conveyed by her expression.

In his later works De Hooch heightened the contrast between light and shadow, which had already played such an important role in *Two Women beside a Linen Chest, with a Child* (see figure 149) At the same time the space in his pictures became increasingly dark, which brought about a sharper contrast between the light and shadow. Furthermore, despite the strong colours that the artist now preferred, his pictures made a cooler impression than they had. And whereas in Delft and during his first years in Amsterdam he – like most Dutch artists – preferred upright formats, after 1665 he favoured horizontal ones, which allowed him to crowd more figures into a room. Characteristic of De Hooch's work around 1670 is *A Woman Giving a Coin to a Maid* (fig. 159) from c. 1668-1672. The work shows clearly that the master's manner was smoother than it had been, and that he now favoured rather dark tones, which he contrasted with bright but cool colour accents.

fig. 157
PIETER DE HOOCH
Woman with a Child and a Serving Woman, c. 1668-1672
canvas; 70 x 63.5 cm
United Kingdom, private collection. Photo: Prudence Cuming Associates Ltd., London

As in most of his pictures from this period, naturalism has given way to stylised grace and elegance. There is also something artificial about his figures, which seem taller and thinner. These stylistic developments reflect the artistic taste of the contemporary patriciate. Especially in portraiture the transition to idealised – and more especially taller – proportions is clearly evident. These innovations occur in De Hooch's genre scenes from the late 1660s onward. In the Los Angeles painting, the reflection in the mirror of the still life on the table is particularly striking; the artist repeated the composition several times. One variation on it is *Woman with a Child and a Serving Woman* from a British private collection (fig. 157). The work shows a rather dimly lit interior, with a woman seated alongside her daughter by a hearth, prodding the fire with a pair of tongs. A maid stands on the left. The scene is filled with many more objects than one would expect from the artist. On the back wall, for instance, high above the seated woman, hangs a wooden shelf with white Delftware scalloped dishes. And in the right fore-ground, the corner of a table with a German stoneware jug functions as a repoussoir. Here the space was evidently less important to the artist than the domestic scene. Only the beam of light that pierces the gloom and brightly illuminates the seated woman recalls his unrivalled ability to combine light, colour and space.

THE SCHOOL OF PIETER DE HOOCH
The work of Pieter de Hooch must have made a deep impression on his contemporaries, who both in Delft and elsewhere imitated his manner of painting. With their handling of light and their *doorkijkjes*, or vistas, they sometimes approximated their model so effectively that they have become known as the School of De Hooch, even though De Hooch never had any pupils. The designation indicates succinctly what these painters have in common; in several cases there is even evidence of mutual influence. We shall first discuss Ludolf de Jongh, the putative teacher of De Hooch. Then we will turn to Hendrick van der Burch, whose acquaintance with De Hooch even before becoming his brother-in-law is well documented. The next in line are Jacobus Vrel, Esaias Boursse, Pieter Janssens Elinga, and the only truly Delft artist in this list, Cornelis de Man. After having a look at anonymous Delft interior pieces, we shall conclude the chapter with an excursion to Dordrecht, where Samuel van Hoogstraten and Cornelis Bisschop experimented with light and perspective. What makes the work of these artists 'Hoochian', and what distinguishes them from De Hooch?

LUDOLF DE JONGH (1616-1679)
Ludolf de Jongh, whose name was mentioned earlier as having possibly taught Pieter de Hooch, is the eldest of the 'Hooch School' painters. De Jongh was born in the village of Overschie (near Rotterdam), in 1616, as the son of the prosperous tanner and cobbler Leendert Leendertsz de Jongh and Annetge Leuvens.[31] The eighteenth-century biographer Arnold Houbraken tell us that De Jongh received drawing lessons for some time from the Rotterdam master Cornelis Saftleven.[32] In the early 1630s he studied briefly under the Delft painter Anthonie Palamedesz and later worked with the Utrecht artist Jan van Bylert (1597/1598-1671). After travelling around France for about seven years, he settled in Rotterdam in 1643, where he resided until 1665. Like his father he

was not impecunious. This enabled him to rise within the civic militia to the rank of major. In 1665 he moved to nearby Hillegersberg, where he was appointed sheriff. In 1679 he died, childless but well-to-do.

As De Jongh was not forced to depend upon his art financially and held various public offices, his oeuvre is relatively modest. He could afford to try his hand at many genres. Besides portraits and peasant scenes he painted elegant interiors, pastoral themes, hunting scenes and representations of rich burghers enjoying themselves on their country estates. Exactly how many pictures De Jongh painted is not known, but some eighty are currently attributed to him. Owing to the modest extent and heterogeneous character of his production, De Jongh was virtually forgotten. In the course of time his works have been attributed to specialists in the various pictorial genres. For some decades now his talent has won growing recognition. There are striking parallels between the early work of Pieter de Hooch and that of Ludolf de Jongh, who was approximately ten years his senior; chances are that De Jongh inspired his younger townsman in the late 1640s to paint scenes of soldiers and peasants. Indeed he may well have taught him for some time.

The earliest known works by De Jongh, which date from the 1640s, are dark stables and guardrooms with jovial, drunken peasants and soldiers. These 'peasant interiors' (or 'Boerenhuysen', as they were called) were especially popular in Rotterdam. Important artists such as Hendrick Martensz Sorgh, Pieter de Bloot and Cornelis Saftleven are known to have painted them. Besides the influence of Rotterdam, De Jongh's depictions of revelling country folk likewise point to the soldier scenes of his teacher Anthonie Palamedesz. These influences can clearly be seen, for example, in

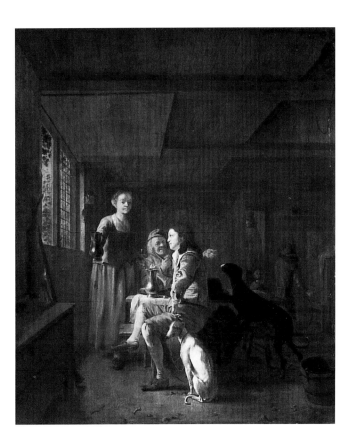

fig. 158
LUDOLF DE JONGH
Hunters in an Inn, c. 1650-1655
panel; 72 x 62.5 cm
Basel, Öffentliche Kunstsammlung,
Kunstmuseum, cat. 1946, p. 74

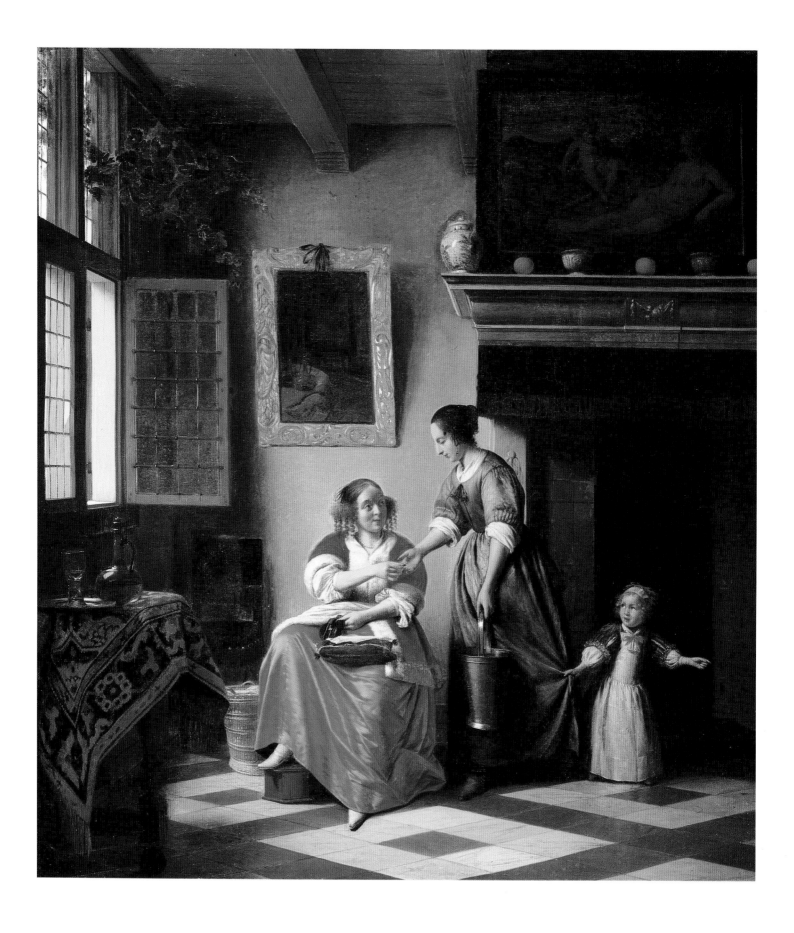

The Reprimand (see figure 122), where the figures, like those of Saftleven and Palamedesz, appear rather small in the centre of the image, but as a group are not very cohesive. Like many Northern Netherlandish artists, De Jongh's figures underwent a number of changes in the early 1650s: their numbers decline, they are more carefully arranged, they become larger in size, and they are more brightly lit.

The artist also began to pay more attention to the rendering of the spatial setting of his scenes. He painted them in lighter tones, moreover, using sunlight that enters through a window. For instance, *Hunters in an Inn* at Basel (fig. 158), which has been dated between 1650 and 1655, is uncomparable to his older work. The space is handled so cleverly that the illusion is perfect. The figures are grouped in a closely-knit compositional scheme, so that the interaction between them comes to life before the eyes of the viewer. In the interior of an inn, suffused with the sunlight from the windows on the left, a woman pours a glass of wine for a seated hunter. A somewhat older man behind him at the table feeds the hunting dogs some morsels of bread. In the background children can be seen playing with a hoop as a man enters through an open door. The artist was so clever as to have the sunlight coincide with the imaginary line that runs from the corner of the room just above the windows, over the heads of the three figures, and along the back of the black dog, thereby emphasising the triangular arrangement of the figural group. Typical of De Jongh is the steep recession, with the orthogonal lines running back to a vanishing point that is relatively near the picture plane. This curious,

165

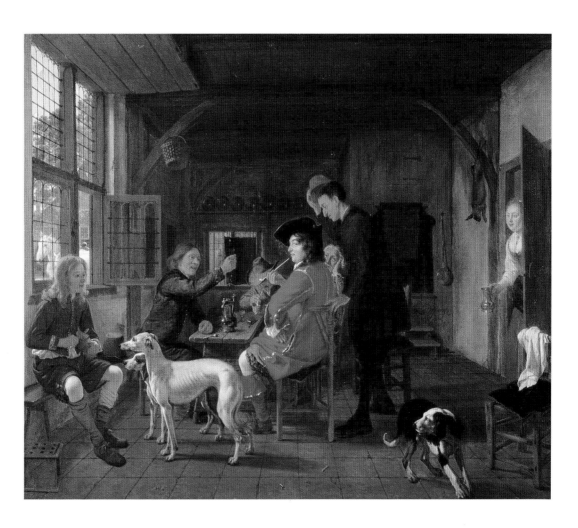

Pieter de Hooch and Delft genre painting

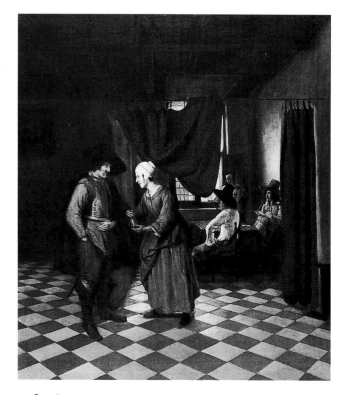

fig. 161
LUDOLF DE JONGH
A Soldier Paying the Hostess
canvas; 66 x 63 cm
New York, private collection.
Photo: Rijksbureau voor
Kunsthistorische Documentatie,
The Hague

fig. 162
PIETER DE HOOCH
A Soldier Paying the Hostess, 1658
canvas; 71 x 63.5 cm
United Kingdom, coll. Marquis
of Bute

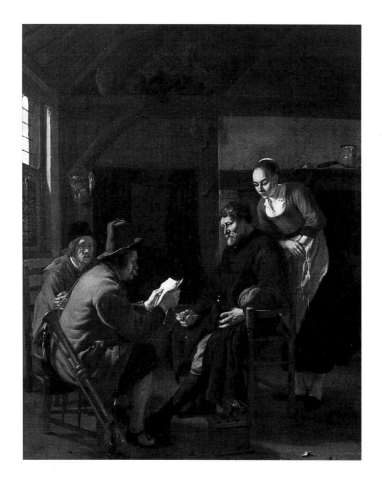

fig. 163
LUDOLF DE JONGH
The Message, 1657
canvas; 65 x 53.5 cm
Mainz, Landesmuseum, inv. no. 800

and not terribly realistic, construction is found in many of De Jongh's paintings and distinguishes his work from that of Pieter de Hooch, who as we have seen was a master of perspective. Indeed, later on, toward the end of the 1650s, we find that De Jongh adopts the younger artist's methods in this respect.

In 1658 Ludolf de Jongh painted a similar composition with the same theme. Likewise entitled *Hunters in an Inn*, the canvas is preserved in the Groninger Museum at Groningen (fig. 160). However much the two images correspond, they differ rather notably with regard to atmosphere. In the Groningen painting a small group of hunters is seated around a table in an inn, smoking and drinking. The stylish red costume of the hunter in the foreground is particularly striking. Behind him stands a modestly dressed man who, as he speaks to the hunter, politely doffs his hat. In the left foreground a boy cuts pieces of bread for two hungry-looking hunting dogs. Sunlight falls through the window. Outside two greys can be seen by the inn – probably the hunters' horses – and in the distance a farm.

The neat and orderly atmosphere of the Groningen inn contrasts with the disorderly peasant inn shown in the panel at Basel. There, the floor is strewn with bits of trash, dust and straw, while in the Groningen canvas, aside from two broken pipe stems, the red tile floor is swept spotlessly clean. The ambience of this room is prosperous compared to that in the earlier painting, which seems more rustic. Not only the ambience but also the handling of the two works is different. In the Groningen version De Jongh used purer colours than before, which contrast with the reddish brown monochrome of the background. Thanks to the greater variety, his palette is richer and more lively than in the preceding years. This penchant for more pronounced colours characterises the work produced by most Dutch painters in the 1650s, including De Hooch.

That De Hooch remained in contact with De Jongh in the first half of the 1650s is evidenced by several borrowings he made from pictures by his elder colleague. In *A Soldier with Dead Birds* (fig. 126), for example, the palette and the rendering of the space are directly based on De Jongh's *Hunters in an Inn*. The attitude of the seated soldier, with his left hand resting on his hip, also resembles the pose of De Hooch's smoking soldier in the *Trictrac Players* (fig. 118). For that matter, De Jongh often painted this attitude, and it is not inconceivable that De Hooch borrowed the motif from him as well.

Another example of such borrowings is provided by two pictures that are both entitled *A Soldier Paying the Hostess* (figs. 161 and 162), the one by Ludolf de Jongh, the other by Pieter de Hooch. De Jongh's panel shows a soldier searching for coins in his trouser pocket in order to pay his bill. De Hooch tried his hand at the same theme several years later. A comparison between the two works reveals not only parallels, but also differences.

The picture by De Jongh shows a stable in which the illusion of depth is achieved through steep recession. In the centre of the composition a hostess – presumably the wife of the innkeeper – asks an officer to pay his bill. With a sheepish look the man gropes in his pockets for coins. Behind him one of his companions has already mounted his horse and is ready to leave. In the background another steed, most

likely that of the guilty soldier, is being brought out. In the right foreground another soldier smirks knowingly at the viewer, sharing his pleasure at the stupidity of the officer, who cannot live within his means. The viewer cannot fail to grasp the gist of the anecdote.

In De Hooch's treatment of the subject, both the hostess and the soldier are depicted in the middle of a room, part of which can be screened off with curtains. Behind the curtains we can see two soldiers and a girl by a window. Evidently the protagonists have nothing to do with this group. Whereas De Jongh sought to tell a story as clearly as possible with a view to amusing his audience, and therefore involved all the figures in the action, De Hooch's handling of the incident takes on meaning only through the gestures of the woman and the man. De Jongh painstakingly recorded the reactions of his characters, while De Hooch concentrated on accurately describing the space and the light. Of the two, De Jongh is clearly the more talented figure painter, De Hooch more skilled at creating a sense of depth. It is interesting to see how the younger artist characteristically constructed the pattern of the tiled floor with the help of two distance points on either side of the image, demonstrating once again his knowledge of geometry and perspective. De Hooch's method of indicating the source of light is wonderfully refined, but where is the light source in De Jongh's picture? His figures are brightly lit, but the floor remains in shadow! The ingenious device of the curtains enabled De Hooch to light the floor indirectly, effectively unifying the space. This unity and emphasis on the emotional involvement of the personages characterises the work of De Jongh, as exemplified by *The Message* (fig. 163).

Until about 1658 De Hooch regularly borrowed motifs from the work of De Jongh, but after that date the situation is usually the reverse: elements occur in the compositions of Ludolf de Jongh that he had seen in the work of Pieter de Hooch.[33] After De Hooch moved to Amsterdam the two artists probably stayed in touch. It was increasingly the older artist who drew inspiration from the younger one, but even in the 1660s De Jongh occasionally influenced his colleague. Consider, for example, De Jongh's *Woman Receiving a Letter* (fig.164) of about 1663-1665, which can be compared to a number of De Hooch's canvases from several years later. The architectonic structure of the composition and the placement of the female figure in several pictures, such as *Woman Sewing, with a Child* and *Mother and Child with a Boy Descending a Stair* ('*The School Boy*') from 1668 (figs. 165 and 166), is generally derived from De Jongh.[34] Both canvases show a room with a woman and child in the light of a window. De Hooch probably borrowed the basic structure of the space from De Jongh. Despite the parallels, there are also differences, especially with respect to the intensity of the light from the windows. With De Jongh, the transitions from light to shadow are much harder and more emphatic, the contrast between them much sharper. De Jongh's painting seems somewhat like an overexposed photograph, taken into the sun. In short, De Jongh had an important influence on the development of De Hooch's interiors and could, thanks to his continued relations with that artist, contribute to the popularisation and dissemination of his great innovations in the field.

Similar representations of porches and front rooms were painted around 1670 above all by Jacob Ochtervelt (1634-1682). Through the contrast between light and shadow,

168

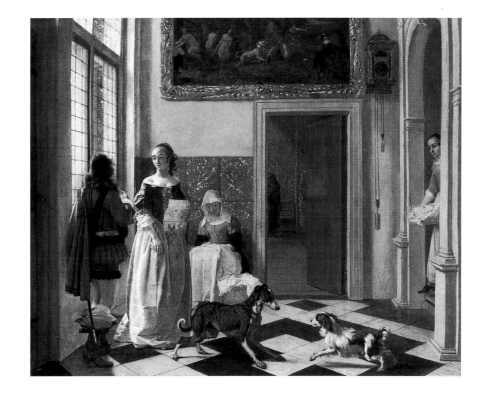

fig. 164
LUDOLF DE JONGH
Woman Receiving a Letter,
1663-1665
canvas; 59.6 x 73.3 cm
Ascott (Rothschild Collection),
Leighton Buzzard,
Buckinghamshire, United
Kingdom. The National Trust
for Places of Historic Interest
or Natural Beauty

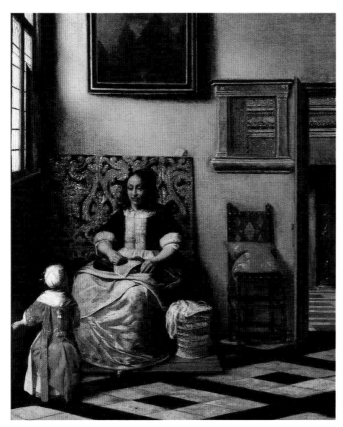

fig. 165
PIETER DE HOOCH
Woman Sewing, with a Child
canvas; 54.6 x 45.1 cm
Madrid, Fundación Colección
Thyssen-Bornemisza,
inv. no. 1958.7

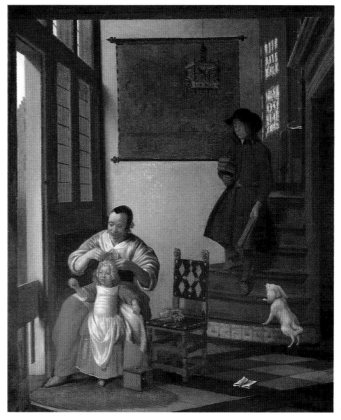

fig. 166
PIETER DE HOOCH
The School Boy
canvas; 65 x 53 cm
Germany, private collection,
by courtesy of Hans Cramer,
The Hague

the motif provided the artist with visually attractive opportunities; furthermore it made it possible for him to work out the contrast between indoors and outdoors, as well as the juxtaposition of various social classes. Whereas De Hooch seems to have been primarily interested in the rendering of depth and the suggestion of space, Ochtervelt was apparently fascinated most of all by human activity. A very succesful example of this is *The Cherry Seller* (fig. 168) by Ochtervelt.[35] Through a doorway, before which a woman sells cherries, a beam of bright light falls on the floor. The depiction of the interior in shadow serves to create lively, irregular patterns of light and darkness. The naturalistic handling of the light and the figures painted in contre-jour sunlight are highly reminiscent of De Hooch. A particularly nice touch is the reinforcement of the indoor-outdoor relationship by means of the couple walking in the sun, who seem to look at what transpires in the foreground.

Jan Steen (1625/1626-1679), who managed a brewery in Delft in the period 1654-1657, likewise adopted the motif of the front room in a depiction of *The May Queen* (fig. 169), in which the strong contrast between light and shadow served to highlight the motif of the queen and the girls singing behind her.

170

Hendrick van der Burch (1627-in or after 1666)

Hendrick van der Burch is one of the first artists to have been influenced by Pieter de Hooch both thematically and stylistically.[36] His patent affinity with the art of De Hooch can undoubtedly be explained at least in part by the latter's marriage to Annetge van der Burch, in 1654.

Hendrick van der Burch was born in the village of Honselersdijk, near Delft, in 1627, to the candlemaker Rochus van der Burch. In 1633 the family moved to Voorschoten, and eight years later to Delft. Here Van der Burch was inscribed in St Luke's guild in 1649. In 1655 he settled in Leiden, where, on 24 November 1655, he married Cornelia van Rossum, who bore him five children. The family moved into a house on the Rapenburg, opposite the Academy.[37] In the early 1650s Van der Burch apparently moved to Amsterdam, but shortly thereafter, in 1661, he was back in Leiden. In 1664 he registered in the Delft guild once again, but gave Leiden as his place of residence. Where and when he died is not known.

As to the size and development of Van der Burch's oeuvre we can only guess. Only nine signed works by him are known, none of which is dated. As if to make matters even more difficult, he changed subject and style regularly. The authenticity of all other attributed works therefore has to be tested against this very small group of secure paintings.[38]

Like his brother-in-law Pieter de Hooch, at the beginning of his career – around 1650 – Hendrick van der Burch painted guardrooms with soldiers gaming and drinking. Later on, in the 1660s, he turned his hand to interiors with genre scenes and executed two family portraits. The influence of Pieter de Hooch is unmistakable in his interiors. First of all, the subjects correspond, as Van der Burch was also fond of painting mothers with their children and, more especially, elegant companies. Like De Hooch he placed his figures in clearly structured spaces with various glimpses into the distance. In addition to

fig. 167
HENDRICK VAN DER BURCH
Woman and Child at a Window
canvas; 41.5 x 33 cm
Delft, Stedelijk Museum Het Prinsenhof (on loan from the Rijksdienst Beeldende Kunst, The Hague), inv. no. NK 2422.
Photo: Tom Haartsen, Ouderkerk aan de Amstel

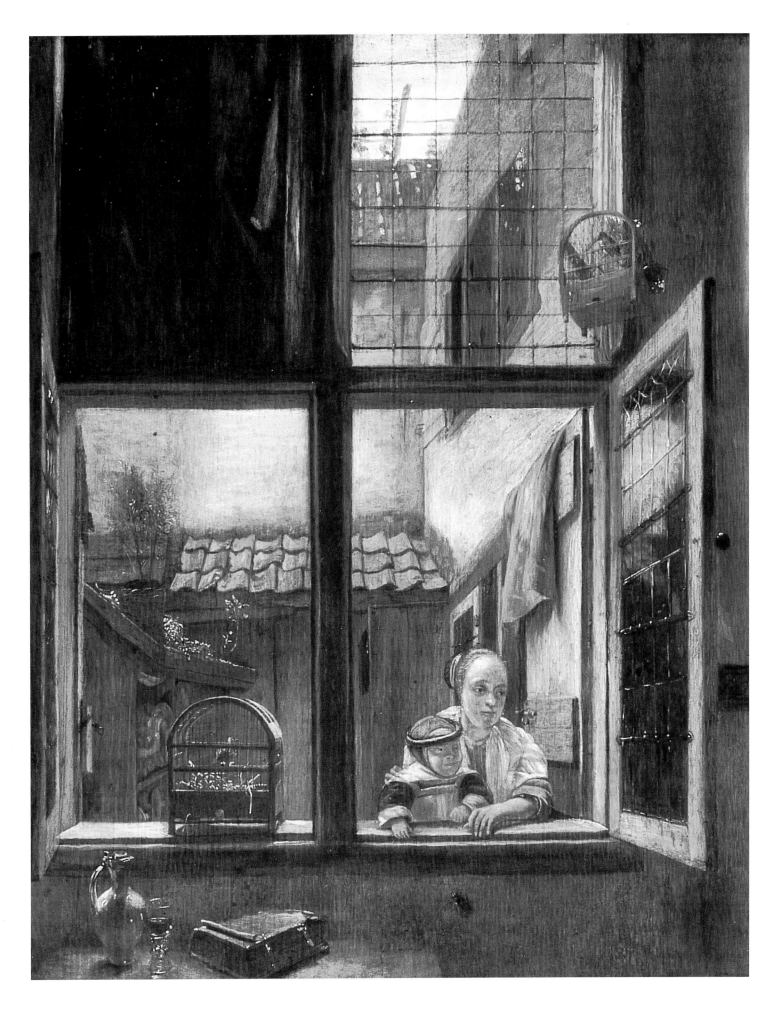

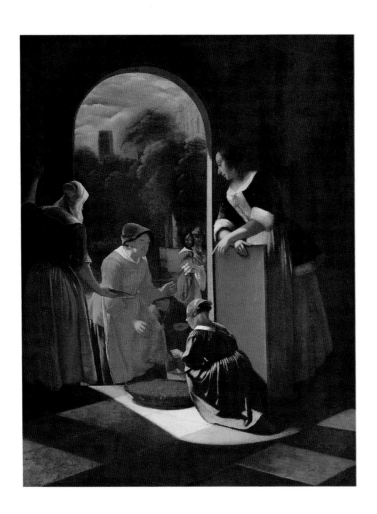

fig. 168
JACOB OCHTERVELT
The Cherry Seller, c. 1668-1669
canvas; 77 x 81 cm
Antwerp, Museum Mayer van
den Bergh. Photo: Frans Claes,
Antwerp

172

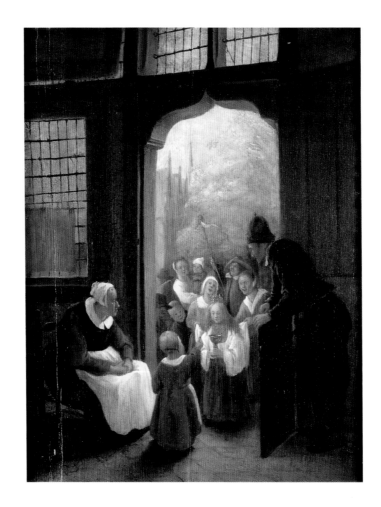

fig. 169
JAN STEEN
The May Queen
panel; 36 x 38.5 cm
The Netherlands, private collection

the evident thematic parallels Van der Burch, too, preferred a light palette, and took particular pains with the sunshine flooding into his compositions through doors and windows.

One of Hendrick van der Burch's first paintings, *The Oyster Eaters* (fig. 170), shows a table with a platter of oysters. At the right end of the table sits a woman with a white earthenware jug. Behind the table stands a man smoking. At the left end of the table we see a servant, and a man wearing a cuirass in the foreground. In this panel Van der Burch was primarily concerned with the figures, which he painted in clear, strong colours. As in the early work of De Hooch the background is monochrome and dark, so that there is hardly any suggestion of space. A sense of depth is solely achieved through the grouping of the figures round the table.[39]

The Museum Hct Prinsenhof preserves Hendrick van der Burch's *Woman and Child at a Window* (fig. 167), which was probably painted several years later. The picture shows a view from an interior into a courtyard, where a woman and her child stand gazing inside.[40] The modest dimensions of the canvas notwithstanding, the brightness of the light is striking. Largely executed in yellowish brown ochres, the work is rather subtly enlivened by means of several white and red accents. The window takes up nearly the

173

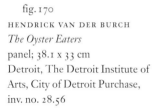

fig. 170
HENDRICK VAN DER BURCH
The Oyster Eaters
panel; 38.1 x 33 cm
Detroit, The Detroit Institute of
Arts, City of Detroit Purchase,
inv. no. 28.56

Pieter de Hooch and Delft genre painting

entire image: only at the bottom and the right is some of the wall visible. The lower section of the windows is open, while one of those in the upper section is covered with a green curtain. On the table below the windows we can see a white Delftware jug, a glass of white wine and a book. There is a small birdcage standing on the sill, and another hanging from the right side of the windowframe near the top. The wooden shutters are opened outward and over the one beside the woman a red cloth is hung. The small courtyard is entirely surrounded by walls and roofs. Only a small piece of the sky appears at the top.

Although vistas through windows rendered frontally do not occur in De Hooch's oeuvre, the atmosphere of the image nonetheless calls up associations with his work.[41] The reason, of course, is the handling of light and the vista. Here the viewer looks into the light, as in many Delft paintings by De Hooch. The master would probably have emphasised the contre-jour effect by keeping the shaded areas, like the view of the girl and the walls, a little darker, ensuring that the contrasts would be sharper. There is no trace of this in Van der Burch's panel, which even gives the impression that there is a second source of light in the room. The contrasts between light and shadow are minimal as a result. The almost exaggerated recession, which was undoubtedly intended to enhance the sense of depth, is characteristic. The construction of the perspective is revealed by drawing a line along the upper edge of the open window and the shutter. Curiously, the artist seems to have miscalculated the format of the woman looking in, so that the window appears to be proportionately much too large.

The small panel *Woman and Child at a Window* (see figure 167) of Van der Burch may be reminiscent of De Hooch, but in fact the theme of a woman by a window depicted frontally was much more popular with artists who were active in Leiden. The motif is found not only in the work of Gerard Dou, the nestor of the Leiden *fijnschilders*, who are noted for their highly polished manner, but also in that of Quiringh Gerritsz van Brekelenkam, for instance. Mixing motifs commonly associated with Leiden and Delft is characteristic of Van der Burch.

Yet, as evidenced by both the subject and atmosphere of his pictures, De Hooch was Van der Burch's greatest source of inspiration. Occasionally he is even known to have repeated works by his brother-in-law. For instance, *Conversation by a Hearth* (fig. 171) is patently based on *A Soldier Smoking, with a Woman by a Hearth* (fig. 146).[42] Nor, as we have noted, are these artistic parallels coincidental. Consider these two pictures, for instance. In Van der Burch's canvas, the strongly focused lighting of the characters, so typical a feature of De Hooch, and the contrasts between light and shadow seem less emphatic: the space as a whole is lighter, more evenly lit. Van der Burch, on the other hands, pays more attention to details, such as the figure in the doorway and the small, three-legged table in the foreground, as if he found De Hooch's canvas too empty. The net effect of all these details is rather distracting.

The Card Players contains a slightly less striking correspondence with a design by De Hooch (fig. 172). Again, this is hardly accidental. Van der Burch's composition shows a room with a chequered floor and in the right background a stairway to a room on an upper level. An officer and a woman are seated at a triangular table by a window playing cards. A black servant pours the woman a glass of wine. In the left foreground a child

fig. 171
HENDRICK VAN DER BURCH
Conversation by a Hearth
canvas; 77 x 54 cm
Whereabouts unknown. Photo:
Rijksbureau voor Kunsthistorische
Documentatie, The Hague

plays with a dog lying on a chair. The structure of the space and the manner in which the sunlight is used to illuminate the subject correspond roughly with two pictures by De Hooch discussed earlier, namely *Mother and Child with a Boy Descending a Stair ('The Schoolboy')* and *A Woman Sewing, with a Child*, which were inspired in turn by a composition of Ludolf de Jongh (fig. 164).

As with many artists from the early 1660s, the interiors of Hendrick van der Burch likewise become richer and more luxurious. We have noted this already in the work of Pieter de Hooch, and the same holds true for Jacob Ochtervelt and Emanuel de Witte. This development is clearly manifest in the aforementioned *Officer and a Woman Conversing* (fig. 155) by Pieter de Hooch. With evident pleasure the master painted the visually satisfying contrast between the rigid geometrical patterns of the floor and the dynamic decoration of the gilt leather wallhanging.[43] Van der Burch chose a similarly elegant interior as the setting for his *Officer and a Standing Woman* (fig. 173). The walls of the room are entirely covered with sumptuous gilt leather. In the foreground, almost in the centre of the image, stands a woman; an officer is seated beside her, a rummer of wine in his hand. He gazes at the woman with a bemused expression. Sunlight falls through the window on the left side of the image, illuminating the woman above all. The birdcage in the window also occurs in other works by the painter, including *Woman and Child at a Window* . The doorway in the wall on the right affords a glimpse of a room on an upper level, where a woman seated on a raised wooden platform does her mending. As in most of Van der Burch's oeuvre, the sensation of

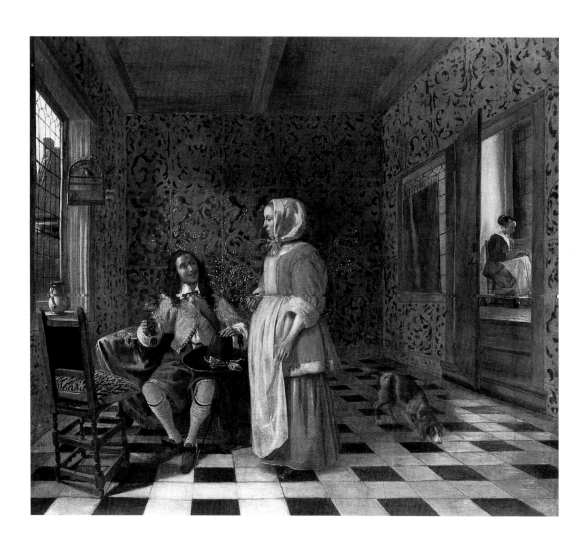

fig. 173
HENDRICK VAN DER BURCH
Officer and a Standing Woman
canvas; 57.8 x 64 cm
Philadelphia, Philadelphia Museum
of Art, The William L. Elkins
Collection, inv. no. 28.56

fig. 174
HENDRICK VAN DER BURCH
Card Players in an Interior
canvas; 63 x 75 cm
Chicago, private collection. Photo:
courtesy of The Art Institute of
Chicago

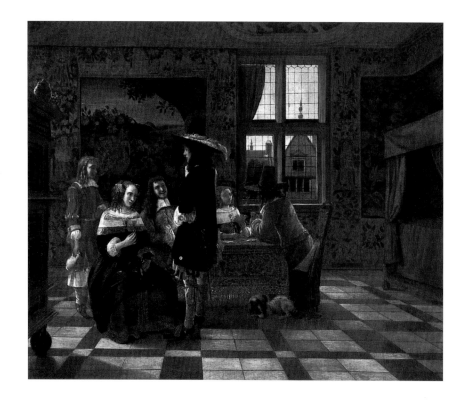

depth is heightened by means of the tiled floor, with its linear pattern receding to the background. By placing the imaginary horizon line on the level of the man's shoulders – quite low, in other words – the artist managed to make the foreshortening seem all the more naturalistic.

Perhaps the best example of such a richly furnished room in a picture by Hendrick van der Burch is *Card Players in an Interior* (fig. 174). Here the walls are hung with splendid tapestries representing landscapes with animals, trimmed with a border of floral and foliate motifs. The artist makes effective use of the cupboard in the foreground, the corner of which serves as a repoussoir to increase the illusion of depth, as does the pattern of the tiled floor. Near the exact centre of the image is a table. Before it stands a man gazing at a seated woman with a wine glass in her hand. He appears to ask her something; another man witnesses the scene, laughing. To the left of the table stands a servant with a stone jug in his hand. On the other side of the table a man and woman are playing cards. Behind these last two figures is a frontal view of a window, through which the façade of a house on the other side of the street or canal can be seen. The room is illuminated in part from the left; the rest lies in shadow. Flecks of light pick out the head and shoulders of the woman seated before the table. As in an *Officer and a Standing Woman* (fig. 173) the horizon is rather low, thus giving the viewer the impression of actually standing in the room.

These examples leave no doubt that the contact between Van der Burch and De Hooch left a mark on the former's work. He imitates the development of his brother-in-law and regularly borrows from him. Stylistically and iconographically Van der Burch's work also echoes artistic developments in the cities where he worked, namely Delft, Leiden and Amsterdam. Although he himself made no contribution to these developments, his works do have great charm. The inspiration he drew from the Delft interior pieces of De Hooch corroborates the importance of that master's innovations.

JACOBUS VREL, ESAIAS BOURSSE AND PIETER JANSSENS ELINGA

The work of Jacobus Vrel (active circa 1654-1662), Esaias Boursse (1631-1672) and Pieter Janssens Elinga (1623-before 1682) is generally associated with that of Pieter de Hooch.[44] Motifs in their work such as contre-jour effects, rooms painted in foreshortening and, finally, women performing their household chores link their art to that of Pieter de Hooch. Were these painters in fact familiar with the work of their distinguished colleague? In light, at least, of the motifs they have in common, this seems likely. The relationship between them is complicated by the fact that Vrel painted his first interiors with housewives as early as 1654, which means he anticipated De Hooch's paintings of this theme by some three or four years. Although the label 'School of Pieter de Hooch' for these three painters is therefore somewhat misleading, the stylistic and thematic parallels between their work and that of De Hooch are obvious.

The painter Jacobus Vrel, whose life is very poorly documented, executed a series of interiors between 1654 and 1662. These comprise a small number of motifs that recur in ever-changing combinations. There are usually no more than a few figures, preferably a

woman seen in profile or from the back, gazing out a window or sitting by a hearth. Very seldom is her face shown.

In the nineteenth century several of Vrel's domestic interiors were sold as Vermeers. They therefore came to be associated with Delft painting, especially with the work of De Hooch and Vermeer. Hence the inevitable inclusion of Vrel's eccentric pictures in surveys of painting in Delft.[45] Although the subdued backlighting and the predominance of women in Vrel's work recall De Hooch's from 1658, some of his interiors actually predate those of his confrère. His earliest dated effort in this genre is a *Woman at a Window* from 1654 (fig. 175), which is already listed in the inventory of Archduke Leopold Wilhelm from 1659.[46] The panel shows a woman leaning out of an open window on her elbows. The light admitted by the window illuminates the room only in part: the floor is bright, while the side wall is in shadow. In the foreground Vrel painted a fire in a hearth. Beside the hearth are a stoneware pitcher and a chair with curiously short legs. Save the cupboard, the other pieces of furniture in the room are exceptionally low as well.

178

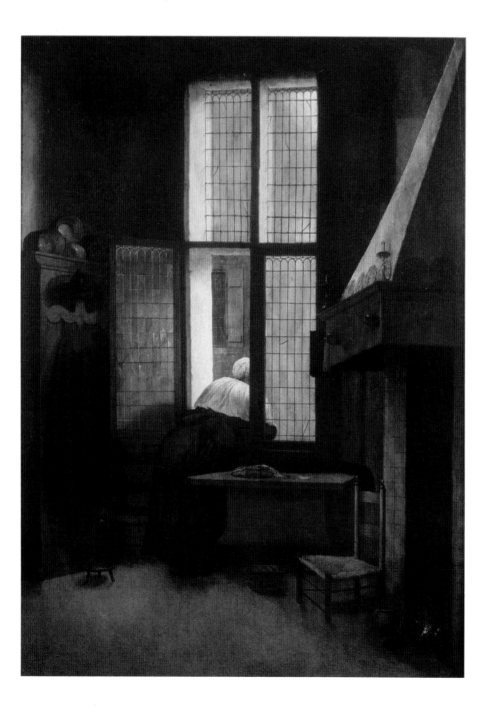

fig. 175
JACOBUS VREL
Woman at a Window, 1654
panel; 66 x 47.5 cm
Vienna, Kunsthistorisches Museum,
inv. no. GG 6081

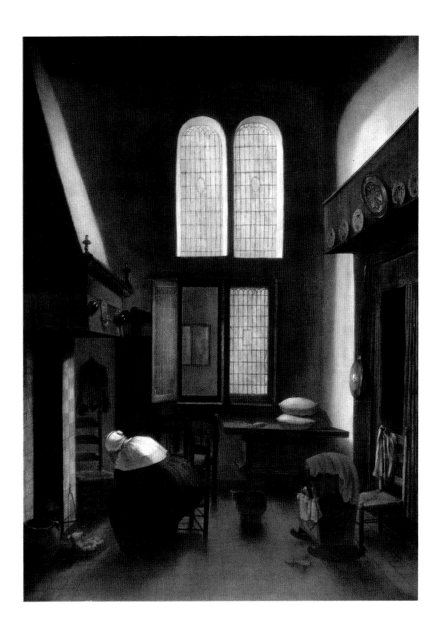

fig. 176
JACOBUS VREL
A Woman by a Hearth
panel; 65 x 48 cm
Germany, private collection.
Courtesy of Sotheby's, London

179

High on the uppermost shelf the pots and pans are stacked: without a stool the woman could not possibly reach them. Low chairs and stools are found in all of Vrel's pictures. As the perspective of the room is inaccurate and imbalanced, the illusion of depth and space leaves something to be desired. There is something rather crude about these panels, moreover; the touch is not very refined and there is little evidence of feeling for subtle colour contrasts. Yet the approach to the subject and the simple, almost naïve manner of these unpretentious little paintings are delightful nonetheless.

Jacob Vrel produced some thirty pictures in all. Half are townscapes, the other half intimate domestic interiors, such as a *Woman at a Window*. Not only the subject, but also the composition, the touch and the orthogonal recession are similar. *A Woman by a Hearth* (fig. 176) shows a room with tall windows suffused with subdued daylight. By a hearth sits a visibly weary woman who leans forward with her head in her hands. Behind her stands a crib with a red cloth draped over it. To the right, the curtain of a box bed is just visible, a brass bedwarmer hanging beside it. Through the open lower window we can see a house on the opposite side of a rather dark, narrow street. As in a *Woman at a Window* the rendering of the room is rather awkward and the geometric structure

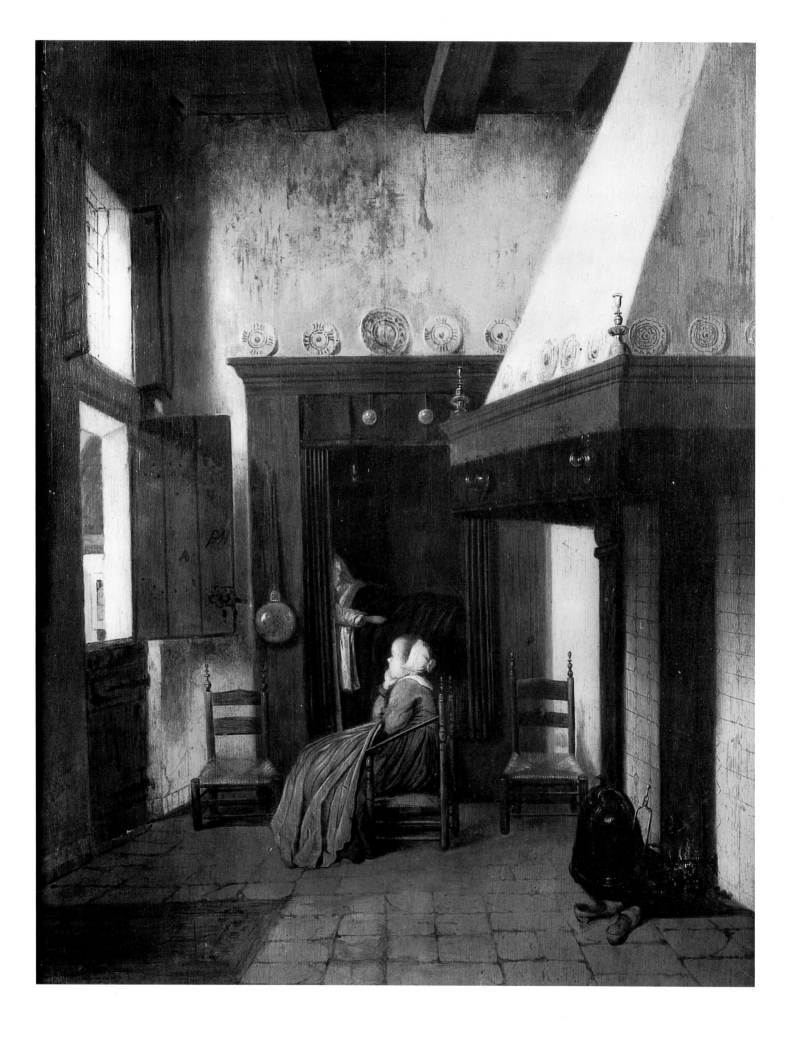

incorrect. The characterization of the worn out woman is moving, on the other hand.

The Little Nurse in Antwerp (fig. 177) is one of the artist's most successful compositions. In the middle of a room a girl is seen sitting in a low armchair, looking out the window with her head leaning on her arm. Her bluish grey dress makes a lovely contrast with the white and the reddish brown tones of the rest of the room. Particularly characteristic of Delft are the orderliness of the space, the whitewashed walls, the outdoor vista and the orthogonal lines of the tiled floor. Vrel always used the same elements in different combinations. The blue-and-white plates on the mantelpiece, the rows of tiles on either side of the fireback and, finally, the box bed with the bedwarmers also appear in other paintings (figs. 175, 178 and 179).

Taking Vrel's oeuvre as a whole, the thematic affinity with that of De Hooch is unmistakeable: both artists specialised in scenes of women going about their daily, domestic business. The slightly melancholic mood of Vrel's works is completely alien to De Hooch's (fig. 180). For whatever reason, the latter was evidently averse to any sign of emotion.

fig. 177
JACOBUS VREL
The Little Nurse
panel; 56 x 45 cm
Antwerp, Koninklijk Museum voor
Schone Kunsten, inv. no. 790.
Photo: Hugo Maertsen, Bruges

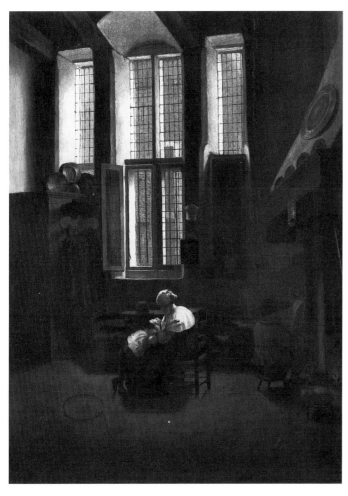

fig. 178
JACOBUS VREL
Woman Delousing a Child's Hair
panel; 63 x 48 cm
Lille, Musée des Beaux-Arts,
cat. 1909, no. 103

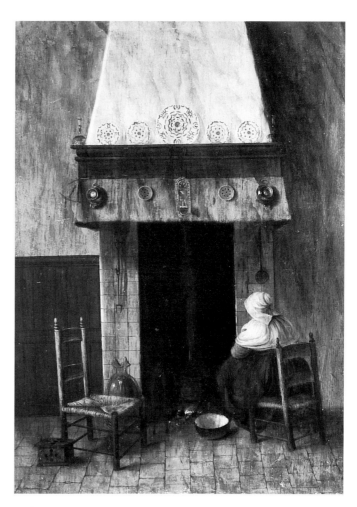

fig. 179
JACOBUS VREL
Woman by a Hearth
panel; 35.9 x 27.6 cm
St Petersburg, The State Hermitage
Museum, cat. 1901, no. 1760

Esaias Boursse, who was active in Amsterdam, is another artist whose compositions invite comparison to those of De Hooch from the late 1650s. Like those of Hendrick van der Burch, many of Boursse's paintings have carried a false signature of De Hooch. In 1631 he was born into a Walloon family at Amsterdam. His inscription as a master in the guild of St Luke occurred around 1651. Shortly thereafter he probably spent some time in Italy, but in 1653 he was back in the city on the Amstel. Between 1661 and 1663 he sailed to the East Indies as a midshipman with the Dutch East India Company (VOC). Ten years later he embarked on a similar journey, only to die at sea on 16 November 1672. He painted mostly women working, in or outside the house (figs. 182.A and 182.B).

The Rijksmuseum at Amsterdam preserves an interior by Boursse that is dimly lit by windows at one end of the room (fig. 181). A woman is shown in profile at her spinning wheel. Beside her, by the hearth, sits a man with his back to us. Before him stands a pail: he is presumably doing housework. Three earthenware plates stand on the mantel-piece. A door in the back wall is half open, affording a glimpse into another room. Before the window are a bench and a table covered with a carpet. A stoneware jug stands at the right end of the window seat, beneath a birdcage suspended from the frame of the window. The man's chair, the spinning wheel and the table are carefully disposed along

fig. 180
JACOBUS VREL
Woman behind a Window,
Waving at a Child
panel; 46 x 39 cm
Paris, Collection Frits Lugt,
Institut Néerlandais

182

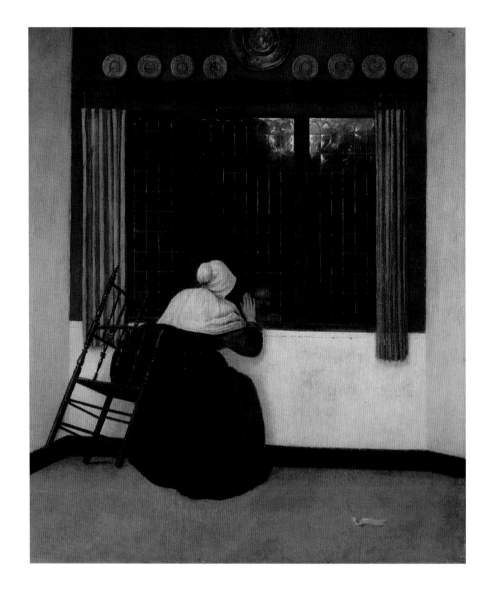

an orthogonal line that runs to the vanishing point. The oblique structure of the left side of the room and the yellowish red tiled floor enabled the painter to suggest space and depth. Comparison of this orderly sitting room from 1661 with De Hooch's interiors from about 1658 reveals striking parallels in the employment of contre-jour and the rendering of space. In the nineteenth century Boursse's canvas, with its false signature, was taken for a work by Pieter de Hooch. De Hooch's domestic scenes are flooded with sunlight, however, while Boursse's room is shrouded in gloom.

The theme of Boursse's picture calls to mind works by the Leiden artist Quiringh Gerritsz van Brekelenkam, such as an interior of a *Tailor's Workshop* (see figure 129). This artist, too, was fond of painting women preparing food alongside their husbands by the hearth. Couples performing household chores together was a familiar motif in seventeenth-century Holland and was considered virtuous comportment. Contemporary emblems admonished men and women to work together, not with a view to financial gain but in the hope of eternal life.[47]

Janssens Elinga is another artist of the 'Hooch School'. His oeuvre is rather small. Indeed, his correct name was only discovered at the end of the last century.[48] Up until

183

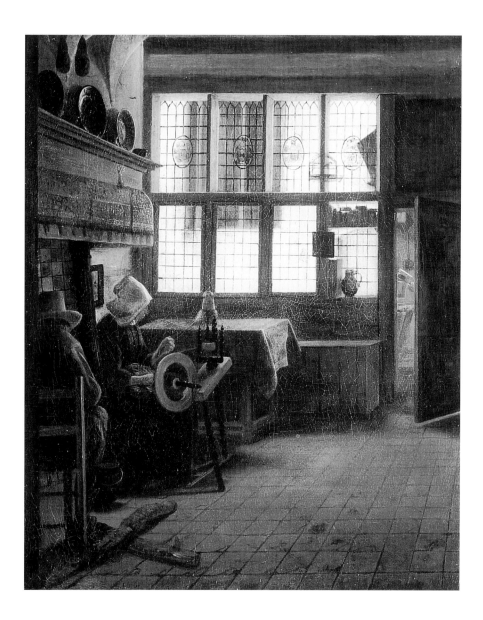

fig. 181
ESAIAS BOURSSE
Interior with Woman Spinning, 1661
canvas, 60 x 49 cm
Amsterdam, Rijksmuseum,
inv. no. A747

then, those of his pictures that comprised female figures were thought to be by the hand of Pieter de Hooch. There is nothing odd about the attribution in view of the artist's close approximation of De Hooch's work with respect to composition, light and space.

Pieter Janssens Elinga was born at Bruges in 1623, the son of the painter Gisbrecht Janssens. Little more is known about his life. From whom did he receive his training, and where? Presumably he was given his first lessons by his father, who died, however, when Pieter was only fourteen years old. In 1663 an inventory of his possessions was drawn up in Rotterdam following the death of his first wife. When he became a citizen of Amsterdam in 1657 he gave musician as his occupation. He died in 1682.

Elinga is known for his still lifes and domestic interiors with women reading or sweeping. Only two of his pictures are signed, not a single one is dated. His work is patently inspired by De Hooch's interiors from the late 1650s or early '60s – the same period from which the paintings of Elinga probably date.[49] The rigid, simple construction of his perspective accounts for the rather stilted effect of his works.

Woman Sweeping (fig. 186), in the Hermitage, St Petersburg, is characteristic of Elinga's art. It shows a brightly lit room with a woman sweeping the floor. She stands with her back to the observer, but her face is reflected in the mirror between the windows. The shutters before the bottom section of the windows are shut. Against the right wall a blanket chest stands between two chairs. Above it hang two small landscapes. In the right foreground an open door provides a glimpse of another space. The interior is the very model of domestic diligence: the floor is brightly polished and every piece of furniture is in its place, and yet the woman is *still* sweeping ...

The Phoenix Art Museum in Phoenix, Arizona preserves Elinga's *Woman Playing a Guitar* (fig. 187). Although the room is virtually identical to that in *Woman Sweeping*, the American canvas creates an altogether different impression: it shows a dimly lit room where a woman is absorbed in her guitar playing. Her surroundings are just as disorderly as the interior shown by the Russian painting is neat and tidy. Books – musical scores? – lie scattered about the floor, together with a pair of slippers. The white Delftware platter of fruit resting on a chair whose cushion has fallen to the floor suggests the woman suddenly stopped whatever she was doing to amuse herself. Her face is reflected in the mirror between the windows. The American and the Russian paintings are one another's pendant in every respect: while the virtuous housewife performs her everyday chores conscientiously, her antipode abandons herself to the dubious pleasures of music, thus forsaking her duty.

These pictures are manifestly indebted to Pieter de Hooch, as evidenced by the backlighting and the perspective. The strict, almost rectilinear division of light and shadow is particularly striking.[50] Women situated by or before a window viewed frontally were also painted by Vrel and Boursse.

Elinga also painted compositions with more than one figure. For instance, *Room with a Woman and a Man Drinking* (fig. 184) shows a large, wide room where in the subdued backlighting of a window a soldier holds a rummer of wine aloft. On the left a woman stands looking at him. The same elements recur in other works by the same artist, such as the blanket chest between two chairs and the vista beside it. When, in the nineteenth century, these paintings were still believed to be by the hand of De Hooch, the chest and

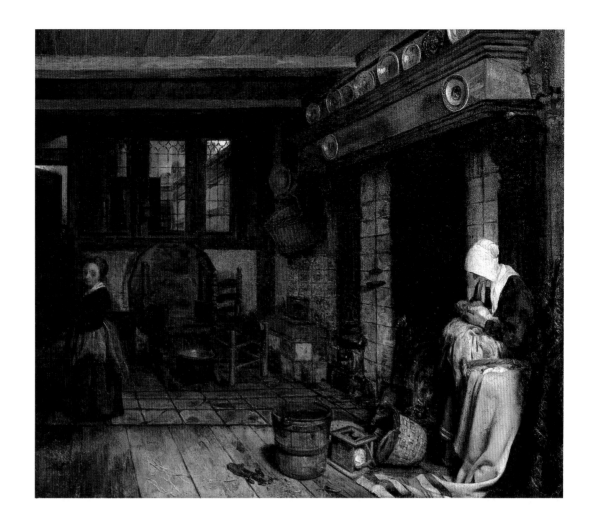

fig. 182.A

ESAIAS BOURSSE
Interior with a Woman by a Hearth, and Child
canvas; 51.5 x 59.5 cm
Berlin, Staatliche Museen zu Berlin–Preußischer Kulturbesitz, Gemäldegalerie, inv. no. 2036.
Photo: Jörg P. Anders, Berlin

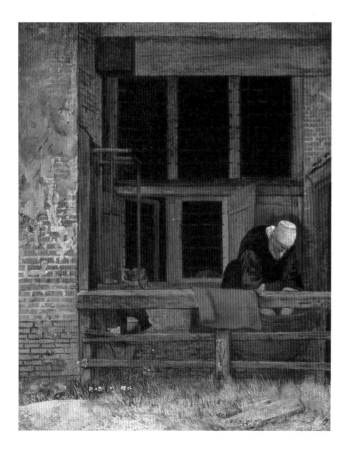

fig. 182.B

ESAIAS BOURSSE
The Laundress
canvas; 37.7 x 30 cm
Rotterdam, Museum Boymans-van Beuningen (Willem van der Vorm Fundatie), inv. no. VdV 5. Photo: Tom Haartsen, Ouderkerk aan de Amstel

the two chairs were considered characteristic of the master – so characteristic, in fact, that a restorer added the motif to the background of a canvas signed by De Hooch to make it seem even more 'Hoochian'.

The Städel Institut at Frankfurt preserves Elinga's *Woman Reading with a Maid Sweeping* (fig. 183). The format has been widened to include a view through a doorway into another room in the left background. The illumination of the woman with light from the window in the upper left is characteristic of the artist; none of De Hooch's works are lit in this way. Like De Hooch, Elinga regularly repeated his compositions with minor variations, a common practice in the seventeenth century. For instance, the general theme and design of the painting in Frankfurt is echoed by an *Interior with a Woman Reading a Letter, a Man Standing and a Maid* in Oslo (fig. 185). This painting likewise features a frontal view of a window which, in contrast to a *Woman Reading with a Maid Sweeping* affords a view of the roofs of neighbouring houses. Besides the number of figures and their disposition, the two rooms are also similar in the sense that they draw the eye to a vista of a brightly lit space in the left background.

These scenes feature a woman who reads a love letter, amuses herself playing the guitar or carries on an elegant conversation with a drinker. In each case she lends the

fig. 183
PIETER JANSSENS ELINGA
Woman Reading with a Maid Sweeping
canvas; 83.7 x 100 cm
Frankfurt am Main, Städelsches Kunstinstitut, inv. no. 1129

186

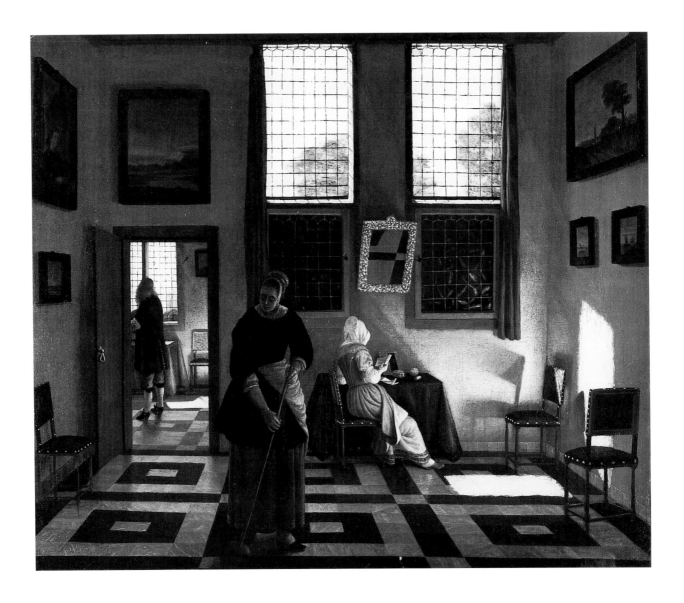

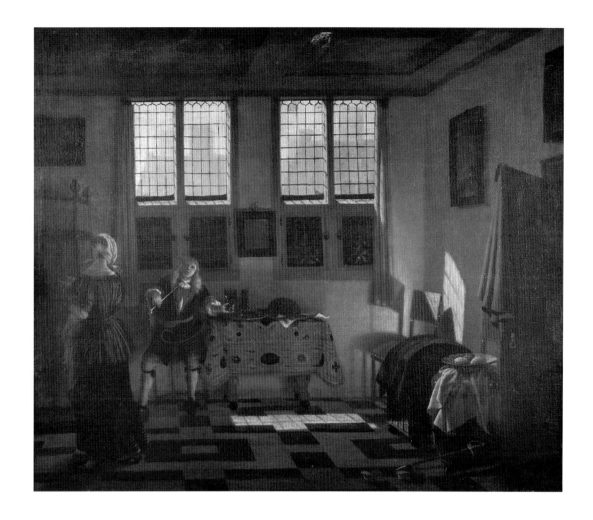

fig. 184
PIETER JANSSENS ELINGA
*Room with a Woman and a Man
Drinking*
canvas; 52 x 61 cm
Lier, Stedelijk Museum Wuyts-
Van Campen en Baron Caroly,
inv. no. 85

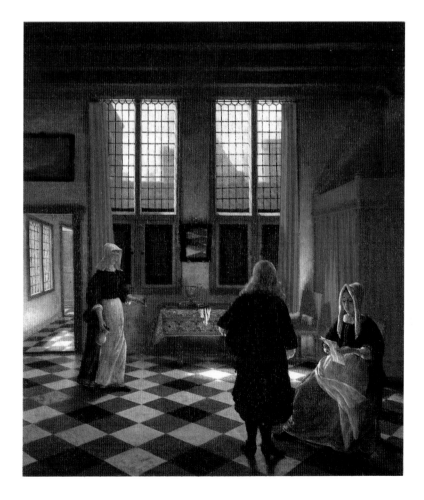

fig. 185
PIETER JANSSENS ELINGA
*Interior with a Woman Reading,
a Man Standing and a Maid*
canvas; 76.5 x 67 cm
Oslo, Nasjonalgalleriet,
inv. no. NG.M.01372

Pieter de Hooch and Delft genre painting

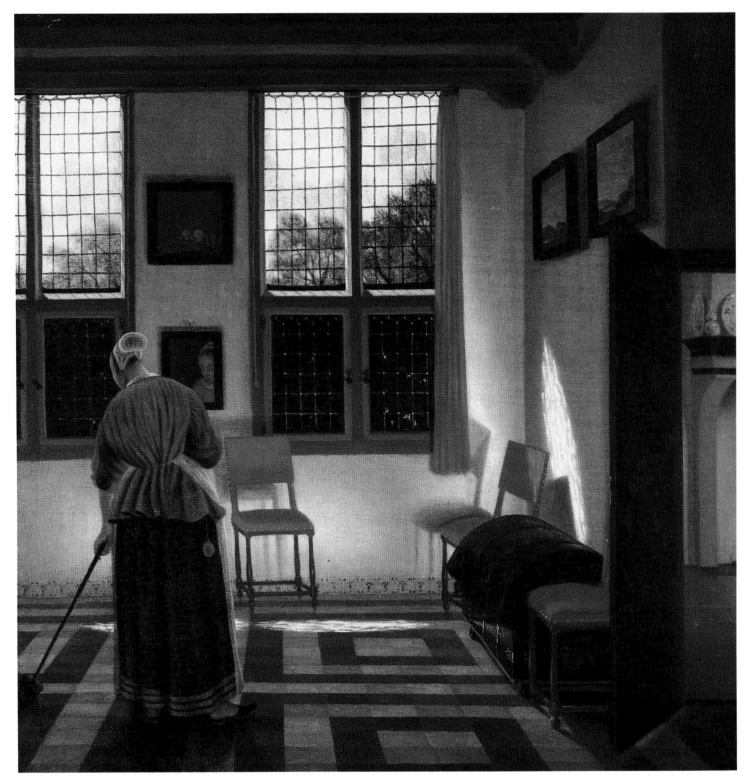

fig. 186
PIETER JANSSENS ELINGA
Woman Sweeping
canvas; 61.5 x 59 cm
St Petersburg, The State Hermitage
Museum, inv. no. 1013

image a sensual, one might even say erotic air. Pieter Janssensz Elinga contrasts these vices with a virtuous sweeping maid. The same contrast is found in *Woman Playing the Virginal* (fig. 188) by Emanuel de Witte. As we have seen, De Witte was one of the two renewers of the Delft church interior in the early 1650s. By experimenting with perspective and using bright lighting he managed to record the interiors of the Oude and the Nieuwe Kerk very naturalistically. There can be no doubt that De Hooch knew these paintings.[51] The manner of suggesting space and the direct sunlight certainly influenced the genre scenes of De Hooch. As in Delft, De Witte continued to paint church interiors after moving to Amsterdam around 1652. He also executed several portraits of Amsterdam patricians. Thematically, *Woman Playing the Virginal*, in which the artist rendered the space and depth masterfully, is anomalous. We see a room with a woman playing a virginal before a window on the right. The doorway opens a vista down a hall connecting a series of rooms. The effect of the alternating light and shadow is very attractive. On the left side of the room a man lies in a four-poster bed, his clothes on the chair in the foreground. The work may possibly illustrate the maxim *Amor docet musicam* (Love teaches music). The counterpart of the sensual element is formed by the maid diligently sweeping in the distance. Curiously, the vista in De

189

fig. 187
PIETER JANSSENS ELINGA
Woman Playing a Guitar
canvas; 73.1 x 62.7 cm
Phoenix, Arizona, Phoenix Art
Museum. Gift of Mr. and Mrs.
Donald D. Harrington,
inv. no. 64-235

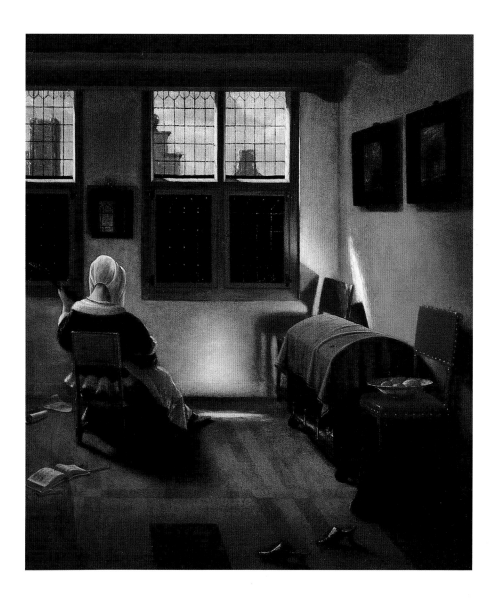

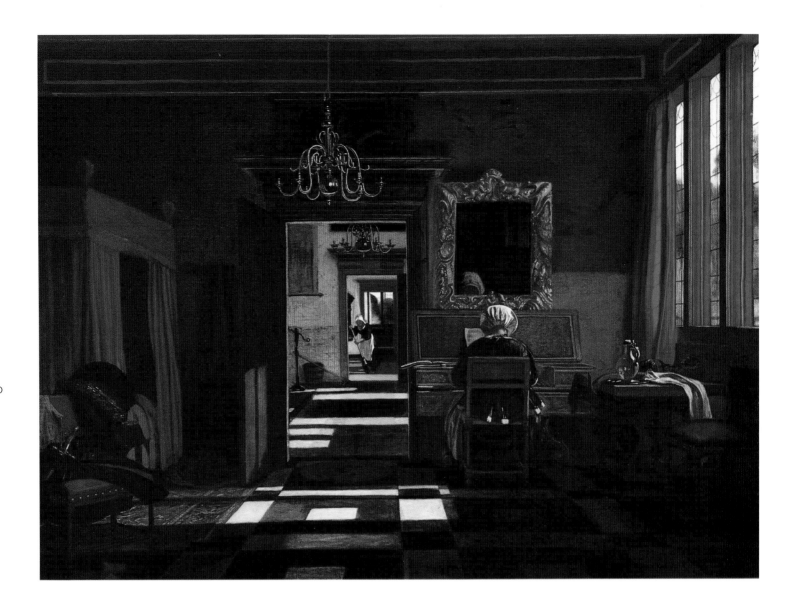

Witte's painting recalls the compositional structure of Elinga's pictures in Frankfurt and Oslo. The view through three successive spaces and the open door recall De Hooch, although prospects with alternating light and shadow do not occur in his work. The refined division of light and shadow is often found in De Witte's church interiors. However convincing the space may seem in this painting, it is a figment of the artist's imagination: such deep houses did not exist in the Netherlands. Is it any surprise that the work was once attributed to De Hooch? In the lower right corner of the canvas the false signature of the Delft painter is still legible. The former attribution to De Hooch was undoubtedly based on the clever spatial effects.

Cornelis de Man

Although the Delft painter Cornelis de Man (1621-1706) regularly borrowed from the work of De Hooch and Vermeer, his pictures have a recognisable idiom and an individual character. More than in the art of De Hooch and Vermeer, the emphasis is on the anecdote.

Nothing is known about the youth or training of De Man, who was born on 1 July 1621. On 29 December 1649 he entered Delft's guild of St Luke, and then spent the following years travelling through France and Italy. Until about 1654 he probably

fig. 188

fig. 189
CORNELIS DE MAN
A Couple Playing Chess
canvas; 97.5 x 85 cm
Budapest, Szépmüvêszeti Múzeum,
cat. 1954, no. 320. Photo: András
Rázsó, Budapest

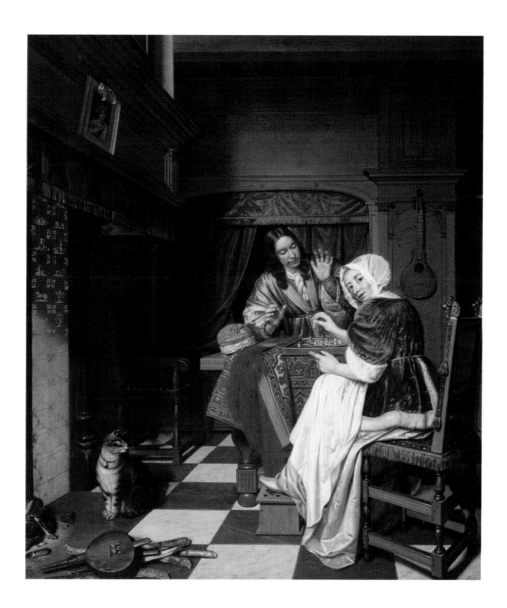

191

remained in Italy, where he visited Florence, Rome and Venice, among other places. The first documentary evidence of his return to his native town dates from 1654. Together with the Delft painter and draughtsman Leonaert Bramer (1596-1672) he executed the decoration for the hall in the new quarters of the guild of St Luke on the Voldersgracht. In the 'Chamber of Charities' in the Schoolstraat is found an allegorical chimney piece by his hand representing *Charity*. He was regularly elected headman of the guild, a position he held together with Vermeer in 1672. From this we may infer he was respected as an artist and was comfortable financially. Around 1700 De Man is documented in The Hague, where he died unmarried on 1 September 1706.[52]

At first Cornelis de Man painted portraits and uproarious peasant companies. From 1661 – probably after De Hooch had left the city, in other words – he executed several church interiors, but concentrated primarily on elegant domestic scenes. His work betrays the influence of a series of artists, including Pieter de Hooch, Johannes Vermeer, but also Gerard Dou and Jan Steen. Like Pieter de Hooch, Cornelis de Man was very much interested in rendering space in accordance with the rules of perspective. Black-and-white chequered floors were one of the devices he frequently employed. In contrast to De Hooch, De Man was a gifted figure painter, full-length human figures accordingly

play a prominent role in his genre scenes. Whereas articulating the spatial context of his subjects was apparently De Hooch's foremost concern, De Man placed a higher priority on the anecdote or the action involved. On this point his pictures are comparable to those of Vermeer, from whose oeuvre De Man also borrowed motifs and subjects. But unlike Vermeer, who preferred to veil the significance of his subjects, De Man eschewed ambiguity.

Around 1670 De Man painted *A Couple Playing Chess* (fig. 189). Typically, in contrast to De Hooch and Vermeer, De Man's walls are not whitewashed but covered with costly oak panelling inlaid with ebony and further decorated in the style of the Dutch Renaissance. In the centre of the room a man and woman are seated at a table, playing chess. The woman, clad in a white dress and an olive-green jacket trimmed with ermine, gazes at us over her shoulder as she moves a knight with her right hand. With her left index finger she draws attention to her strategy. Her companion, clad in a handsome, purple dressing gown, is shocked and surprised, to judge from his gesture. The handling of the texture of their lustrous costumes is masterful. In marked contrast to any known work by De Hooch, a beam of light from an indeterminate source illuminates the couple, while the rest of the room is half in shadow. The space is constructed in an uncomplicated single-point perspective, with the vanishing point situated in front of the woman's face, at the level of the man's right elbow. The artist suggested depth by means of the receding pattern of the tiled floor. The chair, which functions as a repoussoir, draws the eye into the image.

In *A Man Weighing Gold* (fig. 190) the construction is more complex. It is the only example of a genre painting by a Delft master with diagonal (or two-point) perspective, which Pieter de Hooch never employed. Architectural painters favoured this form of perspective, characterised by vanishing points on the left and right.[53] Cornelis de Man may be counted among their number, since he also painted the interior of the Oude and the Nieuwe Kerk a few times. The centre of such compositions is usually occupied by a large, striking element, past which we can look in either of two directions. In church interiors, of course, this is in most cases a column. In domestic interiors motif of such prominence is more difficult to find. Here De Man has made clever use of a table, the corner of which is turned toward the observer so as to direct the gaze to the left and right.

A Man Weighing Gold features the same interior that we saw in *A Couple Playing Chess*. But the figures, the furniture and, naturally, the angle of view make it seem totally different. In the centre of the room stands a middle-aged man in a dressing gown and hat, busily weighing gold coins at a ball-foot table. There are coins on the table, which is normally covered by the carpet which is now thrown back. In the right foreground we see one end of an open strongbox. From behind the table a woman regards the beholder, her arms folded as though she were cold. On the left a boy lays a fire in the hearth. A wicker basket filled with firewood stands beside him. The couple are evidently loyal to the House of Orange, for a portrait of Prince Maurice hangs above the mantelpiece. On the right some rolled-up bedclothes.

When Cornelis de Man painted this scene around 1670, weighing gold was an old-fashioned theme: in the Low Countries, at least, it had been especially popular in

fig. 190
CORNELIS DE MAN
A Man Weighing Gold
canvas; 81.5 x 67.5 cm
Montreal, coll. Mr. and Mrs. Michal Hornstein. Photo: Christine Guest, Montreal

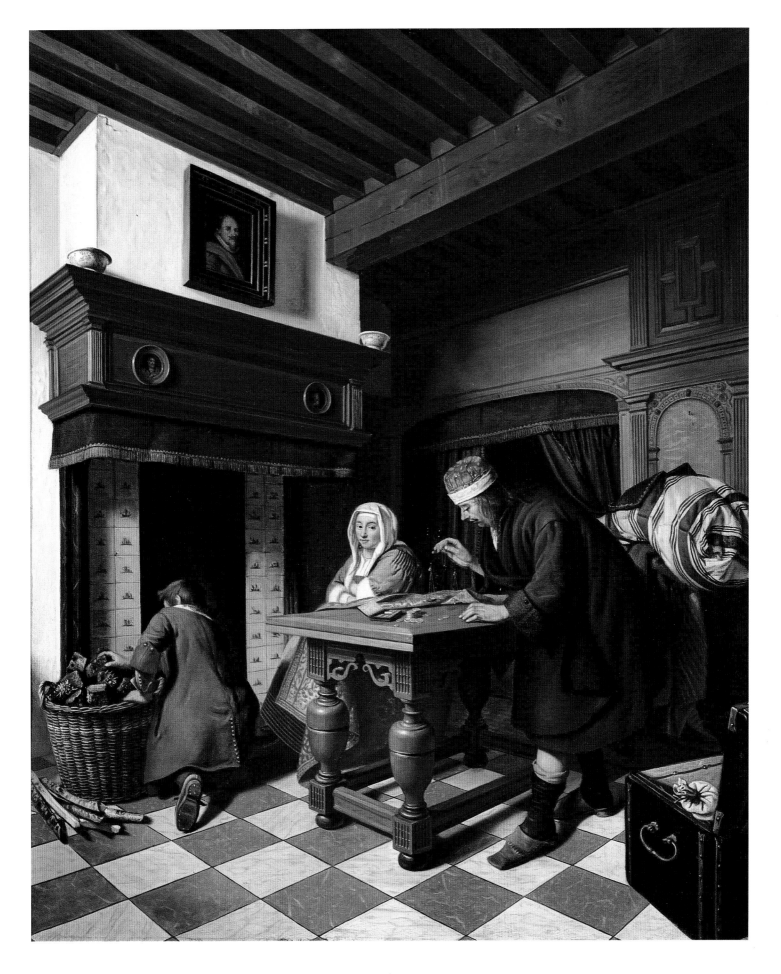

the second half of the sixteenth century. Weighing gold had numerous connotations in art, but it was most commonly associated with miserliness and the vanity of human life. The warning implicit in these images – including that of De Man – is that one can better concentrate on God and thus gain eternal salvation, than on the short-lived, futile pursuit of material wealth. The theme was likewise painted by Vermeer around 1670.

De Man often turned to Vermeer in his search for themes. But where Vermeer would depict single figures, usually captured at a contemplative moment, De Man preferred figural groups engaged in a distinctive action. Like Vermeer, De Man several times represented scholars in their studies. Such thematic correspondences are found in *Three Scholars around a Globe* (fig. 191) and *Scholar in a Study* (fig. 192). The former work features three men in dressing gowns around a table with a globe. The only member of the group who is shown standing rests his right hand on the globe in much the same attitude as Vermeer's *Astronomer*. Another scholar, seated behind the table supporting his head with his left hand, looks on attentively while pointing at an illustration in a book with his other hand. In the left foreground part of a sideboard can be seen, a bust placed on its corner. The background is largely taken up by a brightly lit stairway. A mirror on the back wall reflects the faces of the men at the table; Vermeer used the same motif in

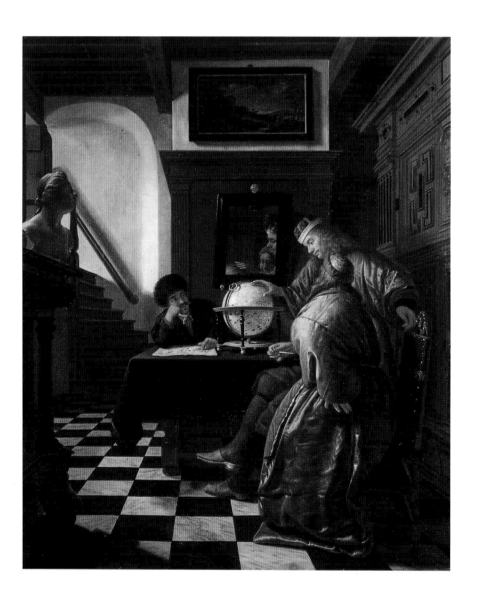

fig. 191
CORNELIS DE MAN
Three Scholars around a Globe
canvas; 81 x 60 cm
Hamburg, Hamburger Kunsthalle,
inv. no. 239. Photo: Elke Walford,
Hamburg

The Music Lesson.[54] A landscape hangs above the wainscotting. It is interesting to see how the artist created the illusion of depth. The repoussoirs on either side of the image lead the eye into the space as if one were looking into a tunnel. The relatively simple rules of single-point perspective have been applied, and the vanishing point placed between the globe and the face of the man with the fur hat. De Man does not show the source of light, as do Vermeer and De Hooch. Only the brightly lit vista with the whitewashed walls of a room on a higher level recalls the Delft interiors of De Hooch.

In De Man's *Scholar in a Study* the 'Delft' associations with De Hooch and especially Vermeer – the whitewashed wall, the principal figure in sunlight before a window – are stronger still. Indeed, the canvas has been sold as a Vermeer many different times![55] In the sunlight that falls through the window, a man in the same dressing gown and hat known from other works by the same artist raises the lid of his writing box. Beside him on the table, which is covered with a Persian carpet, lies an open folio. The thick cushion on the bench, decorated with a coat of arms and floral motifs is strongly reminiscent of the embroidered magistrates' cushions produced by the Delft tapestry workshops. On the back wall hangs a map from 1648 of Olinda and Recife, Brazilian possessions of the Dutch West India Company.[56] Particularly noteworthy is the deftly painted trompe

195

fig. 192
CORNELIS DE MAN
Scholar in a Study
canvas; 74 x 60.5 cm
The Netherlands, private
collection. Photo: Tom Haartsen,
Ouderkerk aan de Amstel

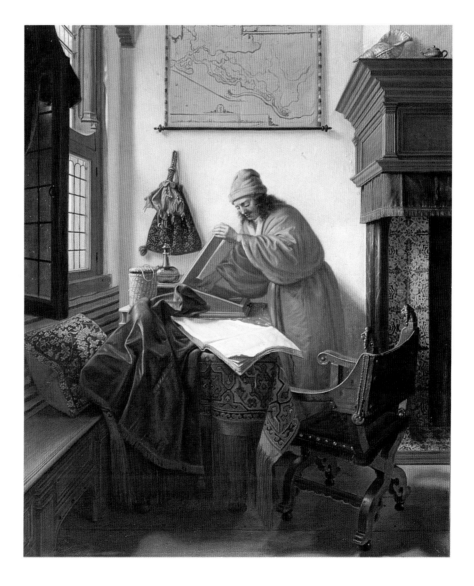

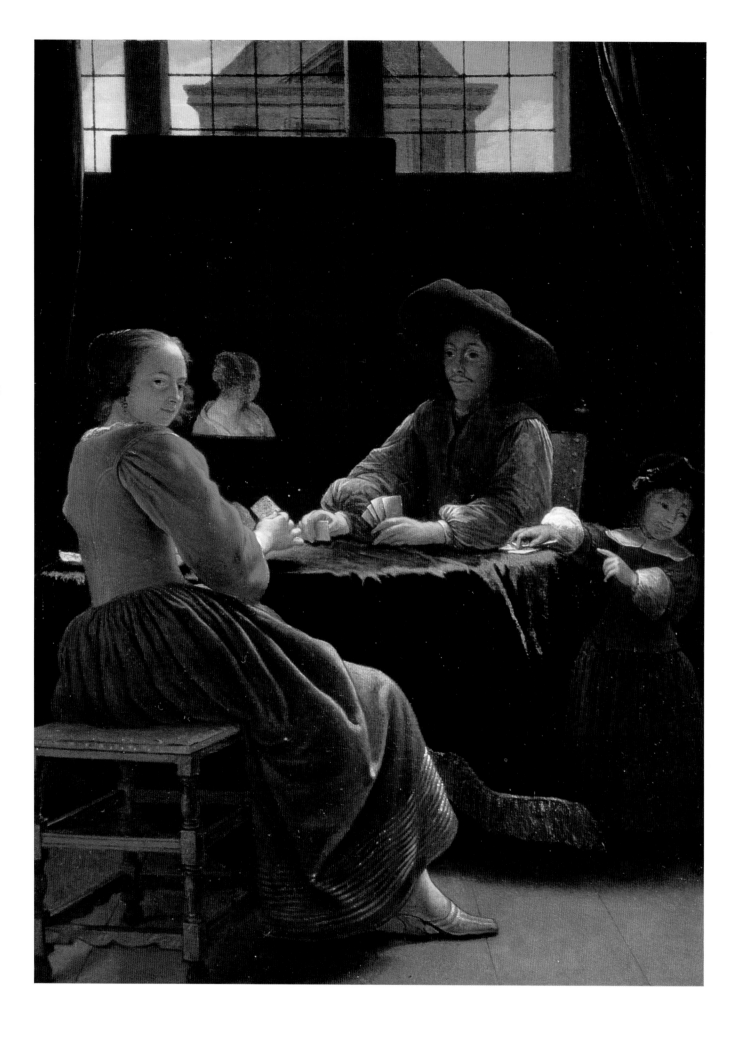

l'oeil near the wooden hearth on the back wall, where the artist faithfully imitated the appearance of cracked plaster and a rusty nail hammered into the wall. While in other pictures De Man was primarily intent upon representing a figural group in an illusionistic space, here it was evidently the light and the colour contrasts that interested him. The attractive painting entitled *The Card Players* (fig. 193) attests to the same preoccupation.[57]

Against the light of a high window shown frontally, which offers a glimpse of the upper façade of a pedimental edifice, a man and a woman are seated at a table playing cards. The man gazes lasciviously at the bosom of his opponent.[58] The woman sits before the table, seen in a three-quarter view from the back, and looks, like the child beside the table, to the right. The absence of anything to see on the right suggests that the panel was cut down on that side. The child points at the woman. The woman's face and décolleté are reflected in the mirror hanging on the wall in the left background. Cards were considered immoral in the seventeenth century and stood for deceit, discord and indecency. The revealing dress of the woman and the prominent placement of her slippers are meant to underscore the erotic connotations of the image.[59] Given that the picture was presumably reduced on the right side, we cannot be certain of its full significance.

The backlighting, with the sun playing over the contours of the woman, is very 'Hoochian'. Because the scene occupies almost the entire picture plane, the image has the intimate, closed character commonly associated with the 'Delft School'.

Anonymous pictures and Dordrecht illusionism

As should by now be evident, Pieter de Hooch's artistic influence was considerable. He had followers not only in Delft but throughout Holland. The naturalistic images they created usually have a decidedly intimate character.[60] It was not for nothing that a French art historian dubbed these followers 'intimistes', which so effectively evokes the atmosphere of their work.[61] It is clear that the painters we have just discussed were not the only ones to profit from De Hooch. Some came under his influence temporarily, thus causing some thorny attributional problems. In the previous century almost every painting of a 'Delft' subject was attributed to either De Hooch or Vermeer. The quality of De Hooch's work declined as it became more repetitive toward the end of his career; that, and the fact that similar tendencies can be noted in other cities, makes it all the more surprising that so many different artists can now be distinguished. Compared to several decades ago, the number of problem pictures, whose authors remain unidentified, is much smaller. A few of them deserve a closer look.

A Woman Sewing (fig. 194) is traditionally attributed to Hendrick van der Burch, but could equally well be by the hand of Ludolf de Jongh. The placement of the industrious woman in the light of a window should by now seem unmistakeably 'Delft'. Indeed this has long been the consensus, for in 1779 and 1792 the canvas was sold as a Vermeer.[62] It shows a woman in black with a hat doing her mending at a window; a wicker basket with her sewing stands beside her on the ground. The red-and-black Persian carpet on the table is surely one of the reasons why the work was attributed to Vermeer, who repeatedly availed himself of similar repoussoirs. The view into the distance, the orthogonal recession of the tiled floor and the bright lighting are stylistic elements that play a crucial

fig. 193
CORNELIS DE MAN
The Card Players
panel; 43.2 x 33 cm
Polesden Lacey, near Dorking, Surrey, United Kingdom, The National Trust for Places of Historic Interest or Natural Beauty, inv. no. 57. Photo: National Trust Photographic Library/Angelo Hornak

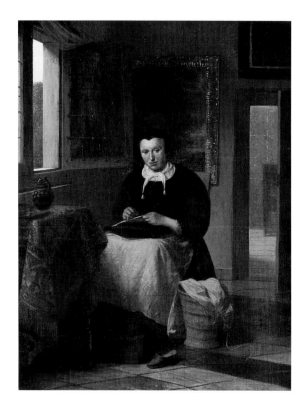

fig. 194
ANONYMOUS
A Woman Sewing
canvas; 50 x 38.5 cm
Hanover, Niedersächsisches
Landesmuseum, inv. no. Pam 893

198

role in the art of both De Hooch and Vermeer, but also in that of all their followers – with varying degrees of success. To complicate matters further, there was also considerable interest in this theme at Leiden, as well. Gerard Dou popularised the subject of a man or woman working by a window. One example of this Leiden variant is the *Interior with a Woman, a Baby and Two Boys* by Adriaen van Gaesbeeck (fig. 195): at an open window a woman is seen doing her embroidery. It is not inconceivable that this canvas was in turn inspired by 'Delft' compositional schemes with vistas.

A Mother and Child (fig. 196), possibly painted by Hendrick van der Burch, presents a similar problem.[63] The picture is completely devoid of references to typical Delft characteristics; only the theme of the mother and child calls to mind the paintings of De Hooch. But an attribution to a Leiden painter seems no less arguable. In this curious composition the woman appears to be more interested in her glass of wine than in the child crying for attention at her side. The texture of her olive green, fur-trimmed jacket and the dress adorned with gold brocade are skilfully rendered by the anonymous master.

The authors of the many genre pieces by the De Hooch School are difficult to determine. After all, painters in Dordrecht displayed a similar interest in the illusionistic suggestion of space with perspective and light, which is considered typically Delft. Consider, for instance, the Dordrecht artist Nicolaes Maes, whose vistas predate those of De Hooch. Nor should we forget Samuel Hoogstraten. Like his fellow townsman Maes, as well as the painter Carel Fabritius, who was active in Delft from 1650, Hoogstraten was a pupil of Rembrandt. Early on – in the early 1650s – he exchanged the style and themes of his teacher for trompe l'oeil subjects, besides experimenting with perspective to make his work seem more true to life. We can therefore not be certain whether such 'Hoochian' elements as the tiled floors and sunshine are

fig. 195
ADRIAEN VAN GAESBEECK
*Interior with a Woman, a Baby
and Two Boys*
panel; 52 x 41 cm
Karlsruhe, Staatliche Kunsthalle.
Photo: A. Dingjan, The Hague

fig. 196
ANONYMOUS
A Mother and Child
canvas; 50 x 39.5 cm
Bonn, Rheinisches Landesmuseum,
inv. no. GK 99. Photo: H. Lilienthal,
Bonn

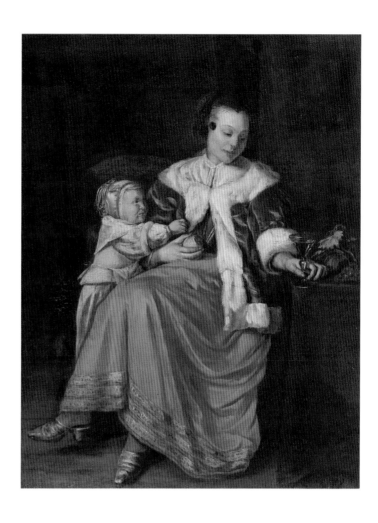

fig. 197
CORNELIS BISSCHOP
The Jacket
canvas; 43.5 x 36.5 cm
Berlin, Staatliche Museem zu
Berlin – Preußischer Kulturbesitz,
Gemäldegalerie, inv. no. 912D.
Photo: Jörg P. Anders, Berlin

Delft Masters

Hoogstraten's own inventions or can be traced to De Hooch. *The Slippers ('Les pantoufles')* (fig. 198) undeniably illustrates the interest that was felt at Dordrecht in 'deceptions' (*bedriegertjes*) and the illusion of space and light for which Delft was renowned. Like many pictures with typical Delft traits, this one, too, had received a spurious signature in the course of time: *P.D.H. 1658*. The date seems to make some sense. Through a hall and then an open doorway, the observer is shown an elegant interior. In the hall are the two slippers which gave the painting its title. By alternating the intensity of the lighting – shadow, light, shadow, and then a brightly lit back wall – the artist effectively enhances the depth of the image, which is enlivened by the warm and varied palette. The skill with which he captured the texture of both the tablecloth and the shimmering yellow fabric on the chair is strongly reminiscent of Terborch, one of whose pictures is shown hanging on the back wall.[64]

The Jacket (fig. 197) by the little-known Dordrecht artist Cornelis Bisschop (1630-1674) provides further evidence of the fascination with perspective and illusionism in seventeenth-century Holland. The unusual subject inevitably reminds one of a still life. Before a whitewashed wall with a still life by Simon Luttichuys (1610-1661) a woman's jacket trimmed with ermine is draped over the back of a chair. Jackets of this kind were common around 1660 and can be seen in paintings by Pieter de Hooch, Johannes Vermeer and the Leiden painter Frans van Mieris, for instance. Before the chair stand two slippers, on the left is a vista of a hallway. The atmosphere could not be more quintessentially 'Delft'. As the paintings of Hoogstraten and Bisschop show, De Hooch's experiments with space and perspective were echoed in Dordrecht.

PIETER DE HOOCH AND JOHANNES VERMEER

The only artist who exceeded the achievements of De Hooch was Johannes Vermeer. Ever since the 'rediscovery' of Vermeer and De Hooch around the mid-nineteenth century, the work of both artists has been compared repeatedly and much has been written about their artistic relationship. At first Vermeer was considered the great renewer of the domestic interior piece in Delft, but there is now little doubt that the innovations in genre painting were first manifest in the work of De Hooch. Even before Vermeer, he painted sunlight falling through windows and more than any other artist he took pains constructing perspective. Like his contemporaries, Vermeer must have been impressed with the verisimilitude of De Hooch's work; however, he saw the ultimate possibilities that De Hooch's innovations offered.

For De Hooch, stylistic and compositional innovations seem to have been a goal in and of themselves: he sought to represent interiors as illusionistically as possible. Vermeer utilised his colleague's findings to enhance the atmosphere of his images, an aim for which they offered untold possibilities. But while we have established that there are a great many stylistic and thematic parallels between their work, we have not explained why we experience the pictures of De Hooch and Vermeer so differently.

Every discussion of the reciprocal borrowings and influence of De Hooch and Vermeer is undermined by the total lack of documentary evidence that the two artists ever met. The archives only tell us that De Hooch was in regular contact with Hendrick van der Burch and the Leiden painter Barent Gast (1628-1709)[65]; in the same way we

fig. 198
SAMUEL VAN HOOGSTRATEN
The Slippers ('Les pantoufles'), 1658
canvas, 103 x 71 cm
Paris, Musée du Louvre,
inv. no. RF 3722. Photo: Agence
Photographique de la Réunion des
Musées Nationaux

201

also know that Vermeer was well acquainted with the Delft painter and draughtsman Leonaert Bramer and that he was introduced to Gerard Terborch in 1653. However, as virtually every painter who lived in the relatively small town of Delft belonged to the local guild of St Luke, we may safely assume their paths would have crossed. Nonetheless, seeking to determine stylistic and iconographic sources remains a speculative business.

Around 1658 Pieter de Hooch executed the first interiors with figures in Delft that heralded a completely original treatment of the genre. In these works he carried the illusion of reality to an unprecedented degree. The elegant company playing cards in a room sparkling with sunshine is an excellent example of this (fig. 135). De Hooch took precise notice of the light reflecting on the walls and floors, recalling the marvellous interiors of the Oude and the Nieuwe Kerk, where the sunlight lends the space a rarefied, completely open character. One can hardly imagine that De Hooch's revolutionary interiors escaped the notice of Johannes Vermeer.

Around 1658, when De Hooch was painting his innovative genre scenes, Vermeer's art underwent a radical thematic change as well: he turned his attention to figure paintings based on daily life. At first Vermeer was not particularly interested in such – typically Delft – pictorial elements as light and perspective, preferring the Utrecht Caravaggists for inspiration. But shortly after completing these pictures he focused on Delft, and the influence of De Hooch in his work becomes palpable. Starting in 1658 he painted three pictures of men and women around a table. The theme and composition of these works undeniably derive from his colleague.

The *Officer and Laughing Girl* (fig. 199) shows a corner of an interior. Streaming through a window, sunlight illuminates a seated girl who laughs at a soldier. It plays over the leonine finial on the back of her chair, makes her dress sparkle, and draws the eye to her animated face. The officer sits in the shadow, his right hand resting on his hip – a favourite pose of De Hooch, as we now know. Only on his left shoulder is there a glinting highlight. Using him as a repoussoir, Vermeer placed the officer as close as possible to the picture plane. He thus appears larger than the girl and completely dominates the left half of the image. Seen against the light, his bright red but nonetheless shaded jacket contrasts strongly with the back wall which is bathed in unfiltered sunshine. The positioning of the officer in the foreground, partly cut off by the frame, makes him seem almost tangible.

Comparing this with the elegant companies of De Hooch, we find similarities as well as differences. De Hooch's endeavours in the same vein could not but have made a deep impression on Vermeer; encounters between the sexes is a subject that clearly interested both. Instead of painting an entire room, Vermeer limited his composition to a corner by a window, thus concentrating, on the one hand, on the arrangement of the figures in the space (and thus on the meeting of the man and woman), and, on the other, on the effects of the brilliant sunlight. Strikingly, De Hooch's interiors appear more accessible than Vermeer's. Although the officer functions as a repoussoir, he effectively blocks our access to the image.[66] De Hooch was not given to placing figures so prominently in the foreground and found other means of creating the illusion of three-dimensional reality. As a result his scenes seem less remote, but the figures appear less tangible, less physically present.

203

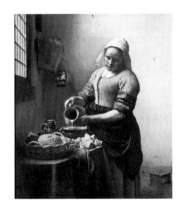

The concentration on the figure and the illusion of its proximity is even more pronounced in *The Milkmaid* (fig. 200). Despite the modest size of the canvas there is a larger-than-life, monumental quality about the young woman. In Northern Netherlandish painting of the seventeenth century we would have trouble finding a figure of comparable monumentality. This is of course the result of the almost physical, plastic impression she makes. Even more so than in the *Officer and Laughing Girl*, she stands free of the wall, in three-dimensional space. To achieve this effect Vermeer drew a fine white line along the contour of her right shoulder and emphasised the contrast between the bright illumination of her upper body and the shading of the white background. The effectiveness of these stylistic ploys is enhanced by the sublime modelling of her body and costume. Her skin is rendered meticulously, moreover, with myriad dabs of paint in various tones; seen at a distance they coalesce, creating a highly naturalistic impression.[67]

This figure, too, stands in a corner of a room, where in the light of a window she pours milk from a pitcher into a brown earthenware bowl. Like De Hooch, Vermeer preferred moments of concentration, when his figures appear 'frozen' if only for a second. That fleeting quality – of which one is oblivious in daily life – accounts in part for the fascination of his work. Vermeer was fond of contrasting the ephemeral and the perpetual, and of elevating the one to the level of the other. As we have said, Vermeer designed his pictures in such as way as to focus all attention on the figure. The oblique edge of what is in fact not a rectangular but a trapezial table leads the eye to the woman. The same applies to the orthogonal recession: every detail propels the observer in her direction. Vermeer seems consciously to limit his field of vision and to concentrate on both the woman and the light playing on the still life on the table.

Curiously, Vermeer never depicted children, as De Hooch was wont to do. In such scenes De Hooch seems to allude to the adage 'Like mother, like daughter': the older

generation setting an example for the younger. De Hooch was thus reminding his contemporaries of how the ideal mother should behave. Vermeer's picture of *The Milkmaid* serves the same purpose. Lost in her work, she is utterly oblivious of the beholder. Vermeer thus compels the spectator to identify with the woman so completely that he experiences the scene through her eyes, becoming part of her world and looking at it from her perspective.[68] Like the women with children in De Hooch's art, she is a realistic personification of the devoted mother and virtuous housewife.

Unlike most seventeenth-century artists, who aimed at telling moralising stories as clearly as possible, Vermeer and De Hooch leave much to the viewer's imagination. The interpretation of the image takes place primarily on an associative level. Both artists have this in common with Gerard Terborch who, as Sturla Gudlaugsson has noted, understood that an artist could hold the attention of his audience by concealing something of the meaning and subject of his work.[69]

While we saw that in the late 1650s Vermeer availed himself of elements he had witnessed in the work of De Hooch, in the first half of the 1660s De Hooch seems to have looked at the work of Vermeer and even quoted it quite literally. Thus he based *A Woman Weighing Gold and Silver Coins* (fig. 202), painted circa 1664, on a similar composition by

204

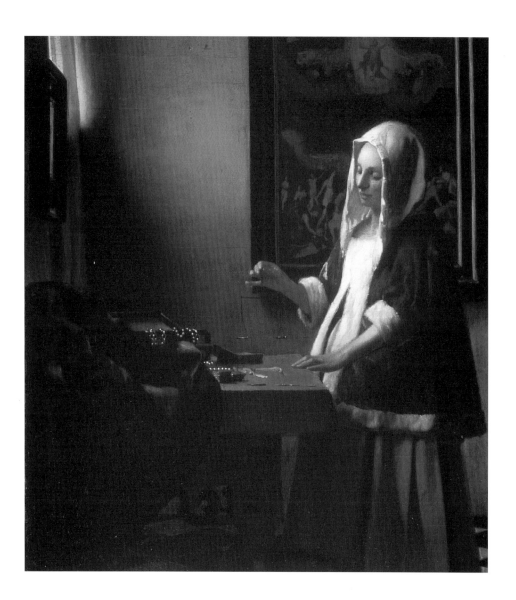

fig. 201
JOHANNES VERMEER
A Woman Holding a Balance,
c. 1662-1664
canvas; 42.5 x 38 cm
Washington, D.C., The National
Gallery of Art, Widener Collection,
inv. no. 693

Vermeer. An intriguing comparison can be drawn between the vision and conception of *A Woman Holding a Balance* (fig. 201) by Vermeer and the painting by De Hooch. Vermeer depicted an angle of a dimly lit interior. A band of light from the upper left illuminates the head of a woman who, dressed in a white hood and a dark blue, fur-trimmed jacket, holds a balance in her right hand. On the table before her lie coins and strands of pearls. A *Last Judgement* hangs on the wall.

The contrast between the treatment of the foreground and the theme of the picture in the background reminds the observer of the brevity of human life and the eternity of the hereafter. God will weigh our souls on Judgement Day and separate the wheat from the chaff once and for all. Recently the point was made that the tranquil expression of the woman, who appears to have no fear of the future, seems to defuse the implicit warning, and that the pans of the balance are empty. Indeed, this complicates the iconographical programme: what does the woman's action mean if the balance is in fact empty? Although we can do no more than guess at the precise significance of these various elements, the canvas undoubtedly affirms the necessity of moderation and balanced judgement.[70]

Thanks to the carefully considered placement of the figure and to the selective

fig. 202
PIETER DE HOOCH
A Woman Weighing Gold and Silver Coins, c. 1664
canvas; 61 x 53 cm
Berlin, Staatliche Museem zu Berlin – Preußischer Kulturbesitz, Gemäldegalerie, inv. no. 1041B

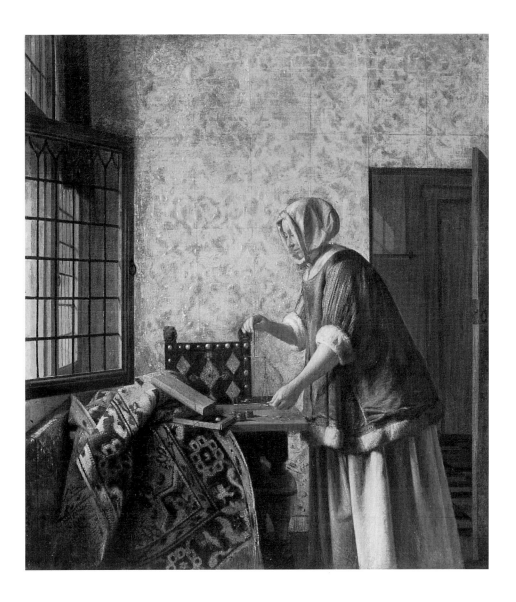

lighting, we immediately recognise the woman with the balance as the subject of the canvas. Yet we cannot fail to notice the picture in the background, as the figure of Christ hangs just above the head of the woman. Vermeer thus emphasised the thematic parallels between the scene and the painting on the wall. He accentuated the balance, moreover, by placing it almost directly before the vanishing point, so that we cannot fail to miss it.

The atmosphere of De Hooch's *Woman Weighing Gold and Silver Coins* differs considerably from that of Vermeer. As the reddish gold lighting is far more even, both the woman and the space in general are more brightly lit. Vermeer chose to emphasise the woman and especially her action by means of highlights. Whereas the woman in Vermeer's work holds a clearly visible – but apparently empty – balance, the one in De Hooch's is placing coins in the pans, and the balance itself is difficult to distinguish from the chair in the background. Vermeer's composition is inconceivable without the woman, but De Hooch's would hold visual interest even if she were not there. As always, De Hooch could not resist emphasising the geometrical structure of the room. We are also given a glimpse of the hall beyond, with – interestingly – a mirror that reflects the hall window. The detail apparently appealed to him, more so than whatever meaning, moral or otherwise, it may have had.

The contrast between the two artists is evident in their later work as well. Vermeer's *The Love Letter* is a good example (fig. 203). Here Vermeer employed trompe l'oeil motifs in the foreground, like those that occur so often in the work of Fabritius and Van Hoogstraten. A curtain has been drawn aside to reveal an open doorway to a room where a woman can be seen with her maid. Surprised by the letter she has just received, she stops her musicmaking and regards the servant with a somewhat anxious expression. Note the trompe l'oeil motifs such as the books on the red chair at the left. The wall in the left foreground is covered with a map of the Seven Provinces, which guides the eye into the depth as a repoussoir. As he was wont to do, Vermeer blocks our access to the image with a broom and a pair of shoes, heightening the sense of a perspective box, or 'peep-show'. We do not belong to the same universe as the woman and her maid; we cannot step into the scene, as it were. Interestingly, Vermeer does not reveal the source of light in this case, which lifts the two figures out of the image and accentuates them.

The theme of men and women writing letters was especially popular in the third quarter of the seventeenth century. It was treated not only by Pieter de Hooch, but also (and more especially) by Gabriel Metsu and Frans van Mieris. Although we can never be certain, in this case the letter seems to be amorous. As ships are the playthings of the fickle elements, the marine views in the background would have reminded contemporaries of the vicissitudes of love. If we compare this painting with *Two Women beside a Linen Chest* (see figure 149) from about the same period as Vermeer's painting, we see that De Hooch did not really succeed in creating a relationship between the figures, as Vermeer did. The maid holding the stack of linen stares into space, and could just as easily have stood anywhere else in the composition. In Vermeer's canvas the two women actually interact, on the other hand, and indeed the entire image is designed to ensure we focus on their interaction.

fig. 203
JOHANNES VERMEER
The Love Letter, c. 1670-1672
canvas; 44 x 38.5 cm
Amsterdam, Rijksmuseum,
inv. no. A 1595

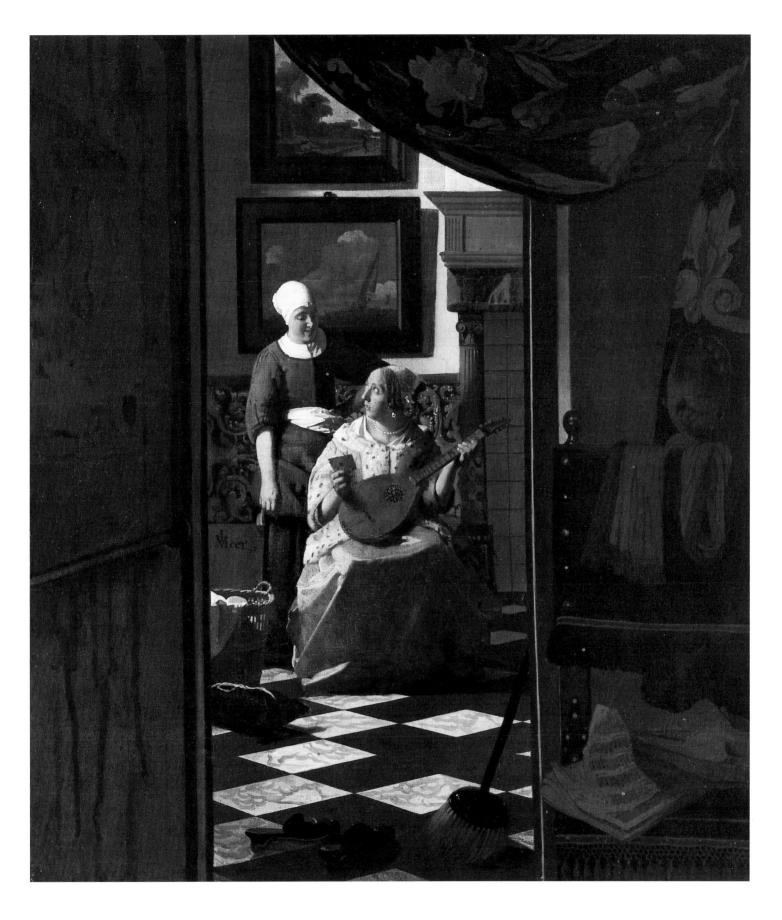

Three hundred years ago, on 16 May 1696, twenty-one of Vermeer's paintings were sold at Amsterdam. They belonged to the estate of the Delft printer Jacob Abrahamsz Dissius, who owned the printer's shop 'The Golden ABC' on Market Square. The announcement of the sale speaks of "21 pieces extraordinarily powerful and beautifully painted by the late J. Vermeer of Delft, depicting various Compositions, being the best that he ever made."[71] These included *The Milkmaid* (see figure 200), which is described in the catalogue as "exceptionally good [uytnemende goet]." Using such glowing terms to describe an artist's work would seem to guarantee eternal renown. In the eighteenth and much of the nineteenth century, however, Vermeer's reputation seemed far less secure. Because the artist left a relatively small oeuvre, his work did not often occur in sales of the 1700s and early 1800s. As a result, he was much less well known than Rembrandt or Dou. Collectors and connoisseurs have always admired his art and sometimes paid large sums for it. Rehabilitated in the mid-nineteenth century, his works are now among the most cherished possessions of many institutions. Their rarity has naturally played an important role in this, but Vermeer's popularity would never have reached such heights if there were not something elusive about his art. This timeless aspect, the 'Vermeer mystique', as it were, leaves critics no choice but to discuss it in rather unscientific, intuitive language. Vermeer fully realised that works of art only retain their actuality if they can be interpreted afresh by each successive age. He thus gave his admirers the opportunity to construe his art in more ways than one.

As we have seen, Vermeer could not have managed to create works of such virtuosity and universal appeal had it not been for his contemporaries. The Delft interiors of Pieter de Hooch were crucial to his success. Without these phenomenal domestic interiors, with their silvery light and orderly space, the paintings of Vermeer would have looked very different.

1 Liedtke 1993, pp. 90, 93 and note 2; Wheelock 1995, pp. 1-2.

2 Houbraken 1718-1721, vol. 2, pp. 34-35.

3 For more on the journey that Berchem may have made to Italy, see Jansen 1985, pp. 13-17; in Amsterdam 1993, p. 130, Peter Schatborn doubts that Berchem ever went to Italy.

4 Sutton 1980-A, p. 145, doc. no. 14.

5 See Sutton 1980-A, pp. 145-147, doc. nos. 14, 20, 22, 24, 28.

6 Sutton 1980-A, p. 9 and pp. 145-146, doc. nos. 18, 19 and 21.

7 Sutton 1980-A, p. 10 and p. 147, doc. no. 50.

8 Ronald Fleischer has concentrated primarily on the very beginning of De Hooch's career, especially the period until c. 1657. He has devoted particular attention to De Hooch's relations with the Rotterdam painter Ludolf de Jongh (see Fleischer 1978). In 1980 Peter Sutton published an extensive monograph on De Hooch along with a catalogue raisonné; the present essay follows the course of development sketched in that book, and could not have been written without the benefit of Sutton's exemplary scholarship (see Sutton 1980-A). Wilhelm Valentiner's monograph from 1929, of which an English translation appeared in 1930, is still worth reading. The small book in Dutch about De Hooch by Fr. van Thienen (Van Thienen n.d.) is very readable as well.

9 On the peasant scenes of Adriaen Brouwer that belonged to Delft collections around 1650, see Plomp 1986, pp. 108-09.

10 Sutton 1980-A, p. 12 and fig. 2.

11 On the peasant genre in Rotterdam, see Roel James in Rotterdam 1994, pp. 132-41, and cat. nos. 50 and 51. On Brouwer's influence on Sorgh, see Sutton 1980-A, pp. 11-12 and fig. 2.

12 For more on De Jongh and his relations with De Hooch, see Fleischer 1978.

13 Pieter De Hooch could have met Gerard Terborch in Delft, for in 1653 Terborch was in the city. This is documented by a notarial act that he signed at the time, together with Johannes Vermeer. See Blankert 1987, p. 210 (doc. dated 22 April 1653). A painting by Terborch belonged to a Delft private collection, furthermore. For more on this, see Plomp 1986, pp. 103-10. That De Hooch already knew the work of Terborch in the first half of the 1650s is evidenced by his *Bearer of Ill Tidings*, which is a repetition of Terborch's *Unwelcome News*: See Sutton 1980-A, cat. no. 16, pl. 15 and fig. 5.

14 In the foreground, where the dead birds now lie, De Hooch had originally painted a soldier whose wound was being dressed by the seated one. In his monograph on the artist Peter Sutton notes that the overpainting created a new theme that is "virtually unique in the guardroom tradition." See Sutton 1980-A, p. 14 and note 20.

15 Van Thienen places particular emphasis on this point. See, for example, pp. 36-38.

16 The Hague/San Francisco 1990-1991, cat. no. 35, pp. 303-04. See now also Wayne E. Frantis, *Paragons of Virtue, Women and Domesticity in Seventeenth-Century Dutch Act* (Cambridge, Mass 1995²).

17 Cf. Blankert 1987 (1992), p. 83.

18 Roscam Abbing 1993, pp. 10 and 41.

19 Blankert 1987, p. 81.

20 Sutton 1980-A, p. 20 notes that the correspondences between the work of De Hooch and Maes around 1658 are one further indication that there was interest in perspective and illusionism in both Delft and Dordrecht. They both used unmixed pigments in a similar manner, moreover, to give bright and lively colour accents. But in addition to these stylistic and compositional parallels, there are also thematic ones: both painters display an interest in women engaged in their daily activities. Pictures of this type could all be grouped under the title *The Good Housewife*.

21 Sutton 1980-A, p. 20.

22 See Leiden 1988, p. 14, fig. 3.

23 Sutton 1980-A, pp. 22-23.

24 On the exact meaning of the word 'juffertjes', see Blankert in Washington/The Hague 1995-1996, pp. 32-33.

25 Philadelphia/Berlin/London 1984, pp. 200-01, cat. no. 43.

26 See The Hague/San Francisco 1990-1991, pp. 303-04 concerning the official (but nonetheless anachronistic) title of this painting (*The Bedroom*), which is why *The Bedstead* is given as the title here as well.

27 Sutton 1980-A, p. 147, doc. nos. 40, 43, 45.

28 For more on Vermeer's perspective constructions, see Jorgen Wadum in Washington/The Hague 1995-1996, pp. 67-79.

29 See Sutton 1980-A, pp. 29-30 for an excellent stylistic comparison between De Hooch's Delft and Amsterdam periods.

30 The Hague 1990-1991, pp. 298-99, cat. no. 34.

31 On Ludolf de Jongh, see Fleischer 1978 and Fleischer and Reiss 1989, but also Rotterdam 1994, pp. 284-85 for biographical details and literature, as well as Philadelphia/Berlin/London 1984, p. 223, and finally also Scholten 1992.

32 Houbraken 1718-1721, vol. 2, p. 33.

33 One example of this is De Jongh's *View of a Courtyard* in New York (fig. 103) which has much in common with De Hooch's *Woman and Maid in a Courtyard* in London (fig. 102).

34 See Fleischer and Reiss 1989, p. 74, esp. note 30. Although this painting is signed by De Jongh, until well into this century it was still thought to be by the hand of De Hooch.

35 See Kuretsky 1979, cat. no. 51 and pp. 34-39.

36 On Van der Burch, see esp. Sutton 1980-B.

37 Sutton 1980-B, p. 326, doc. nos. 16, 17 and 19.

38 Sutton 1980-B, *passim*. Owing to the lack of clear criteria, it is not surprising that of the 39 pictures that were assigned to him before World War Two, many have since been given to other painters in De Hooch's circle.

39 When the painting was restored in 1995, it became evident that it was unfinished. This occurs rather rarely. Written communication from George Keyes to the Museum Het Prinsenhof, November 1995.

40 Like many paintings of the 'Delft School', this one was also attributed to Pieter de Hooch, but was given to Hendrick van der Burch by C. Hofstede de Groot in 1921. They are very close to a painting signed by that artist: *Woman with a Jug in a Courtyard* now in the Krannert Art Museum, Champaign, Illinois (see p. 119, fig. 107). See also Hofstede de Groot 1921, pp. 16-124.

41 Frontal views of windows through which the observer can see outside are also found in two works by Hendrick van der Burch. R. Fleischer and S. Reiss have now attributed both to Ludolf de Jongh: see Fleischer and Reiss 1993. The two pictures in question are *The Terrace* (canvas; 111.5 x 73.2 cm), Art Institute of Chicago, inv. no. 1948.81 (Valentiner 1929, KdK 251), and *Officer at a Window* (canvas; 112.5 x 70), whereabouts unknown (Valentiner 1929, KdK 243). As Sutton remarks (1980-B, pp. 324-25), it is confusing that the white earthenware pitcher is also found in *The Terrace*, as is the view of a wall with windows. He also reminds us (*ibid.*, p. 323) that Fabritius painted a 'little window' (*raempge*), which could have been the source of this motif.

42 See Sutton 1980-A, p. 90, no. 47 and Valentiner 1929, nos. 232 and 32. The attribution of this painting was made by Valentiner, who was the first to note its stylistic resemblance to no. 32 (New York, Metropolitan Museum).

43 See als Sutton 1980-A, cat. nos. 55 (1663-65), 56 (1663-65), 57 (1663-65), 58 (1663-65), 64 (c. 1664) for comparable interiors by De Hooch

44 On Vrel see Brière-Misme 1935B; on Boursse see Brière-Misme 1954A; on Janssens Elinga see Brière-Misme 1947-1948. For a more recent discussion of all three artists, see also Philadelphia/Berlin/London 1984, pp. 352 (Vrel), 155 (Boursse), 202 (Janssens Elinga).

45 Haak 1984, p. 453.

46 Peter Sutton in Philadelphia/Berlin/London 1984, pp. 353-54, cat. no. 123.

47 Amsterdam 1976, pp. 48-49, cat. no. 5.

48 See Philadelphia/Berlin/London 1984, p. 203.

49 *Ibid.*

50 The rigid structure of his compositions suggests to Sutton (1980-B, pp. 52-53) that Elinga relied heavily on perspective handbooks for artists.

51 See Sutton in Philadelphia/Berlin/London 1984, pp. 127, 361.

52 For the most thorough biography of De Man, with extensive bibliography, see Cynthia von Bogendorf-Rupprath in Philadelphia/Berlin/London 1984, p. 243.

53 See Chapter Two.

54 Blankert 1987, p. 122, plate 17; Washington/The Hague 1995-1996, pp. 128-33, cat. no. 8.

55 De Vries 1939, p. 63.

56 The Hague 1979-1980, p. 164, cat. no. 198.

57 The attribution to Cornelis de Man is not certain. Many motifs deviate from those in other works by the same artist. Hendrick van der Burch, or perhaps even Ludolf de Jongh, could just as easily have painted the canvas. The mirror motif is also found in a picture preserved in the National Gallery, London, which was recently attributed to De Jongh by Ronald Fleische.

58 Amsterdam 1976-B, pp. 150-53, cat. no. 35.

59 On the erotic significance of the feminine footwear, see Amsterdam 1976, pp. 244-45, cat. no. 64,

60 Rosenberg, Slive and Ter Kuile 1971, p. 217.

61 See the various publications by C. Brière-Misme listed in the bibliography.

62 Blankert 1987 (1992), p. 137.

63 Valentiner 1929, p. 254.

64 See Frankfurt 1993-1994, p. 228, cat. no. 47.

65 Sutton 1980-B, p. 145, doc. no. 17.

66 In the late 1650s Pieter de Hooch painted a series of depictions of women working beside windows. The prominence of these motifs in the image could have been inspired by Vermeer's pictures, such as *The Milkmaid*, for instance.

67 Wheelock 1995, p. 66.

68 Interview conducted by Dutch television with Arthur Wheelock, Jr. on the day the Vermeer exhibition opened in Washington, DC, November 1995.

69 Gudlaugsson 1960, p. 9.

70 Wheelock 1995, p. 100.

71 "21 stuks uitnemend krachtig en heerlyk geschildert, door wylen J. Vermeer van Delft, verbeeldende verscheidene Ordonnantien, zynde de beste die hy ooit gemaekt heeft." Blankert 1987 (1992), p. 216.

210

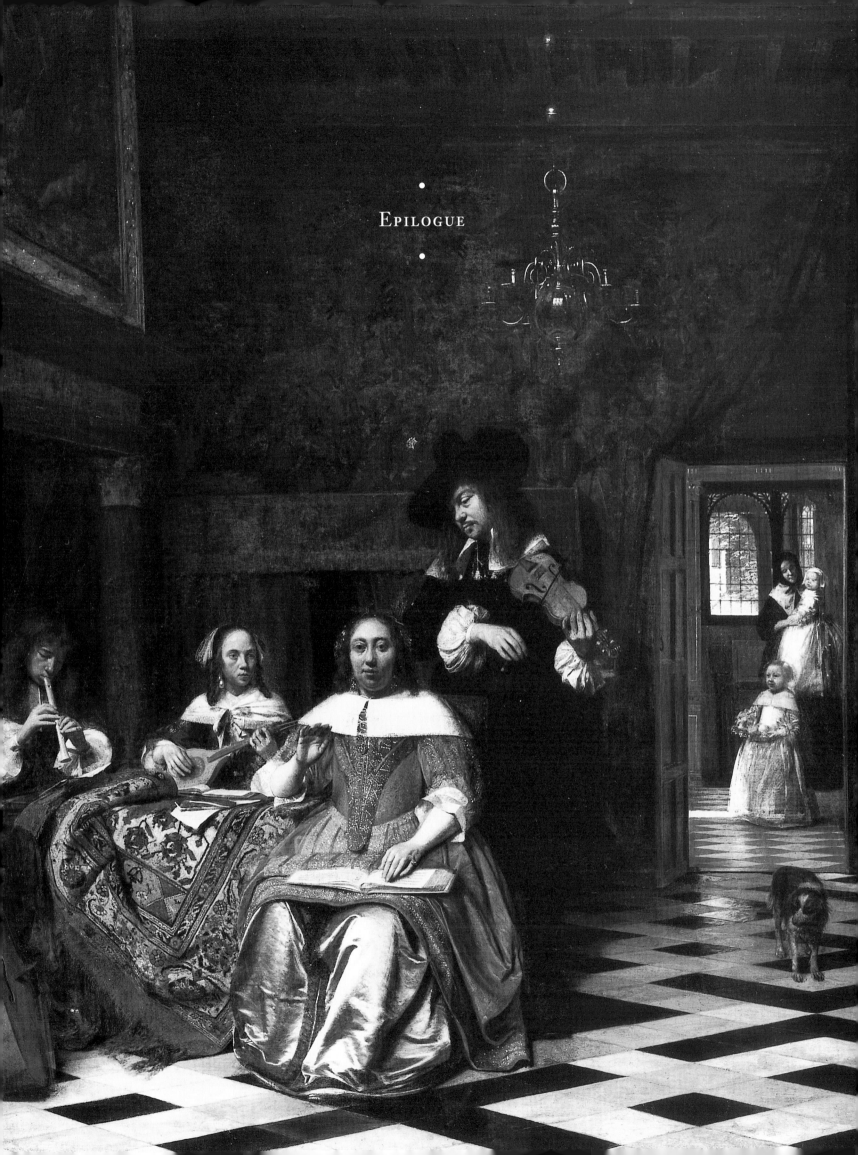

EPILOGUE

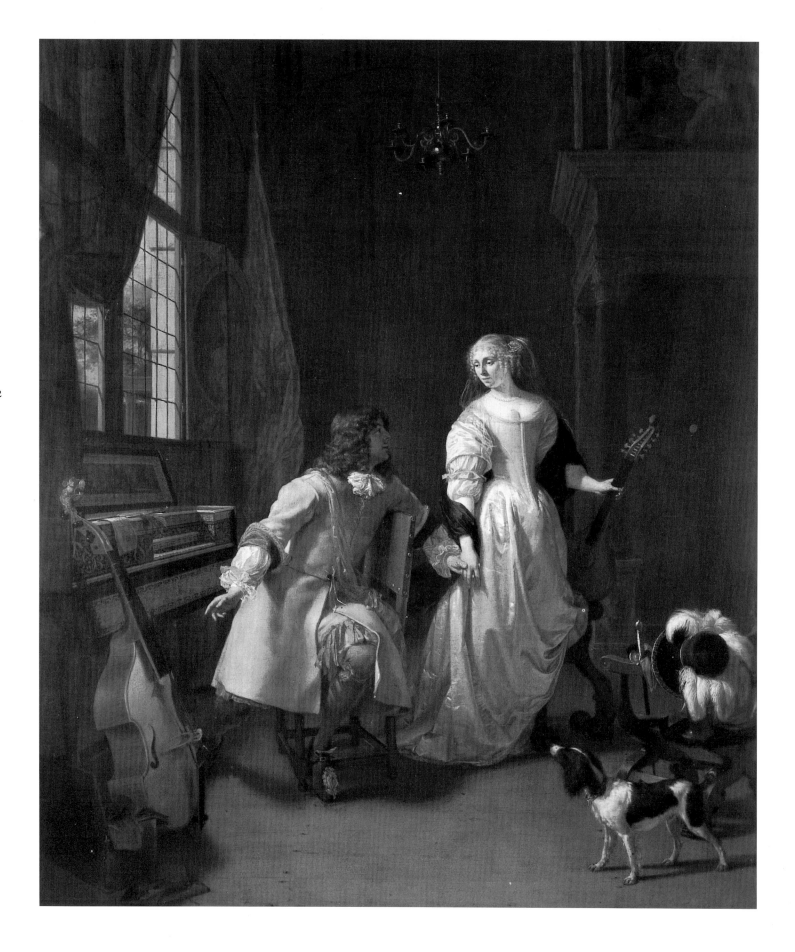

Epilogue

fig. 204

JOHANNES VERKOLJE
Elegant Couple in an Interior, 1674
(or 1671)
canvas; 96.3 x 82 cm
London, sale (Sotheby's),
7 December 1994, lot 18

Just as suddenly as Delft had become a leading centre of painting in the 1650s, in the course of the 1670s it reverted to being a small backwater, bereft of any really important artists.[1] Gerard Houckgeest had already settled in Steenbergen (near Bergen op Zoom) in the spring of 1651. Around 1651 Emanuel de Witte moved to Amsterdam, followed by Pieter de Hooch in 1660/1661. Carel Fabritius died in the gunpowder explosion of 1654. After such auspicious beginnings in the 1660s, Johannes Vermeer, Cornelis de Man and Hendrick van Vliet were the only painters who remained. In the centuries that followed, the art of Vermeer – even more so than that of Pieter de Hooch – would be identified with Delft. Vermeer understood the consequences of the new approach being taken by De Hooch, Frans van Mieris and other contemporaries, and brought them to perfection.[2] Stagnation than set in, however, and in contrast to Rembrandt and De Hooch, Vermeer did not generate a school.

Delft was simply too small to support an artistic community of any size. There were no major commissions to be had and, if only for that reason, it was impossible for ambitious painters to make a mark for themselves. Famous artists such as Gerard Lairesse (1640-1711) and Adriaen van der Werff (1659-1722) worked in large centres such as Amsterdam or Rotterdam. The career of the Delft still-life painter Willem van Aelst (1627-after 1683) is indicative. Upon his return from Italy, where the young artist had earned an excellent reputation, he opted not to settle in his native town, but rather in Amsterdam. Nor, ironically, did the improving communications in Holland do anything to strengthen Delft's hand. On the contrary: easier access to The Hague and Amsterdam meant that local patrons were more likely to have their portraits painted there, despite the fact that portraiture had long been a specialty of Delft.

The only painter still worth mentioning, who was single-handedly responsible for a sort of Indian summer in Delft painting, is Jan Verkolje (1650-1693). According to the biographer Arnold Houbraken, Verkolje, who was originally from Amsterdam, studied under Jan Andries Lievens (1644-1680), in whose studio he finished genre pieces by Gerard Pietersz van Zijl (1619-1665). In 1672, three years after Vermeer had died, Verkolje

arrived in Delft. The attraction was presumably a resident of the city by the name of Judith Voorheul, for in October of that same year the two were married. Six months later Verkolje registered in the local guild of St Luke, of which he later served as headman between 1678 and 1688. In Delft he specialised in mythological subjects and fashionable genre scenes. The latter betray the influence of Gabriel Metsu and more especially Gerard Terborch.

There is some evidence to suggest that Verkolje was also inspired by De Hooch. In the 1670s, at just about the time Verkolje came to Delft, the atmosphere and palette of his works became notably lighter.[3] One example of this development is *Elegant Couple in an Interior* (fig. 204). In a tall, fashionably decorated room a young man can be seen who, turning away from a virginal, takes the hand of a young lady. Gazing at her, he points at a viola da gamba. A small dog in the background watches them. The placement of the figures in the space is balanced and the compositional scheme, with the window on the left and the hearth on the right, could be derived from De Hooch. But whether or not the canvas is indebted to the master, it is not representative of his school (see Chapter Four). The sunlight is too subdued and the particular illusion of three-dimensional reality, including the (almost obligatory) vista, which one associates with De Hooch, is lacking. Even the Delft 'origin' of the work is imperceptible, as, indeed, is that of Verkolje's other late oeuvre. The refined technique, the meticulous handling of texture and the elegant poses of the figures in his paintings are characteristic not so much of any city in particular as of seventeenth-century Dutch art as a whole. The distinguishing features of a given school have been supplanted by a general, finished, and academic style that points to French classicism.

There is no obvious lesson or moral in *Elegant Couple in an Interior* like those that are embedded in so many seventeenth-century Dutch genre pieces, in contrast to *The Messenger* (fig. 205). An elegantly dressed lady and a gentleman are shown playing trictrac; the woman is seen from the back, so that her brilliantly rendered white silk dress catches the light. Just as she raises her hand to toss the dice, a messenger enters. From his evident bewilderment and the anxious expression of the man, we may infer the news is bad. The trictrac game holds the key to the significance of the painting. In the seventeenth century it was called 'verkeerspel', or literally 'game of change', from the verb 'verkeren', meaning to vary, to change, to turn around. This explains the alternate title of the painting, *'t Kan verkeren* (Things can change), the motto of the popular poet Gerbrand Adriaensz Bredero (1585-1618).[4] One's luck can change from one moment to the next. The belief that our lives, and more especially those of the rich and powerful, are subject to the whims of fate, was widely held by contemporaries. Any number of paintings could be adduced that were meant to propagate this message, sometimes even more explicitly. The moral of this painting, 'Things can change', would be an appropriate title for this epilogue, for around 1700, when Verkolje laid down his brush, painting in Delft suffered a definitive reversal.

Having attained such dizzying heights so swiftly, the fall of painting in Delft was that much more profound. But the city was not alone in its ignominy. Delft's experience was indicative of a general tendency in the Republic, which made itself felt in the 1670s and '80s. Many specialties had reached full maturity and therefore ceased to develop. The younger generation brought renewal only in certain points and the quality of their work was generally inferior to that of their forerunners. The artistic decline more or less paralleled that of the Dutch economy. In the second half of the seventeenth century trade

and industry in the Republic were on the downgrade. The wars with England and France in the 1650s, '60s and '70s were a sign that the nearly limitless freedom of the Dutch on the high seas was no longer tolerated. The stagnating population of Europe had serious repercussions for agriculture as well. Notwithstanding the occasional upturn, this trend would continue well into the eighteenth century.

The economic decline we have just outlined must have been felt particularly in Delft.[5] The population shrank dramatically, for instance. While there were still twenty-four thousand souls living in the city in 1680, by 1733 that number had dropped to only fifteen thousand. Famine and poor health conditions were the main culprits. Apart from Delft-ware, local industries fell upon hard times. Owing to the grave straits it was in the city lost its economic allure and immigration ground to a halt. The commercial and service sectors of the economy remained intact, but their importance diminished as a result of the dwindling population and the growing competition from The Hague and Rotterdam. How these misfortunes directly affected the life of a painter becomes clear from the account of the death of Johannes Vermeer by his widow: "during the long and ruinous war with France not only had [my husband] been unable to sell any of his art but also, to his great detriment, was left sitting with the paintings of other masters that he was dealing in. As a result and owing to the very great burden of his children, having no means of his own, he had lapsed into such decay and decadence, which he had so taken to heart that, as if he had fallen into a frenzy, in a day or day and a half he had gone from being healthy to being dead."[6] However exaggerated this story may or may not be,[7] it nonetheless gives some idea of the serious consequences such external factors could have for artists and dealers.

The malaise of Delft was not lost on its inhabitants. The Municipal Archives are full of complaints about "the decline and diminution of the citizens of this city and the unemployment."[8] Attempts were made to turn the tide, but to no avail.

Notes

1 See B.M. van der Goes, "De schilderkunst in Delft en Delfshaven [1667-1813]," in Delft 1982-1983, pp. 126-29.

2 Blankert 1987, p. 148.

3 Philadelphia/Berlin/London 1984, no. 115 (repr.).

4 The message is underscored by the painting in the background, showing *The Death of Adonis*. (Paintings within paintings, which served to clarify the moral, are quite common.) The goddess Venus discovers the lifeless body of her beloved Adonis, signifying that even the fortunes of the gods could take an unexpected turn for the worse. See also *De Rembrandt à Vermeer. Les peintres hollandais au Mauritshuis de la Haye*, Galeries nationales du Grand Palais, Paris 1986, pp. 346-49.

5 Delft 1982-1983, pp. 45-64.

6 "Tijdens de langdurige en verwoestende oorlog met Frankrijk was het [mijn man] niet alleen onmogelijk zijn werk te verkopen, maar bovendien was hij, tot zijn schade, blijven zitten met de schilderijen van andere meesters met wie hij handel dreef. Dientengevolge en ook vanwege de belasting van zijn kinderen, terwijl hij van zichzelf in het geheel niet over middelen beschikte, raakte hij zozeer in razernij en verval dat hij in een of anderhalve dag van een gezonde toestand overging in de dood." Quoted by Blankert 1987, p. 57; trans. Montias 1989, p. 212.

7 Montias 1989, p. 212.

8 "het verval ende vermindering dezer stede burgerij en de neeringloosheid"; see Delft 1982-1983, p. 59.

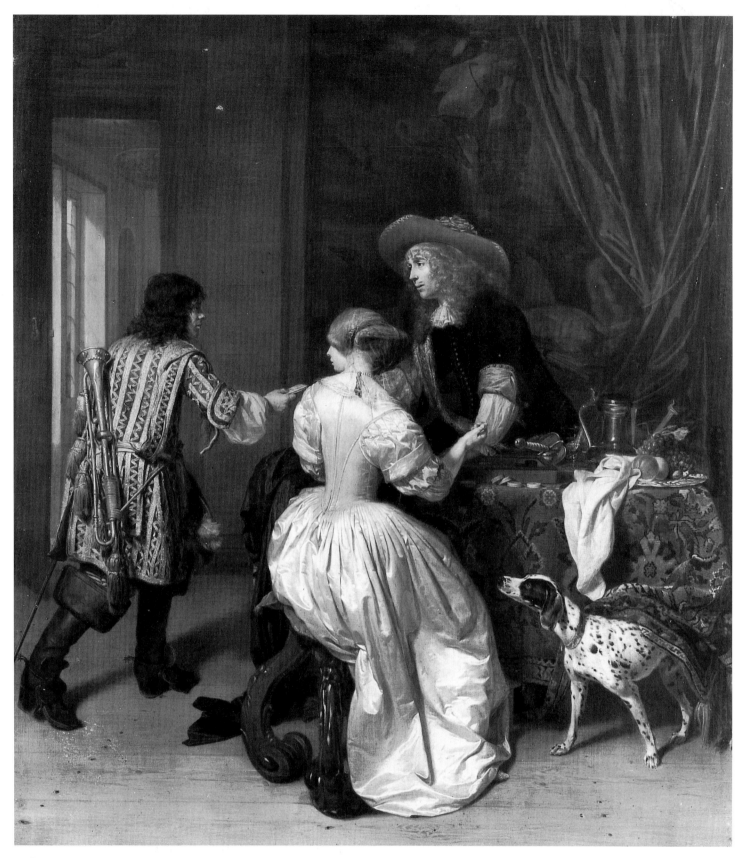

fig. 205
JOHANNES VERKOLJE
The Messenger, 1674
canvas; 59 x 53.5 cm
The Hague, Koninklijk Kabinet
van Schilderijen Mauritshuis,
inv. no. 865

Bibliography

AA 1852-1878
A.J. van der Aa, *Biographisch Woordenboek der Nederlanden*, 7 vols. (and supplement), Haarlem (repr. Amsterdam 1969) 1852-1878

AMSTERDAM 1976-A
Amsterdam, Rijksmuseum, *Alle schilderijen van het Rijksmuseum te Amsterdam*, by P.J.J. van Thiel et al., 1976

AMSTERDAM 1976-B
Amsterdam, Rijksmuseum, *Tot lering en vermaak. Betekenissen van Hollandse genrevoorstellingen uit de zeventiende eeuw*, by E. de Jongh et al., 1976

AMSTERDAM 1986
Amsterdam, Rijksmuseum, *Kunst voor de beeldenstorm. Noordnederlandse kunst 1525-1580*, 1986

AMSTERDAM 1989
Amsterdam, Rijksmuseum, *De Hollandse Fijnschilders: van Gerard Dou tot Adriaen van der Werff*, by P. Hecht, 1989

AMSTERDAM 1993-A
Amsterdam, Rijksprentenkabinet, *Tekeningen van Oude Meesters. De verzameling Jacobus A. Klaver*, Zwolle (by M. Schapelhouman and P. Schatborn)

AMSTERDAM 1993-B
Amsterdam, Rijksmuseum, *Meeting of Masterpieces: De Hooch-Vermeer*, 1993

AMSTERDAM 1993-1994
Amsterdam, Rijksmuseum, *Dawn of the Golden Age. Northern Netherlandish Art 1580-1620*, 1993-1994

AMSTERDAM/BOSTON/PHILADELPHIA 1987-1988
Amsterdam, Rijksmuseum, *Masters of 17th-Century Dutch Landscape Painting*, by P. Sutton, 1987

AMSTERDAM/TORONTO 1977
Amsterdam, Amsterdams Historisch Museum, *Opkomst en bloei van het Noordnederlandse stadsgezicht in de 17de eeuw*, 1977

ARASSE 1994
D. Arasse, *Vermeer: Faith in Painting*, New Jersey 1994

ASEMISSEN 1989
H.U. Asemissen, *Vermeer. L'Atelier du peintre ou l'image d'un métier*, Paris 1989

BADT 1961
K. Badt, *Modell und Maler von Jan Vermeer: Probleme der Interpretation. Eine Streitschrift gegen Hans Sedlmayr*, Cologne 1961

BERGER 1972
H. Berger, "Conspicious Exclusion in Vermeer: An Essay in Renaissance Pastoral," *Yale French Studies* 47 (1972), p. 243

BERLIN 1986
Berlin, Gemäldegalerie Staatliche Museen Preußischer Kulturbesitz, *Gemäldegalerie Berlin. Gesamtverzeichnis der Gemälde*, Berlin 1986

BIACONI 1967
P. Biaconi, *The Complete Paintings of Vermeer*, New York 1967

BLADE 1971
T.T. Blade, "Two Interior Views of the Old Church in Delft," *Museum Studies, The Art Institute of Chicago* 6 (1971), pp. 34-50

BLANKERT 1977
A. Blankert et al., *Johannes Vermeer van Delft 1632-1675*, Utrecht/Antwerp 1977 (revision of 1975 ed.)

BLANKERT 1987
A. Blankert, J.M. Montias, G. Aillaud, R. Ruurs, W.L. van de Watering and P. Resche-Rignon, *Vermeer*, Amsterdam 1987 (2nd ed.)

BLEYSWIJCK 1667
D. van Bleyswijck, *Beschryvinge der Stadt Delft*, (2 vols.) Delft 1667. Supplement 1674

BLOCH 1954
V. Bloch, *Tutta la pittura di Vermeer di Delft*, Milan 1954

BLOCH 1963
V. Bloch, *All the Paintings of Jan Vermeer*, New York 1963

BLUM 1946
A. Blum, *Vermeer et Thoré-Bürger*, Geneva 1946

BODE AND BREDIUS 1905
W. von Bode and A. Bredius, "Esaias Boursse. Ein Schüler Rembrandts," *Jahrbuch der königliche preußischen Kunstsammlungen* 26 (1905), pp. 65-78

BOER 1988
P.G. de Boer, *Enkele zeventiende-eeuwse kerkportretten opnieuw bekeken*, Delft, 1988 (diss.)

BOSTRÖM 1950
K. Boström, "De oorspronkelijke bestemming van C. Fabritius' Puttertje," *Oud Holland* 65 (1950), pp. 81-83

BOSTRÖM 1951
K. Boström, "Jan Vermeer van Delft en Cornelis van der Meulen," *Oud Holland* 66 (1951), pp. 117-22

BOURICIUS 1925
L.G.N. Bouricius, "Vermeeriana," *Oud Holland* 42 (1925), pp. 271-73

BRUNSWICK 1983
Brunswick, Herzog Anton Ulrich-Museum, *Niederländische Malerei aus der Kunstsammlung der Universität Göttingen*, 1983

BREDIUS 1880
A. Bredius, "Cornelis de Man," *Nederlandsche Kunstbode* 2 (1880), p. 375

BREDIUS 1881-A
A. Bredius, "Iets over de Hooch," *Nederlandsche Kunstbode* 3 (1881), p. 126

BREDIUS 1881-B
A. Bredius, "Nog eens de Hooch," *Nederlandsche Kunstbode* 3 (1881), p. 172

BREDIUS 1882-1883
A. Bredius, "Een schilderij der gebroeders Vosmaer, 'geretrukeert' door Carel Fabritius," F.D.O. Obreen, *Archief voor Nederlandsche Kunstgeschiedenis*, vol. 5, Rotterdam 1882-1883, pp. 167-69

BREDIUS 1885
A. Bredius, "Iets over Johannes Vermeer ('De Delftsche Vermeer')," *Oud Holland* 3 (1885), pp. 217-22

BREDIUS 1888
A. Bredius, "De Haagsche schilders Joachim en Gerard Houckgeest," *Oud Holland* 6 (1888), pp. 81-86

BREDIUS 1909
A. Bredius, "De schilder Pieter Janssens Elinga," *Oud Holland* 27 (1909), pp. 235-37

BREDIUS 1910-A
A. Bredius, "Nog iets over Carel Fabritius," *Oud Holland* 28 (1910), pp. 187-88

BREDIUS 1910-B
A. Bredius, "Nieuwe bijdragen over Johannes Vermeer (de Delftsche)," *Oud Holland* 28 (1910), pp. 61-64

BREDIUS 1915-1922
A. Bredius, *Künstler-Inventare ... (8 vols.),* The Hague 1915-1922

BREDIUS 1916-A
A. Bredius, "Italiaansche schilderijen in 1672 door Haagsche en Delftsche kunstenaars beoordeeld," *Oud Holland* 34 (1916), pp. 88-93

BREDIUS 1916-B
A. Bredius, "Schilderijen uit de nalatenschap van den Delft'schen Vermeer," *Oud Holland* 34 (1916), pp. 160-61

BREDIUS 1920-A
A. Bredius, "Nieuwe gegevens over de schilders Fabritius" *Oud Holland* 38 (1920), pp. 129-37

BREDIUS 1920-B
A. Bredius, "Schilders-musicanten [Pieter Janssens Elinga, Michiel Nouts]," *Oud Holland* 38 (1920), pp. 180-83, 232

BREDIUS 1928
A. Bredius, "Pieter de Hooch und Ludolph de Jongh," *Kunstchronik und Kunstliteratur* 62 (1928), pp. 65-67

BREDIUS 1939
A. Bredius, "Een vroeg werk van Carel Fabritius," *Oud Holland* 56 (1939), pp. 3-14

BREMEN 1991
Dokumentation der durch Auslagerung im 2. Weltkrieg vermißten Kunstwerke der Kunsthalle Bremen, Bremen 1991

BRIÈRE-MISME 1921
C. Brière-Misme, "Un Pieter de Hooch inconnu au Musée de Lisbonne," *Gazette des Beaux-Arts* 63 (1921), pp. 340-44

BRIÈRE-MISME 1923
C. Brière-Misme, "Un petit maître hollandais: Emmanuel de Witte," *Gazette des Beaux-Arts* 65 (1923), pp. 137-56

BRIÈRE-MISME 1925
C. Brière-Misme, "Deux Boîtes à perspective Hollandaises du xviie Siècle," *Gazette des Beaux-Arts* 67 (1925), pp. 156-66

BRIÈRE-MISME 1927
C. Brière-Misme, "Tableaux inédits ou peu connus de Pieter de Hooch," 3 vols., *Gazette des Beaux-Arts* 69 (1927), pp. 361-80; 69 (1927), pp. 51-79; 258-86

BRIÈRE-MISME 1935-A
C. Brière-Misme, "Un émule de Vermeer et de Pieter de Hooch: Cornélis de Man," *Oud Holland* 52 (1935), pp. 1-26, 97-120, 281-82

BRIÈRE-MISME 1935-B
C. Brière-Misme, "Un 'intimiste' hollandais, Jacob Vrel," 1-2, in: *Revue de l'art ancien et moderne* 68, June-Dec. 1935, pp. 97-114, 157-72

BRIÈRE-MISME 1947-1948
C. Brière-Misme, "A Dutch intimist Pieter Janssens Elinga," *Gazette des Beaux-Arts* 89-90 (1947-1948), pp. 89-102, 151-64, 159-76, 347-66

BRIÈRE-MISME 1950
C. Brière-Misme, "Un petit maître hollandais: Cornelis Bisschop (1630-1674)," *Oud Holland* 65 (1950), pp. 24-40, 104-16, 139-51, 178-92, 227-40

BRIÈRE-MISME 1954-A
C. Brière-Misme, "Un 'Intimiste' hollandais, Esaias Boursse, 1631-1672," *Oud Holland* 69 (1954), pp. 18-30, 72-91, 150-66, 213-21

BRIÈRE-MISME 1954-B
C. Brière-Misme, "L'Enigme du Maître C.B.," *La Revue des Arts* 4 (1954), pp. 143-52

BROWN 1976
C. Brown, *Dutch Genre Painting,* London 1976

BROWN 1981
C. Brown, *Carel Fabritius,* Oxford 1981

BROWN 1984
C. Brown, *Scenes of Everyday life, Dutch Genre Painting of the Seventeenth Century,* London 1984

BROWN 1994
C. Brown, "Review of Plomp 1994", *The Burlington Magazine* 136, pp. 63-67.

BÜRGER 1865
W. Bürger, "Notes sur les Fabritius," *Gazette des Beaux-Arts* 7 (1865), pp. 80-84

CARSTENSEN AND PUTSCHER 1971
R. Carstensen and M. Putscher, "Ein Bild von Vermeer in medizinhistorischen Sicht," *Deutsches Ärzteblatt-Ärtzliche Mitteilungen* 68 (1971), pp. 1-6

CAVALLI-BJÖRKMAN 1986
G. Cavalli-Björkman, *Dutch and Flemish Paintings I, c.1400-c.1600,* Nationalmuseum, Stockholm 1986

CHONG 1992
A. Chong, *Johannes Vermeer: Gezicht op Delft,* Bloemendaal 1992

COLLINS BAKER 1925
C.H. Collins Baker, *Pieter de Hooch. Masters of Painting,* vol.1, London 1925

COLLINS BAKER 1930
C.H. Collins Baker, "De Hooch or Not De Hooch," *The Burlington Magazine* 57 (1930), pp. 198-99

CUNNAR 1990
E. R. Cunnar, "The Viewer's Share: Three Sectarian Readings of Vermeer's Woman Holding a Balance," *Exemplaria* 2 (1990), pp. 501-36

DELFT 1950-1951
Delft, Stedelijk Museum Het Prinsenhof, *Het koninklijke kabinet 'Het Mauritshuis' in het museum 'Het Prinsenhof' te Delft,* 1950-1951

DELFT 1952
Delft, Stedelijk Museum Het Prinsenhof, *Prisma der bijbelse kunst,* 1952

DELFT 1974-1975
Delft, Stedelijk Museum Het Prinsenhof, *Delftsche Deurzigten,* 1974-1975

DELFT 1981
Delft, Stedelijk Museum Het Prinsenhof, *De stad Delft: cultuur en maatschappij van 1572 tot 1667* (2 vols.), 1981

DELFT 1982
Delft, Stedelijk Museum Het Prinsenhof, *De stad Delft: cultuur en maatschappij van 1667 tot 1813* (2 vols.), 1982

DIDI-HUBERMANN 1986
G. Didi-Hubermann, "L'Art de ne pas décrire. Une aprie du détail chez Vermeer," *La Part de l'œil* 2 (1986), pp. 113ff

DONAHUE 1964
S. Donahue, "Daniel Vosmaer," *Vassar Journal of Undergraduate Studies* (1964), pp. 1-27

DUMAS 1991,
C. Dumas, *Haagse stadsgezichten 1550-1800, Topografische schilderijen van het Haags Historisch Museum,* Zwolle 1991

EISLER 1916
M. Eisler, "Der Raum bei Jan Vermeer," *Jahrbuch der Kunsthistorischen Sammlungen des Allerhöchsten Kaiserhauses* 33 (1916), pp. 213-91

EISLER 1923
M. Eisler, *Alt-Delft, Kultur und Kunst,* Amsterdam 1923

EKKART 1989
R.E.O. Ekkart, "Een tekening door Jacob Delff de Oude," *Bulletin van het Rijksmuseum* 37 (1989), pp. 322-28

FINK 1971
D. Fink, "Vermeer's Use of the Camera Obscura – A Comparative Study," *The Art Bulletin* 5 (1971), pp. 493-505

FLEISCHER 1978
R.E. Fleischer, "Ludolf de Jongh and the Early Work of Pieter de Hoogh," *Oud Holland* 92 (1978), pp. 49-67

FLEISCHER 1989
R.E. Fleischer, *Ludolf de Jongh (1616-1679). Painter of Rotterdam,* Doornspijk 1989

FLEISCHER AND REISS 1993
R.E. Fleischer and S. Reiss, "Attributions to Ludolf de Jongh: some old, some new," *The Burlington Magazine* 135 (1993), pp. 668-77

FOUCART 1976
J. Foucart, "Un troisième Pieter de Hooch au Louvre," *La Revue du Louvre* 26 (1976), pp. 30-34

FRANKFURT 1993
Frankfurt, Kunsthalle, *Leselust, Niederländische Malerei von Rembrandt bis Vermeer,* by S. Schulze et al., 1993

GASKELL 1984
I. Gaskell, "Vermeer, Judgement and Truth," *The Burlington Magazine* 126 (1984), pp. 557-61

GASKELL 1989

I. Gaskell, *Seventeenth-Century Dutch and Flemish Painting. The Thyssen-Bornemisza Collection*, London 1989

GERSON 1977

H. Gerson, "Recent Literature on Vermeer," *The Burlington Magazine* 119 (1977), pp. 288-90

GLANG-SÜBERKRÜB

A. Glang-Süberkrüb, *Der Liebesgarten. Eine Untersuchung über die Bedeutung der Konfiguration für das Bildthema im Spätwerk des Peter Paul Rubens*, Bern 1975 (Kieler Kunsthistorische Studien 6)

GOLDSCHNEIDER 1964

L. Goldschneider, "Vermeer's Lehrer," *Pantheon* 22 (1964), pp. 35-38

GOODMAN-SOELLNER 1989

E. Goodman-Soellner, "The Landscape on the Wall in Vermeer," *Konsthistorisk Tidskrift* 58 (1989), pp. 79-83

GOWING 1951

L. Gowing, "Light on Baburen and Vermeer," *The Burlington Magazine* 93 (1951), pp. 169-70

GOWING 1952

L. Gowing, *Vermeer*, London 1952 (2nd ed. New York 1970)

GOWING 1953

L. Gowing, "An Artist in His Studio: Reflections on Representation and the Art of Vermeer," *Art News* (November 1953), pp. 85ff

GOWING 1960

L. Gowing, *Johannes Vermeer*, Utrecht 1960

GRIMME 1974

E.G. Grimme, *Jan Vermeer van Delft*, Cologne 1974

THE HAGUE 1974

The Hague, Mauritshuis, *Gerard Ter Borch: Zwolle 1617, Deventer 1681*, 1974

THE HAGUE 1979-1980

The Hague, Mauritshuis, *Zo wijd de wereld strekt*, 1979-1980

THE HAGUE 1987

The Hague, Mauritshuis, *Meesterwerken in het Mauritshuis*, by B. Broos, 1987

THE HAGUE/SAN FRANCISCO 1990-1991

The Hague, Mauritshuis, *Hollandse meesters uit Amerika*, by B. Broos et al., 1990-1991

THE HAGUE 1991

The Hague, Museum Bredius, *Museum Bredius. Catalogus van de schilderijen en tekeningen*, by A. Blankert, Zwolle 1991

THE HAGUE 1994

The Hague, Mauritshuis, *Vermeer in het licht*, by J. Wadum, 1994

THE HAGUE 1994-1995

The Hague, Mauritshuis, *Paulus Potter. Schilderijen, tekeningen en etsen*, by A. Walsh, E. Buijsen and B. Broos, 1994-1995

HAAK 1984

B. Haak, *Hollandse schilders in de Gouden Eeuw*, Milaan 1984

HAARLEM 1986

Haarlem, Frans Halsmuseum, *Portretten van echt en trouw: huwelijk en gezin in de Nederlandse kunst van de zeventiende eeuw*, by E. de Jongh, 1986

HANNEMA 1926

D. Hannema, "The Children of the De Potter Family by Carel Fabritius," *The Burlington Magazine* 48 (1926), p. 277

HARWOOD 1983

L.B. Harwood, "Les Pynacker du Louvre, à propos d'une récente acquisition," *La Revue du Louvre* 33 (1983), pp. 110-18

HARWOOD 1985-A

L.B. Harwood, *Adam Pynacker*, diss. Courtauld Institute, London 1985

HARWOOD 1985-B

L.B. Harwood, "Revelling in Contemplation: Adam Pynacker (c.1620-73) and British Collectors," *Country Life* (1985), pp. 486-88

HARWOOD 1988

L.B. Harwood, *Adam Pynacker (c.1620-1673)*, Doornspijk 1988

HARWOOD 1994

See: Williamstown 1994

HAVARD 1888

H. Havard, *Les artistes célèbres. Van der Meer de Delft*, Paris 1888

HAVELAAR 1911

J. Havelaar, "Iets over Paulus Potter en zijn 'Stier'," *Elsevier's geïllustreerd Maandschrift* 42 (1911), pp. 176-85

HECHT 1986

P. Hecht, "The debate on symbol and meaning in Dutch seventeenth-century art: an appeal to common sense," *Simiolus* 16 (1986), pp. 173-87

HENNUS 1936

M.F. Hennus, "Emanuel de Witte, 1617-92," *Maandblad voor beeldende kunsten* 13 (1936), pp. 3-12

HEPPNER 1935

A. Heppner, "Vermeer: Seine künstlerische Herkunft und Ausstrahlung," *Pantheon* 16 (1935), pp. 255-65

HEPPNER 1938

A. Heppner, "Thoré-Bürger en Holland: De ontdekker van Vermeer en zijn liefde voor Neêrland's kunst," *Oud Holland* 55 (1938), pp. 17-34, 67-82,129-44

HOFSTEDE DE GROOT 1890

C. Hofstede de Groot, "Johannes Janssens," *Zeitschrift für bildende Kunst* 1 (1890), pp. 106-09

HOFSTEDE DE GROOT 1891

C. Hofstede de groot, "De schilder Janssens, een navolger van Pieter de Hooch," *Oud Holland* 9 (1891), pp. 266-96

HOFSTEDE DE GROOT 1892

C. Hofstede de Groot, "Proeve eener kritische beschrijving van het werk van Pieter de Hooch," *Oud Holland* 10 (1892), pp. 178-91

HOFSTEDE DE GROOT 1907

C. Hofstede de Groot, *Jan Vermeer van Delft en Carel Fabritius*, The Hague 1907

HOFSTEDE DE GROOT 1916

C. Hofstede de Groot, "Jacobus Vrel," *Oude Kunst* 1 (1916), pp. 209-11

HOFSTEDE DE GROOT 1921

C. Hofstede de Groot, "Hendrick van der Burgh, een voorganger van Pieter de Hoogh," *Oud Holland* 39 (1921), pp. 121-28

HOFSTEDE DE GROOT 1927

C. Hofstede de Groot, "Isaac Koedijk," in *Festschrift für Max. J. Friedländer. Zum 60. Geburtstag*, Leipzig 1927, pp. 181-90.

HOUBRAKEN 1718-1721

A. Houbraken, *De Groote Schouburgh der Nederlantsche konstschilders en schilderessen*, (3 vols.), Amsterdam 1718-1721

HULTÉN 1949

K.G. Hultén, "Zu Vermeer's Atelierbild," *Konsthistorisk Tidskrift* 18 (1949), pp. 90-98

JAMES 1994

R. James, "Van 'boerenhuysen' en 'stilstaende dingen'," *Rotterdam* 1994, pp. 133-42

JANSEN 1985

G. Jansen, "Berchem in Italy: notes on an unpublished painting," *Hoogsteder-Naumann Mercury* (1985), pp. 13-17

JANTZEN 1909

J. Jantzen, "Hollandsche kerkportretten," *Onze Kunst* 15 (1909), pp. 141-50

JANTZEN 1910

H. Jantzen, *Das Niederländische Architekturbild*, Leipzig 1910

JOHANSEN 1920

P. Johansen, "Jan Vermeer de Delft, A propos de l'ordre chronologique de ses tableaux," *Oud Holland* 38 (1920), pp. 185-99

JONGH 1968

E. de Jongh, "'Interieur' Emanuel de Witte," *Openbaar Kunstbezit* 12 (1968), pp. 6-9b

JUYNBOLL 1935

W.R. Juynboll, "Pieter de Hoogh of Peter Angillis," *Oud Holland* 52 (1935), pp. 190-92

KEITH 1994

L. Keith, "Carel Fabritius' 'A view in Delft': some observations on its treatment and display," *Technical Bulletin National Gallery* 15 (1994), pp. 54-63

KELLEN 1876

D. van der Kellen, "Pieter de Hooge," *Eigen Haard 1876*, no. 18, pp. 151-52

KERNKAMP 1943

G.W. Kernkamp, *Prins Willem II*, Amsterdam 1943

COLOGNE/UTRECHT 1987

Cologne, Wallraf-Richartz-Museum, *Nederlandse 17de-eeuwse schilderijen uit Boedapest*, 1987

KONINGSBERGER 1967-1968

H. Koningsberger, *The World of Vermeer 1632-1675*, New York 1967

KOSLOW 1967

S. Koslow, "'De wonderlijke perspectyfkas': An Aspect of Seventeenth-Century Dutch painting," *Oud Holland* 82 (1967), pp. 32-56

KURETSKY 1979

S. Donahue Kuretsky, *The Paintings of Jacob Ochtervelt (1634-1682)*, Oxford 1979

LEBEL 1953

R. Lebel, "Introduction à l'intimisme hollandais," *Connaissance des arts* (1953), no.17, pp. 24-29

219

LEIDEN 1988
Leiden, Stedelijk Museum De Lakenhal, *Leidse Fijnschilders. Van Gerrit Dou tot Frans van Mieris de Jonge 1630-1760*, by E.J. Sluijter et al., 1988

LIEDTKE 1970
W.A. Liedtke, "From Vredeman de Vries to Dirck van Delen: Sources of Imaginary Architectural Painting," *Rhode Island School of Design Bulletin* 57 (1970), no. 2, pp. 15-25

LIEDTKE 1976-A
W.A. Liedtke, "The New Church in Haarlem series: Saenredam's sketching style in relation to perspective," *Simiolus* 8 (1975-1976), pp. 145-66

LIEDTKE 1976-B
W.A. Liedtke, "The 'View in Delft' by Carel Fabritius," *The Burlington Magazine* 118 (1976), pp. 61-73

LIEDTKE 1979
W.A. Liedtke, "Pride in Perspective, the Dutch Townscape," *The Connoisseur* 200 (1979), pp. 264-73

LIEDTKE 1982-A
W.A. Liedtke, *Architectural Painting in Delft*, Doornspijk 1982

LIEDTKE 1982-B
W.A. Liedtke, "Cornelis de Man as a Painter of Church Interiors," *Tableau* 5 (1982), pp. 62-66

LIEDTKE 1991-A
W.A. Liedtke, "Pepys and the Pictorial Arts," *Apollo* 1991, p. 234

LIEDTKE 1991-B
W.A. Liedtke, "De hofstijl: architectuurschilder-kunst in 's-Gravenhage en Londen," *Rotterdam* 1991, pp. 31-41

LIEDTKE 1992
W.A. Liedtke, "The Delft School, Circa 1627-1675," *Milwaukee* 1992, pp. 23-35

LIEDTKE 1992-1993
W.A. Liedtke, "Vermeer teaching Himself," Stockholm, National Museum, *Rembrandt and his age*, by G. Cavalli-Björkman et al., 1992-1993, pp. 89-105

LILIENFELD 1924-1925
K. Lilienfeld, "Wiedergefundene Gemälde des Pieter de Hooch," *Zeitschrift für Bildende Kunst* 58 (1924-25), pp. 185-88

LONDON 1991
London, National Gallery, *Catalogue of the Dutch School* (2 vols.), by N. MacLaren, revised and expanded by C. Brown, 1991

LOWENTHAL 1986
A.W. Lowenthal, "Response to Peter Hecht," *Simiolus* 16 (1986), pp. 188-90

LUGT 1936
F. Lugt, "Italiaansche kunstwerken in Nederlandsche verzamelingen van vroeger tijden," *Oud Holland* 53 (1936), pp. 97-135

MACCOLL 1916
D.S. Maccoll, "The New De Hooch at the National Gallery," *The Burlington Magazine* 29 (1916), pp. 25-26

MALRAUX 1952
A. Malraux, ed., *Vermeer de Delft*, Paris 1952

MANKE 1963
I. Manke, *Emanuel de Witte 1617-1692*, Amsterdam 1963

MANKE 1972
I. Manke, "Nachträge zum Werkkatalog von Emanuel de Witte," *Pantheon* 30 (1972), pp. 389-91

MELLAART 1923
J.H.J. Mellaart, "An unpublished Pieter de Hoogh at the National Gallery," *The Burlington Magazine* 43 (1923), pp. 269-70

MIEDEMA 1980
H. Miedema, *De archiefbescheiden van het St. Lukasgilde te Haarlem 1497-1798*, Alphen aan den Rijn 1980

MIEDEMA 1987
H. Miedema, "Kunstschilders, gilde en academie. Over het probleem van de emancipatie van de kunstschilders in de Noordelijke Nederlanden van de 16de en 17de eeuw," *Oud Holland* 101 (1987), pp. 1-34.

MILWAUKEE 1992
Milwaukee, Patrick and Beatrice Haggerty Museum of Art, *Leonaert Bramer 1596-1674. Painter of the Night*, by F. Fox Hofrichter et al., 1992

MIRIMONDE 1961
A.P. de Mirimonde, "Les sujets musicaux chez Vermeer de Delft," *Gazette des Beaux-Arts* 103 (1961), pp. 29-50

MOCQUOT 1968
M. Mocquot, "Vermeer et le portrait en double miroir," *Le club française de la médaille* 18 (1968), pp. 58-69

MONTIAS 1977-A
J.M. Montias, "The guild of St. Luke in 17th-century Delft and the economic status of artists and artisans," *Simiolus* 9 (1977), pp. 93-105

MONTIAS 1977-B
J.M. Montias, "New Documents on Vermeer and his Family," *Oud Holland* 91 (1977), pp. 267-87

MONTIAS 1978-1979
J.M. Montias, "Painters in Delft, 1613-1680," *Simiolus* 10 (1978-1979), pp. 84-114

MONTIAS 1980
J.M. Montias, "Vermeer and his Milieu: Conclusion of an Archival Study," *Oud Holland* 94 (1980), pp. 44-62

MONTIAS 1982
J.M. Montias, *Artists and Artisans in Delft in the Seventeenth Century: A Socio-economic Study of the Seventeenth Century*, Princeton, New Jersey 1982

MONTIAS 1987
J.M. Montias, "Cost and Value in 17th-Century Dutch Art," *Art History* 10 (1987), pp. 455-66

MONTIAS 1989
J.M. Montias, *Vermeer and his Milieu. A Web of Social History*, Princeton, New Jersey 1989

MONTIAS 1991-A
J.M. Montias (cum sociis), "A Postscript on Vermeer and his Milieu," *The Hoogsteder Mercury* (1991), no.12, pp. 42-52

MONTIAS 1991-B
J.M. Montias, "'Perspectiven' in de zeventiende-eeuwse boedelbeschrijvingen," *Rotterdam* 1991, pp. 19-29

MONTIAS 1993
J.M. Montias, *Vermeer en zijn milieu*, Baarn 1993 (trans. Hans Bronkhorst)

NASH 1991
J. Nash, *Vermeer*, London 1991

NAUMANN 1981
O. Naumann, *Frans van Mieris (1635-1681) The Elder* (2 vols.), Doornspijk 1981

NEURDENBURG 1942
E. Neurdenburg, "Johannes Vermeer. Eenige opmerkingen naar aanleiding van de nieuwste studies over den Delftschen schilder," *Oud Holland* 59 (1942), pp. 65-73

NEURDENBURG 1951
E. Neurdenburg, "Nog enige opmerkingen over Johannes Vermeer van Delft," *Oud Holland* 66 (1951), pp. 34-44

NICHOLSON 1966
B. Nicholson, "Vermeer's Lady at a Virginal," *Gallery Books* 12, London 1966

OOSTERLOO 1948
J.H. Oosterloo, *De Meesters van Delft. Leven en werken van de Delftse schilders der zeventiende eeuw*, Amsterdam 1948

PARIS 1967
Paris, Musée des Arts Décoratifs, *La vie en Hollande au XVIIème siècle*, Paris 1967

PEER 1946
A.J.J.M. van Peer, "Was Jan Vermeer van Delft Katholiek?," *Katholiek cultureel tijdschrift* 4 (1946), no.12, pp. 468-70

PEER 1957
A.J.J.M. van Peer, "Drie collecties schilderijen van Jan Vermeer," *Oud Holland* 72 (1957), pp. 92-103

PEER 1959
A.J.J.M. van Peer, "Rondom Jan Vermeer van Delft," *Oud Holland* 74 (1959), pp. 240-45

PEER 1960
A.J.J.M. van Peer, "De doop van Jan Vermeer," *Archief voor de Geschiedenis van de Katholieke kerk in Nederland* 2 (1960), pp. 299-07

PEER 1968
A.J.J.M. van Peer, "Jan Vermeer van Delft: drie archiefvondsten," *Oud Holland* 83 (1968), pp. 220-24

PHILADELPHIA/BERLIN/LONDON 1984
Philadelphia, Museum of Art, Berlin-Dahlem, Gemäldegalerie, London, Royal Academy of Arts. *Masters of Seventeenth Century Dutch Genre Painting*, by P. Sutton, 1984

PLASSCHAERT 1924
A. Plasschaert, *Johannes Vermeer en Pieter de Hooch*, Amsterdam 1924

PLIETZSCH 1911
E. Plietzsch, *Vermeer van Delft*, Leipzig 1911

PLIETZSCH 1939
E. Plietzsch, *Vermeer van Delft*, Munich 1939

PLIETZSCH 1949
E. Plietzsch, "Jacobus Vrel und Esaias Boursse," *Zeitschrift für Kunst* 3 (1949), pp. 248-60

220

PLOMP 1986
M. Plomp, "'Een Merkwaardige verzameling Teekeningen' door Leonaert Bramer," *Oud Holland* 100 (1986), pp. 81-153

PLOMP 1994
M. Plomp et al., *Leonaert Bramer (1596-1674). Ingenious Painter and Draughtsman in Rome and Delft*, Zwolle 1994

VAN REGTEREN ALTENA 1983
I.Q. van Regteren Altena, *Jacques de Gheyn, Three Generations* (3 vols.), The Hague/Boston/London 1983

REBEYROL 1952
P. Rebeyrol, "Art Historians and Art Critics, 1; Théophile Thoré," *The Burlington Magazine* 44 (1952), pp. 196-200

RICHARDSON 1938
E.P. Richardson, "De Witte and the Imaginative Nature of Dutch Art," *The Art Quarterly* 1 (1938), pp. 4-17

ROOSES 1894
M. Rooses, "De Hollandsche Meesters in den Louvre. Pieter de Hoogh of de Hooch," *Elsevier's Geïllustreerd Maandschrift* 8 (1894), pp. 179-83

ROSCAM ABBING 1993
M. Roscam Abbing, *De schilder & schrijver Samuel van Hoogstraten 1627-1678. Eigentijdse bronnen & œuvre van gesigneerde schilderijen*, Leiden 1993

ROSENBERG, SLIVE AND TER KUILE 1971
J. Rosenberg, S. Slive and E.H. ter Kuile, *Dutch Art and Architecture 1600-1800*, Harmondsworth 1971 (1st ed. 1966)

ROTTERDAM 1935
Rotterdam, Museum Boymans, *Vermeer, oorsprong en invloed Fabritius, De Hooch, De Witte*, by D. Hannema et al., 1935

ROTTERDAM 1991
Rotterdam, Museum Boymans-van Beuningen, *Perspectiven: Saenredam en de architectuurschilders van de 17de eeuw*, by J. Giltay et al., 1991

ROTTERDAM 1994
Rotterdam, Historisch Museum Rotterdam, *Rotterdamse Meesters uit de Gouden Eeuw*, 1994

RUDDER 1913
A. de Rudder, *Pieter de Hooch*, Brussels 1913

RUURS 1983
R. Ruurs, "Pieter Saenredam: zijn boekenbezit en zijn relatie met de landmeter Pieter Wils," *Oud Holland* 97 (1983), pp. 59-68

RUURS 1987
R. Ruurs, Saenredam. *The Art of Perspective*, Amsterdam 1987

RUURS 1991
R. Ruurs, "Functies van architectuurschildering, in het bijzonder het kerkinterieur," in *Rotterdam* 1991, pp. 43-50

SAFARIK 1990
E. Safarik, *Fetti*, Milan 1990

SALOMON 1983
N. Salomon, "Vermeer and the Balance of Destiny," *Essays in Northern European Art Presented to Egbert Haverkamp-Begemann*, Doornspijk 1983, pp. 216-21

SCHATBORN 1975
P. Schatborn, "Figuurstudies van Ludolf de Jongh," *Oud Holland* 89 (1975), pp. 79-85

SCHMIDT-DEGENER 1912
F. Schmidt-Degener, "Het Geboortejaar van Carel Fabritius," *Oud Holland* 30 (1912), pp. 189-91

SCHNEEMAN 1982
L.T. Schneeman, *Hendrick Martensz. Sorgh: A Painter of Rotterdam*, The Pennsylvania State University, 1982 (diss.)

SCHNEIDER 1994
N. Schneider, *Jan Vermeer 1632-1675. Verborgen gevoelens*, Hedel, 1994

SCHOLTEN 1992
F. Scholten, "Bespreking van Fleischer 1989," *Oud Holland* 106 (1992), pp. 49-53

SCHUURMAN 1947
K.E. Schuurman, *Carel Fabritius*, Amsterdam, n.d. [1947]

SCHWARZ 1966
H. Schwarz, "Vermeer and the Camera Obscura," *Pantheon* 24 (1966), pp. 170-82

SETH 1980
L. Seth, "Vermeer och Van Veen's 'Amorum Emblemata'," *Konsthistorisk Tidskrift* 49 (1980), pp. 17-40

SEYMOUR 1964
C. Seymour Jr., "Dark Chamber and light-filled room: Vermeer and the Camera Obscura," *The Art Bulletin* 46 (1964), pp. 323-31

SLUIJTER 1973
E.J. Sluijter, "Bespreking van Wagner 1971," *Oud Holland* 87 (1973), pp. 244-52

SMITH 1990
D.R. Smith, "Carel Fabritius and Portraiture in Delft," *Art History* 13 (1990), pp. 151-74

SNOEP 1973
D.P. Snoep, "Jacob Vrel: De Ziekenoppas," *Openbaar Kunstbezit* 17 (1973), pp. 29-32

SNOW 1979
E. A. Snow, *A Study of Vermeer*, Berkeley/Los Angeles/London, 1979

STECHOW 1966
W. Stechow, *Dutch Landscape Painting of the Seventeenth Century*, London 1966

STEENHOFF 1920
W.J. Steenhoff, "Pieter de Hoogh," *Van Onzen Tijd* 20 (3-7-1920), pp. 164-67

STRAATEN 1977
E. van Straaten, *Johannes Vermeer, 1623-1675: Een Delfts schilder en de cultuur van zijn tijd*, The Hague 1977

SUMOWSKI 1964
W. Sumowski, "Zum Werk von Barend und Carel Fabritius," *Jahrbuch der Staatlichen Kunstsammlungen in Baden-Württemberg*, 1 (1964), pp. 188-98

SUMOWSKI 1968
W. Sumowski, "Zu einem Gemälde von Carel Fabritius," *Pantheon* 26 (1968), pp. 278-83

SUTTON 1979
P.C. Sutton, "A Newly Discovered Work by Pieter de Hooch," *The Burlington Magazine* 121 (1979), pp. 32-35

SUTTON 1980-A
P.C. Sutton, *Pieter de Hooch*, Oxford 1980

SUTTON 1980-B
P.C. Sutton, "Hendrick van der Burch," *The Burlington Magazine* 122 (1980), pp. 315-26

SWILLENS 1929
P.T.A. Swillens, "Een perspectivische studie over de schilderijen van Johannes Vermeer," *Oude Kunst* 7 (1929), pp. 129-61

SWILLENS 1935
P.T.A. Swillens, *Pieter Janszoon Saenredam*, Amsterdam 1935

SWILLENS 1950
P.T.A. Swillens, *Johannes Vermeer, painter of Delft 1632-1675*, Utrecht/Brussels 1950

THIENEN
F. van Thienen, *Vermeer*, Amsterdam [n.d.]

TIETZE-CONRAT 1922
E. Tietze-Conrat, *Die Delfter Malerschule. Carel Fabritius, Pieter de Hooch, Jan Vermeer*, Leipzig 1922

TÒTH-UBBENS 1969
M. Tòth-Ubbens, "Kijken naar een vogeltje," *Miscellanea I.Q. van Regteren Altena*, Amsterdam 1969, pp. 233-40

UTRECHT/BRUNSWICK 1986-1987
Utrecht, Centraal Museum, *Nieuw Licht op de Gouden Eeuw. Hendrick ter Brugghen en tijdgenoten*, 1986

VALENTINER 1929
W.R. Valentiner, *Pieter de Hooch. Des Meisters Gemälde in 180 Abbildungen mit einem Anhang über die Genremaler um Pieter de Hooch und die Kunst Hendrick van der Burchs*, Klassiker der Kunst (deel 35), Berlin/Leipzig 1929

VALENTINER 1932
W.R. Valentiner, "Carel and Barent Fabritius," *The Art Bulletin* 14 (1932), pp. 197-40

VALENTINER 1935
W.R. Valentiner, "Carel Fabritius," *Gazette des Beaux-Arts* 77 (1935), pp. 27-34

VRIES 1948
A.B. de Vries, *Jan Vermeer van Delft*, Basel 1948

VRIES 1964
A.B. de Vries, "Het Puttertje van Carel Fabritius," *Openbaar Kunstbezit* 8 (1964), no. 33

VRIES 1975
L. de Vries, "Gerard Houckgeest," *Jahrbuch der Hamburger Kunstsammlungen* 20 (1975), pp. 25-56

VRIES 1976
L. de Vries, "Post voor Jan van der Heyden," *Oud Holland* 90 (1976), pp. 267-75

VRIES 1984-A
L. de Vries, Bespreking van Liedtke 1982, *Simiolus* 11 (1984), pp. 134-40

VRIES 1984-B
L. de Vries, *Jan van der Heyden*, Amsterdam 1984

VRIES 1991
S. de Vries, "A 'Holy Family' by Gerrit van Honthorst from the 'Provenhuis van Nordingen' at Alkmaar," *The Hoogsteder Mercury* (1991), no. 12, pp. 17-28

WAGNER 1971
H. Wagner, *Jan van der Heyden. 1637-1712*,
Amsterdam/Haarlem 1971

WANSINK 1987
C.J.A. Wansink, "Some History and Genre
Paintings by Willem van der Vliet," *Hoogsteder-
Naumann Mercury* 6 (1987), pp. 3-10

WASHINGTON/THE HAGUE 1995-1996
Washington, National Gallery of Art, *Johannes
Vermeer*, by A.K. Wheelock Jr. et al., 1995

WELU 1975
J.A. Welu, "Vermeer: His cartographic Sources,"
The Art Bulletin 57 (1975), pp. 529-47

WELU 1978
J.A. Welu, "The Map in Vermeer's Art of
Painting," *Imago Mundi* 30 (1978), pp. 9-30

WELU 1986
J.A. Welu, "Vermeer's Astronomer: observations
on an Open Book," *Art Bulletin* 68 (1986),
pp. 263-67

WHEELOCK 1973
A.K. Wheelock Jr., "Carel Fabritius: Perspective
and Optics in Delft," *Nederlands Kunsthistorisch
Jaarboek* 24 (1973), pp. 63-83

WHEELOCK 1975-1976
A.K. Wheelock Jr., "Gerard Houckgeest and
Emmanuel de Witte: architectural painting in
Delft around 1650," *Simiolus* 8 (1975-1976),
pp.167-85

WHEELOCK 1977-A
A.K. Wheelock Jr., *Perspective, Optics and Delft
Artists Around 1650*, New York and London 1977

WHEELOCK 1977-B
A.K. Wheelock Jr., Review of Blankert 1977,
The Art Bulletin 59 (1977), pp. 439-41

WHEELOCK 1977-C
A.K. Wheelock Jr., "Constantijn Huygens and
Early Attitudes towards the Camera Obscura,"
History of Photography 1 (1977), pp. 93ff

WHEELOCK 1978
A.K. Wheelock Jr., "Zur Technik zweier Bilder
die Vermeer zugeschrieben sind," *Maltechnik,
Restauro* 4, 84 (1978), pp. 242-58

WHEELOCK 1981-A
A.K. Wheelock Jr., *Jan Vermeer*, New York 1981

WHEELOCK 1981-B
A.K. Wheelock Jr. "Vermeer's Painting
Technique," *Art Journal* 41 (1981), pp. 162-64

WHEELOCK 1985
A.K. Wheelock Jr., "Pentimenti in Vermeer's
Paintings; Changes in Style and Meaning,"
Holländische Genremalerei im 17. Jahrhundert,
Symposium Berlin 1984, *Jahrbuch Preußischer
Kulturbesitz* Sonderband 4 (1985), pp. 385-412

WHEELOCK 1986
A.K. Wheelock Jr., "St. Praxedis: New Light on
the Early Career of Vermeer," *Artibus et historiæ*
14 (1986), pp. 71-89

WHEELOCK 1988-A
A.K. Wheelock Jr., "The Art Historian in the
Laboratory: Examination into the History,
Preservation and Techniques of 17th Century
Dutch Painting," The Age of Rembrandt. Studies
in Seventeenth-Century Dutch Painting. *Papers in
Art History from the Pennsylvania State University* 3
(1988), pp. 220-45

WHEELOCK 1988-B
A.K. Wheelock Jr., *Jan Vermeer*, New York 1988

WHEELOCK 1989
A.K. Wheelock Jr., "History, Politics, and the
Portrait of a City: Vermeer's View of Delft," *Urban
Life in the Renaissance*, ed. Susan Zimmerman and
Ronald F.E. Wiessman. Newark 1989, pp. 165-84

WHEELOCK 1995
A.K. Wheelock Jr., *Vermeer & the Art of Painting*,
New Haven and London 1995

WHEELOCK AND KALDENBACH 1982
A.K. Wheelock Jr. and C.J. Kaldenbach,
"Vermeer's View of Delft and his Vision of
Reality," *Artibus et historiæ* 6 (1982), pp. 9-35

WICHMANN 1923
H. Wichmann, *Leonaert Bramer, sein Leben
und seine Kunst; Ein Beitrag zur Geschichte der
holländische Malerei zur Zeit Rembrandts*, Leipzig
1923

WIJNMAN 1931
H.F. Wijnman, "De schilder Carel Fabritius
(1622-1654): Een reconstructie van zijn leven
en werk," *Oud Holland* 48 (1931), pp. 100-41

WILLIAMSTOWN 1994
Williamstown, Sterling and Francine Clark Art
Institute, *A Golden Harvest. Paintings by Adam
Pynacker*, by L.B. Harwood, 1994

WRIGHT 1976
C. Wright, *Vermeer*, London 1976

WURFBAIN 1970
M.L. Wurfbain, "Hoe was het 'Puttertje' gebekt?"
Opstellen voor H. van de Waal, Amsterdam/Leiden
1970, pp. 233-40

222

Pictures exhibited at Delft

AMSTERDAM, RIJKSMUSEUM
Esaias Boursse, *Interior with a Woman Spinning*,
inv. no. SK-A-767
Pieter de Hooch, *A Woman Delousing a Child's
Hair*, inv. no. SK-C-149
Pieter de Hooch, *A Company in a Courtyard behind
a House*, inv. no. SK-C-150

ANTWERP, KONINKLIJK MUSEUM VOOR SCHONE
KUNSTEN
Hendrick Cornelisz van Vliet, *Interior of the
Nieuwe Kerk, Delft*, inv. no. 196
Emanuel de Witte, *Interior of a Protestant Church*,
inv. no. 789

ANTWERP, MUSEUM MAYER VAN DEN BERGH
Jacob Ochtervelt, *The Cherry Seller*,
inv. no. 895 (1933)

BERLIN, STAATLICHE MUSEEN ZU BERLIN –
PREUßISCHER KULTURBESITZ, GEMÄLDEGALERIE
Cornelis Bisschop, *The Jacket*, inv. no. 912 D
Esaias Boursse, *Interior with a Woman by a Hearth,
and Child*, inv. no. 2036

BUDAPEST, SZÉPMÜVÉSZETI MÚZEUM
Pieter de Hooch, *Woman Reading a Letter by
a Window*, inv. no. 5933
Cornelis de Man, *A Couple Playing Chess*,
inv. no. cat. 1954, 320

BONN, RHEINISCHES LANDESMUSEUM
Hendrick van der Burch (toegeschreven aan),
A Mother and Child, inv. no. GK 99

CHAMPAIGN, KRANNERT ART MUSEUM
Hendrick van der Burch, *Young Woman in a Court*,
inv. no. 51-1-1

CHICAGO, THE ART INSTITUTE OF CHICAGO
Cornelis de Man, *Interior of the Oude Kerk, Delft,
with Pulpit*, inv. no. 1965.1176

CLEVELAND, THE CLEVELAND MUSEUM OF ART
Pieter de Hooch, *Family Making Music*,
inv. no. 51.355

DELFT, STEDELIJK MUSEUM HET PRINSENHOF
Hendrick van der Burch, *Woman and Child at a
Window*, inv. no. NK 2422 (R.B.K.)
Egbert van der Poel, *The Explosion of the Powder
Magazine at Delft on Monday, 12 October 1654*,
inv. no. NK 2430 (R.B.K.)
Egbert van der Poel, *The Explosion of the Powder
Magazine at Delft on Monday, 12 October 1654*,
inv. no. NK 2784 (R.B.K.)
Egbert van der Poel, *Fête on the Oude Delft*,
inv. no. PDS 85
Hendrick Cornelisz van Vliet, *View in the Nieuwe
Kerk, Delft, with the Memorial Plague of Adriaen
Teding van Berkhout* (on loan from the Stichting
Teding van Berkhout)
Hendrick Cornelisz van Vliet, *Church Interior*,
inv. no. PDS 105
Hendrick Cornelisz van Vliet, *Interior of the
Nieuwe Kerk, Delft, with the Tomb of William the
Silent*, inv. no. NK 2433 (R.B.K.)
Daniel Vosmaer, *The Explosion of the Powder
Magazine at Delft on Monday, 12 October 1654*,
inv. no. PDS 107
Daniel Vosmaer, *View of Delft with a fantasy
Loggia*, inv. no. NK 2927 (R.B.K.)

DETROIT, THE DETROIT INSTITUTE OF ARTS
Hendrick van der Burch, *The Oyster Eaters*,
inv. no. 28.56
Jan van der Heyden, *View of the Oude Delft*,
inv. no. 48.218

GERMANY, PRIVATE COLLECTION
Pieter de Hooch, *The School Boy*
GERMANY, PRIVATE COLLECTION
Jacobus Vrel, *A Woman by a Hearth*

THE HAGUE, KONINKLIJK KABINET VAN
SCHILDERIJEN MAURITSHUIS
Pieter de Hooch, *A Man Smoking and a Woman
Drinking in a Courtyard at Delft*, inv. no. 835
Gerard Houckgeest, *Ambulatory of the Nieuwe
Kerk in Delft*, inv. no. 57
Egbert van der Poel, *The Fish Market*, inv. no. 698
Johannes Verkolje, *The Messenger*, inv. no. 865

GRONINGEN, GRONINGER MUSEUM
Ludolf de Jongh, *Hunters in an Inn*,
inv. no. 1931-113
Jacobus Vrel, *Binnenhuis met man aan haardvuur*,
inv. no. 1931-125

HAMBURG, HAMBURGER KUNSTHALLE
Cornelis de Man, *Three Scholars around a Globe*,
inv. no. 239

LEIPZIG, MUSEUM DER BILDENDEN KÜNSTE
Hendrick Cornelisz van Vliet, *Interior of the Oude
Kerk, Delft*, inv. no. J.1568/591

LIER, STEDELIJK MUSEUM WUYTS-VAN CAMPEN
EN BARON CAROLY
Pieter Janssens Elinga, *Room with a Woman and a
Man Drinking*, inv. no. 85

LIVERPOOL, NATIONAL MUSEUMS & GALLERIES
ON MERSEYSIDE, WALKER ART GALLERY
Hendrick Cornelisz van Vliet, *Interior of the
Nieuwe Kerk, Delft, with the Tomb of William the
Silent*, inv. no. WAG 1994.1

LONDON, THE NATIONAL GALLERY
Carel Fabritius, *View in Delft, with a Musical Instrument Seller's Stall*, inv. no. NG 3714
Pieter de Hooch, *Woman with Servant in a Courtyard*, inv. no. NG 0794

LOS ANGELES, LOS ANGELES COUNTY MUSEUM OF ART
Pieter de Hooch, *A Woman Giving a Coin to a Maid*, inv. no. M.44.2.8

MADRID, COLLECTION THYSSEN-BORNEMISZA
Pieter de Hooch, *Woman Sewing, with a Child*, inv. no. 1958. 7

MALIBU, THE J. PAUL GETTY MUSEUM
Jacobus Vrel, *Street Scene*

MONTREAL, MR. AND MRS. MICHAL HORNSTEIN
Cornelis de Man, *A Man Weighing Gold*
Emanuel de Witte, *Interior of the Oude Kerk, Delft*

NETHERLANDS, PRIVATE COLLECTION
Pieter de Hooch, *A Soldier Smoking, with a Woman by a Hearth*

NETHERLANDS, PRIVATE COLLECTION
Cornelis de Man, *Scholar in a Study*

NETHERLANDS, PRIVATE COLLECTION
Emanuel de Witte, *Interior of the Oude Kerk, Delft, during a Sermon*

NETHERLANDS, PRIVATE COLLECTION
Jan Steen, *The May Queen*

NEURENBERG, GERMANISCHES NATIONALMUSEUM
Pieter de Hooch, *Officer and a Woman Conversing, and a Soldier at a Window*, inv. no. Gm 406

NEW YORK, THE METROPOLITAN MUSEUM OF ART
Pieter de Hooch, *A Merry Company with Two Men and Two Women (The Visit)*, inv. no. 29.100.7
Ludolf de Jongh, *Scene in a Courtyard*, inv. no. 20.155.5

OEGSTGEEST, M.L. WURFBAIN FINE ART
Hendrick Cornelisz van Vliet, *Interior of the Oude Kerk, Delft, with a funeral procession*

OHIO, COLUMBUS MUSEUM OF ART
Cornelis de Man, *Interior of the Oude Kerk, Delft*, inv. no. 81.018

OSLO, NASJONALGALLERIET
Pieter Janssens Elinga, *Interior with a Woman Reading, a Man Standing and a Maid*, inv. no. NG.M.01372
Jan van der Heyden, *The Oude Kerk on the Oude Delft at Delft*, inv. no. NG.M.00029

PARIS, COLLECTION FRITS LUGT, INSTITUT NÉERLANDAIS
Jacobus Vrel, *Woman behind a Window, Waving at a Child*

PARIS, MUSÉE DU LOUVRE
Samuel van Hoogstraten, *The Slippers ('Les pantoufles')*, inv. no. RF 3722

PHILADELPHIA, PHILADELPHIA MUSEUM OF ART
Hendrick van der Burch, *Officer and a Standing Woman*, inv. no. 28.56
Daniel Vosmaer, *Delft after the Explosion of the Powder Magazine in 1654*, inv. no. J 500

PHOENIX, PHOENIX ART MUSEUM
Pieter Janssens Elinga, *Woman Playing a Guitar*, inv. no. 64.235

POLESDEN LACEY, NEAR DORKING, SURREY, UNITED KINGDOM, THE NATIONAL TRUST FOR PLACES OF HISTORIC INTEREST OR NATURAL BEAUTY
Cornelis de Man, *The Card Players*, inv. no. 57

PONCE (PUERTO RICO), MUSEO DE ARTE DE PONCE
Daniel Vosmaer, *The Harbour of Delft*, inv. no. 59.0088

POUGHKEEPSIE, THE FRANCES LEHMAN LOEB ART CENTER, VASSAR COLLEGE
Daniël Vosmaer, *View of a Dutch Town*, inv. no. 1962.2

ROTTERDAM, MUSEUM BOYMANS-VAN BEUNINGEN
Emanuel de Witte, *Woman Playing the Harpsichord*, inv. no. NK 2685 (R.B.K.)
Esaias Boursse, *The Laundress*, inv. no. vdV 5

SALZBURG, RESIDENZGALERIE
Emanuel de Witte, *Interior of the Nieuwe Kerk, Delft*, inv. no. 557

ST PETERSBURG, THE STATE HERMITAGE MUSEUM
Pieter Janssens Elinga, *Woman Sweeping*, inv. no. 1013
Pieter de Hooch, *A Woman and a Maid with Pail in a Courtyards*, inv. no. 943

ST PETERSBURG, FLORIDA, ADELE AND GORDON GILBERT
Quiringh Gerritsz van Brekelenkam, *Tailor's Workshop*

STOCKHOLM, NASJONALMUSEUM
Hendrick Cornelisz van Vliet, *Interior of the Nieuwe Kerk, Delft, with the Tomb of William the Silent*, inv. no. NM 464

UNITED KINGDOM, PRIVATE COLLECTION
Pieter de Hooch, *Woman Placing a Child in a Cradle*

UNITED KINGDOM, PRIVATE COLLECTION
Pieter de Hooch, *Woman with a Child and a Serving Woman*

UNITED KINGDOM, PRIVATE COLLECTION
Pieter de Hooch, *Woman with Broom and Pail in a Courtyard*

UNITED STATES OF AMERICA, PRIVATE COLLECTION
Isaac Koedijck, *The Foot Operation*

VIENNA, GEMÄLDEGALERIE DER AKADEMIE DER BILDENDEN KÜNSTE
Hendrick Cornelisz van Vliet, *Sermon in the Oude Kerk, Delft*, inv. no. 685

VIENNA, KUNSTHISTORISCHES MUSEUM
Jacobus Vrel, *Woman at a Window*, inv. no. GG 6081

ZURICH, KUNSTHAUS
Hendrick van der Burch, *Woman with a Child Blowing Bubbles in a Garden*, inv. no. K 36
Pieter de Hooch, *Three Soldiers and a Hostess*, inv. no. K 35